Praise for *The Unseen Truth*

"Absolutely brilliant. Uniquely astute. Sarah Lewis grows *The Unseen Truth* from her superb Vision & Justice project into a work of stunning originality. There is so much here as Lewis 'unsilences' the past in a voice both informative and seductive. Her astonishing cast of characters stars Caucasians, Circassians, and most revealingly, Woodrow Wilson. Each chapter exposes the 'racial detailing' that has constructed a repressive racial regime that, once seen, can be undone."

—NELL IRVIN PAINTER, author of the *New York Times* bestseller
The History of White People

"Sarah Lewis's *The Unseen Truth* isn't just a groundbreaking work of visionary scholarship. It's an earthquake. Here is the map key to seeing—or, as she shows, re-seeing—the fault lines of race and how, after the Civil War, they were buried beneath an onslaught of constructed American fictions diabolical in their details and devastating in what they taught generations to filter out, allowing them to see only in Black and white. All credit to Lewis for removing the blindfold."

—HENRY LOUIS GATES, Jr., author of *The Black Box: Writing the Race*

"Race is a fiction, even as it overwhelms and shapes our history. In *The Unseen Truth*, born of her long study of visuality, Sarah Lewis returns innovatively to the story of race as a creation of how we see or unsee. She beautifully illuminates an American and human tragedy—that we may be much better at seeing race than we ever are at understanding it. In a sweeping history from the Civil War to the Great War era, Lewis shows historically how Americans forged a lethal racial regime with their eyes as much as their minds."

—DAVID W. BLIGHT, author of the Pulitzer Prize–winning
Frederick Douglass: Prophet of Freedom

"In a work of great originality and scholarly imagination, Sarah Lewis opens our eyes to what we have been too blinded to see in the narratives of race that have defined our nation. Her insights are transformative and indispensable."

—DREW GILPIN FAUST, author of *This Republic of Suffering:
Death and the American Civil War*

"In *The Unseen Truth*, it is almost as if Sarah Lewis has given us a new pair of glasses that allow us to see history in ways that were previously unclear. Every chapter is suffused with revelations that expand and clarify our understanding of the past. This book has changed the way I look at history. It has changed the way I observe the world. Lewis has provided us with an indispensable resource to better see ourselves."

—CLINT SMITH, author of *How the Word Is Passed: A Reckoning with the
History of Slavery Across America*, winner of the National Book Critics Circle
Award for Nonfiction

"An engaging, compelling read from a remarkable scholar. *The Unseen Truth* shines light on a long-silenced history, offering endless ways to realize the possibilities for justice."

—DEBORAH WILLIS, prizewinning photo historian and author of
Reflections in Black: A History of Black Photographers 1840 to the Present

"Writing about race is like hunting for the origins of a lie. In this masterpiece of American history, written with verve, delicacy, and imagination, Sarah Lewis takes the color line and blows it up, capturing a moment in the late nineteenth century when the older rhythms of racial sight broke down and a new, pernicious attention to detail emerged. The supposed truth of tiny distinctions, she shows us, is a lie of enormous, heartbreaking consequence for the decades that followed."

—MATTHEW PRATT GUTERL, author of *Skinfolk: A Memoir*

"A watershed in the study of art, social, and cultural history, *The Unseen Truth* is probing and brilliant, based on superb research and filled with remarkable discoveries. Sarah Lewis illuminates what it means to both 'see' and create race, deepening our ability to pursue justice."

—IMANI PERRY, author of *South to America: A Journey Below the Mason-Dixon to Understand the Soul of a Nation*, winner of the National Book Award

"Exhaustively researched, deeply original, and analytically brilliant, *The Unseen Truth* is a landmark in the literature on race. Sarah Lewis has uncovered elements that are both literally and metaphorically hidden in plain sight and offered a new way of seeing the racial fictions that surround us. The canon of indispensable books on the volatile alchemy of race has just grown by one."

—JELANI COBB, author of *The Substance of Hope: Barack Obama and the Paradox of Progress*

"In this richly researched and capacious text, Sarah Lewis traces the fictions of race that subtend racial domination and the ways that their maintenance demands a simultaneous seeing and unseeing. With its sustained attention to art, photography, popular culture, and performance, *The Unseen Truth* enacts 'a system break in the usual circuits' of 'racial sight' and representation. This is necessary reading."

—CHRISTINA SHARPE, author of *Ordinary Notes*

"In this extraordinary book, Sarah Lewis opens our eyes to the centuries of sedimented prejudice that continue to shape our present. Taking us on a journey from the Caucasus to America, where new racial imaginaries were being forged, she shows how the instability of the Caucasus as a signifier of race reveals the fragile, spurious nature of racialized thinking itself."

—REBECCA RUTH GOULD, author of *Writers and Rebels: The Literature of Insurgency in the Caucasus*

"*The Unseen Truth* is a call to arms."

—MAURICE BERGER, author of *For All the World to See: Visual Culture and the Struggle for Civil Rights*

THE UNSEEN TRUTH

THE UNSEEN TRUTH

When Race Changed Sight in America

SARAH LEWIS

Harvard University Press

CAMBRIDGE, MASSACHUSETTS | LONDON, ENGLAND | 2024

Printed in Canada

First printing

Publication of this book has been supported through the generous provisions of the Maurice and Lula Bradley Smith Memorial Fund.

Library of Congress Cataloging-in-Publication Data

Names: Lewis, Sarah Elizabeth, author.
Title: The unseen truth : when race changed sight in America / Sarah Lewis.
Description: Cambridge, Massachusetts : Harvard University Press, 2024. |
 Includes bibliographical references and index.
Identifiers: LCCN 2024001351 (print) | LCCN 2024001352 (ebook) |
 ISBN 9780674238343 (cloth) | ISBN 9780674297739 (epub)
Subjects: LCSH: Racism against Black people—United States—History. |
 Black race—Color—United States—Public opinion—History. | Caucasian
 race—Public opinion—History. | Color vision—Social aspects—
 United States—History. | Visual communication—Social aspects—
 United States—History. | Race awareness—United States—History. |
 Scientific racism—United States—History. | African Americans—
 Segregation—History. | Caucasus, Northern (Russia)—History—
 Russian Conquest, 1831–1859—Influence. | United States—Race
 relations—History.
Classification: LCC E185.61 .L535 2024 (print) | LCC E185.61 (ebook) |
 DDC 305.800973—dc23/eng/20240212
LC record available at https://lccn.loc.gov/2024001351
LC ebook record available at https://lccn.loc.gov/2024001352

CONTENTS

I am all the things I have seen:
The New York Caucasian newspaper, the
scarred back of Gordon the Slave, the Draft Riots, darky tunes, and merchants distorting my face to sell thread, soap, shoe polish, coconut.

 —TONI MORRISON, Preface, *The Black Book* (1973)

The term "Caucasian" is dropped by recent writers on Ethnology;
for the people about Mount Caucasus, are, and have ever been, Mongols.
The great "white race" now seek paternity . . . in Arabia . . . Keep on,
gentlemen; you will find yourselves in Africa, by-and-by.

 —JAMES MCCUNE SMITH, Introduction to Frederick Douglass,
 My Bondage and My Freedom (1855)

Some things are just too unjust for words . . . and too
ambiguous for either speech or ideas.

 —RALPH ELLISON, *Invisible Man* (1952)

A NOTE ON LANGUAGE

Throughout the book, I have largely chosen not to capitalize *black* or *white*. There is some equivocation about the style convention at the moment: some insist on capitalizing the word *black*, others do not. This moment in history does not permit equivocation about the facts. As Wesley Lowery notes, "racism is deadly real" but "race itself is a fiction." Retaining the lowercase, following writers including Toni Morrison and Lowery, challenges how we legitimate race as a biological fact at a time when it is critical to do so. This book addresses how the construction of race required turning fictions into fact, with deadly consequences in American life. To capitalize *black* or *white* would undermine the very evidence I present in these pages.

Introduction

Race changed sight in America. The transformation, difficult to observe, has led to a way of seeing that is now so practiced that this very fact can seem unremarkable.

I caught a glimpse of the legacy of this shift in vision when I saw the headline of the verdict in the case of the police shooting of Michael Brown, an unarmed black teenager, in Ferguson, Missouri. I had come home late after teaching a course entitled "Vision and Justice," which considers how images have both expanded and limited our notions of national belonging. Upon checking the news online, I found a *Time* magazine article with the headline "Ferguson Decision Reveals the Brutality of Whiteness." Twenty minutes later, the headline had changed. The word "whiteness" had been edited out. It now read "Ferguson Decision Reveals the Brutality of Racism."[1]

The decision to replace "whiteness" with "racism" did not surprise me. The magazine had used the term whiteness to describe a system of oppression rather than a racial identity, breaking the script of the American racial vernacular. What made me pause was the unnerving ease of the headline change, the all too nimble cut-and-paste operation. The deletion appeared as if a flicker, a system break in the usual circuits, the revelation of a set of decisions being made, constructed, then unmade. I was asked to picture one culprit—whiteness—and then asked to forget what I might have seen and picture another: racism. Even the argument of the article itself had changed. The dynamic mimicked how the unstable production of the nation's racial regime required a shift in vision to stabilize racial ideology resting on specious facts.[2]

We often narrate the history of racial domination around overt actions. These are legion. "Anything but unmoored or isolated, white power was

reinforced in this new era by the nation's cultural, economic, educational, legal, and violently extra-legal systems, including lynching," Henry Louis Gates, Jr. deftly notes.[3] Yet in the United States, the stability of racial ideology was also shaped, crucially, by what was left out. Racial domination under white supremacy came to have the critical feature of erasure, of negative assembly. Sight became a form of racial sculpture; vision became a knife excising what no longer served the stability of racial hierarchy. From the nineteenth century through the segregationist age, cementing racial hierarchy meant disregarding contradictions and falsehoods through conditioned sight, an enduring legacy.

Confections—racial fictions—are not merely assembled. They are not merely formed through racist caricature and distorting stereotypes. They are carved, formed through removals. Learning to unsee the cracked foundations of the project of scientific racism allowed the myth of racial hierarchy to remain intact, making it more difficult to dislodge today.

Racial regimes became stable through a transformation of vision. It is a near maxim that what we see—representation from portraits to stereotypes—changed perceptions of race. The opposite is also true: the use of race as a fundamental category for making meaning in the world has altered how we see it. What emerged between the nineteenth century through the segregationist age were tactics—from silencing to conditioned sight—required to see *around* the instability of the foundations that justified racial hierarchy in the United States. It is this transformation of vision that let obvious fictions remain at the basis of the racial project and settle into a kind of truth.

To understand the birth of this shift in vision means tracing a surprising history little discussed and less known despite its impact on our lives: there was a time when the Black Sea region from which we derive the term Caucasian for whiteness, the Caucasus, was exposed as not racially white at all, nothing like the image put forth by racial science.[4] During the Enlightenment era, the influential German naturalist Johann Friedrich Blumenbach had authoritatively designated the Caucasus region as the homeland of whiteness.[5] But the Caucasian War (1817–1864)—the Russian Empire's centuries-long struggle to conquer the Caucasus in order to gain access to the Black Sea—led to reports that ungrounded the racialized sense of the faraway region in the United States.[6]

This seemingly irrelevant fact about the Caucasus—distant from the United States and racially illegible—did more than challenge narratives

about white racial supremacy. It forced a reckoning with the fictions underneath the foundation of racial hierarchy, ones that had to be shut down for white supremacy to survive. In the context of scientific racism, the narrative of the Caucasus, the locus of racial whiteness, became an unstable point of reference for everyone from students and teachers in segregated classrooms to Supreme Court justices alike.

Yet to glimpse the baselessness of the foundation of racial hierarchy was unspeakable. Sight became more than observation; it meant reading around the *lack* of evidence used to naturalize racial hierarchies under white supremacy in the United States. Racial domination became a process of conditioning, editing out what had to remain unseen.

There comes a point in history when, as Michel-Rolph Trouillot wrote, a society "must decide if a particular narrative belongs to history or to fiction."[7] Few representations offer us a glimpse of this transformation of vision required to unsee and then challenge the history of racial domination more clearly than this forgotten history of the image of the Caucasus in the United States.

There was, indeed, a time when the fault lines of race, the fictions underneath the entire structure of racial hierarchy, were exposed in various cultural forms in the United States, only to be reinterred by a new shared language through which to dismiss them. These fictions were never buried completely. Even while segregation was being federalized in the nation's capital during Woodrow Wilson's administration, the president himself was privately questioning the fabrications underlying its foundation, asking for a report about women from the Caucasus region. It is one of the hidden facts of the production of race in the United States that Wilson's own study of images would help define his racialized, visual policy of American federal segregation.

There are moments of racial rupture that reveal the enormous amount of work done to shore up perceptual coherence in the face of fractured racial myths.[8] The start of the transformation can first be seen in the unexamined connections between the charnel ground of the American Civil War and the Caucasian War. The battlefields in the Caucasus offered Americans a safely distanced yet clear analogy for strife and disunion in the United States. Photographs, prints, paintings, and performances circulating in the United States about the Caucasian War turned the region into an area bound by purported opposites: Europe and Asia, Christianity and Islam,

groups appropriately nestled between tonally contrasting white and black mountains.[9] The effect of this symbolic resonance and rupture was so widespread that at the end of the Civil War, headlines in the United States focused on the demise of Circassia in the Caucasus as if it were an analogy for the end of America's Confederate South.

News about the Caucasian War had started to blend into news exclusively about the United States. During the American Civil War, both Circassia in the Caucasus and the Confederate States of America were self-governing nations. Both were republics contending with a "War of Northern Aggression," fighting to avoid becoming aligned with a dominating power. The leader of the Caucasian War resistance, Imam Shamil, was even referred to as the region's Jefferson Davis.[10] Recent estimates show that by 1865, more than 700,000 soldiers had perished in the American Civil War. By 1864, over 500,000 Circassians had died during the last phase of the Caucasian War in the fight against invading Russian forces.[11] Many accounts in American newspapers described Circassian bodies being "thrown out"—cast overboard with a frequency that recalled slaving practices—and "washing on shore" on the Black Sea coast. As reports emerged about the Circassian plight, the vision of mass death, suffering, and national upheaval echoed Civil War nightmares.

As the war-torn disunited states confronted fears about the porousness of constructed racial boundaries, facts emerged about the battle-torn Black Sea region of the Caucasus that challenged the very idea of racial whiteness and exposed the area associated with white racial purity to visual scrutiny. The change in the perceptions of the Caucasus from racially white to a site of Muslim leadership and anticolonial resistance seemed to disqualify it as a legible, transparent homeland of whiteness.[12] This emergent focus positioned the Caucasus as its own antagonist, a racial contranym, and a contradiction in the public imagination, making it an arena for sorting out concerns about the boundary lines of race in the United States.

Frederick Douglass's 1855 narrative *My Bondage and My Freedom* even centered this splintering incoherence about the Caucasus as a racial concept, a place, and a demography. In the book's preface, physician and abolitionist James McCune Smith wrote, "The term 'Caucasian' is dropped by recent writers on Ethnology; for the people about Mount Caucasus, are, and have ever been, Mongols. The great 'white race' now seek paternity . . . in Arabia . . . Keep on, gentlemen; you will find yourselves in Africa, by-and-by."[13] The prominence of this comment in the widely popular narrative hints at the breadth of focus on the region, not only in the history of

racial and natural science, but also in American popular culture, visual art, and political discourse during the nineteenth century.

The groundlessness of the constructed image of the Caucasus endured in the minds of those involved in the cultural complex in the United States. We see this in the work of a range of figures—from P. T. Barnum to Woodrow Wilson—all involved in the international project of racial formation from the Civil War to World War I and beyond. This hidden history betrays an earlier interest in the region than has been previously understood.

The collapsed racialization of the Caucasus put pressure on visual culture and assessment to sustain, assemble, and challenge narratives about racial formation and hierarchies. It made assessment a visual negotiation used to determine, regulate, and uphold racial hierarchies as social rule. The urgent need to shore up the idea of race despite its false foundations profoundly transformed racial society in the United States.

When I first came across the history of interest in the Caucasus, unaware of the full nature of its impact on racial domination, I tried to dismiss it. After all, we think we know how the story ends: the idea of the Caucasus region would remain an incongruous relic with the idea of homogenous whiteness—an ignored, curious, but irrelevant source of the foundational fiction turned into fact in the United States. This process was critical for understanding how, as Charles Mills maintains, "racial superiority insulates itself from refutation," such that unmarked whiteness retains its power.[14]

What I was finding in the archives, however, startled me enough to continue. Scholars have long thought that the confusion about the idea of the Caucasus and being Caucasian was mainly articulated in scientific literature, not reaching popular discourse until the twentieth century. After Reconstruction, other terms were used, from Anglo-Saxon to Nordic to Aryan. Matthew Frye Jacobson deftly outlines how a range of immigrant groups—from Irish to Italian—were replaced by the category Caucasian with a sense of "certainty."[15] The use of the term Caucasian came about through a determined effort to bear the incoherence, resulting in "amnesia," as Jacobson puts it, regarding the idea "that today's Caucasians had ever been anything other than a single, biological, unified, and consanguine racial group."[16]

The growing, unsettling dissonance between the Caucasus region as a racial emblem on the world stage and the actual appearance of its inhabitants

mattered, even in Supreme Court cases. From the period of Reconstruction to the mid-twentieth century, who could be considered "Caucasian" preoccupied nearly every federal or Supreme Court case about the racial prerequisites of citizenship.[17]

Beginning in the 1870s, when whiteness was no longer the sole racial precondition of naturalization in the United States, the Supreme Court had to confront these fabrications about the Caucasus and excise them from American life. The courts determined that "common knowledge"—our collective stories about race, our everyday assessment—was the new "legal meter of race."[18] These crucial cases, now "largely forgotten," as Ian Haney López notes, would often lay out in detail the absurdities surrounding the term Caucasian. Although these cases were once "at the center of racial debates in the United States for the fifty years following the Civil War, when immigration and nativism were both running high," there is little discussion about what created the common knowledge that masked the false foundations created by racial science. There is little mention about the work of culture in conditioning sight to create this collective judgment.[19]

During this nineteenth-century moment when the idea of the Caucasus was revealed to be contradictory in racial nature, the sutures or "visible seams" of race were exposed. Visualizing the Caucasus developed a way of seeing that required piecing together fragments.[20] This history is generally unseen. Circassians were so decimated during a conflict sustained over decades—now considered a genocide—that few people in the United States have even heard of their diaspora, which spans the world from New Jersey to Jordan and Turkey.[21] It is not uncommon to see in a standard atlas of the environs around the Black Sea both an early map indicating where Circassians lived from 1800 to 1860, and another, later map that simply omits them, as if they were a mythical group.[22] Yet in the United States, this history once mattered. In the nineteenth century, to contemplate the history of Circassia was to consider the racially complicated fate of America itself.

Racial observation is not just about what is seen, but also about what can be disregarded and *how*. Under discussion here is the double action required to glimpse the fabricated basis of racial hierarchies and nevertheless to naturalize it as part of the social order—to see and then unsee, to publish and then edit out. It is not a narrative we tell often, if at all. Understanding the urgency behind this shift in vision demands attention to a set of largely

unexamined visual images, from paintings about the Caucasus to racially coded photographs, that expose the broad sense of internationalism in the transatlantic discourse on American racial formation that, in the nineteenth century, extended beyond the Black Atlantic world to the eastern shores of the Black Sea.

This book traces a hidden story of how the specious grounds of racial domination came to be unseen, and how conditioned this process became through a series of operations, from picturing to negative assembly to detailing. What precipitated this shift was not only the coincidence between the end of slavery and the new era of picturing born of the medium of photography, but also the creation of a new visual regime, an understudied moment when aesthetics had to assume greater authorial language for describing contested racial categories for the public sphere. Without a single fact on which to base the legitimacy of racial domination, by the twentieth century even the Supreme Court was relying on a new form of visual rule, not law and norms alone, to understand governing concepts of race and citizenship.

Silences in the historical record, as Toni Morrison reminds us, are often not mere evidence of lack of significance, but of pregnant recognition. In her seminal work *Playing in the Dark: Whiteness and the Literary Imagination,* Morrison offers a line of inquiry appropriate for the examination of silence in racial provocation. She focuses in particular on the "significant and underscored omissions" and the failure to discuss "startling contradictions" in American literature as suggestive of the "dark and abiding presence," the "Africanist presence," that these looming omissions attempt to obscure.[23]

The project of modernity requires that we modulate our understanding of how race transformed what we even call vision. Race, as W. J. T. Mitchell notes, is a medium and a frame, "something we *see through.*" It is "a frame, a window, a screen, or lens, rather than something we look at."[24] Yet what do we make of moments of rupture when society realized that the frame, specifically as it related to the idea of the Caucasus and racial science, was not only broken, but unstable from the start? While I follow Mitchell's argument, the history of seeing the Caucasus exposes that the processes of sight and racial formation are so fused, so bound together, that we must question how we describe the act of *seeing* itself. The impact of this shift in sight was great enough, and altered the mechanics of sight itself to such an extent, that other descriptions are required.

Viewing through the filter of race changed the very nature of assessment through excision, silencing, and racial detailing. It reframed vision—never purely a retinal act—into a reading exercise, a visual search for narratives to legitimate a social stratigraphy at risk of collapse.[25]

It has long been overlooked that this period of the "second founding" of the United States made visual culture and especially visuality, what was seen and unseen, central for racial contestation.[26] The second founding has been defined as the Civil War period that established the Thirteenth, Fourteenth, and Fifteenth Amendments, which abolished slavery, made birthright citizenship a constitutional right along with the equal protection of the law, and granted the right to vote to black men. Together, these amendments worked to modernize the United States by instantiating equality in the law—and faced a powerful backlash.

Visual representation of all kinds—images, culture, performance—became central for showing the blind spots of norms and laws that did not honor the full humanity of all in the United States. As Eric Foner notes, the ongoing struggle to enact the second founding was so anticipated that the amendments end with a clause granting Congress power to enforce them.[27] Ultimately, the second founding was gutted; the Supreme Court narrowed the amendments. This meant that representation itself—how we see each other—became the unstated testing ground for justice in American democracy.

Representation is an issue that preoccupied Frederick Douglass even in the midst of the Civil War as he wrote about the transformation of race and pictures on the act of perception. Much of the development between politics and aesthetics has sharpened in recent years due to the examination of Douglass's philosophy of politics and aesthetics.[28] Douglass, the most photographed American man in the nineteenth century, gave a speech in 1861 and again in 1865 that once languished in the Library of Congress but has since been taken up as a framework for our contemporary discourse about what I would call representational justice—the connection between democratic representation and being represented justly.[29] In one version of this speech, "Pictures and Progress," Douglass turned his attention away from the Civil War, to the surprise of his audience, and focused instead on the potential of the new medium of photography, especially on the shift in adjudication that it prompted in viewers. The topic of the speech was

perplexing, delivered during a time of heightened American violence, when it might seem unusual to be speaking about pictures and photographs. Yet race would turn images into weapons, a form of representational violence that had the potential to be as insidious as the consequences of combat itself.

Douglass's "Pictures and Progress" speech dwells upon how race and images changed our notion of vision—a process of seeing the world through what he called "thought pictures." Many scholars have begun to consider why Douglass would write on the medium when considering racial reconciliation during the Civil War.[30] He was a man of action. Yet the very reason Douglass seems an unusual actor is what positions him to be a perfect vehicle for ideas about the phenomenology of pictures, and how pictures and photographs were used as a racial technology. Douglass presciently articulated that the revolution of the new medium was as much about representation as perception; he would become one of the first American thinkers to make a case for the twofold political force of pictures—as both object and prompt, a mental picture that could either reinforce or critique stereotypes. Douglass argued that the same medium that had been used "to read the Negro out of the human family" could be subversively used "to read him back in."[31] Just as images had served to reify racial boundaries, they could also undo them. The innovation was not so much in our ability to picture the world around us, but in how images impacted the politics of assessment and judgment.

Part of the reason that Douglass's speech languished in the Library of Congress for over one hundred and fifty years was the revolutionary nature of his thesis. For all the focus on pictures in the speech, Douglass spends no time on the work of any one image, despite the fact that he valued images—he bequeathed his pictures to his daughter and a portrait of himself to his wife in his last will and testament, purchased photographs, and redrafted the speech about pictures three times over the course of his life.[32] He was most interested in what photographs create in us. It is Douglass's seeming flight into the metaphysical dimension where we glimpse his theorization of the relationship among race, images, and perceptions. Collective mental pictures, narratives meant to hold a racial order, have had deadly and, as Douglass argued, could also have liberatory consequences on American soil. To do this, he focused on the seemingly insignificant—the political cartoon, the lyrics of a ballad—not the grand work of one well-known photography studio. Embedded in this decision is the recognition

that a shift in adjudication required a way of seeing born of the idea of assembly, based on piecing together fragments, some that included even images documenting this interest in the Caucasus.

The Unseen Truth is part of an ongoing investigation about how race has impacted vision and justice in American society. It is a moment in which we are grappling with important truths that we cannot see, but that are nevertheless borne of the constructed image—mental racial pictures, a merger of ideological and visual narratives that we use to tell the story of who we are in the United States. The digital landscape has transformed these moments and events into pictures and videos, making increasingly prevalent instances of racial terror and violence hypervisible. Each of these images offers the reminder that our lives are payment for the failure to comprehend the foundations of these narratives. The filter of race, as a lived construct, continues to shape how images, however dismissed, can increasingly be used as a deadly technology of public policy in American life.

Some might say that a focus on such details about the fragmented image of the Caucasus should not matter in the face of much broader concerns about the history of race and visuality. It is precisely this focus on the granular that defined the shift in vision underway in the nineteenth century, a shift that would solidify in the twentieth century with federal segregation. The primary structure of enforcement that coalesced into segregationist policy cohered around racial detailing—a practice of maintaining racial domination by obscuring it through a mass of discrete, seemingly small procedures that define how one moves through space, society, and institutions in every moment of daily life in a racialized democracy. As the national interest in eugenics heightened the importance of physiognomy, the details of one's appearance became part of the language of everyday exchanges of assessment and power. Detail was also part of the new attention to precision in the language of rationalization surrounding scientific management, as Wilson discussed in his scholarship on rational administration.

This importance of detail was also the result of a conceptual merger between the arts and the sciences at the turn of the twentieth century, a merger that forged Wilson's ideas about the "constructive imagination" and so defined his sense of the marriage of modernity, race, and sight for racial governance. After the Civil War, when abolition legally erased the most stubborn visual line of racial demarcation, perhaps the greatest deception

concerned the development of a false foundation on which to enforce racial boundary lines. In order to shore up the oppressive logic of the Jim Crow era, precise details of figurative measurement—even those of some individuals in the embattled Caucasus region—became a matter of policy.

The chapters of this book focus on the transformation of vision and a highly circulated set of images—from maps to paintings to photographs—that were brought to bear on the formation of race in the United States, from a geography that had largely existed in the US imagination. The first three chapters focus on the period after the Civil War when images of the Caucasus began to circulate in American civic life. The final chapters consider the devastating consequences of this change for both domination and resistance through the period of segregation and Jim Crow rule.

The enduring images about this region tell us as much about the inner worlds of cultural, artistic, and political leaders from Barnum to Wilson as they do about the fugitive notions of racial formation, claims to citizenship, and ultimately the emerging concepts of internationalism in the early twentieth century.

In September 2019, I took a trip to the Caucasus along the Black Sea, traveling with the acclaimed historian Nell Painter. As we toured around, researching and presenting at a conference, we asked the people we met, "How did you learn that the term Caucasian also means racially white?" For the most part, they had no idea what we were talking about. Our translator was so baffled by the question that the picture I took of her shows bemusement and slight alarm.

Yet those we interviewed who had learned about the relationship between the Caucasus and racial whiteness did so through visual culture and policies of racial adjudication found in the United States. One woman, for example, had learned about the term by filling out a US immigration form. She saw a box for Caucasian and her father told her that whatever it meant, she was "the original Caucasian," so it would be fine to just check that one. Another learned by getting her blood taken and being asked her race on a form at the clinic. Some learned about it from studying anthropology and the history of racial science. One man learned about it from visiting the United States for a study abroad program and meeting a white supremacist who, as he recalled, treated him "like a God."[33]

The point of our trip was not to retread the ground of racial science. Instead we wanted to witness the region that had generated such contradictions in the United States that the coherence of the American racial regime had nearly fallen apart. The trip made plain that what had developed in nineteenth-century America was an enduring mode of picturing that compensated for the use of racial terms based on fictions that had hardened over time into so-called facts, but it was a visual regime with limits.

"Why do we continue to use the term Caucasian, given all of this?" I received this question at a presentation at the New York Public Library. It brings up the deliberateness behind our collective double action of seeing and unseeing this region. Yet uprooting the term Caucasian is not necessarily my aim. The issue is not with the term Caucasian, but the process that has let it remain. Indeed, with every use of the term Caucasian as a category for racial whiteness, we are reminded that race changed sight in America.

What is assembled here is a history of what many have refused to see. It is a history most capaciously told by being attuned to the slow, precise consideration of information that falls off the edges of our vision. "If some events cannot be accepted even as they occur, how can they be assessed later?" Trouillot asked. One answer is to look at the shape created by the unacceptable, the "unvisible," around this history.[34] We see it by looking at the untouched files, the resistance to attempts at unsilencing.

The processes that have masked over this hidden history have enacted a form of epistemic violence, naturalizing the reproduction of fictions beneath our racial order. It may be said that there is, as Trouillot writes, an invective, a near representational violence, in silencing this history.

The Unseen Truth assembles a new record, holding a mirror up to the system of assembly that, like the *Time* piece, is so easy to miss, contained as it is in such scattered shards that you might not see it if you move too quickly past works in galleries, in archives, and on museum walls. The purpose of this book is to make this history significant and so defamiliarized that we pause long enough to see it anew. The longstanding of adjudication is so pervasive and devastating that it is only possible to fully see, withstand, and process by assembling at last these long-ignored fragments.

"We accept the illogic of race because these are the things we have been told," Isabel Wilkerson deftly argues in *Caste: The Origins of Our Discontents*.[35] We can be more precise still. We have not been *told* about

the fabricated fictions that have resulted in the illogic of race; we have been conditioned not to see them.

Unearthing the images, texts, and objects from the Civil War through World War I that lay bare this forgotten history offers a view of the country caught off guard, a glimpse of an era coming to terms with the fact that seeing racial ideology—including and because of the construction of racial whiteness—required narrative assistance, namely a conditioned assembly, silencing, and adjudication. It is a view of a nation as nervous about the unfixed boundary lines of race as it was determined to demarcate and reinforce those lines through Jim Crow rule and federal segregation. It exposes a time when the country negotiated a new merger of visual assessment to make sense of a racial regime with specious foundations. Yet the mode of vision birthed during this time is so familiar to us today that if we fail to stop and carefully bear witness to the pieces of the story, trying to grasp the residue of its mechanics is like trying to see air.

1

Ungrounding

The Caucasian War and the
Second Founding of the United States

In the fall of 1919, less than a year after the armistice agreement to end World War I had been signed, President Woodrow Wilson should probably have been doing something—anything—other than asking for "a report on the legendary beauty of the Caucasus women."[1] Yet there he was, requesting it from none other than Major General James G. Harbord, once the chief of staff of the Army Expeditionary Forces, and now the head of a commission touring regions including Armenia. It was an odd request, even if the region had long been a focus of interest for Wilson and others. By the spring of 1919 Wilson's war-related reasons for studying the Caucasus region had dwindled. Any hopes for a more extended resolution to territorial disputes for self-determination had come to an end.[2] Wilson had no shortage of competing demands on his time. Just a month before this inquiry, the president had embarked on a grueling seventeen-state tour, presenting his argument in favor of the Treaty of Versailles and establishing the League of Nations. "An American president had never before spoken, as Wilson did during the war, on such a grand stage, to such a broad audience, and with such a widespread effect," historian Erez Manela notes.[3] Now in the midst of this work, Wilson was asking about the appearance of women from the place where we receive the term Caucasian for racial whiteness.

It is curious. It could seem innocent enough, and that he had reason. When Wilson made his request for the Caucasian report, a portrait of a girl from Transcaucasia hung above his fireplace. This painting by Hovsep

Pushman, *L'Esperance* (*Hope*, ca. 1916) was framed as a plea for empathy and aid for survivors of the massacre of Armenians, now considered a genocide. It centers on a young girl wistfully contemplating a single snowdrop flower, "the first flower of spring," to convey "the hope of her scattered race." (Pushman was known for his portraits; his portrait of the Egyptologist Archibald H. Sayce of Oxford was lauded as a "Caucasian head of the highest and finest type."[4]) Wilson had received the painting as a set of Armenian leaders came to the White House. It was of a "typical Armenian child" and the painter's wife hoped that "our President in looking at it will realize that Children like her . . . are the sort that are tortured by the Turks and are perishing daily by thousands."[5] The painting was installed in the White House and then in the main drawing room of Wilson's final home in Washington, DC, where it remained for the rest of his life (Figure 1.1).

In 1919, Wilson had just sent Harbord to assess the state of Anatolia and Armenia in the context of a potential League of Nations mandate. The plight of Armenians, largely considered a political and humanitarian crisis, fell under Wilson's broader interest and had required a careful focus on shifts in the Caucasus region. Armenians were part of a larger set including Kurds,

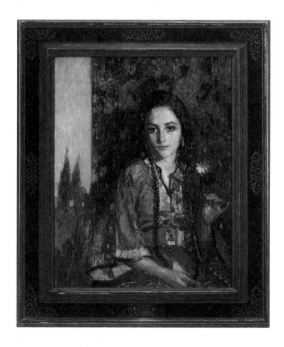

1.1. Hovsep Pushman, *L'Esperance* (*Hope*, ca. 1916), oil on board.

Koreans, Georgians, Syrians, and Lebanese who wanted what Wilson would call self-determination—government by popular consent.[6] In this postwar settlement, Wilson aimed to position "international sovereignty and equality" not as "a prize to be won or a privilege to be earned but a basic right that any nation could claim."[7] He was concerned about such "unorganized" people as he referred to them, in that they "have no political standing in Europe."[8] When it came to considering the outcome of the region, Wilson was concerned with peoples who, he said, are "of our own blood."[9] The US Supreme Court would soon rule in *United States v. Cartozian* that Armenians should be designated as white, as immigrants were negotiating their place in the umbrella of racial whiteness in the United States. Yet as the conception of whiteness became regimented in the early twentieth century, the myths about the Caucasus region re-emerged.

It is common to discuss Wilson's segregationist administration as a topic separate from the international politics that defined his presidency. This was a frequent criticism of the United States during World War I: the US government was making policy abroad and condemning injustices while not attending to racial violence within its own borders. Yet Wilson's concern about the self-determination or independence of stateless and non-Western groups after World War I forced him to take the same fine-grained approach to studying the world that he had developed in the years leading up to the Red Summer of racial riots, violence, and contestation in Washington, DC, when his administration became the first to introduce segregation as a federal policy.[10]

Someone across the Atlantic must have seen Wilson's request as not only curious but loaded. The system of racial caste seemed secure, regulated through America's segregationist regime. Wilson himself had inaugurated federal segregation and had passed restrictive immigration policies founded on fears about racial "degeneracy" and eugenics. He had famously screened director D. W. Griffith's 1915 *Birth of a Nation* at the White House, which granted an all but official presidential seal of approval to the Ku Klux Klan–lauding film glorifying white supremacy. (The film's intertitles even included excerpts from Wilson's published writing.) Alongside the economic innovations of his landmark New Freedom platform, with its anti-trust legislation, banking reform, and tariff reductions, he presided over a political period when concerns over the threats to the supremacy of racial whiteness sheeted the US political and cultural landscape like a shroud. At

this midnight in American life, he maintained near total silence in the face of racial violence.[11]

To honor Wilson's request, a party of seventy women from the Caucasus region filed into a building in Tiflis (now Tbilisi), Georgia, in October 1919.[12] Organizing the gathering had fallen from Harbord to the High Commissioner for Transcaucasia, Georgia, Azerbaijan, and Armenia, Sir Oliver Wardrop.[13] It would have been an odd task for him, an officer ensconced in negotiations with foreign ministers. Wardrop made that clear in a letter to his wife—"parties" are "not in my line," he wrote. His aim was to help "prevent quarrels and possibly bloodshed."[14] Yet he did not balk. The women he gathered were from Georgia, but, as Wardrop wrote, "not one person in a thousand knows that the Georgians and Circassians are distinct peoples."[15] Circassians, an indigenous group in the Caucasus, were seen by the founders of scientific racism as the purest of the Caucasian race. The women from the Caucasus were presented for inspection to Harbord, whose opinion of them "was desired by President Wilson."[16]

I could not be the only one who thought it was unusual. The stakes of World War I included a sharp focus on grounding the order of racial domination. "We are the only one of the great White nations that is free from war today, and it would be a crime against civilization for us to go in," Wilson told his adviser and trusted confidant Colonel Edward Mandell House in 1917, just before his decision to enter the war. He continued to see the conflict in color-coded racial terms. "With the terrific slaughter taking place in Europe, if we, also, entered the war, what effect would the depletion of man power have upon the relations of the white and yellow races?" he asked. "Would the yellow races take advantage of it and attempt to subjugate the white races?"[17] If it can be argued that one effect of the American Civil War "was to replace the sentiment of section with the sentiment of nation," as Louis Menand writes, then one effect of America's involvement in World War I was to expose the conflation of the concept of nation with racial whiteness.[18]

Wilson would publish and govern based on a regime of visual literacy, which he considered central to fashioning the modern racialized world. He first developed his idea during the period of cultural backlash after the end of slavery, the period of so-called Redemption in the United States—"when the gains of Reconstruction were systematically erased and the country witnessed the rise of a white supremacist ideology," as Henry Louis Gates, Jr. argues. Wilson's notion became a totalizing visual regime that compensated for the use of racial terms based on specious foundations and helped to instantiate racial domination.[19]

It was a war in the Caucasus, however, that would unground the racial image of the region in the United States. The Caucasus was a front—a battlefield and a racial facade. As the Caucasian War ensued, what seemed to be under attack, in reporting in the United States, was a racialized frontier. Unlike the Crimean War, it could not be easily seen. There was no clear front line to glimpse the Caucasian War. Few would travel there. Yet reports about the war would reveal the Caucasus for what it really was and still is—one of the most demographically complex places on earth.

Wilson's request would reveal that buried beneath the history of racial segregation and Jim Crow rule was a problem: what we think we know about race in the modern age, built up over centuries, has been grounded by accommodating fictions and crafted narratives—an entire system of assembly to justify racial hierarchies and domination. Despite the hardening of racial lines around the legitimacy of white racial domination, there were two images of the Caucasus in the United States—one that was racially white, and another that was impossible to categorize because it was so heterodox.[20] Wilson's inquiry exposed an entire world of racial assessment shaped by detailing, silences, and omission—a transformation of what we call sight to justify the lies that shaped the narrative foundation of racial hierarchy in the United States.[21]

To understand the origins of this transformation requires going on an unexpected journey that begins, of all places, in the dynamic entertainment complex of New York City shaped by none other than impresario Phineas T. Barnum.

In 1864, in the midst of the American Civil War, P. T. Barnum, the "Greatest Showman of the Century," capitalized on the confusion about racial categories with a widely popular spectacle about the Caucasus region. At his American Museum on Broadway in New York City, he advertised a Circassian Beauty, a refugee of the Caucasian War whom he promoted as an "extraordinary living FEMALE SPECIMEN OF A NEW RACE from a remote corner of Circassia" (Figure 1.2).[22] The impresario would later refer to her as Zalumma Agra, "Star of the East." There were soon several more, all with Z names—from Zoe Meleke to Zoe Zuemella—in his museum, roving circus, and in dime museums around the country.[23]

Each Circassian Beauty had their hair teased into an afro-approximating style—"frizzled," described as a "wig" done up "in a great mass, like the

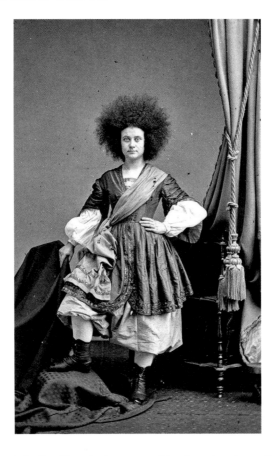

1.2. Mathew Brady Studio, *Circassian Beauty*, ca. 1860–1870, glass plate collodion negative.

boll of a ripened dandelion," large enough to "just about fit a bushel basket," "round like an electrified mop" or "moss-haired"—around her alabaster-white, stoic face.[24] At a time in the nineteenth century when hair became a cranial exoskeleton, a new way to fixate on racial construction, there would be many comments about the Beauties' hair, but never to detail racial types. These adjectives were so odd, mechanical, and disconnected from the body that they register a near disavowal of racial terms. Barnum would push this further. As Americans "found hierarchy in hair," as Louis Menand said, describing part of the findings from a trip undertaken by Barnum-fascinated Louis Agassiz, the Beauties, with their white afro hair, had toppled it.[25]

The Circassian Beauties would become some of his highest-grossing performers, which was fortunate for Barnum, who "practically invented the notion of fame," because when he debuted the first Circassian Beauty, he was bankrupt. He needed a new performance for his American Museum to "make a second fortune."[26] During the opening season of September 1864, the Circassian Beauty gained popularity; that season, he was able to raise the entrance fee to thirty cents and was soon solvent.[27]

Why were the Beauties from the Caucasus so wildly popular? The reasons have been "only half glimpsed."[28] Barnum's staging mined the sphere of entertainment to do what few others could—offer the public a space to debate persuasive fictions. His spectacles included the display of Joice Heth, who was outrageously claimed to be 161 years old and the former enslaved nurse to George Washington, as well as ethnographic displays called "missing links" and "What Is It?" But what ran throughout each was his invention of the American "humbug"—a hoax that, as Kevin Young argues, was critically needed for the new American republic to process its "hypocrisies" and the "contradictions of freedom and slavery, exploration and faith." These spectacles had a clear enough artifice to give viewers a chance to not simply be "fooled" during what was called the Age of Imposture, but also have an arena to process *how* they had been duped.[29]

What does it mean that an aesthetic that now could connote black empowerment was once associated with an incendiary performance of racial whiteness in the nineteenth century? I wondered this as I first stared at photographs of women from circa 1870, magnum coiffed, self-possessed, and sartorially arranged with personal flair (Figure 1.3). The image of legendary 1960s and 1970s black power activists with outsized afros, from Kathleen Cleaver to Angela Davis, has become part of the signature "style / politics" of the black empowerment movements.[30] These performers of African descent, being displayed as representatives of pure whiteness, would embody the hidden truth about the unstable foundations of racial hierarchy on American soil.

Stripped of the ground of racial science, mounted as a figurative display, Barnum's presentation of the Circassian Beauties challenged the grounds of the regime of racial ideology and hierarchy in order to advance his supreme goal—to profit by confounding his audience. His "operational aesthetic" lampooned the unstable foundations of racial hierarchy with a reportorial strategy.[31] The impresario's entrepreneurial acumen suggests that the perception of the Caucasus had broadly penetrated society at large.

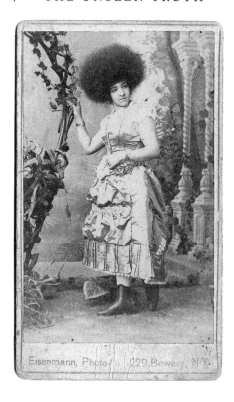 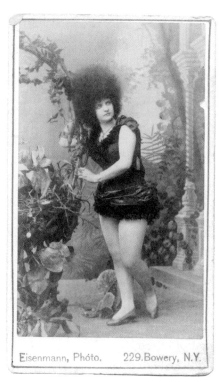

1.3. *A (left).* Charles Eisenmann, *Circassian Beauty,* ca. 1880, carte de visite. *B (right).* Charles Eisenmann, *Circassian Beauty,* undated, carte de visite.

From Barnum's performers to everyday maps and court cases, the public would, as we will see, confront the absurd and the significant in order to grasp it: the idea of the Caucasus was a racial fabrication in American life.

For Americans, this mattered. After the Civil War, "white supremacist ideologies continued, unbridled and disengaged from the institution of slavery."[32] To see the ruse of racial ideology unsettled the ground, and required new regimes to stabilize it.

Shortly after Barnum premiered the Circassian performers, Confederate agents tried to set his American Museum on fire. The following year, Confederate sympathizers irate over his display of a wax figure of "Jefferson Davis in his wife's petticoats, trying to escape capture" nearly burned the museum to the ground completely.[33]

Newspapers reporting on the arsons, from the *New York Times* to the *Philadelphia Inquirer,* included a strange detail: the Circassian performers, the so-called exemplars of white racial purity, were supposedly the first to

notice the danger, the first to decide to leave the building, and the first to emerge from the flames. During the trial of one of the Southern arsonists, it was revealed that the Circassian Beauty was in fact nowhere near Barnum's American Museum that evening.[34] Yet even the museum fire became a scene for the staging of Americans' fixation on the Caucasus as a symbol of primacy, in this case through a literal race out of the building.[35]

The provocative display was a shrewd move on Barnum's part. Battle-torn Circassia was quickly becoming a potent racial contradiction in the cultural imagination, just as the permeability of the constructed racial boundaries was gaining national importance. When the Circassian Beauties were making their debut, the influential German anatomist physiologist Johann Friedrich Blumenbach was releasing a third edition of *On the Natural Variety of Mankind* (1795), which established a canonical racial categorization and cemented Circassia in the Caucasus as the homeland of white racial purity.[36] Yet the war would undo the image crafted by racial science.

Even in 1913, the fixation on the fractured grounds of racial domination made news in the United States, as images emerged of villages in Circassia in the Caucasus that were somehow made up entirely of "Negroes" (Figure 1.4). They were "Batumi Negroes," black families who lived on roughly six-acre tracts of land.[37] The first American to travel the entire length of the Caucasus between the Black and Caspian Seas, George Kennan, had laid bare the fictitious racial image projected onto the region. His writing, lectures, and robust speaking circuit made him one of the most popular lecturers in the United States in the nineteenth century.[38] Kennan had collected an image from his travels, now archived in the Library of Congress, suggesting that he too was aware of this Caucasus narrative plot twist.[39] He was not alone. In 1927, the Russian writer Maxim Gorky went to the village of Adzyubzha to discern for himself the origins of these black Caucasians.

In the 1930s, poet Langston Hughes, too, would visit Transcaucasia and describe his feelings of "disorientation" while traveling south within the Soviet Central Asian republics. He wrote in his diaries that he was surprised to find himself around people who were "brown as russet pears" or "dark as chocolate."[40] Hughes seemed to know about the racial heterodoxy of the broader region. When he came across a Ukrainian-speaking black man in Kiev, Hughes speculated that the man was likely of "Abkhasian descent from the small colony of former Turkish slaves on the Black Sea."[41] Throughout his diaries and published writing, Hughes continually noted that he was

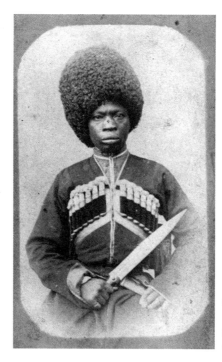

1.4. *Karabakhski*
"Arab" Negro Moun-
taineer, ca. 1870–1886,
carte de visite.

surprised to find himself among those who would be considered pheno-
typically "colored" in America (Figure 1.5).[42]

For Hughes, the world's racial topography seemed to shift with each en-
counter. For example, he went to Merv, a city that his guide told him was
"the cradle of civilization, the place where the world began, and the site
of the original garden of Eden." Hughes recalls being told that "the women
there were still beautiful," as if an oblique reference to the role beauty had
played in the earlier racial designation of the Caucasus. Upon arriving in
the cotton farm of this desert town, with its only twelve cars, by his esti-
mation, Hughes remarked that his view of the city made him wonder if
"perhaps this *had been* the Garden of Eden." To corroborate this sense of
the origins-like city, Hughes offers descriptions of men and women as if
referencing an inner visual catalogue. There were "shepherd boys . . . who
looked like they had stepped straight out of the Book of Moses," and men
who looked like "Sunday School characters" except for their karakul hats,
or "black wild-looking headgear." He recalled a foreman in cotton fields
with a man he describes as "of chocolate skin, who looked as if he could have
come from Harlem."[43] Hughes's descriptions of his time in Transcaucasia
were not just succinct attempts at visual impressions or "travel writing,"

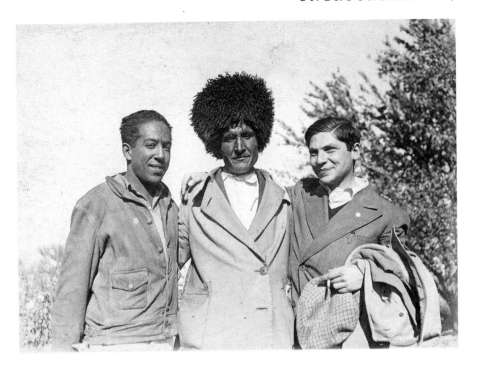

1.5. *Langston Hughes, unidentified comrade, and Arthur Koestler in Soviet Central Asia,* 1932, gelatin silver print.

but constructive correctives—attempts to right the record that had racialized the globe.

As a professor before becoming president, Wilson wrote about the Caucasus, the so-called homeland of racial whiteness in the mid-nineteenth century, in his own publications on American history.[44] The history of racial science gave the region a symbolic charge, conditioning how others saw the geography. The Caucasus became a product of views passed off as knowledge, of insistent vision presented as truth. The claims about the Caucasus had become so widespread that when Alexandre Dumas began his 1859 book *Adventures in Caucasia* with the statement "I have no doubt that my readers know the region as well as I do," he was right, except that their knowledge was based on specious information.[45] A group of approximately two million inhabited this region. It was long said that somewhere between the Black and Caspian Sea is where Noah's Ark had come to rest, according to Genesis 8:1–4.[46] The Caucasus was where Prometheus had been chained

to a rock in eternal punishment for having stolen fire. Beauty—based on subjective categories such as lore and symmetry—became a foundational part of the evidence for Caucasian superiority. And so Circassians, seemingly white, primeval, and supposedly close to God's image for humankind, were cast as the most beautiful racial type.

Scholars focused on the history of whiteness—including Theodore Allen, Matthew Frye Jacobson, Nell Painter, David Roediger, and Reginald Horsman—note that Blumenbach rested his case, in part, on subjective views about women in the region found in narratives by the famed seventeenth-century French jeweler from the court of Louis XIV, the traveler Sir John Chardin.[47] Yet an anonymous eighteenth-century painting of Chardin with his enslaved African young man, wearing a slave collar and holding a map of the environs near the Caucasus, hints at the racial reversal that would come (Figure 1.6). Over time, as Bruce Baum notes, the area's once "exemplary 'whites'" ultimately became seen as "racialized 'blacks,'" or *chernyi* in Russian.[48]

Blumenbach aimed to push back against the rising tide of belief in polygenesis in the 1770s, stressing the common origins of all mankind. Yet his work was a gateway to "a far more insidious form of racialized classification," as Henry Louis Gates, Jr. and Andrew Curran note, because it fixated on differences in anatomy within each racial category.[49] Blumenbach established a canonical racial categorization. It rested on Carolus Linnaeus's *Systema Naturae* (1758) and its cartographically based four-race system: Americanus, Europaeus, Asiaticus, and Afer (African). Blumenbach expanded it to five: "Caucasian," "American" for peoples then in North and South America, "Ethiopian" for Africans, "Mongolian" for east Asians, and "Malay" for South Pacific islanders and Australians.[50]

Blumenbach's assertions made creating a cogent image of the region as tricky as completing the Caucasus jigsaw puzzles that were popular in Europe and America in the 1820s. Elevated to the pinnacle of the constructed hierarchy of racial purity, Circassia was within easy reach for toppling off its perch, due to the geographic contradictions built into his definition. Regions that one could not possibly even glimpse from the top of the Caucasus Mountains came under the area's designation. As a major Supreme Court decision from 1922 put it, the term Caucasian includes "far more [people] than the unscientific mind suspects," including those who are "in color . . . from brown to black," adding that "the average well informed white American would learn with some degree of astonishment that the race to which he belongs is made up of such heterogeneous elements."[51]

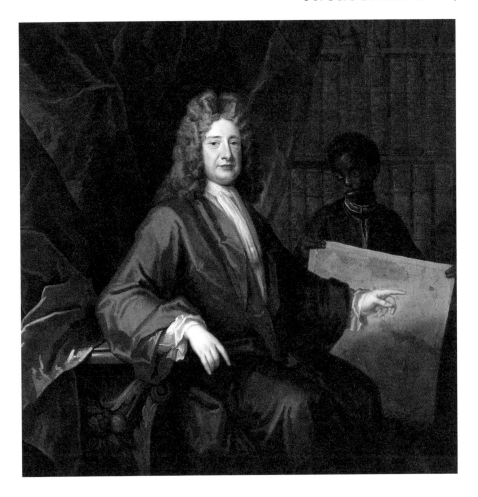

1.6. Unknown artist, *Sir John Chardin with an Unknown Male Attendant,* ca. 1711, oil on canvas.

Another problem lingered and with it came an opportunity for Barnum: for all of the discussion about the Caucasus, there were few images of actual people from the region.[52] There were also few such images in the United States.

Woodrow Wilson turned the mission in Georgia into an uncanny update of Barnum's Circassian Beauty show—women were presented; racial narratives assessed. The performers were a consistent feature of one of his favorite establishments, Keith's. This dime store on Fifteenth Street in New York also had a Washington, DC location that Wilson would famously patronize while in the White House. Circassian Beauties were on stage at

Keith's when Wilson was courting his fiancée, Ellen Axson, in New York City in the 1880s (Figure 1.7).[53] In an 1880 newspaper report, a man recalled when "three Circassian girls sat in a row" as the lecturer in a dime store in New York City spoke with "solemnity" about their homeland in Circassia, mentioning that "they were selected for their beauty and goodness, and are the most wonderful objects in ethnology now on view before the American public."[54] Decades later, Wilson's rumination would disclose confusion over racial concepts about the world by many living in the midst of what seemed to be a settled racial regime, including those who would instantiate a regime of racial domination in the federal government.

Seeing the world fictions undergirding racial hierarchy, has been, in effect, "unthinkable," per Michel-Rolph Trouillot, due to the lack of frameworks or concepts.[55] Barnum's stage—those like Keith's—offered one. The arena of culture made this transformation to narrative assembly a condi-

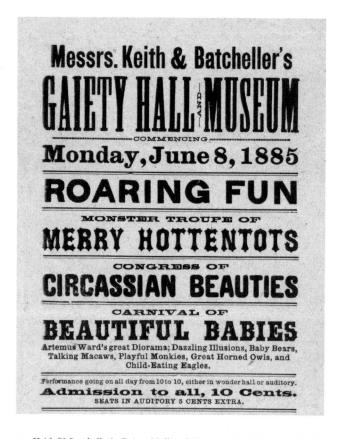

1.7. *Keith & Batcheller's Gaiety Hall and Museum.* Playbill, 1885 *(detail).*

tioned experience. The crowd-pleasing hoax tactics of Barnum's shows—adjudicating world histories and racial beliefs—mapped onto the transformation of vision required to secure racial hierarchy in the United States.[56]

The ungrounding of race in the wake of the Caucasian War diagrams a period when we glimpse *why* the tactics of unseeing became critical for securing racial domination through Jim Crow rule, segregation, and narratives of racial difference. The idea of the Caucasus was irreconcilable. What had been gleaned from reading "facts" about the Caucasus was exploded by images; what was learned from "seeing" the Caucasus could not be confirmed by any textual works at all.

The Caucasian War would force a reckoning. The national fascination with the distant, visually complex Caucasus honed how natural scientists, politicians, artists, and citizens interpreted world-historical narratives to both critique and operationalize racial domination in our everyday lives. It transformed vision into a process of constant construction far earlier than has been understood in studies on modernism and US history at large.

The Beauties' performance exposed the nation's own hoax: the public had been tricked into believing that racial hierarchy rested on foundational, objective facts. The wake of the Caucasian War—Barnum's famed show, Wilson's request—would dislodge, for many, the unstated truth: there was a time when American society could see the fault lines of race, the fictions underneath the entire structure of racial categorization and whiteness, and had pressed on.[57]

The gambit of the Circassian Beauty seems simple enough. For months, the so-called Caucasian figure sat still on the museum stage as Barnum read from a biographical pamphlet that referenced precise, publicized details about the Circassian expulsion of the 1860s during the Caucasian War. He emphasized her experience fleeing the conflict along the Black Sea, with authenticating details about the Caucasus—from the Terek River to the Caucasus Mountains—framed as the locus of white racial purity.[58] The public learned of the Beauties by seeing them in circus sideshows, on dime museum stages, and by purchasing their photographs sold year-round. In much the same way that Barnum would bring traces, ephemera, or even figures central to political struggles from an increasingly international stage into his museum, he now brought a so-called embattled Circassian to the public in the hopes that the widespread interest in the Circassians' collective plight would make her an attraction. He was right.

Scholars have long argued that the popularity of these performers was due to their resonance with the history of racial science, racial stereotypes, and white slavery—the eastern slave trade for the practice of sexual slavery in Ottoman harems.[59] For some time, I thought so as well. The languid poses of some of the later images of the Circassian Beauties make these references pronounced. In Eisenmann's studio from the 1870s onward, the dress of the performers was often scanty—pantaloons and bustiers—with each woman positioned in a repeated state of recline resonant with the representation of harems in paint, in print, and in performances of the day. The performers played on the interest in Orientalism and white slavery, a thinly veiled Barnum humbug that trafficked in the libidinal economy of race, gender, and sexuality (Figure 1.8).[60]

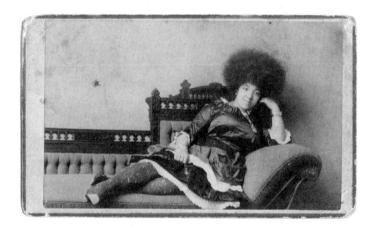

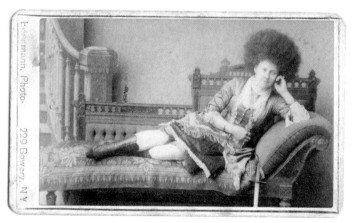

1.8. *A (above)*. Charles Eisenmann, *Circassian Beauty*, undated, carte de visite. *B (below)*. Charles Eisenmann, *Circassian Beauty*, undated, carte de visite.

Even the pamphlet for Barnum's *Zoe Meleke: Biographical Sketch of the Circassian Girl* (1880) dedicates a significant amount of its sixteen pages to praising the United States as a site of salvation, reminding the reader that Zoe, shown sitting with her hair coiffed into a magnum afro, had reportedly just escaped enslavement in a sultan's harem. The narrative told the audience about her appreciation for her unparalleled "freedom" in American culture. Barnum recounted that she "expresses her preference for America over Europe and thinks the people of the United States are the most prosperous and free in the world."[61]

Tales of Circassians sold into white slavery were already circulating. Mark Twain wrote about Circassians in *The Innocents Abroad*. William Thackeray would reference the history of the Circassians in *Vanity Fair*. In the 1860s, it was hard to read the news and not see a mention of the Caucasus Mountains, made famous by Leo Tolstoy, Lord Byron, and Alexander Pushkin, whose *A Prisoner of the Caucasus* (1822) became the template for staged performances, operas, and literature about the region. It was a fabled land of imagination: the Caucasus was where, in Greek mythology, Prometheus stole fire as his gift to civilization and was then chained by Zeus to the Caucasus Mountains for his exile. It was a land written and conjured into being—a "literary Caucasus."[62] Many of these narratives reflected Orientalism, with its exoticism and racialized and gendered differences, to bring what Edward Said has famously called the "imaginative geography" of the Middle East and North Africa closer to home.[63]

At a time when slavery was precipitating the American Civil War, comparisons between representations of transatlantic slavery and white slavery were impossible to ignore.[64] White slavery, Daphne Brooks notes, was "the ultimate appeal to abolitionist audiences" to challenge the associations of race and bondage across the Black Atlantic world.[65] They were also historically tied. As Ottoman Turkey captured Constantinople and closed the entrance to the Mediterranean from the Black Sea, sub-Saharan Africa became the prime source for the enslaved.[66] The inhumane trades were connected; white slavery foreshadowed the transatlantic slave trade's development from an operation with permanent posts and forts into a complex organization that coordinated the long-distance shipment of the enslaved by sea to multinational markets.[67]

Stories about white slavery and the Caucasus provoked interest and moral outrage. "Parcels of Circassian girls" in Constantinople became seen as

the Caucasus's most visible product.[68] "They sell their own children, their wives, and their mothers," Immanuel Kant asserted about the "inhumanity" he witnessed in the Black Sea region. Voltaire summarized it this way: "The Circassians are poor, and their daughters are beautiful, and indeed, it is in them they chiefly trade."[69] *Harper's Weekly* trafficked in the currency of the story with an article published on June 16, 1860, about an American man who went to "have his likeness taken at a photographer's," was sent into a "manipulating-room," and was "disconcerted on seeing a Circassian beauty . . . chained, and on her knees."[70] The production of culture, commerce, and discourses on morality fueled the interest in white slavery. Enlightenment-era social movements, and sentimentalism connected to the propriety of white Victorian womanhood, kept this history urgent and current.[71]

Reports on the fire at Barnum's American Museum even paired the Circassian Beauty with Hiram Powers's well-known marble sculpture of white slavery—*The Greek Slave* (1844), a nude, manacled, female captive that had become one of the most famous works of sculpture and ultimately, abolition (Figure 1.9). Accounts of the fire included a widespread story of the Circassian Beauty leading a procession out of the building, which concluded with this sculpture being hauled out last by a policeman. A second version of the sculpture toured across America between 1847 and 1849, from Boston to Louisville and New Orleans.[72]

The Greek Slave became a lightning rod for criticism of the inhumane practice of slavery; Frederick Douglass would keep a miniature of the work in his parlor.[73] The sculptor had fashioned the many versions of this popular nude statue with the figure's hands at her side and in front of her. Even the earliest reviews of *The Greek Slave* took the sculpture as a reference to both the transatlantic slave trade and the trade of enslaved Greeks by the Turks during the Greek War of Independence.[74] When Freeman Henry Morris Murray, an early art historian working as a federal clerk in the Woodrow Wilson administration, wrote the first book on the history of race and representation in the United States, he opened with a discussion of *The Greek Slave*. Murray would call it "American art's first anti-slavery document in marble."[75] Powers made his eventual direct critique of slavery clear in the work's sequential production. In the final version of the sculpture, executed after the Civil War and ratification of the Thirteenth Amendment, he rendered the figure not in chains, but in manacles as a direct allusion to transatlantic slavery.[76]

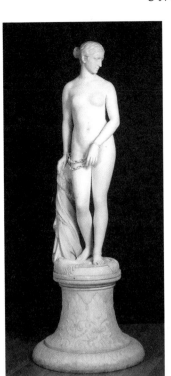

1.9. Hiram Powers, *The Greek Slave*, 1850 (after an original of 1844), marble.

White slavery became read through the lens of the transatlantic slave.[77] In 1851, the British magazine *Punch; or, The London Charivari* published an engraving of a black woman chained to a pedestal in the same position as the sculpture, entitled "The Virginian Slave, Intended as a Companion to Powers' 'Greek Slave.'"[78] (The magazine was influential; Frederick Douglass argued that it had such strong rhetorical "power" that it was "more potent than parliament."[79]) Antislavery demonstrations centered around *The Greek Slave* (1844, first version) at the first international exhibition, the Great Exhibition of the Works of Industry of All Nations. The American exhibition space, housed in the Crystal Palace in Hyde Park, London, was nearly empty before the sculpture arrived—with the notable exception of a photographic display of Mathew Brady's "Illustrious Americans," alongside "boat oars from Boston" and "a meat biscuit from Texas." This sparse showing was excused in a review by the *New York Times* because "it was

hardly to be expected that so young and simple a people as that of the United States would make a very brilliant debut."[80]

Prior to this moment, Blumenbach had represented the Caucasian ideal with the skull of a woman sold into white slavery. The "Caucasian" skull was from Georgia, the country where the gathering was held at the behest of Wilson.[81] Blumenbach had three main arguments to center the Caucasian idea: the mythical associations of the area, the white skin and physiognomic symmetry of skull measurements, and claims regarding the beauty of the women, in particular, popularized through white slavery narratives. He borrowed the term Caucasian from his colleague and rival Christoph Meiners. Instead of citing Meiners, he referenced Chardin's unreserved praise of the beauty of the women in Circassia. From the start, the elevation of Circassians as paragons of whiteness was laid on subjective ground.[82]

Circassian beauty became the stuff of lore.[83] Immanuel Kant focused on Circassian women in his comments on race in *Observations on the Feeling of the Beautiful and Sublime* (1764). He maintained that "Circassian and Georgian maidens have always been considered extremely pretty by all Europeans who travel through their lands" and affirmed, their "*pretty figure* is judged by all men very much alike."[84] His views, and those of other men, ran through the press. Soon after Blumenbach's treatise had been published, a gazetteer in New Jersey in 1805 summarized the hardening belief this way: Circassians have a beauty that "cannot be defined, but which yet exists, and necessarily constitutes beauty, since all men pay it homage."[85]

"Circassia" became "a household word."[86] There were even popular hair products such as Circassian Curling Fluid and Radway's Circassian balm, along with Circassian eye water, lotion, and oil, promoted in circulars and advertisements featuring Barnum's Circassian Beauty performers. Near to Barnum's American Museum, a store called The Golden Rule sold Smith's Circassia Oil that claimed to "keep the hair in curl."[87] Many a home was even decorated with goods from the Caucasus (or by items that had been branded as such)—everything from upholstery fabrics named "Colored Circassian," "Circassian plaid," and "fine black Circassian," to the woods "black Circassian" and "Circassian walnut."[88]

Is that all there was to it? The Caucasus-based performances, the story goes, would have been easily seen and dismissed; they were just mere satire about

the seemingly obvious resonance with transatlantic slavery and the sexual trade of white slavery. Was that truly all?

As Charles King notes, "almost everything" about the performers "was fake, courtesy of P. T. Barnum," but what is important is "how much of it was actually true."[89] Through their reportorial staging, the Circassian Beauties became a safe portal, an enduring spectacle through which to usher in a racially provocative aesthetic to skewer the unstable foundations of the racial project. That truth has been rendered silent.

Circassians as an actual group were never seen as Barnum had displayed them for the public. As people responded to the show, it became clear that the Beauties conveyed more than merely the history of Orientalism. The interest in the performers endured and brought on more than the racial resonance of Orientalism and slavery.[90] The stakes of this discourse were influenced by a sharpened focus on the battle across the Black Sea.

Barnum managed to turn their image into a spectacle with particular resonance for the American nation. His faux-journalistic style lampooned the vaunted symbolism of the Caucasus region at a time when it was resonant with the American Civil War. Writers frequently made Christian intonations of glory about the descriptions of the Caucasus itself. "I now understand better than ever the words in Genesis—'God said, Let there be light, and there was light,'" Tsar Nicholas I said in 1837 when visiting the Caucasus.[91] Dumas began his travel narrative by saying, "This was the Caucasus, a drama whose hero was a Titan and whose actors were gods! . . . How can one of the mightiest works of the Lord be drawn with a bit of pencil on a sheet of paper? No pen could describe, no brush could paint, that glorious scene." As the Beauties sat on a chair embodying their advertised role, Barnum would parody what Russian literary scholar Harsha Ram has termed this "odic triumphalism" in language consistently used to describe the famed wartime Caucasus resistance leader Shamil in journalistic accounts.[92]

Barnum did one thing more: he layered onto the Circassian Beauty's posture, sartorial arrangement, and conical hairstyle a near reportorial display that framed her as a doppelgänger for the wartime Caucasus resistance leader Shamil, then widely known throughout Europe and America (Figure 1.10.B). In Europe, "newspapers devoted columns to his exploits" and even "questions were asked in the House of Commons as to Britain's

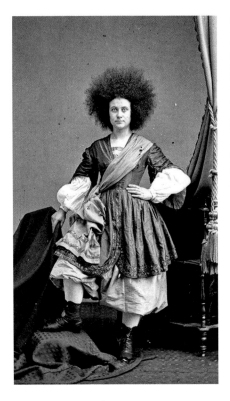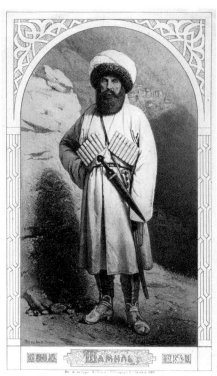

1.10. *A (left).* Mathew Brady Studio, *Circassian Beauty,* ca. 1860–1870, glass plate collodion negative. *B (right). Portrait of Imam Shamil,* Private Collection.

commitments in the Caucasus" as "his bravery was extolled from public platforms."[93] The region was so identified with him that in the late 1870s it was called "Schamyl's country," though he had passed years earlier.[94] Alexandre Dumas's novel *Adventures in Caucasia,* for example, makes little reference to the leader in his text but publishes his image as its frontispiece.

The fixation on Shamil in the United States is not discussed. From the mid-eighteenth through the nineteenth centuries, in both the United States and England, characters in Shamil's likeness appeared in operas, plays, and vernacular theater productions. Shamil was the head of the resistance in the region, then called Russia's "south," a fixation of abolitionists decrying the Caucasus's practice of white slavery.[95]

Barnum now slyly proclaimed that the Circassian woman's corona of "luxuriant tresses"—her afro—was akin to "the aureole of a saint." In 1854, *The National Era* reported that Shamil's turbaned headgear made him ap-

pear as if "with the halo of extraordinary sanctity," conflating its Muslim significance with Christian grace.[96] The received narrative of the Caucasus was, he revealed, in fact an open script.

In Brady's photograph, Barnum's Beauties appear with a fabric sash seemingly made of silk cutting diagonally across their frame, echoing the scabbard strap that Shamil wore across his chest in earlier depictions. Barnum's performers had red hair in a conspicuous circular mound as a sly rhyme to the shape of his turban, one customary for a Sufi sheikh. A descendant of Zalumma Agra recalled that her "flaming" red hair was part of Barnum's interest. Shamil's henna-stained "dark orange" beard was as much a part of his images as his "red-tasseled turban" (Figure 1.11.*B*).[97]

Their wartime resonance is what made the performers' image endure. The Circassian Beauties were staged as mimetic emblems of the region that became a tool to comprehend and confound the fictions of racial difference. At a time when images had a discursive power to process the stakes of the

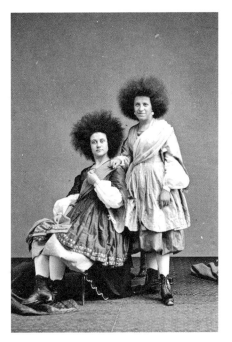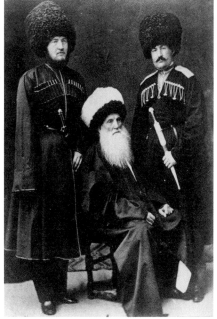

1.11. *A (left)*. Mathew Brady Studio, *Circassian Beauties,* ca. 1860–1870, glass plate collodion negative. *B (right)*. Alexander Roinashvili, *Imam Shamil with His Sons,* date unknown.

union-severing conflict, the performers became racial emblems for two imperiled nations—Circassia and the United States.

When Barnum debuted the Beauties, the country had read the news for decades: the Circassians, representatives of racial whiteness, were in peril. "The news from Circassia is highly important," the *New Hampshire Sentinel* proclaimed as early as 1839.[98] Over the course of the thirty-year-long Caucasian War, multiple outlets, from the *New York Tribune* to the abolitionist *National Era,* followed incursions into the Caucasus region by Russia. If there was "another great Circassian victory to report," the newspapers did so.[99]

As Barnum displayed the performers, news about the Caucasian War began to merge with reports about the United States. From Hawai'i to South Dakota to Maine, the press followed the "gallant resistance of the Circassians" against Russia with great interest and pride.[100] On April 30, 1864, the *New York Tribune* reported on "the sufferings of the poor Circassians" that "has been going on now for three or four years."[101] Just before the start of the American Civil War in January 1860, the Connecticut newspaper *The Constitution* listed news from Columbus, Georgia, about the attempt to "abduct three negroes"; Liberia's "observance" of a "day of public Thanksgiving"; and then concluded with this: "The war between Russia and Circassia is over. One hundred thousand Circassians have laid down their arms. Circassia is to be a province of the Russian Empire."[102]

By the time of the American Civil War, the Caucasus was a racially coded site of a widely followed, ongoing war for independence. As early as the 1820s, it was possible to call a battle "as bloody as Circassia at the present day, or England in the time of Ivanhoe."[103] Newspaper reports from as far north as Portland, Maine, and Halifax would use the symbol of Circassia to evoke an image of carnage.

I thought of this hidden history when I walked past a display of Caucasian swords, rifles, and armor in the permanent collection of the Arms and Armor wing on a trip to the Metropolitan Museum of Art.[104] Interest in the Caucasian War maps onto collecting patterns in the United States from the 1870s through the 1930s. Objects from the Caucasian conflict started to enter US collections during the period of Reconstruction in a flow that peaked at the height of white supremacy and Jim Crow rule. The fact that the museum can refer to, publish, and display a section of the Arms and Armor collection as "Caucasian" and not clarify that it references weap-

onry from the Caucasus region indicates the conditioned sight and semi-
otic shifts that have taken place over the course of the last century.

There has been no scholarship to my knowledge on the resonance be-
tween the Caucasian War and the Civil War. As Charles King argues, it has
been easier to imagine that Chechens and Dagestanis dominated the focus
of foreign observations of the violence of Russian rule, but in fact Circas-
sians were the object of this attention in the early nineteenth century due
to the overlap of their resistance efforts with the US Civil War. As newspa-
pers of record carefully followed what was reported on as the Circassian
plight, visions of mass death, suffering, and national upheaval held special
significance for a nation laying its fallen soldiers to rest. This forgotten res-
onance unearths an untold story: the once rabid interest in the Caucasus
became a divining rod for the racial consequences of America's Civil War.

When the Circassian Beauties first arrived at Mathew Brady's photographic
studio, it was already famous for his Civil War photographs. In the first
American war covered photographically, Brady's outfit was the epicenter
of the coverage for the Union.[105] He had dedicated the previous years to
producing and displaying images of the nation-severing conflict, hiring
photographers who would go on to prominence: George Barnard, Alexander
Gardner, James Gibson, and Timothy O'Sullivan.[106]

Viewers would enter Brady's studio from Broadway, an avenue where dra-
matic shifts in the world and in the Civil War were read, processed, and
vocalized. Barnum's American Museum, set on the corner of Ann Street
and Broadway, was responsible for some of the city's vitality, but "the pho-
tographic emporium of our friend Brady," Nathaniel Parker Willis claimed
in 1859, was "the spot where the city of New York is the liveliest."[107]

Brady's gallery not only offered a new space for the public sphere; it also
helped shape it. His aim was to capture the present moment and view it as
history.[108] His space on 359 Broadway displayed his camera jutting out from
the second floor, as if surveying the world. In 1860, when Brady moved his
gallery up to Tenth Street—his fourth studio—it was called "the National
Portrait Gallery."[109] Leaders of all kinds, from Abraham Lincoln to the Prince
of Wales, frequented the new site. It had become a "a theater of desire," one
that was "devoted to performance: the making of oneself over into a social
image."[110]

"Let him who wishes to know what war is, look at this series of illustra-
tions," Oliver Wendell Holmes wrote in reference to Brady's pictures of

battle, campgrounds, and carnage of the conflict in the *Atlantic Monthly*.[111] Out of images of the "tragic years of the war" came "a transcendent image of the nation."[112] A *New York Times* review of the wartime images on display at Brady's gallery described viewers "bending over" to view the photographs more carefully, as if looking down on soldiers in their graves.[113] New York City then "belonged almost as much to the South as to the North" due to merchant loyalties that included many prominent Southern sympathizers, among them the city's third-term mayor, Fernando Wood, and Governor Horatio Seymour, who would go on to campaign for president with the slogan, "This is a white man's country: Let white men rule." This display of Civil War images had a broad audience.[114]

In October 1862, the Circassian Beauties were in Brady's studio while he was exhibiting Civil War photographs from Antietam, the deadliest one-day battle in the history of the war, which had occurred just one month earlier in Maryland after a Confederate invasion. The gallery resembled a collective wake as viewers "spoke in hushed tones" about the dead.[115] His exhibition marked photography as an organ for collective communication, a development that had begun earlier with the Crimean War. The mass circulation of such images shifted the medium from a luxury good to a dominant organ for processing foundational events and changes in collective American life.

In 1862, in Brady's gallery, "crowds of people" were "constantly going up the stairs" to view images of the country's Civil War dead brought to the viewing public. Brady's photographs had "done something to bring home to us the terrible reality and earnestness of war," the *Times* stated. "If he has not brought bodies and laid them in our door-yards and along the streets, he has done something very like it."[116] As James McPherson emphasizes, "more than twice as many Americans lost their lives in one single day at Sharpsburg as fell in combat in the War of 1812, the Mexican War, and the Spanish-American War *combined*."[117] Photographs from Brady's studio—taken by George Barnard, Alexander Gardner, and John Reekie—showed the full extent of the decomposition and neglect in graphic terms. *A Burial Party, Cold Harbor, Va.* (April 1865), for example, functioned as a visual telegraph of the true toll of war. One of the five men who tended the field of the forgotten dead rests next to dry, skeletal heads scattered over discarded clothes and a pile of corpse limbs (Figure 1.12).[118]

The horror at the need to care for so many casualties ran throughout reports on both the war in the Caucasus and the American Civil War. Historian Drew Gilpin Faust recounts a vivid remark from one soldier from

A BURIAL PARTY, COLD HARBOR, VIRGINIA.

1.12. John Reekie, photographer; printed by Alexander Gardner, *A Burial Party, Cold Harbor, Virginia*, negative April 1865; print 1866, albumen silver print.

South Carolina who fought in Virginia and was preoccupied with the "horor [*sic*] of being thrown out in a neglected place."[119] Even bodies that were buried were often placed in shallow, hastily dug graves that were easily disturbed. On the march to Gettysburg, a private in the 23rd Virginia Infantry Regiment, led by Robert E. Lee over the battleground of Antietam, saw "hogs rooting [bodies] out of the ground" with "others lying on top of the ground with the flesh picked off and their bones bleaching," describing it as "one of the most horrible sights that my eye has ever beheld." On the Gettysburg battlefield, some bodies literally disappeared, "vaporized by the firepower of this first modern war."[120]

Picturing the Civil War exposed the instability of racial hierarchies. Bodies on fields "blackened" after death had been a shocking physical encounter for civilians and soldiers alike, as Faust notes in her landmark

study of death and the Civil War. A veteran of Gettysburg was among the many soldiers shocked that without adequate means of burial, "the faces of the dead as a general rule, had turned black—not a purplish discoloration, such as I had imagined in reading of the 'blackened corpses' so often mentioned in descriptions of battlegrounds, but a deep bluish black, giving to a corpse with black hair the appearance of a negro," Faust notes.[121]

This fear of corpse-coloring blackness was so well known that one Washington-based undertaker, Dr. F. A. Hutton, boasted, "Bodies Embalmed by us NEVER TURN BLACK, but retain their natural color and appearance . . . so as to admit of contemplation of the person Embalmed, with the countenance of one asleep."[122] The permeability of the constructed racial boundaries extended even to death.

These embalming advertisements speak to a fixation on both color and idealized bodily form that went beyond families' and funeral directors' natural concern over decomposition and decay. There was extensive discussion in the industry about how to avoid having a body turn black—"the worst mishap that may befall the undertaker"—to maintain racial specificity and preserve particularly well those who were considered "model specimens."[123]

At the turn of the twentieth century, embalmers registered a heightened concern for their abilities to keep a body white. "How do you prevent the arm you inject and sometimes the face from turning brown, or what remedy do you employ to restore the color?" asked an instructor in Iowa City in 1906. "That question has been presented to me quite frequently this year, not so frequently last year, and up to two or three years ago we didn't hear much about it."[124] The questions had become so common that the answer was published in the main newspaper for the industry. Embalming fluid that gave the appearance of a "complexion whitened" was in high demand.

This fear of white corpses turning tonally black reveals more than a concern over the inability to police the boundary lines of race. It indicates a mounting concern about whether there was an enduring basis for lines of racial demarcation at all.

In the midst of this peril, the Confederacy telegraphed its belief in white racial supremacy down to an emblem. Between 1861 and 1863, Southerners in the former Confederacy sent design models to the Confederate Committee and to Jefferson Davis to broadcast their beliefs on a global stage.

Many of these little-known flag designs were visually explicit about the right to continue race-based slavery and a belief in the legitimacy of racial domination. One proposed Confederate-seal design was a slave scene—a black driver of a mule, with a whip and a white cavalry soldier—with the suggested motto "Slavery, inequality, and the rights of masters."

Another Confederate flag model, proposed in 1862, hung in the windows of the Richmond *Dispatch* newspaper and was entirely white, black, and red to symbolize the "three races of our people." The black bar was "below, to indicate subjection," the red to the side to symbolize the "Indian," and the white color above would "denote superiority." It was proposed by James McFadden Gaston, a physician who had set up the hospital at Fort Sumter, South Carolina and a contemporary of famed naturalist and Harvard professor Louis Agassiz, one of the proponents of the idea of polygenesis—the belief that races are, in fact, separate species. As for the "crescent of white stars," Gaston explained, they would denote "the control of the white man over the other races, and his increasing ascendency" (Figure 1.13*A*).[125]

A similar concept inspired another flag design: a white field bisected by a black diagonal bar meant to symbolize a "faith in the 'peculiar institution,' and be an enduring mark of our resolve to retain that institution while we exist as an independent people."[126] Enforcing the white spaces on the flag are the words "WHITE." accented with a period at the end. The emblem hung in the *Charleston Mercury*'s Broad Street office window and was published in the newspaper (Figure 1.13*B*).[127]

In the end, none of these would work for the world stage: the color white could suggest surrender; black also was not an appropriate color according to the rules of heraldry, the coat of arms and insignias of nations. Slavery constituted a tenet of the Confederacy, but it was considered ignoble as a mission statement for a new republic on the global stage. The question of how to symbolize white racial domination without a sign, symbol, or geography to reference as foundational for this world order would continue to vex the social order of life in the United States, with fatal outcomes.

The landscape of the Civil War became a grave, racially framed site of meditation even in paintings. Winslow Homer's *The Veteran in a New Field* (1865) symbolizes this shift (Figure 1.14). Homer, once embedded with a Civil War regiment as a reporter for *Harper's Weekly*, was America's most prominent

WHITE.

WHITE.

1.13. *A (above)*, *B (below)*. Confederate flag proposals.

painter. His contemplative painting, reproduced at the end of the war in *Frank Leslie's Illustrated Newspaper,* emblematizes a return to society and what it had cost.[128] It centralizes a back-turned figure in a field of wheat, largely uncut, as the stalks gather behind him. The visual clue of a regiment jacket and cap on the brown soil indicates his service in the Union Army. Homer here recapitulates the thematic paradox of a history painting—it shows an ordinary man in the midst of an extraordinary symbolic event.

The battlefields of war are the harvest grounds in Homer's work.[129] The skew-stacked blades bear the index of the man's labor and activity and suggest a blast of force. Interspersed in those yellow blades are scattered black marks—not brown, but a deep black—that register at once as soil and serve as a tonal reminder of the death found in fields of wheat and corn strewn with bodies from the aftermath of the Civil War. He works the fields with a scythe, an antiquated tool with fatal overtones.[130] Yet the gleaming white shirt of the anonymized figure in the midst of heavy labor is nearly unmarked by toil.[131] The painting functions as a psychological portrait of veterans transfixed by the need to create a new symbolic ground. Homer signed his name in an unusual fashion—not only is it in red paint, but so is the date, 1865. The "5" terminates in an elongated line, as if a metaphor for the year that ended the country's most profound collective wound.[132]

1.14. Winslow Homer, *The Veteran in a New Field,* 1865, oil on canvas, 24 1/8 × 38 1/8 in.

During the American Civil War, headlines were focused on the demise of Circassia as if it were an analogy for the nation-severing conflict. In the early days of Barnum's show, even reviews of the Circassian performers were mixed with expressions of concern about the Caucasian War. Some audiences responded as if they were a reportorial performance. The photographic staging and performed narrative referenced Caucasus-related signs that would have been legible to a mid-nineteenth century public—ethnographic features of Circassian narratives, an assertion of their exemplary racial status, and a unique, highly recognizable template resonant with the wartime resistance leader from the Caucasus.

One review in the Connecticut paper *The Constitution,* published just over a month after the Beauties' debut, moved seamlessly from Barnum's spectacle to Circassian history and a discussion of the Black Sea region. "Since Mr. Barnum has introduced a Circassian to his Museum, there will be interest in knowing how the Circassians expelled by Russia fared in Turkey." The article then cited reporting from the London *Times* describing how Circassians had been forced to emigrate:

> *The Times* correspondent, who has visited some of the Turkish towns occupied by the Circassians, who recently emigrated under pressure to the shores of the Danube, says: . . . What I saw during my journey, and the information I received, prove to me that I had not nearly exhausted the history of the sufferings and disasters of these unhappy exiles . . . there has been a mortality of six thousand in the last three weeks out of a number of forty thousand.

Without any mention of Orientalism or the performers being humbugs, the article had transitioned from the performers to Circassian mortality rates.[133]

As the performers sat, Barnum read from a pamphlet about another one of the Circassian Beauties, Zobeide, that referenced precise, publicized details about the Circassian expulsion of the 1860s during the Caucasian War. "When Zobeide was of a very tender age," Barnum told his audience, "Circassia was convulsed by one of those terrible Russian invasions, which, during the period of which we write, had been as frequent as they were devastating, and which drove many of her country in almost hopeless despair."[134] He offered up facts about and features of the Caucasus region with authenticating details from rivers to mountain ranges.

Barnum's narrative again accurately retold part of the exact history of the once Circassian (now Russian) town and its Terek River of the eastern Caucasus, two references that echoed the coverage of the Caucasian War. It was common to describe the Caucasus as "a country, fertile, picturesque, almost indescribable, watered by the great rivers, The Terek and the Couban [*sic*]" in advertisements for the many travel narratives published about Circassia and Shamil in the 1850s.[135] (As one example, J. Milton Mackie's 1856 travel account was marketed as a chance to learn more about "the luxuriant valleys of the Kuban and Terek," which had rapidly become the region's distinctive natural attribute as much as its "black" and "white" mountains.[136]) The valley of the Terek River also became a well-known site of conflict, where the heroic "prophet-warrior" would fight in the last battles of the Caucasian War.

Barnum's show emphasized Zobeide's experience fleeing the Caucasian War. Her parents, he said, found "their fields desolated and their flocks more than decimated by the Czar's subjects, and their own lives and those of their kindred imperiled." What was left? "There was no alternative but to gather their little remnants of property and with their children seek a refuge, amid the mosques and minarets of Constantinople."[137] The impresario had conjured what had become the mental image of the Circassian exodus, a central visual trope of the region.

When Barnum's Beauties were on display, Caucasian War reports were filled with analogies for the American political landscape—a fact that is largely omitted from broadly distributed histories of the Caucasus region. Circassian resistance is often omitted entirely in histories of the region, as in Neal Ascherson's, *Black Sea*.[138] Even in a standard textbook from the Caucasus region, *An Introduction to the History of the Kuban*, the map of the region from 1801 to 1860 shows where the Circassians lived, but in the map from 1860 to 1877, the Circassians are simply gone. There is no mention of a Caucasian War. The textbook offers what became the standard explanation: Russian empress Catherine II gave the region to the Cossacks "in gratitude for their military service."[139] "Who now remembers the Circassians?" Oliver Bullough asked in *Let Our Fame Be Great: Journey among the Defiant Peoples of the Caucasus*. "The Circassian exodus attracted headlines at the time, but the nation's fate has drifted out of history."[140] The erasure of this history of Circassia is confusing and misleading. During the Civil War, Americans knew the plight of the Circassians well.[141]

The image this exodus conjured is best exemplified by *Mountaineers Leave the Aul* (1872), by Pyotr Nikolayevich Gruzinsky.[142] In the foreground of the painting is a scattered caravan—a mother holding the hand of a small child who wanders off in one direction, while trudging figures head off in another—all in a procession away from their homeland (Figure 1.15).[143] In the painting's background, a land of emptied shelters with darkened entrances lies below unnatural blueish-white clouds suggestive of smoke, a sign of the recent combat. Expelled from their homeland, the painting conjured an image of Circassians leaving a symbolic locus that Blumenbach's scholarship had proclaimed was the cradle of civilization.

Circassia also entered a national conversation about America's Indigenous populations as a "vanishing race" while Native groups were being forcibly removed from their homes during decades of genocide and settler colonialism.[144] Articles with titles such as "The Last of the Circassians" referenced the famous novel *The Last of the Mohicans* (1826) by James Fenimore Cooper.[145] The memoir of one American visitor to the Caucasus in 1850,

1.15. Pyotr Nikolayevich Gruzinsky, *The Mountaineers Leave the Aul,* 1872, oil on canvas, 300 × 400 in.

George Leighton Ditson, included a line that made the comparison plain: "The Circassians are just like your American Indians."[146] "Like our own American Indians, all that will be left of [the Circassians] will be a broken remnant, a story, and a name," echoed a Boston newspaper years later.[147] Native identity was often used in nineteenth-century narratives by non-Natives to "negotiate or escape 'black / white' binaries."[148] American newspapers would also emphasize the "frontier process" dynamic in the Caucasus, framing the Cossacks as settlers given their economic dependency on the region and their practice of nativization through violence.[149]

When the deadline set by Tsar Alexander II for Caucasus inhabitants to leave their homeland came on February 20, 1864, "foreign newspapers began to refer to it as an 'exodus,' as if no other word could do justice to its horrors" or capture the sense of biblical reverence accorded to "Caucasia."[150] One British correspondent for the *Spectator* described it as the "Suicide of a Nation."[151] The Russian policy specified that either "Circassians resettle north, in the marshes of Kuban, and serve in the Russian Army or leave," often for Ottoman lands.[152] Pushkin described that "Circassians detest" the Russians for having "driven them out of their free land, leaving the villages in 'ruins.'"[153]

"In this year 1864, a deed has been accomplished almost without precedent in history," the main staff commander of the Caucasus Army wrote to the tsar. "Not one of the mountaineer inhabitants remains on their former places of residence, and measures are being taken to cleanse the region in order to prepare it for the new Russian population."[154] As the headline of the *New Haven Daily Palladium* put it on June 2, 1864, "Circassia is blotted from the map."[155] The *Boston Daily Advertiser* echoed the line the next day: "The Russian successes in the Caucasus, after the gallant resistance of the Circassians, have at last blotted the latter from the map as an independent people."[156]

The fatalities of the Caucasian War were discussed as wholesale obliteration. "The brave Circassian race no longer exists," stated a report as early as 1860.[157] Now it was clear: the Circassian warriors, who often died without burial, seemed to vanish. Reports about the Caucasus were vivid, gruesome, and exact. On November 23, 1864, one day before the fire in Barnum's American Museum, the *Albany Journal* published a nearly thousand-word article from Larnaca, Cyprus about how the bodies of "Circassian emigrants" who had left on ships for their city were now being found, along with "evidence of [their] being thrown in the water alive."[158]

"What should be done with the body?" was a "pressing and grimly pragmatic problem" during the Civil War, Faust recounts. By 1865, over 700,000 soldiers had died in the American Civil War. By 1864, more than 500,000 Circassians had died in the last phase of the Caucasian War, in the fight against invading Russian forces. Many accounts in American newspapers described Circassian bodies being "thrown out," cast overboard, with a frequency reminiscent of slaving practices, and then "washing on shore," meaning on the Black Sea coast. In reports about the combat, the death toll, and the specter of the Caucasian War were echoes of the horrors of the Civil War.

As Richmond was captured by Union forces and Confederate troops were diverted to the Blue Ridge Mountains in defense, white Southerners were compared to Caucasians being forced out of their homeland. "The world will see the spectacle of a new Caucasus in the country between the mountain ranges west of Lynchburg and east of Knoxville," ran an article in the *New York Herald* on March 19, 1865, when "all the armies of the confederacy will be moved through the Blue Ridge [Mountains]."[159] It was as if the visual template of General William Tecumseh Sherman's March to the Sea through Georgia had become a way to imagine, to see, the conflict on the Black Sea, with white southern identity being compared to that of the Caucasians in Russia's "south," viewed as a "pure" race under attack, victimized for its practice of slavery.

By 1865, when the war ended, the Caucasus had become yoked to Southerners' status as rebels of a seceded nation as Circassia came up in articles about policy questions.[160] On February 26, 1862, the *New York Daily Herald* ran an article "The War in the South-West," with an extended debate about how to handle the confiscation of Confederate property. The journalist cited US Senator Samuel C. Pomeroy from Kansas who said in Congress, "Suppose Russia, in the intermittent war going on between that country and Circassia, should take the land of the Circassians and apparition [*sic*] it out among the Nobles of Russia?"[161]

After Lincoln's second inaugural address on March 4, 1865, the *Milwaukee Daily Sentinel* reported that "[Rep.] Mr. Long, the other day, in Congress, hazarded the assertion that . . . the Southern confederacy, so called, would come out of the present struggle with [success]." The journalist noted, however, that "If Mr. Long had read history," then he would "have arrived at a very different conclusion," writing that "the Circassians, after years of heroic struggle, were unable to maintain their mountain fastnesses against successive attacks of their Russian invaders"—as if the devastation of the Caucasus foreshadowed the Confederacy's fate.[162]

Many US newspapers reported that the Caucasus's "Confederate Chiefs" had formed a separate "republic" in 1861 and then, in 1864, had become "a nation exterminated."[163] "The last hope of Circassia has vanished," the *Deseret News* stated, "so has come at last the end of a brave and heroic people." The Circassian warriors seemed to vanish, regarded as an "extinct race" that was "beginning to disappear from the face of the earth."[164]

As reports emerged about the Circassian plight in the US press during the Civil War, the significance for a nation laying its fallen soldiers to rest was clear.[165] To contemplate the history of Sochi, of Circassia—now Russia's "South"—was to consider the racially complicated fate of America itself.[166]

In front of Brady's lens, the Circassian Beauty condensed Circassia's Civil War–resonant history into a physical stance, gesture, and costume. Zalumma Agra stood with a fierce directness, one knee raised on a shallow platform and her arm akimbo. It was a position generally imitative of the senatorial posture and severe frontality of male politicians and generals who had stood in the studio before her. It was also evocative of the pictures of Shamil whose exploits became known across the nation, nestled into daily news.

The American public had become fascinated with the wartime Caucasus leader, Shamil. "Few men have played a part upon the stage of European history who appeal more to the imagination than the last great leader and prophet of the Caucasus," one journalist put it as late as 1893 in the *Seattle Times*.[167] One of the most popular works of Circassian literature was written by the co-creator of Sweeney Todd, Thomas Peckett Prest: *Schamyl; or the Wild Woman of Circassia: An Original Historical Romance* (1856). The work's disjunctive title conveys the dominance of these two figures in the press; Barnum had staged them, both the warrior and a woman from Circassia. Fascination with Shamil was such that by the end of the Caucasian War, at least thirty-eight novels about the leader had appeared in print within six years, published in Boston, Berlin, Edinburgh, Florence, Paris, London, and New York.[168] Twenty-eight had appeared within two years alone, between 1854 and 1856, due to the heightened interest in the region because of the related Crimean War. There were songs about his final siege: "The Schamyl Schottishe" and "The Circassian March." Leila Aboulela's twenty-first-century novel of identity exploration, *The Kindness of Enemies,* told through a Shamil descendant as the protagonist, is one example of the enduring hold the legendary leader has had on the public imagination.[169]

Woodrow Wilson had written not only about the Caucasus, but also about Shamil in the context of abolition in the United States.[170] His works on governance, such as his book *Congressional Government*, had become widely influential, and were even quoted in statements on the floor of the House of Representatives. As a professor at Princeton University before becoming president, Wilson wrote *A History of the American People* for a popular audience. The book was published as a five-volume series for *Harper's*, just before he was elected president of Princeton in 1902. For a section on the American abolitionist John Brown's raid at Harpers Ferry in 1859, Wilson wrote that Brown had not only studied "all the books upon insurrectionary warfare that he could lay his hands on," but also "had become very familiar with the successful warfare waged by Schamyl, the Circassian Chief."[171] Brown's raid, a failed but symbolic insurgency against the slaveholding regime, was one of the most well-known news stories of the time. His armed attempts against attacks on abolition made him a hero to many after he was jailed and sentenced to death, and made him prescient as an oracle—bloodshed, he predicted, would be the only way for the United States to abolish slavery. Brown was deified as a martyr, as was Shamil for his exploits to hold back Russian incursions.

When Wilson began to write about the warrior, actors playing Shamil already frequently appeared in theaters. In the fall 1854 dramatic season, *Schamyl, the Circassian Chief* was reviewed as "spectacular," starring "Bowery idol" Edward Eddy and popular actor James R. Anderson decked out in a tunic and sheepskin hat worn by Caucasian warriors (Figure 1.16).[172] The drama revolves around US aid offered to Shamil; the main dramaturgical event is the presentation of Circassians to the American audience, "requiring two hundred extras in 'classically correct costume.'"[173] In 1859, the *San Francisco Bulletin* reported that a "son of Schamyl, the famous Circassian Chief" was in New York and "frequents all the theaters and clubs."[174] By June 18, 1860, the play *Schamyl* was featured in the reopening of the popular Bowery Theater, which Walt Whitman described as typically "pack'd from ceiling to pit."[175] Shamil would appear on American stages until 1876, with a play staged at Wood's Museum and Menagerie in New York City.

The Circassian Beauties were not merely satirical; they were mimetic of the embattled, unseen region that had increasingly become a tool for America's national self-comprehension.

On his stage, Barnum fashioned Zalumma Agra as a sly wartime double— both a "Beauty" and a proxy for a commander-in-chief. Five years before Barnum would debut the Circassian Beauty, Shamil had himself become a

1.16. *Schamyl,* Metropolitan Theatre, December 15, 1854 *(detail).*

living spectacle. At the end of his life, the most iconic figure of the Caucasus spent his days as a prisoner on display in the Russian town of Kaluga, 150 kilometers southwest of Moscow. Shamil, the "second most famous celebrity—behind only the tsar—in the [Russian] empire," was in a "golden cage," as a *tableau vivant* in what is now the town's Caucasus Museum.[176] Ira Aldridge, a black American-born performer who became famous in Great Britain for headlining Shakespearean plays, visited Shamil in Kaluga in January 1864 when on a tour in Europe. Aldridge described the defeated hero

as if a living tableau that "looks more like a placid Patriarch of old than a fierce mountain warrior."[177]

This resonance with the Civil War kept discussions about the Caucasus germane for American racial conflict. This extension of the Caucasian War subjected the region to scrupulous examination. The American press followed the uprising against Russia in the Caucasus between 1876 and 1877 as much as it had the Caucasian War largely because the racial and religious characterization of the region had shifted. The year 1876 was also the time of one of the "Circassian revolts," as it was called in newspapers in the United States.[178]

What the Caucasus meant to American audiences shifted from a racially focused site to one centered on Islamic identity and anticolonial resistance. During the Caucasian War, news outlets and the penny press had commonly replaced Shamil's Muslim identity with Judeo-Christian titles, calling him a "warrior-priest" instead of an Imam. Now reports were emphatic about his Muslim identity. Tales of Shamil's exploits were coupled with those of an Algerian military leader during the French conquest of Algiers, so that people mentioned "Schamyl and Abd el Kader, the heroes of Algeria and the Caucasus" in the same breath.[179] What was called the "Circassian Revolt" in 1876 was called the "Mahamedan revolt" as soon as the following year.[180]

In the antebellum period, Shamil had been compared to the Circassian Beauties as a figurative embodiment of racial whiteness. A fixation on the extreme whiteness of the Shamil performer's skin once registered in nearly all descriptions of the region's defeated leader, "more white than any of his countrymen."[181] English biologist and anthropologist T. H. Huxley would write about the "peculiar fairness and delicacy of skin" that "distinguishes his countenance." Huxley's "study" suggests an ethnographic entry with its use of staccato, entry-like language to offer a textual portrait of the leader: "of middle stature has fair hair, grey eyes overshadowed by thick well-marked eyebrows, a regular well-formed nose, and a small mouth."[182] Dumas would write in his book *Adventures in Caucasia* about the Caucasian leader's extreme whiteness as a rhyme to his "long flowing white robes," as both warrior and divine.[183]

The feminization of Shamil that allowed him to be a template for a female performer marked the use of gender as a mode of connoting racial distinction. In 1854, the *Fayetteville Observer* in North Carolina noted, "His

complexion is white, and as delicate as that of the Circassian Beauties who are sometimes exposed for sale in the private bazaars in Constantinople." As the journalist continued, the public was struck by "the contrast of his feminine appearance with his extraordinary courage and impassability in the presence of danger," which "may have contributed to excite admiration."[184]

Yet Shamil's Muslim identity ultimately helped shape the reconsideration of the region's racial image. Shamil was a guardian of what was seen as the so-called homeland of white racial purity.[185] After the American Civil War, the connection of the Caucasus with racial whiteness would be disavowed entirely. Now it was considered a land of "Mahomedans," also called "Oriental," "Eastern," or Asian. Foreign correspondence in newspapers from Jackson, Mississippi to Philadelphia eased into this geographic shift by using the term "semi-Asiatic."[186] The sense of the divide between Asia and Europe would remain in twentieth-century natural science and literature, as I will explore in later chapters. Even the title of Bertolt Brecht's play *The Caucasian Chalk Circle*, set in Georgia between the Black and Caspian Seas, is an allusion to a Chinese parable and a biblical story of Solomon's judgment adapted by the verse play by Li Qianfu during the Mongol Yuan dynasty.

The Caucasus became a racial Babel. At the end of the Caucasian War as accounts emerged about Shamil living in exile in the late 1860s, the hero's envoy to the Circassians, Muhammad-Emin, nearly fell over with laughter telling post-defeat tales about their inability to communicate with a Circassian group. The Abadzekhs spoke in a language of guttural clicks that was utterly undecipherable to the Dagestan-born hero and the Chechen brigades.[187]

Reporters would anticipate confusion from readers used to hearing about the Circassians' exemplary racial status. One admitted that "they are a fine race of people physically, the men tall, slender and elegantly formed, and both sexes as fair in complexion as if the sun had never shone on them," and, echoing the tone of the commentary about their thirty-year Caucasian resistance against Russia, acknowledged that "as a cavalry force for dashing forays and swooping charges they cannot be excelled."[188] The article then launched into a vilifying attack. If racial whiteness was determined by "fitness for government," the lack of organization and the consistent state of rebellion had taken its toll on the perceived race of those who lived in the Caucasus.[189]

The pendulum swing on the Caucasus region was so extreme that an 1876 article—a reprint of a piece that had already appeared in the *London*

Standard and in the United States—ran with the title "Circassian Soldiers Not so Bad as They Have Been Represented."[190] The decade was filled with equivocation, with writers veering from admiration of the physical prowess of the Circassian as a human ideal, to repulsion at reports of their "blood-thirstiness" and "ferocity."[191] Safeguarding the Caucasus as a "foundational fiction" had become a vexing form of adjudication.[192]

The Caucasus region conflict during the American Civil War, the start of the second founding of the United States, would force the start of a reckoning: racial domination would require conditioned sight to disregard the fictions of the racial project. Wilson's request was a sounding: an attempt to make sense of what cannot be fully seen, to determine where a shape, a form—here the ground for the idea of white racial supremacy and racial hierarchy—has hit a limit.[193] It is an activity that, per Tina Campt citing Fred Moten, precedes our understanding of what is before us.[194] It was an echo of what had been happening for decades—tunneling through layers of myths about the Caucasus region in an attempt to secure the foundations of racial science.

Wilson wrote extensively on racial domination and vision, developing a theory of racial administration for the segregationist age that still lingers today. His request for an image from the Caucasus was an extension of this fundamental work, long overlooked, as we will see. Securing racial hierarchies in the modern age, Wilson argued, would require a process of racialized, visual assembly that shaped tactics of resistance movements and had consequences for governance in the United States.

Between the second founding of the United States and the Caucasian War through to World War I, a fundamental change took place to unsee the evacuated grounds of racial hierarchy. Visual regimes became not merely a weapon to assert norms, instantiate stereotypes, and resist oppression, but a form of negative assembly to compensate for the lack of foundations of the project of racial domination at large.

What are the stakes of continuing to ignore that the idea of the Caucasus—the keystone in the archway of the racial project—was a constructed, unstable projection, or that the adjudication we live with today allowed the system of racial ideology and domination to not fully fall apart? They were too high for leaders such as Frederick Douglass to ignore.

When Wilson began to write about the marriage of vision, race, and politics as a form of governance and administration, Douglass had already

anticipated the transformation of vision underway during the second founding. He also understood that combating it would be essential for challenging racism and the legacy of slavery. Douglass's ideas, squared with theatrical and photographic stagings like the Circassian Beauties, together offer a rare glimpse of the early transformation of vision required to challenge the fictions that legitimated the foundations of racial domination in the United States.

2

Racial Adjudication

Frederick Douglass and the Circassian Beauties

In 1861, in the midst of the Civil War, Frederick Douglass articulated what would take decades to make clear: telling the truth about race and citizenship required a new way of seeing on American soil. The abolitionist, author, journalist, and reformer was the first theorist to write about the nature and function of visuality, race, and images in American political life (Figure 2.1). Throngs—thousands—would come out to hear him speak about the direction of the nation amid seemingly intractable disputes over slavery and racial contestation. On this occasion, Douglass focused on the critical role of what some might consider mere trifles in the face of a nation-severing conflict: pictures and the impact they have on the critical imagination for political progress in racial life.[1]

In his speech titled "Pictures and Progress," Douglass carefully outlined what he considered the crucial role images could play in achieving the promise of American democracy despite the defining role of slavery and racial inequality in the nation's founding.[2] He redrafted this speech three different times over the course of many years. Taken together, the many versions of his statement offer one of the earliest articulations of the power of culture for the transformation of both racial and class relations in American public life.

Douglass anticipated a concept that is at the core of politics in a democracy: what it means to be made visible, to be represented, and to count would require culture. Justice, he understood, would take more than the law. Born enslaved, Douglass would live to see slavery's collapse, the rise of rights

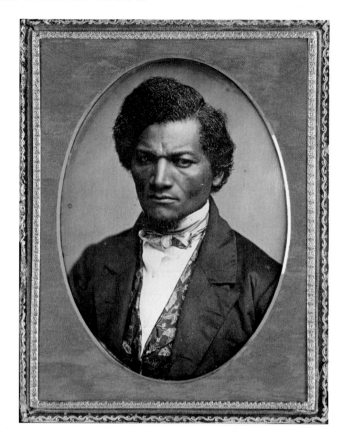

2.1. Samuel J. Miller, *Frederick Douglass*, ca. 1847–1852, daguerreotype.

for black Americans, then after 1877, the stripping of those rights. He understood that political representation would be closely tied to representation itself—how we see through symbols, images, and the full cultural landscape in American life. He knew that politics is inextricably tied to how we see each other and, quite literally, how we fail to see each other. His was a prescient, urgent speech that called attention to the continued importance of visuality for representational justice and equality today.

What made Douglass's meditation so crucial was his fundamental insight: images had the potential to achieve, in the realm of representation, that which he most ardently sought in the social and political realities of the country he loved—to be, effectively, a leveler of race, of class, of gender. Pictures of all kinds, he would go on to argue, played an unheralded, outsized role in racialized democracy. What ignited his speech was the

development of the new medium of photography. He saw that this new, remarkable, yet affordable technology could accomplish what social movements aspired to achieve but, painfully, had not yet been able to. He championed photography as prophetic of all that society could be, a place where the astonishing variety of faces that constitute the nation could occupy their full measure of equality within their splendid frames. It is a speech that reminds us of how important representation is in a democratic society: to be seen as we see ourselves, and to see others as they wish to be seen.

Douglass was captivated by images and their power. Over the long course of his storied career, he was photographed more than anyone else in the United States. For Douglass, photography was a vehicle for promoting racial equality. The small, emerging middle class of African Americans followed suit and sat for their own photographic portraits when daguerreotype studios spread across the United States in the 1840s. After the Civil War, African Americans of all classes sought out photography studios to affirm that they could now be "seen," following the long and dire centuries of "social death" inherent to human slavery.[3] Douglass understood that picturing was a way to access the truth.

Douglass saw it before most: the revolution of the new medium of photography, the birth of this new age of pictures, was as much about representation as it was a tool to distinguish fact from fiction. It made pictures a crucible of American democracy. In the antebellum period, images trafficking in stereotypes that saturated the media landscape had become arms in the war of racial interpretation. Yet the invention of the photograph would democratize representation. It allowed people to picture themselves as they would like to be seen. Harnessing the power of pictures, Douglass argued, was requisite for achieving justice in American life.

Racial dominance in the United States had turned visual perception into a weapon with a legacy we still live with today. Aesthetics were marshaled to create, solidify, and naturalize the structure of racial hierarchies. In 1854, Douglass had decried the use of pictures by the American School of Ethnology to legitimate caricatures and stereotypes, to "read the Negro out of the human family."[4] In that year, the widely known, circulated, distributed, and consumed antebellum racial treatise entitled *Types of Mankind* (1854), by Josiah Clark Nott and George Gliddon, sought to prove polygenesis—the idea that races have different origins, that there is no common, equal family of humankind. The treatise included a diagram of this idea, placing, as

cognate for whiteness, the famous Apollo Belvedere sculpture—which President Woodrow Wilson wanted to purchase for his home—next to a chimpanzee and a black man to show a hierarchy of human races (Figure 2.2).[5]

Visuality became tethered to racial domination and inequity. It was conditioned by the force of law—including the legacy of the Fugitive Slave Act of 1850—and the biopolitical mode of accounting in slavery that turned surveillance into a racialized act. Signed into law by President Millard Fillmore, the Fugitive Slave Act was a concession to the slaveholding South. The main question was about how to keep the balance between slave and free states in light of the vast land the United States had acquired after the War with Mexico in 1848. Part of the compromise involved more stringent fugitive slave laws in the United States. The 1850 Fugitive Slave law not only required US marshals to help slaveowners; it also empowered them to deputize citizens as vigilantes and further stripped federal protections from the formerly enslaved. The doubling of the black population in Ontario in the 1850s is part of what the record shows—that the fierceness of this law made many black Americans flee the United States entirely.[6]

The Fugitive Slave Act conscripted American citizens to participate in racial investigation. It became a federal crime to not report a fugitive slave,

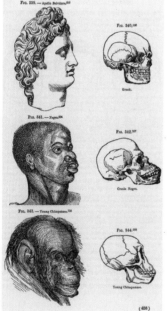

2.2. "Types of Mankind," Josiah Clark Nott and George R. Gliddon, *Types of Mankind: or, Ethnological Researches Based upon the Ancient Monuments, Paintings, Sculptures, and Crania of Races* (Philadelphia: JB Lippincott Grambo & Co., 1854) *(detail)*.

which turned adjudication into a requirement for navigating civic life.[7] This law explicitly codified who was given the right to observe, to testify; namely, whose assessment was granted authority.[8]

The investigative gaze would become a posture of citizenship to maintain racial dominance. The history of fugitivity and slavery had not only enjoined vision and civic authority, but also defined whiteness as a subject position in such a way that allowed for, if not demanded, racial assessment. Douglass's subject in his speech, then, was not the image alone, but also the importance of such acts of judgment that he argued had to be attended to in racialized America.

Just over a decade ago, Douglass's speech could be found only in the Library of Congress and in a publication transcribing his speeches; there was little written on the deep implications of his work. I remember coming across this speech and wondering why, save for a few scholars and literary critics, it had been mainly ignored.[9] Douglass understood that visibility is at the core of politics—a process of becoming seen, in a system of domination, as fully empowered subjects.[10] To make the case then that Douglass was one of the earliest theorists of image, race, and politics in the United States was somehow unthinkable. Yet the record was clear: alongside Sojourner Truth, who was also particularly attentive to the impact of race on image-making, Douglass anticipated the work of philosophers such as Jacques Rancière and others over a century later.[11] And despite all the recent attention to Douglass's "Pictures and Progress" address, it is still somehow an outlier in his writing, is not seen in dialogue with the thinkers of his age, and has not yet permeated standard histories of visuality in the United States.

The full significance of Douglass's lecture on race and representation warrants a reconsideration not only of his ideas, but also of the nature of visuality, race, and history. Key to this is the framework of just adjudication—the apex of his argument. How could one judge the world critically to enable progress? How could one critique cultural narratives that had helped instantiate racial dominance in order to dislodge them? Douglass's answer was clear—by assembling a new image of the possible world.

In his speech, Douglass addressed the gaps in representation, what he argued was missing to be able to address the misperceptions fueling racial domination in American life. He focused on how visual narratives could dislodge the hardened racism, biases, and stereotypes that naturalized racial subjection, institutionalized slavery, and inured so many citizens

against the very principles of equality on which the country had been founded. Douglass's speech concerned not only pictures, but also how the very technology of seeing used to harden racial hierarchy could be harnessed to challenge it.[12]

Representation had become a means to legitimate domination, but also, Douglass argued, had the power to undo it. He began a debate that would emerge years later among leaders like Alain Locke, Langston Hughes, Freeman Henry Morris Murray, and W. E. B. Du Bois about the nature of representation as a critical form of truth-telling necessary to confront the unspeakable.

Central to Douglass's argument was the force of contrast. Pictures offered the ability to contrast lived reality with that of another, set before one as a true image. Pictures, he wrote, could force discernment about what something is and what it could be. This capacity to transform judgment about world narratives was part of the significance of the new technology, and through it, Douglass argued, images could revolutionize the production of history.

Douglass's skill for "observing, comparing, and careful classifying," as James McCune Smith noted in his "Introduction" to *My Bondage and My Freedom* (1855), would become critical to address the visual regime of racial domination, well before it became a topic for the US Courts.[13] Comparative discernment, judgment through contrast, became inextricably tied to defining and challenging the racial boundaries of social order on disputed, unjust grounds. If observation renders viewing static, stable with respect to what is seen, a key operation of racial adjudication would be contrasting forms—and with it came a form of social power.[14]

This was a new phenomenon, the possibility of a constructed object indexing the world to convey an unseen truth. While the truth-telling function of the camera would be debated for decades, Douglass's main point was clear—the camera was not only a weapon that could be used to strike down stereotypes; the use of it also changed how we processed the legitimacy of competing narratives of worldmaking themselves. Douglass considered images about the world "thought pictures" at a time when pictures assumed significant authorial power for describing contested racial categories in judicial decisions and for the public sphere in the United States.

At first it may seem that many of this era's images could demonstrate a shift in vision of the kind that Douglass would describe. Pictures were used to advocate for equality in the antebellum period, to reify stereotypes that

only intensified with the development of the printing press, and to naturalize the policies of immigration reform and the retrenchment of racial ideology at the turn of the twentieth century.[15] As technology became cheaper over the following decades, more and more citizens could afford to have their photograph taken and be seen on their terms.

Yet Douglass was gesturing toward a hidden history that goes beyond the relationship of abolition and image-making and drives straight to the heart of the work of being free even after Emancipation. We see these moments in flashes, snippets of time when the "visible seams" of race construction were exposed.[16] We see them in the images often left out of literature on art and cultural history. We see them in pictures that documented this interest in the region of the Caucasus and contributed to the longevity of these world narratives in the American imagination.

Douglass's 1855 narrative *My Bondage and My Freedom* opens with a preface by James McCune Smith that cautions its readers: they had been fooled by the picture of the Caucasus as the homeland for racial whiteness. The physician and abolitionist introduced Douglass's extraordinary work to the public to prepare them for the fact that it represented a repudiation of the very world stories of white supremacy that the Caucasus had been used to support. Smith's preface alludes to the need not only to hunt, to search for the figurative form, but also to correct the narratives that had animated the mechanics of imperialism and solidified ideas of racial hierarchy.

As mentioned earlier, Smith reminds the reader that "the term 'Caucasian' is dropped by recent writers on Ethnology; for the people about Mount Caucasus, are, and have ever been, Mongols. The great 'white race' now seek paternity . . . in Arabia . . . Keep on, gentlemen; you will find yourselves in Africa, by-and-by."[17] The Caucasus pictured the edge, the boundaries of the narratives that framed raced figures. The region came to represent what would be found if viewers did "keep on" seeing the true ground of the Caucasus—they would come full circle, find themselves "in Africa, by-and-by," and realize that there is no foundation to the project of racial supremacy.

To dwell on the Caucasus at the start of Douglass's narrative preface was not to focus on whiteness itself, but a call to examine the missing truth about racial domination: it was predicated on fictions. The creation of the

Caucasian ideal became an image without a negative, a symbol without a referent. Emptying out any trace of the specific demography of the region had allowed the term Caucasian to remain, in effect, an icon, a framework through which to structure the racial ideology of the United States.

This was significant because US courts came to base racial decisions on the everyday assembly of the *idea* of the Caucasus, and crafted decisions to uphold racial hierarchy based on only "common knowledge" about the world. This brought the world of culture into the public work of determining the contours of racial formation. The coincidence between the end of slavery and the democratic uses and distributive ease of the new medium of photography created a new form of visual literacy to understand race, citizenship, and social life in the United States. Without a basis upon which to lay claim to the legitimacy of racial dominance, particularly after the Civil War, vision transformed into a continual assembly of world narratives.

Douglass's speech itself anticipated why the photographs of performers representing the Caucasus endured. He even articulated what they disclosed about the significant transformation in vision to assessment that had pervaded society. These images became more than a picture of racial refusal. The images of the Caucasus represented an unseen truth—the foundations of racial domination that had emerged from this geography were now in need of being kept off the representational stage.

Eisenmann's Circassian Beauties

In Charles Eisenmann's photographic studio circa 1880, a Circassian Beauty of African descent entered the frame. In his large, two-floor skylit photographic studio on the Bowery in New York City, Eisenmann began to produce the widely disseminated stagings of the Circassian Beauties. Many photographers took pictures of the Circassian Beauties; Eisenmann secured more business from these performers by miles.[18] Just as a deck of playing cards has different suits, he created sets of images in which seemingly white and seemingly black Circassian Beauties copied each other's positions exactly—each woman's hand met a curved vine branch at the same spot, each body leaned to the right at nearly the same angle, and each often wore the same costume down to the very fabric (Figure 2.3). He placed the women in positional conversation. The repeated poses, when seen together, appear odd and stiff, emblematic of the inflexible

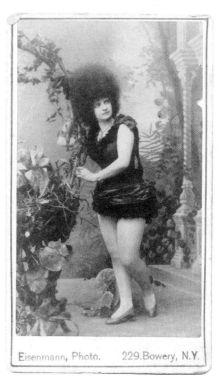

2.3. *A (left)*. Charles Eisenmann, *Circassian Beauty*, ca. 1880, carte de visite. *B (right)*.
Charles Eisenmann, *Circassian Beauty*, undated, carte de visite.

category of race that these so-called exemplars of white racial purity were pushed to embody (Figure 2.4).[19]

Absent from Eisenmann's images was the sense of implicit hierarchy found in one of the most salient images of multiracial staging that involves women from Circassia, John Frederick Lewis's 1849 *The Hhareem*—in which a woman of African descent is presented to the sultan, who is seated next to a group of alabaster-white Circassian women looking on with disapprobation (Figure 2.5). In Eisenmann's image, by contrast, the women have precise positional parity, an exactitude impossible to achieve without conscious, deliberate direction from behind the photographer's lens. The phenotypically white and black performers each have their own image. The borders of the photographs, when set side by side, double as a metaphor for racial boundary lines, shifting hierarchy to equity.

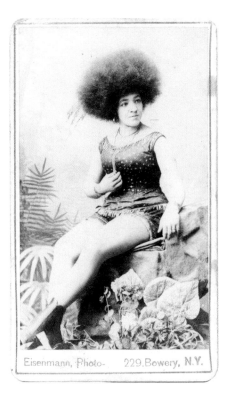 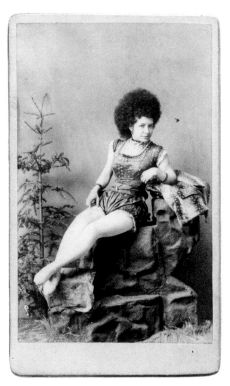

Eisenmann, Photo- 229,Bowery, N.Y.

2.4. *A (left)*. Charles Eisenmann, *Circassian Beauty*, undated, carte de visite. *B (right)*. Charles Eisenmann, *Circassian Beauty*, undated, carte de visite.

It could seem that Eisenmann's repetition was just an accident. Could it be that these images were just a function of the studio photography business becoming an industry in which efficiency, and with it a stable of props and poses, were part of the recipe for commercial success? Or was this diagrammed racial comparison how the Beauties actually performed on theatrical stages—white and black Circassian performers in identical positions as if to suggest parity—in defiance of their status overall as exemplars of white racial purity?

This is not how the performers were shown in public, seated in identical positions in sideshows. Instead, the images scripted a burgeoning form of adjudication—a comparative mode of picturing that audiences took away from seeing the show.[20] The photographs became what Robin Bernstein has called "scriptive" objects, which invited viewers to engage with a repertoire of Caucasian and Civil War–era reporting, the history of white slavery, and

2.5. John Frederick Lewis, *The Hhareem, Cairo,* ca. 1849–1850.

racial science all at once.[21] Facts about the Caucasus were being buried. These images are evidence that something had changed.

The Circassian Beauties performances were creating afterimages, the kind of "thought pictures" that Douglass had described. During the 1870s and 1880s, the performers appeared in theaters and dime stores all across America—from the St. Charles Theater in New Orleans to Platt's Hall in San Francisco to Wood's Museum and Menagerie in New York. The Beauties were so in demand that "the market for them" was "glutted."[22] Sales of the Circassian Beauties' photographs generated the lion's share of the performers' income. Performances and salient events gave them an additional semiotic charge. From Ellen Craft's flight to freedom to Dion Boucicault's play *The Octoroon* to the Janus image of the Caucasus and Alexander Pushkin—these popular, salient works and events fixated their audiences on the penetrable boundary line between races as part of the libidinal economy of race and desire.[23]

For some time, these Circassian images have been solely lumped with scholarship on the development of the history of deceit, as Kevin Young

has powerfully outlined, or the history of performance and sideshows at large.[24] Yet they were not just sly reminders of the legendary Caucasus leader Shamil, heroically holding the line in the Caucasus against invading Russian forces, or the narratives of white slavery. What makes these particular images of the Caucasus significant is that they expose how much unseeing these global narratives continued to matter for dislodging racial hierarchy and the logic of white racial supremacy.

It could seem that there were many more significant images that challenged racial hierarchy within American culture. Photographs at large were the new "green-backs" of society, an integral form of social currency.[25] As scholars including John Tagg, Jonathan Crary, Allan Sekula, and Deborah Willis have argued, building on the observation of Oliver Wendell Holmes and Douglass, photography and currency both became "forms of social power."[26] As photography technology developed, their inexpensive format became a tool for social leveling. With the invention of the *carte de visite* in 1854, patented by Paris-based photographer André Adolphe Eugène Disdéri, the photograph became the calling card of the day. The mounted photograph, a six-by-nine-centimeter image on an engraved calling card, became an aspirational format, a mode of self-presentation and imaginative social comparison.[27]

Customers could purchase as many as a hundred cartes at a time, and disseminate them widely, an ease of access that speaks to Douglass's emphasis on the democratization of the image.[28] As he argued, "what was once the exclusive luxury of the rich and great is now within reach of all. The humblest servant girl, whose income is but a few shillings per week, may now possess a more perfect likeness of herself than noble ladies and even royalty, with all its precious treasures, could purchase fifty years ago."[29] Through a range of manipulations in the studio—presentation, props, sartorial choice, and backdrops—both men and women could document themselves as they wished.

New inventions in photography had also begun to give validity to what people could before only imagine. Many had started trying to take pictures of the granular surface of the moon as soon as Daguerre's photographic method was announced—constructing images of what the eye alone could not yet fully see.[30] Being skeptical became a sign of wisdom; seeing reality justly meant accepting the limits of sight.[31] The unmasking of frauds, humbugs, and optical illusions had the power to confound and challenge the

authority granted to sight alone. Yet what could be seen least of all was the foundation supporting the regime of racial domination.

Abolitionists would sell photographs of emancipated, "racially ambiguous" enslaved children. As historian Mary Niall Mitchell argues, building on the work of Laura Wexler, these images "made it clear that the old ways of 'reading'" race "were insufficient."[32] Such photographs were often souvenirs of staged events. Celebrated minister and abolitionist Reverend Henry Ward Beecher would recount to his congregation the story of enslaved young children such as Fannie Virginia Casseopia Lawrence as "the girl stood quietly beside him" and a collection plate went around to buy the girl's freedom.[33] In the antebellum period and during the Civil War, magazines such as *Harper's Weekly* ran stories about such children that "fascinated and tormented viewers," to incite antislavery support (Figure 2.6).[34] Douglass himself would mention in his speeches how pictures in a "case of specimens" were sold on the street to support abolition.[35]

The unaddressed mystery of Douglass's speech is its fascinating and unexplored breadth. He never dwells on a particular image. Instead, he focuses

2.6. *A (left)*. Charles Paxson, *A Slave Girl from New Orleans*, 1864, albumen silver print, carte de visite. *B (right)*. Charles Paxson, *Freedom's Banner. Charley, A Slave Boy from New Orleans*, 1864, albumen silver print, carte de visite.

on how images at large move us, change us, and allow us to see the world anew. He included a far broader range of sources—satirical prints, photographs, and all manner of pictures—than has been discussed in scholarship on his work. What explains this wide range in focus?

The confluence of eugenics, immigration debates, and racial domination of Jim Crow rule made the cultural arena at large—from photographic stages to theatrical stages—a significant part of the work of conditioning racial sight. The confusion about the foundations of racial domination meant marshaling all kinds of images to secure the racial project. It turned stages, from the performative to the photographic, into sites of truth-telling about racial assembly, even that of the Circassian Beauties.

Eisenmann had crafted his images of the Circassians in New York City on the Bowery—a location that could not have been more different from the Broadway location of Mathew Brady's studio, the landmark photographic stage in the 1860s where the Circassian Beauties were first photographed. Broadway was the aspirants' avenue, a twenty-block strip between Eighth Avenue and Madison Square Park replete with theaters, opera houses, shops, and hotels. The Bowery, running parallel to Broadway, was then riotous and notorious, lined with beer gardens, concert saloons, shooting galleries, and dime museums. A "safety valve" for mounting cultural pressures in New York City, it became a frequent site of racial conflict.[36] It was a clash of communities: Irish to the west of the Bowery, Germans and Polish Jews to the east, with Chinatown sandwiched in between and "Little Africa" in present-day Soho. By the 1870s, New York City was teeming with immigrants, filled with telegraph wires and telegraph poles that leaned at angles suggestive of the careening, dizzying pace of the world around it. On the Bowery, the performers were "one of the favorite attractions."[37]

Dime museums on the Bowery—the People's Theater, the Globe Museum—had names that telegraphed the scope of the area's enterprise: to grapple with the narrative assembly of the world. The environs' racial confrontations seeped into the texture, composition, and provocative quality of their displays.[38] Shows on Bowery theatrical and dime-show stages, from vaudeville to melodramas, were often about blunt stereotypes, opposites, and the traversing of racial divides. A famous comedy team Joe Weber and Lew Fields, for example, was part of a production in 1883 during which the players made "a complete change from white to black in fifteen seconds."[39]

Given the Bowery's extreme ethnic diversity, racially charged theatrical productions had to be stark, clear, and unerringly direct. "With no common cultural heritage, often lacking even a common language, Bowery entertainers took their sordid realities and gave them a comic or sensational twist," critic William Dean Howells described. "The audience's limited comprehension of English, as well as their generally intoxicated condition, meant that the jokes and stories had to be sledgehammered home."[40]

Museums on the Bowery did not offer the expansive collections that we know today. They were typically two-story buildings, with a first floor dedicated to circus sideshows and "self-made wonders" and a second floor filled with curiosities, rare animals, and artifacts. Sideshow and dime museums, Rachel Adams argues, so thoroughly displayed "intolerable fragmentation" and semantic "dissolution" that they forced the audience to rely on narratives and scripts for "coherence."[41] An outside talker or a barker on the street would yelp out the dime museum's headlining and exhibitions to pedestrians, enticing them to come inside. An "inside talker" commonly called the "Professor" would "explain" the exhibits, often in lecture rooms.[42]

These dime museums offered a vital form of self-consideration and staging of collective identity. No matter their subject, by definition the performers would trouble the boundaries of a particular category, often "between self and other, normal and pathological, authenticity and fraudulence."[43] They offered viewers a measuring stick for their own perceived identities and views of society.[44]

For performers like the Circassian Beauties, photographs were critical for both their public image and their income. Tracking the backdrops and props used by Eisenmann's regular clients, biographer Michael Mitchell notes that they exercised choice in their appearance, creating a unique "collaborative aesthetic" that made his studio competitive.[45] In 1884, one Circassian Beauty, Zuleika, made ten dollars a week from various Bowery museums and "quite a large amount extra by selling her photographs to her admirers."[46]

In the nineteenth century, the spectrum of pictures was not as cleanly divided into genres as it may seem now. Photographs of actors and the staging of popular entertainments, often purchased after the performance, allowed for an extended consideration of these displays even in the home. These images could be placed in albums alongside family portraits and personal images. Their wide dissemination gave them a lasting, persuasive power in society as well as in the private realm of domestic life.

Conversations in the home would often center around such photographic albums. As Geoffrey Batchen notes, these albums mixed images

of performers and even ethnographic displays with family photographs. The photographer and the performer created the image; the viewer gave them an afterlife in the imagination.[47] This allowed for a meditation not only on one's family, but also on the human family—and the construction of races at large.[48]

Scrutinizing images was part of the early photographic viewing experience. Viewers pored over photographs—still then a new technology—looking for corporeal clues about the people before their eyes. This near microscopic assessment is exemplified by Émile Zola's novel *La Curée* (1872). The main protagonist, Maxime, and his lover, Renée, analyze a photograph with such precision that Renée notices even the follicles on her nose:

> He had portraits of actresses in all his pockets, even his cigar case. Sometimes he got rid of them and put these ladies in the album which was tossed on the salon furniture and which already contained the portraits of Renée's female friends . . . It ended up always being opened . . . She [Renée] stopped longer on the girls' portraits, studied with curiosity the exact and microscopic details of the photographs, the small wrinkles, the little hairs. One day she even had a magnifying glass brought, since she thought she saw a hair on the nose of the Écrevisse.[49]

These passages detail why Douglass was interested in the private function of pictures for the public work of American racial progress. It is precisely because these images of the Circassian Beauties were not meant to be displayed in public galleries but were instead private objects, haptic, held in the hand, considered over private conversation, that we can access practices of this postbellum period. Eisenmann's comparative sets of images reveal the frequent private considerations of what historian Matthew Frye Jacobson has called the "public fictions" of race.[50]

This archive surrounding these objects—the documented response to them and their construction—gives us a view of the sustained provocation created by images of the Caucasus. By 1885, Circassian Beauties were still a popular part of Barnum's roving circus, his "ethnological congress" replete with performers purportedly from around the globe. When the circus opened in Springfield, Massachusetts, the *Springfield Daily Republican* reported that the Circassian Beauty was selling photographs of herself when

she wasn't busy sitting "to be stared at" and could be heard "sighing over the patter of rain drops on the tent and the tribulations possibly of her race."[51]

Eisenmann's compositions trace this agitational role of the show, the kind of scrutiny and assessment that the Beauties endured.[52] He created interpretative photographic stagings, akin to mental projections. Each diagrammed how the performers were viewed. He created one set of images that presented them as they appeared, and another that showed how they appeared in the minds of their audience. These two modes—the likeness and "thought picture"—were part of ethnological displays in the nineteenth century on both sides of the Atlantic. One mode was to present her as she appeared and the second was an instruction to show viewers *"how to interpret what they see."* The audience's need for these "how-to-read-the-exhibition" posters underscored the "real anxiety" about the authority of sight, "that perhaps the body did *not* speak for itself."[53]

If Douglass argued that photography itself contained an inherent doubleness through its potential to ignite the critical imagination, Eisenmann's studio created photographs that exemplified this dynamic. Eisenmann's photographs of the Beauties were understood as more than figurative diagrams about the permeable contour lines between racial categories. The Circassian Beauty performances challenged the work of conditioned disregard. They laid bare the question of how race had confused the notion of sight itself in the modern world.

The Circassian Beauties would function as an optical exam for a country consolidating its rules of visual racial discernment with, as Frances E. W. Harper might have written in *Iola Leroy: or, Shadows Uplifted* (1892), "practiced" eyes.[54] Michael Leja theorized that the theme of "deception" in late nineteenth-century visual culture would have made viewing the performers a socialized, conditioned act of "distinguishing truth from humbug."[55] Adjusting to modern life meant "looking askance," learning to see skeptically by continually asking the question, "How do I know what I am seeing is real?"[56] This project seeks to add the history of racial formation to the trenchant analysis of the transformation of vision at the turn of the twentieth century.

"Make the hair as white as possible and smoke the sleeves so it blends into her white skin" still remains on the back of a circa 1880 cabinet card of an albino Circassian Beauty. Written by either Eisenmann or one of the photographic operators, it reads as a direction for a technician to manipulate her image, pushing both the color of skin and hair to the edge of the

chromatic scale. Certainly, this was one of many displays of albino figures in paintings, and in staged performances in Britain and the United States, that appealed because they resonated with concerns over racial indeterminacy, social hierarchies, and miscegenation.[57] Another such example comes from Thomas Jefferson's *Notes on the State of Virginia*, where he includes a discussion of six albino enslaved men and women to convey the challenges to taxonomy presented by race with this "anomaly of nature."[58] Other examples include Barnum's complex of displays including "A Negro Turning White," and the exhibition of the painting by Charles Willson Peale, *Portrait of James the White Negro* (1791), which went on view at the American Philosophical Society in Philadelphia and later at his American Museum, which Barnum would acquire.[59] Yet Eisenmann's instructions to craft an image of extreme whiteness on an albino Beauty, a person with stark white hair and an already pale face, underscores the fragility of racial categories in the mid-nineteenth century and the instability of the Caucasus region's associations.

When the Circassian Beauties debuted, other spectacles of racial adjudication would also still have been in the public's mind—from the Janus image of the Caucasus itself dramatized by the work of Alexander Pushkin to a play such as *The Octoroon* (1860). As eugenics ideals were funneled through representation in print, on stages, and through exhibition displays, cultural staging conditioned the American public.[60]

The Octoroon in particular conveyed the transformation in visual adjudication and the fugitive aspect of racial identity as perceived through the camera. Written by one of the most celebrated playwrights and managers in the English-speaking theater world of the nineteenth century, Dion Boucicault, the 1859 melodrama was set on stage in New York City and London. "Everyone talks about the *Octoroon*, goes to see the *Octoroon*, wonders about the *Octoroon*," stated an article in the *New York Times* just eleven days after the transatlantic performance had its opening night.[61] An article from the *Christian Recorder* in 1870 underscored its broad appeal: "Christian parents . . . permit their children to go" to the theater, "especially if the play be the *Octoroon* or *Uncle Tom's Cabin*."[62]

The Octoroon's plot pivots around the anxiety about the limits of the human perception of race when compared to the capacity of photography.[63] It is set on a Louisiana plantation where George Peyton, the nephew of the owner, has learned that he is the heir. One of the main characters of the play is Zoe, a name given to multiple Circassian Beauty performers who, as cultural anthropologist Lee Baker might put it, are "not quite white."[64] Zoe

is a fair-skinned mixed-race woman, an octoroon, a person then classified as one-eighth black. "Look in my eyes, is not the same colour in the white?" Zoe tells her white paramour George, acknowledging that to the naked eye she appears to be as white as he is. She makes clear that his eyes have deceived him. She contrasts the image of her hair to that of her skin as an attempt to reveal her true racial identity. "Could you see the roots of my hair you would see the same dark, fatal mark . . . I'm an octoroon!"[65]

The main object of the play is, in fact, the camera; the main point of the play is to examine the failure of racial vision it disclosed.[66] In one scene, the Yankee plantation overseer Salem Scudder states, "You may mistake your phiz. [physiognomy], but the apparatus don't," likening a photographic portrait to a scientific index used in racial science.[67]

The difficulty of racial reckoning kept the play in the news. Zoe's racial indeterminacy became a fixation for some critics, such as one from the literary journal the *Albion*, who, Daphne Brooks argues, "scrutinize[ed] the body for signs of buried black life."[68] Another critic, who "harbored 'an arithmetical suspicion' that 'it might be something like a double quadroon,'" was "forced to the shameful admission that curiosity goaded him to find out what the 'strange creature' really was like."[69] As Brooks adroitly discussed, *The Octoroon*, placed at the center a "distinctly transatlantic body," was "an icon of sectionalism" as well as of "imperial desire."[70] The stakes of a failure of vision in this context was high, and this failure is what the audience is left to contemplate. At the end of the play, a photographic plate is submitted as evidence to expose a murderous scene that had been hidden to all as if to dramatize the stakes of failed sight.

The fulcrum of the plot is comparison. On trial were the perceptual errors that occur when relying on the eye to determine racial categories. What the play reveals is "the truth" of the racialized body: it is "spectacularly inauthentic."[71] As Brooks cites, the *New York Times* review stated that Boucicault has "taken up bodily the great 'sectional question.'"[72] Yet it did more. It emblematized the nervousness about assessing racial difference in American life.

The Circassian Beauties also debuted at a time of the widely publicized escape of enslaved Ellen and William Craft, who offered a reminder that racial adjudication could not simply be conscripted to law. The Crafts represented one of the most significant cases of fugitivity in the United States and the targets of the first warrant issued under the Fugitive Slave Act of

1850. Ellen Craft, an extremely fair-skinned black, enslaved woman in Macon, Georgia, had disguised herself as a Southern white gentleman in a top hat and suit, and escaped to Boston in December 1848. To complete her disguise, she traveled with her enslaved husband, William, who posed as her slave.[73] Agents sent to Boston by Robert Collins, the Crafts' former slave owner, vowed to stay "to all eternity," if need be, to capture them. Yet trying to capture the self-emancipated couple in the nerve center of the abolitionist movement was "like throwing a rubber ball against a brick wall."[74] Their journey, as William Wells Brown put it in a letter to abolitionist William Lloyd Garrison, was "one of the most interesting cases of the escape of fugitives from American slavery" that has "ever come before the American people."[75]

The lecture tours that recounted the Crafts' fugitive escape, publicized in their 1860 publication *Running a Thousand Miles for Freedom; or, The Escape of William and Ellen Craft from Slavery,* turned their lived reality into a spectacle. The Crafts were international news. Ellen Craft became, as Uri McMillan put it, "a form of bodily evidence . . . that the escape did in fact occur."[76] Just weeks after their escape, the Crafts were already lecturing with Brown on the antislavery lecture circuit, traveling to sixty towns in four months in New England and ultimately to Scotland to address crowds of thousands. In the North, Ellen Craft was celebrated "wherever she went" as "people crowded around to shake the hand of the 'white slave.'"[77] Even as late as 1869, the year Eisenmann emigrated to the United States, there was still such interest in the Crafts that many assumed they would "have a public reception" in Boston.[78] Ellen Craft had passed "*through*" whiteness, as P. Gabrielle Foreman argues, remaining on the other side of the color line while revealing it as a flimsy, constructed boundary that could be trespassed. Like the Fields' Bowery performance in the 1880s, the one in which they made "a complete change from white to black in fifteen seconds," Craft showed how this porous racial boundary enabled their self-manumission.[79]

The Octoroon and the Crafts both spoke to the permeability of racial categories, while the Circassian Beauties spoke to the fundamental instability of the racial project itself. The Beauties not only challenged the relationship between the "new visual economy" of race; they also exposed the fact that this visual economy was based on confounding, contradictory global narratives that underpinned the structure of racial hierarchy, from a region that refused racial legibility entirely.[80] The performers became an emblem that would turn racial adjudication into a composite act of assembly, a process of piecing together narrative fragments to make sense of the world.

Racing the Caucasus

By the 1870s, picturing the region of Circassia had become an act of racial investigation in the American public imagination. The coverage of another large-scale Caucasus rebellion against Russia during the Russian-Turkish War of 1877–1878 was just as assiduously followed in the press as the Caucasian War had been, yet the Caucasus was no longer seen as a place of racial purity protected by a "warrior-priest."[81] A borderland between Europe and Asia, Islam and Christianity, civilization and savageness, it was no longer seen as simply white.[82] Beyond the burgeoning racial boundary lines in American culture, the Janus image of the Caucasus became mapped onto the Circassian Beauty performers.

The truth about the circulating image of the Caucasus fashioned by scientific racism rested on a foundation as rocky as the Caucasus's contrasting, dramatic black and white mountains. For a time, Blumenbach's racial taxonomy had been cast aside by subsequent racial scientists, and Nordic, Anglo-Saxon, and even Aryan defined whiteness instead.[83] Yet the disorientation about the image of the Caucasus vis-à-vis its usage in the United States lingered due to the foundational role the term and region had played in racial discourse. In 1875, one anthropologist attempted to summarize the diversity of the Caucasus and surrendered in defeat: "How such a heterogeneous collection of the tatters, ends, and odd bits of humanity ever blended into one coherent and consistent whole I don't know; but there they are, offering problems to ethnologists and comparative philologists which will be hard to solve."[84]

Even the central figures who popularized the image of the Caucasus in the literary imagination, such as Alexander Pushkin, challenged narratives of racial discernment. The racially doubled image of Pushkin in his literature had become closely identified with the Caucasus in the European and American imagination. When he released his poem *Prisoner of the Caucasus* (1820–1821), people felt that he had "discovered" the region.[85] Pushkin's writing so colored the conception of the Caucasus that his texts seemed autobiographical. It was widely known that Pushkin's great-grandfather was African, born in a town in modern-day Cameroon. He was bought out of slavery in Constantinople to serve the Russian tsar, Peter the Great, who set in motion the Caucasian War.

In January 1832, after Pushkin sustained a public attack because of his black racial heritage, a friend sent him an inkstand that features a shirtless ebony man surrounded by containers for bales of cotton that double as the

receptacles for ink. The figure leans against the upright standing anchor of a ship (Figure 2.7).[86] The sculptural inkstand underscored the relationship between his authorial and racial identity. Pushkin appreciated the gift, "which he kept on his desk to the end of his days."[87]

As Harsha Ram argues, *The Journey to Arzrum*, Pushkin's most significant text from his time in the Caucasus from May through November 1829, is a prismatic lens through which one can see Pushkin "ponder his personal and cultural identity."[88] In one of his most popular texts, *Eugene Onegin*, he envisioned his protagonist leaving from "under the sky of my Africa to sigh for gloomy Russia."[89] He felt a feeling of kinship with black Americans—"my brother Negroes," he would say.[90]

The various images of Pushkin schematized the very contradictions that would come to define the Caucasus region: Pushkin's portraits were as racially doubled as the image of the region. In prints and paintings, his hair was sometimes rendered curly, but other times frizzy or straight. A few artists gave him a dark complexion; more rendered it as fair. His nose at times appeared broad and bulbous and other times flat, aquiline, and thin. As Abram Tertz put it, Pushkin was "one big familiar blur with sidewhiskers."[91] The "taxonomic problem" with his racial heritage, as Russian-American

2.7. Alexander Pushkin's inkwell, ca. early 1830s, gilded and patinated bronze, metal, glass, cardboard, velvet.

novelist Vladimir Nabokov put it, resulted in a bifurcated corpus.[92] The 1827 portrait by Orest Kiprensky that "comes closest to being *the* iconic Pushkin," the most frequent source image for the many that would follow, altered his features (Figure 2.8).[93] Yet by the 1860s, most images were again emphasizing his "Negroid features," just as Pushkin himself had done in his 1827 self-portrait, where he rendered himself as a "blackamoor." Later works such as Ivan Aivazovsky's *Pushkin on the Black Sea Coast* (1868) and Ekaterina Belashova's *Pushkin as a Boy* (1959) come far closer to the thicker lips, wider nose, curlier hair with "a pinch of wildness," and even darker skin

2.8. Orest Adamovich Kiprensky, *Portrait of the Poet Alexander Pushkin (1799–1837)*, 1827, oil on canvas, 64 4 / 5 × 56 1 / 2 in.

tone that Richard Borden describes as on display in early lithographs and paintings.[94]

These variances go so far beyond the physical changes that could have occurred over his lifetime that now there is no "true" image of Pushkin. The only "real" physiognomic trait of Pushkin that we can verify is his hair. In the Alexander Pushkin Memorial Museum, a curl of his hair is prominently on display. No photographs or portraits accompany it. Lock preservation was a Victorian tradition of remembrance of a deceased loved one, yet its public presentation suggests an ethnographic interest in the Caucasus-associated writer even after his death. His locks became so central to the image of Pushkin that it became a part of his posthumously given sobriquet, "the curly haired magus."[95]

Pushkin's prominence in America was heightened through his twinning with Douglass. There was the iconic stature of their lives and the parallel contours of their narratives—lives altered due to their outspoken beliefs about the moral center of their homeland, being descendants of those who were enslaved, and free and renowned by virtue of their authorial prowess. In Russia, Pushkin was hailed as the nation's greatest poet. Abolitionist and free black communities used this contrast between Pushkin's life in Russia and probable fate if he had been born an American writer to agitate for Emancipation.[96]

"Can it be possible that this man, so wonderfully gifted, so honored, so lamented, was a colored man—a negro? Such, it seems, is the fact. Incredible as it may appear to the American reader," maintained a writer for the *National Era* in 1847. The author wrote this ten years after Pushkin had died, such was the black Russian poet's presence in American consciousness.[97] Pushkin's well-known sympathy with enslaved black Americans further cemented his position with American abolitionists and his alignment with black racial identity.

Pushkin was both part of abolitionist discourse and a popularizer of the Caucasus. American audiences came to read Pushkin's Caucasus-associated works largely between 1872 and 1887, due to a delay caused by copyright and translation law. His stories, such as "Married in a Snowstorm," "Queen of Spades," "Marie," and "The Final Shot," appeared in newspapers from Chicago to San Francisco to Keene, New Hampshire.[98] The works were so vivid that readers could just about "inhale the odor of the steppes, and catch glimpses of the semibarbarous" Caucasus inhabitants.[99] His image embodied the very contradictions that would come to define the Caucasus region.

"Practically Exploded": Racial Adjudication and the US Courts

The Beauties' popularity discloses the work required to disregard fictions. Global narratives had to be reassembled to suit the story of racial domination. It would take decades for the challenge that the performers posed to the keystone idea of racial hierarchies to become explicit. "How are you going to read through silences?" many asked me as I researched Eisenmann's photographs. Although in the postbellum period there had been a litany of comments about them, by the turn of the twentieth century, when the Beauties were no longer popular, every revelation about a Circassian Beauty's Irish, mixed, or Jewish identity had elicited an insistence on their authentic racial whiteness. At the height of the Circassian Beauties' popularity during the 1870s and 1880s, the response to their racial provocation was as mute as later commentary about their racial identities would be vocal.

When Toni Morrison argued that silences in the historical record can be evidence of an unspeakable meditation on race, she looked for the literary "signs," "codes," and "strategies" of a racial encounter. One of her extended examples is the failure in literary criticism to address the "interdependency" of racial definition through the focus on the light-skinned enslaved woman, Nancy, in Willa Cather's *Sapphira and the Slave Girl* (1940).[100] Instead, the work has been read as insignificant to Cather's oeuvre (despite how significant it was to Cather herself).[101] Morrison exhorts us to notice how an image of "impenetrable whiteness" was not a signal of a non-response, but rather of a much deeper moment of racial recognition.[102]

In 1899, the well-known circus press agent Dexter Fellows claimed that "Zuleika, The Circassian Sultana, Favorite of the Harem, was really an Irish immigrant from Jersey City."[103] Barnum's contemporary John Dingess also revealed that the first Circassian was a local Jewish woman whom a Turkish man had helped to fashion as a Circassian by using unrinsed beer to help tease her hair.[104] Other articles claimed that "Barnum's Circassian girls" were "museum actors"—that "they were natives of Brooklyn, but had studied up a foreign manner."[105] As late as 1908, *Scientific American* noted that "the blonde loveliness of the Circassian beauty, who delighted our unsophisticated younger days, was, of course, a case of albinoism."[106] Questions about the image of the Circassians and the Caucasus had endured.

By 1922, when the Circassian Beauties were no longer a popular show, there were still full-page articles, like one in the *Salt Lake Telegram* from a

Madison Square Garden circus press agent, that deliberated over whether the Circassian Beauties were really a "consanguineous breed" called the "Jackson Whites," who came from the Ramapo Mountains located in southern New York and northern New Jersey and were described as "an interbred group of Indians, negroes and whites."[107] This isolated, multiracial group of whites, Ramapo Indians, Dutch settlers, and Caribbean immigrants resisted racial categorization as much as the Circassian Beauties had.

To attribute the Circassian Beauties' heritage to the Jackson Whites, a group that refuses racial legibility, was a metaphor for how hopelessly tangled the image of the Circassian region had become. According to legend, the group was made up of the offspring of Hessian soldiers serving in the Revolutionary War and of West Indian women brought to America by one British sea captain named Jackson. When the British left in 1783, the Hessians evacuated New York and left behind the children of these alliances, who then married Dutch settlers and Indians living in the Ramapo Mountains. The tongue-in-cheek term for Jackson's black Caribbean female captives, "Jackson's Whites," stuck as the name for the entire group. Yet there is no evidence for the veracity of this origin myth. "There are half a dozen legends current," as a reporter from *Appleton's Journal of Literature, Science, and Art* put it in 1872.[108] The speculation about a Ramapo Mountain identity for the Circassian Beauties sharply exposes how determined audiences were to write the performers' aesthetic out of the category of whiteness.

The full-page article about how the Circassian Beauties were truly Jackson Whites concluded with a statement of utter disbelief: "I think the circus press agent was wrong."[109] The articles followed a template. After asserting that the performers were not truly Circassian, but another ethnicity, the author would claim that the performers were still irrefutably white and considered "peerless."[110]

"She was the limit," ran the title of a 1910 cartoon about the Circassian Beauty that circulated from Mississippi to New Jersey.[111] It was meant as a pun on limits of a sexual nature; she was drawn next to a sultan as if conjured from his hookah smoking state, as he says that she is the "nine hundred and ninety-eighth girl I have loved and 998 is my limit." The Circassians had also become a signpost for the Janus image of the Caucasus for America's project of racial self-definition.

Articles about the Caucasus performers circulated in the press with as much frequency as they had during their act's peak, yet now they were about race-based recollections. The spectacle waned as a popular act in the first

decades of the twentieth century, but remained, as the *Cincinnati Daily Gazette* reported, one that "the public has not forgotten."[112]

The focus was on the gulf between the reality of the Caucasus and what the audiences had seen. In 1885, the *Cincinnati Enquirer* ran an article by a fifty-year-old man named Paul Nicholase, who claimed to be the first naturalized American from the Caucasus to reside in Wheeling, West Virginia. He described the women of the Caucasus—from wrist to shoulder, to their hair ("long" and "black"), to their "creamy complexions."

"Just think of that picture!" he concluded.

"Then the Circassian Beauties we see in the dime museums are all imposters," the reporter said.

"Sure," the Circassian man says. "There are no women in the country like them."[113]

At the turn of the twentieth century, the trope of the Circassian Beauty performers would continue to emerge not only in literature, such as caricaturist and prose writer Max Beerbohm's satirical novel *Zuleika Dobson* (1911), but also in film. In Josef von Sternberg's *Blonde Venus* (1932), Marlene Dietrich plays Helen Faraday, a German actress who moves to New York and decides to return to the stage to raise money for her ill husband. She is billed as "The Blonde Venus."[114] To unveil her act, Dietrich performs, dancing in a gorilla suit, in dramatic racist caricatures, surrounded by dancing, brown-skinned women all sporting afros. Shedding the gorilla costume, Dietrich runs her fingers through her straight blonde hair before putting on a bleached blonde afro wig. The camera holds on Dietrich's transformation. She permits herself to be examined, silent, swaying with a pursed lipped smile.

This scene is devoted to Dietrich silently swaying for forty-five seconds—a hold time that was once called the longest in cinematic history. She looks out to the audience, offering coy smiles, saying nothing. The silence gives the audience a chance to sort out her very being. The scene resolves through a question that points to the construction of racial formation itself: "Is the gorilla real?" a woman asks the bartender. Dietrich's performance in the scene recapitulates not only the focus on the Janus racial construction central to the Circassian Beauty performance, but also the discernment that became the heart of the earlier spectacle.

By the turn of the twentieth century, audiences were familiar with the impresario's tricks, so why did the trope of the Circassian Beauties endure?

Why was there this insistence on knowing their racial identities? Why was there this cultural focus on examining them? The public knew that curiosities by impresarios like Barnum, as Rachel Adams reminds us, are "not born; they are made, and their making relies on the collaborative efforts of many hands who work behind the scenes."[115]

What had changed? The racial script of the Caucasus was out of order, a set of nearly unintelligible narratives and histories. Documents such as the US Congress–sponsored *Dictionary of Peoples* reinforced the trope of Circassian beauty in 1910. As Nell Painter notes, the classic eleventh edition of the *Encyclopedia Britannica*, published in 1910–1911, featured Circassians with an entry stating that "in the patriarchal simplicity of their manners, the mental qualities with which they were endowed, the beauty of form and regularity of feature by which they were distinguished, they surpassed most of the other tribes of the Caucasus."[116]

During this fulcrum moment, immigration, nativism, and Reconstruction intensified the focus on the idea of the Caucasus as an exclusionary and confounding framework—a history altogether absent from the reception history of these images, let alone other works of the related period. Yet this context is crucial. The US courts would come to base decisions on the everyday assembly of the idea of the Caucasus, in cases that brought the world of culture to bear in determining the contours of racial formation.

In the United States, by the early twentieth century, no one knew what the faces of actual men and women in the Caucasus looked like, and given the forceful, confident hardening of racial lines, it could *seem* that no one fully cared. In the early twentieth century, around the time that Woodrow Wilson wanted to envision the look of people in the Caucasus, Major General Harbord had been nearly abducted in the area. "Harbord Narrowly Escapes Capture" and "Harbord Attacked in Caucasia" ran the many headlines detailing his ordeal at the hands of "bandits a few miles from Mount Ararat" in the Caucasus, where Noah's Ark purportedly came to rest, cited by racial scientists as evidence of the site being the homeland of whiteness.[117] Tales of savagery in the region had become part of the narrative that helped the public make sense of the gulf between the image of the region and its current demography—heterogenous, Muslim, and nothing like the image of whiteness reported by naturalists.

Images of men and women from the Caucasus were unexpected characters, walking on stages unannounced, disrupting American racial scripts. Articles would run that exemplified the confusion over the place and symbolism of images of men and women from the Black Sea region. When

a group of "strange-looking men" were "detained at Immigration Services" and "government interpreters" were "unable to classify them or to understand their language," it was assumed that the men must "be natives of some village in the Caucasus Mountains."[118] Caucasus figures surfaced as revenants.

By 1919, at the time of Wilson's request, the Caucasus had continuously been exposed as racially heterodox, with the grounds for the idea of racial whiteness becoming unstable and illegible. During this period, immigrants were negotiating their place in the umbrella of racial whiteness in the United States. Immigrant groups—Irish and Italian, for example—negotiated their entrance into the category of whiteness through politics, then documented and confirmed their presence by visual culture—illustrations, political cartoons, plays, and more. Yet images of the region that had created the conceptual framework for the very idea of whiteness had exposed the baselessness of racial domination itself. Seeing actual images of the region after the Caucasian War uncovered the inability to ground the racial project in fact.[119]

Common knowledge, as US courts defined it, came to determine whether someone was Caucasian and what the idea of the Caucasus meant for racial order. Yet this common knowledge required conditioning sight. Adjudication—visual, comparative—became urgent work for a society shaped by eugenics, galvanized by nativism, and gripped by debates and policy changes about immigration.

Racial oppression during Jim Crow rule seems to have been absolute in every domain of life. Yet as Jennifer L. Hochschild and Brenna Marea Powell argue, a study of the period through the lens of assessment—through the census, courts, and maps—suggests nervousness about maintaining a "complex and possibly *vulnerable* racial order."[120] Publications by the US Census Office, which took on an increasingly central role in racial assessment and governance, reflect this conflict. Census enumerators were instructed to "be particularly careful" when making racial distinctions in the 1880s. They were reminded that "important scientific results depend upon the correct determination" of race and ethnicity, but were offered startlingly little instruction on how this was to be done.[121] The census introduced an increasingly unstable set of ethnoracial categorizations, down to the percentage of blood admixture. However, there is no explanation for the lack of instruction for how to make these increasingly precise determinations.[122]

At this time, both at the federal and Supreme Court levels, the courts began to focus on naturalization petitions in which plaintiffs claimed their

qualifications for citizenship on the basis of being racially white. Judges now had to parse the arcane history of racial science, focusing on the geography of the Caucasus region to compare it with "the common sense understanding of the term Caucasian."[123] This political focus on the Caucasus intensified in 1877 when Congress received the Report of the Joint Special Committee to Investigate Chinese Immigration.[124] Alongside this, organizations such as the Order of the Caucasians in San Francisco, whose mission was to "drive Chinese out of California," exemplified the nativist sentiment that hardened into the Chinese Exclusion Act of 1882.[125]

In a speech in 1869 titled "Our Composite Nationality," Douglass pointed to the effects of citizenship cases on assessment, which in turn was crucial for understanding the future of America as a "composite nation."[126] In this speech, which Jill Lepore has called "one of the most important and least read speeches in American political history," Douglass focused on the challenges emerging from Chinese immigration to make a case for the ratification of the Fifteenth Amendment, which granted black men voting rights in principle, though not in fact.[127] His discussion of naturalization, citizenship, and voting rights, and his support for naturalizing Chinese immigrants, pushed back against the waves of nativist sentiment. As David Blight notes, this speech was unique in laying out a vision of a "cosmopolitan America," one "better," Douglass argued, for being a composite democracy "composed of different races of men."[128]

This speech about Chinese immigration would expose the rocky logic through which the term Caucasian had come to mean racially white. "The apprehension that we shall be swamped or swallowed up by Mongolian civilization; that the Caucasian race may not be able to hold their own against that vast incoming population, does not seem entitled to much respect," Douglass argued. So pivotal would Chinese immigration be for labor demand in the United States, he wrote, that "the old question as to what shall be done with the negro will have to give place to the greater question 'What shall be done with the Mongolian,' and perhaps we shall see raised one even still greater, namely, 'What will the Mongolian do with both the negro and the white?'"[129]

This legal discourse was happening alongside the use of extrajudicial measures to define the boundaries of racial hierarchy. Scholarship by Jasmine Nichole Cobb and Nicholas Mirzoeff considering the legacy of the "oracular" institution of slavery and its history of surveillance is instructive here, as is the repertoire of fugitive slave advertisements carefully researched

by scholars including Huey Copeland and Charmaine Nelson.[130] The history of fugitivity and slavery had not only enjoined vision and civic authority, but also defined whiteness as a subject position in such a way that allowed for, if not demanded, racial assessment as an act of citizenship.

The rupture of the unstable idea of the Caucasus sent scattered blasts into the culture in the form of artifacts, paintings, and performances that have hidden the impact of this history. "What is the white race?" federal district court judge Henry Smith would ask as late as 1914, after excavating the history of the term "Caucasian" for a key 1913 case, *Shahid*, that denied naturalization to a Syrian man petitioning that he qualified as racially white.[131] Judge Smith cited experts who considered the Caucasus an "odd myth," born of "strange intellectual hocus pocus" and argued that "the general inclination would be to consider the definition of Caucasian as what is supposed to be meant as white. This, however, is very loose and indefinite, for the meaning of Caucasian has been now practically exploded."[132]

Racial adjudication became the foundation of social order. Ian Haney López deftly interrogates the impact of this fractured idea in the context of legal cases, pointing to *Takao Ozawa v. United States* and *United States v. Bhagat Singh Thind*, which were brought before the US Supreme Court and privileged "common knowledge" above specious racial science.[133] In the *Thind* case, Bhagat Singh Thind was deemed ineligible for citizenship as he could not be considered white in the "common" sense, only in the sense that racial science determined that his Indian identity made him part of the Caucasian race. The use of common assessment as bedrock for legal decisions instead of repudiated racial science had material consequences in public life. Yet what the focus exclusively on law omits is that this "practically exploded" idea of the Caucasus indicated a foundational shift that had taken place in US society.

Frederick Douglass would not live to see the tactics of the full-blown expression of eugenics, nativism, and Jim Crow rule during what would become a racial nadir of American life, but the critical shift in unseeing was well underway. He anticipated that the force of racial adjudication would define it and become necessary to challenge it. It was not limited to the work of natural scientists and abolitionists. Picturing as a strategy of racial

adjudicating—discerning between narratives and truth—became, as we will see, a central tactic for combatting injustice after the fractured foundations of racial domination were exposed.

One year before the end of his life, Douglass would emphasize this force of conditioned sight, and identify it as a tactic of racial domination, in his 1894 speech "Lessons of the Hour." "Even when American art undertakes to picture the types of the two races it invariably places in comparison not the best of both races as common fairness would dictate, but it puts side by side in glaring contrast the lowest type of the negro with the highest type of the white man and calls upon you to 'look upon this picture then upon that.'"[134] One of the main questions in American democracy is how to tell the story of who we are. In representational democracy, the answer has always been representation itself. Visual culture has always been a way to work through the blind spots of norms and laws that did not honor the full humanity of all.

In Douglass's library in his final home in Anacostia, he had the works you might expect of a prodigious orator—*The Columbian Orator* by Caleb Bingham, lyric poems by Lord Bryon, iconic works by Homer, and landmark narratives by fellow abolitionists including Harriet Jacobs, Solomon Northup, and Sojourner Truth. He also had a large share of books devoted to the arts, as well as surveys of parts of the world from the South Pacific to the Black Sea.[135]

In his library, these art-related books are the main category that, at first glance, seem to deviate from the central theme of justice, race, and politics. There is no such cluster of, say, books on technological advancements, though there were many at the end of the nineteenth century. There is no set of books on finance despite the developments. Only these art books. John Whittier was not alone in considering Douglass's work the headwaters of a "new, truly *national* literature," as Henry Louis Gates, Jr. states. Douglass also knew that the key to change lies in a literature of pictures, the mental images we hold about racial life.[136] Through his lectures and speeches, he focused on how images offer a new way to understand race and vision. His library reveals, too, that privately he was also engaging with a set of thinkers, from John Ruskin to Oliver Wendell Holmes, who wrote about the intersection of image-making and worldview in the Civil War and postbellum period.

Douglass's books on the arts included texts by Ruskin, all three volumes of the *Pictorial Field Book of the Civil War*, and one copy of the Museum of

Fine Arts, Boston exhibition catalogue from the spring and summer of 1886, the year when the painting *A Circassian* by Frank Duveneck was on view. By the time *A Circassian* went on display, the public was just beginning to accept the racialized idea of this region as a fabrication. A consideration of Duveneck's work, one of the first paintings collected by the museum, offers a case study of how silencing obscured acceptance of the fabricated image of a white racial homeland.

Unsilencing the Past

The Production of Race, Culture, and History

In 1870, artist Frank Duveneck completed a painting titled *A Circassian*. The work centralizes a man from the Caucasus, once seen as the so-called locus of white racial purity, wearing a beige, black, and white *cherkeska*. He appears with mottled skin, darkened tawny limbs, and a face that looks nearly tannish brown. He sits on the floor, his eyes downcast beneath his heart-shaped, black fur *papakha*. The backdrop is rendered with care to surround the figure in bright white, as if spotlit (Figure 3.1).

Seeing the work stopped me in my tracks on a visit to the Museum of Fine Arts (MFA), Boston. High up on the wall, near the ceiling, the painting was nested in the top row of works by artists whose travel outside of the United States was critical to their output. Intrigued not only by the painting, but also by its inclusion in this installation, I lingered to stare at it for some time (Figure 3.2).

I knew that this picture of a Caucasian figure was one of the first to enter the collection of the museum, one of the earliest established in the United States. As to the significance of the work itself, there has long been silence. It is curious. After all, in the nineteenth century there was an active discussion about the rupture between depictions of the Caucasus region, and the foundations of racial ideology and white racial supremacy. Yet when I looked for any writing about the significance of this work, given the symbolic role the region had played in the history of racial formation, I was surprised to find nothing.

How has a painting renamed *Caucasian Soldier* in 1919, before reverting to the original title nearly a century later, engendered no scholarship on

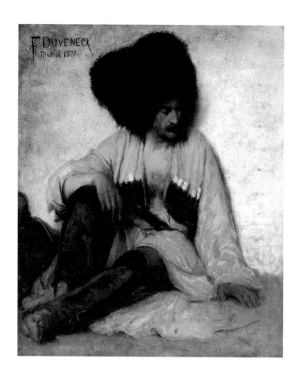

3.1. Frank Duveneck, *A Circassian*, 1870, oil on canvas.

3.2. Installation wall displaying Frank Duveneck, *A Circassian (upper left)* in Art of the Americas, Museum of Fine Arts, Boston.

racial construction in the United States? More striking, how could this si-
lence seem so *unremarkable*—even expected? Why is it so easy to overlook
the unstable ground of racial hierarchy and racial dominance that the Cau-
casus came to represent?

A Circassian has long been seen as an example of artistic prowess. The
work showcases the artist's loose, direct, tenebrist style and brushwork, an
innovative, wet-on-wet painting technique that prompted painter John
Singer Sargent to proclaim that "after all's said, Frank Duveneck is the
greatest talent of the brush of this generation."[1] Duveneck used an *alla prima*
conceptual innovation, adding meaning with each nuanced layer of paint.
Dubbed the unsuspected genius by Henry James, he stacked brushstrokes,
individually visible and fragmentary, as if they were gathered thoughts.[2] His
technique could give viewers a sense of immediacy that led to the sensa-
tion of watching a mind trying to resolve a mental picture.

What *A Circassian* does more broadly is force a consideration of the
unvisible—what is first seen then unseen, even ignored—and the silences
in the construction of both the history of visuality and racial formation. *A
Circassian* not only represented the start of Duveneck's painting style; the
artist's technique and tonal range made the difficult act of *seeing* Circassia
the unstated compositional feature of the work itself. *A Circassian* poses a
riddle: how should one picture the Caucasus at a time when a "Caucasian"
ideal was revealed to be a racial fiction hardened into foundational fact?
Duveneck's painting, unconsciously or not, encoded the disavowal about
the Caucasus as a site of racial formation. His technique forced complexity
in how to read his works racially. The painting emerged as a metaphor for
the struggle to unsilence the Caucasus region's racial connotations as the
nation recovered from the Civil War.

One of the gifts of the field of Black Studies is a set of methods for seeing
the shape of absence, of omissions, of silence.[3] As Michel-Rolph Trouillot
writes, "effective silencing does not require a conspiracy, not even a political
consensus. Its roots are structural."[4] What can we learn from the mecha-
nisms that have permitted a silencing of this history? At the turn of the
twentieth century, both perception and disavowal—silencing—became
foundational for racial adjudication. This painting is an orienting guide to
understand this fulcrum moment.

In the 1870s, critics in the largely white viewing public in Boston tried to
puzzle out whether Duveneck's painted figures were, in fact, based on white

models from the United States. Were his studies of racial and ethnic types from the 1870s to be believed? "The talent of Duveneck's is no common thing . . . One would think he could paint anything," one Boston critic observed, arguing that his skill "should be exercised only on the noblest subjects," prompting the question, what is meant by a "noble subject" exactly?[5] "There is something annoying and even exasperating in this uncertainty in which we are left in regard to the meaning of the scene before us," one reviewer complained about a suite of Duveneck's works. As curator Julie Aronson wrote, much of the audience found the "painting's ambiguity disconcerting."[6] The process of assessment was great enough to prompt a bodily response—not confused or quizzical, but frustrated, as if not knowing had consequences. During this era, sight was becoming a precise judgment that drove toward narrative racial clarity. *A Circassian* shows what thwarted this process.

Is it possible that what could not be said, but could be expressed through frustration, was that Duveneck's work was violating an emerging visual code?[7] Models were not meant to disrupt the proscenium stage, to alter viewers' understanding of the very act of seeing past the curtain or into the frame, by conveying themselves as other than who they were. They certainly were not meant to do so when portraying an idealized type that intersected with a fraught racial category. We are so accustomed to narrative certainty about race that it is easy to evacuate from the record evidence of the tense process by which we naturalized racial classification and hierarchies. The questions regarding racial discernment surrounding *A Circassian* reveal this to be a moment when American artists representing racial whiteness in the nineteenth century engaged in visual negotiation that required conditioned sight.[8]

At the time of the work's execution and display in 1876, the term "Caucasian" would start to be questioned throughout the judicial system in the United States, in widely popular lectures, and in aesthetic programs such as monument-building projects to honor the invariably white common soldier. *A Circassian* was on display at the MFA, Boston, during the widely followed uprising against imperial Russia in the Caucasus between 1876 and 1877. The "Circassian Revolt," as it was often called in reporting in the United States, became almost universally termed a "Mahomedan revolt" in the United States the year after it erupted. The region previously identified as racially white was recast as Muslim and Asian, described as a place filled with "alien racial elements."[9]

When the museum acquired Duveneck's work in 1876, the P. T. Barnum Circus—advertised then as "The Greatest Show on Earth"—traveled to Boston in June and July of that year with the Circassian performers described earlier. A "Circassian Lady" named Zuruby Hannum appeared, as did Zoe Meleke, and they were billed as "Human Curiosities."[10] As the war in the Caucasus raged and P. T. Barnum staged his "Circassian Beauties," towns and cities in and around Boston were also receiving their first Civil War common soldier monuments. How to create the look of a representational "white" soldier, down to the specific geographically located racial type, was a question, as Kirk Savage argues, for what would become "the most prolific figure in public sculpture."[11] The Caucasus presented a challenge suggested in Duveneck's painting—how does one read a body as "Caucasian"? It is a history that has fallen out of our sociopolitical understanding of the period, but can and must be understood today.

We see what stabilized racial hierarchy by examining what we have learned *not* to see. The use of race as a mode of assembling life in the project of modernity conditioned the act of seeing into a complex process of fraught judgment, of thwarted yet constant assessment. We "see" race in the production of history when we study the act of looking. As Tanya Sheehan has argued, the question of "where and when we go looking for signs of race" invites more questions, including a rarely asked one: "Can we trust what we see in the twenty-first century when it comes to understanding representations of race in the nineteenth century?"[12]

Visual transformations in the nineteenth century extended beyond representations of race to include ways to see around the instability of the racial project. Yet we have very few frameworks to consider how representation—paintings, performances, prints, and photographs—telegraphed the lingering *instability* of racial hierarchies, categorizations, and formations. We have few concepts that let us see the process of the neutralizing fictions underneath the term Caucasian to recall a time when it was a contested idea.[13] This silence, this lack of framework, lets us look at shards of information—Caucasian armor, a painting of *A Circassian*, a note in the archives about Woodrow Wilson wanting to see women from the Caucasus—and move on. The visual regime of disregard emerged from representing this complex Black Sea region that became vital for racial formation.

The silence about the racial valences of *A Circassian* is not due to some error on the part of any scholar or curator or any documented resistance. The adjudication of race through representational regime—from the common soldier monument to the legal fixation on the term Caucasian to the focus on the Caucasian War—has not entered any of the discussions on the reception history of *A Circassian*. The history of racial formation has been, in effect, "unthinkable" in the writing on Duveneck. Here I am referencing Pierre Bourdieu's conceptualization of the idea via Trouillot, who argues that the unthinkable occurs not out of "ethical or political dispositions" but due to lack of conceptual frameworks, to a want "of instruments of thought" whether they be "concepts, methods, and techniques."[14]

There is a shape created by the unvisible. There is a shape created by the opacity of unseeing this history. As Ann Laura Stoler has argued, the "unwritten," in the context of colonial, imperial, and slaveholding territories, can emerge for a number of reasons: there is "what was 'unwritten' because it would go without saying and 'everyone knew it,' what was unwritten because it could not be articulated, and what was unwritten because it could not be said."[15] To this, one might add other reasons, such as the episteme crafted by racial formation. The lingering assembly of the Caucasus in the European and American imagination—seen and then disavowed—has determined what is pertinent to discuss or not about the region: the representational regime of Orientalism is on the table, for example, yet the equally pertinent and related history of racial science is often not.

Examining the full reception of Duveneck's *A Circassian* unsilences history. Silences, variable and distinct, can enter at various moments in the assembly of history, from the archives to the production of narratives. There is a shape to this silence akin to a conceptual black hole, per Evelynn Hammonds, that influences the discourse that surrounds it.[16] What Trouillot calls silences occurred through conditioned unseeing—facts or ideas glimpsed, even understood, then tactically ignored. To unsilence this history is to telegraph the patterns in art and culture that have secured racial hierarchy in American life.

What accounts for the belated recognition of the shift to racial adjudication is the failure to integrate the discursive force of race into studies of vision and visuality. For decades, there was a tendency in historical and art historical discussions to merely genuflect to subjective complexities without outlining what they are. For years, such studies in visual culture and art history have presumed a neutrality in vision on the level of racial formation, whereas scholarship in Black Studies has focused more on representation

than ways of seeing.[17] The result has been to treat the history of racial formation and racial hierarchy as a problem to address more through social science frameworks and not methods and evidence found in the arts and humanities when, in fact, all issues that result in structural inequality and bias stem from the imbrication of race, perception, and vision itself. This early divorce between the study of the arts, visuality, and racial formation has influenced the production of art and cultural history in ways that require narrative correction today.

It is in the spirit of wanting to address this gap, to investigate the structure of epistemic production, that I ask: How do we come to know what we think we know? How has the broader history surrounding this painting seemingly fallen outside of anyone's expertise or disciplinary boundaries? In answering these questions, it is crucial to consider not only what is in the archives, but what is or *appears* to be left out of their conceptual organization.[18] The fragmentation of this history of *A Circassian* slips off the edges of various disciplines. It exemplifies how racialized narratives have remained submerged, not seen as pertinent, even as we retrieve facts to assemble history.[19]

Tracing the submerged history around *A Circassian* is an example of what Sean Anderson and Mabel O. Wilson argue is part of the critical work of productive "unbuilding" as we assess the period of Reconstruction and backlash to Emancipation.[20] This work has come to us in a contemporary sense through a reckoning about the location and choice of monuments in public squares and courthouse lawns and the parallel rise in an instantiation of racial domination. It also requires examining how the work of aesthetics and visual culture led to the naturalization of racial hierarchies.

The response to Duveneck's *A Circassian* exposes an early, sustained, yet overlooked shift in the history of visual adjudication and racial formation. It centralized the difficult act of seeing the Caucasus from the vantage point of the burgeoning racial order in the United States. It allows for a glimpse of the turn from a geographically based idea about race in the nineteenth century to one based on the uncertainty and illegibility of the body for racial interpretation. It illuminates how unreflective, how unaware we still are about this history, and how easy it is to miss its evidence.

We have already seen how images of Circassia and the Caucasus—by American painter Winslow Homer, photographers Mathew Brady and

Charles Eisenmann, and performances staged by impresario Phineas T. Barnum—began to circulate in the United States after the Civil War. Duveneck was one of a group of nineteenth-century artists living in the United States and training in Europe who made the Caucasus a subject in their work and provoked a public conversation about visual assessment and racial identity. A fuller extent of racial adjudication in the nineteenth century becomes plain when we examine how the public engaged with and was disturbed by Duveneck's figurative representation at a time when the Caucasus region was revealed to be an unstable foundation for the idea of racial domination. Addressing this requires that we first investigate the international context of Duveneck's work beyond Orientalism to perceive its intersection with the racially storied Black Sea region, then turn to the history of the white common soldier monument, before investigating court cases that questioned racial ideals associated with the Caucasus. Without this broader context, the bewilderment about *A Circassian* stands as a mere curious fact, when it is actually one of the hidden keys required to understand the transformation in sight in the nineteenth century that still impacts our contemporary age.

A Circassian on Display in Boston

A Circassian was one of the first paintings to enter the collection of the Museum of Fine Arts, Boston, in 1876, the year the museum opened. "Whatever Duveneck may do in the future, this picture seems to me to have a permanent value of its own," patron Alice Sturgis Hooper wrote to the museum director when offering *A Circassian* for the collection. The MFA would come to occupy a focal place in Boston. From a city population of approximately three hundred thousand in 1877, the museum recorded more than half that number of visitors that year alone.[21] How would this painting of a man from Circassia have been received when it went on view in the nineteenth century, when Frederick Douglass might have seen it, possibly even purchasing the catalogue while speaking in the city? And why was it one of the first works to enter the museum?

The gift of *A Circassian* may seem an unusual choice. The figure's cartouche-lined shirt in the painting suggests the subject is a soldier, yet he is cast in a rare pose for a military portrait. On the left side of the foreground, his sole is exposed, inviting the eye to travel up to a near erotically exposed leg, full torso, and visible chest—a *repoussoir* device, as if presenting the figure as a body to be inspected. There is also, in effect, a second body

present—an index of Duveneck's own. His signature in the upper left of the canvas is so large that it nearly doubles as a second textual portrait.[22] It is a declarative flourish, offering "F. Duveneck" in a large black font specific to the northern German writing style of *Fraktur*—calligraphic, bold, and large. Below it is the city name, Munich, and the year, framing the body of the Circassian soldier as one that must be seen as connected to the contemporary world of the viewers themselves. While *A Circassian* was made in the decade when the American realist dazzled critics with his tenebrist brushstroke, the subject matter of his works in this period was "a vexation" to his public.[23]

Sarah Burns has asked an important, related question about the perplexing response to Duveneck's work—why was it seen as "threatening" by so many critics?[24] Duveneck's paintings alarmed his viewers. The artist's aesthetic was part of what was called "Munich style," and the painter was part of the reason for its scrutiny. Duveneck had been studying in Munich with Wilhelm von Diez since the fall of 1870, first in a painting technique course that he raced through before moving on to a composition class. He was one of a growing number of American artists who went to the Bavarian capital for training at the Royal Academy of Fine Arts instead of heading to Paris or London.[25] His training in Munich impressed on Duveneck a focus on virtuosic brushwork via the influence from realist painter Wilhelm Leibl's *alla prima* technique—working without glazes or underpainting—one that, as André Dombrowski argues, Duveneck honed as his own. This approach, which involved leaving brush marks legible, and often aiming to finish a work "all in one day," offered a transparent view of the artist's process of seeing and rendering a subject.[26]

Duveneck left his subjects unvarnished and startlingly unidealized. Henry James praised the paintings' "unmixed, unredeemed reality" as describing why so many considered him the "American Velásquez."[27] After Duveneck showed in the 1877 National Academy Exhibition in New York alongside William Merritt Chase, George Inness, and others, he was called "the most brilliant of the company of young Americans whose works . . . startled the Academicians and almost monopolized the attention of critics."[28]

Duveneck's developing style had made observation itself a subject within his work. His paintings were "centrifugal," as Dombrowski has argued— figurative features are the main points of focus; the use of chromatic strategy creates "more summarily" drawn outer edges of the work.[29] Just as in *A Circassian*, the thick atmosphere of the outer edges gestures toward a world suffused with a rumination found in the inward, pensive body language of

the sitter himself. Duveneck's *A Circassian,* portraying the act of figurative preoccupation, is a demonstration of the strength of his developing style from his time studying abroad. The reduced palette shows off the painter's ability to calibrate tonal values from white to gray, beige, brown, and black while registering a light source, all while offering a masterful handling of perspective in the soldier's legs and foreshortened arms. What distinguished Duveneck's early works, most of them character studies, was the compositional and conceptual interest in his brushstroke itself and the unvarnished look of his subjects.

The answer to why this style would become so disconcerting, Burns argues, "had as much to do with subject matter as technique; combined the two were unsettling."[30] Burns argues that the models had no explicit "connection to American life," but maintains "that they got under many viewers' skins nonetheless because, paradoxically, they hit too close to home. Munich beggars and ragamuffins called to mind the criminals and guttersnipes of New York and other big American cities just at a time of extreme class conflict and social upheaval."[31] Here Burns focused on class conflict and economic conditions in the 1870s and charts the New York City Tompkins Square riots of 1874 in the coeval period of the exhibition. Yet significant as this history is, the discussion omits a conversation about the construction of race during this period of Reconstruction.[32]

I thought of Duveneck's work when I gave a talk at the University of Kentucky Art Museum and learned about a painting he had co-created titled *Portrait of a Negress,* ca. 1890, later called *Head of a Black Woman* (Figure 3.3). The museum is connected to the University of Kentucky College of Fine Arts, not far from where Duveneck was born in Covington, Kentucky. With a few hours to spare before my presentation, I spent time in the collection. The director gave me a tour. I asked to look at the storage holdings. As we walked past paintings on the gray metal storage racks, I asked about Duveneck's work.

The museum had an oil painting I had never seen, one that had not come up in any literature I had read. To my knowledge, it has never been reproduced in any exhibition catalogue on the artist's work. The painting was on a rack so close to the wall that I saw it first from the side. From that angle, the impasto paint marks were thick enough that they seemed to rise up off the canvas, making it hard to see the subject of the painting until the art handler moved it onto a table for me to view. I was told before I saw the

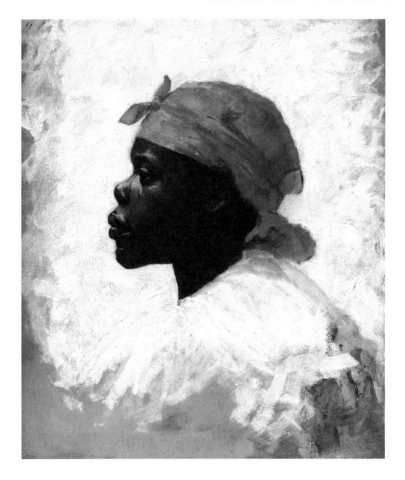

3.3. Mary Kinkead with Frank Duveneck, *Head of a Black Woman*, ca. 1890, oil on linen, attached to auxiliar linen support.

work that it was made during Duveneck's time teaching at the Cincinnati Art Museum. He had returned to the United States after the death of his wife, Elizabeth "Lizzie" Otis Lyman Boott, and had taught at what is now the Art Academy of Cincinnati.

This Duveneck oil painting, *Head of a Black Woman*, made with his art student turned artist and teacher Mary Kinkead, centers a profiled black woman in a yellow headwrap, emerging out of a mound of white paint. The facial rendering is completely smooth on the linen canvas. On the back of the painting is an inscription noting that Duveneck was the one who "painted into the head."[33] What had blocked my view was white paint surrounding the woman's head, laid down as a thick impasto with radiating

brushstrokes. The thick paint marks had created a mountainous form around the face, transforming the white paint into a visible, near haptic material. The conservation images taken under raking light to accent each mark offer a clear image of how these brushstrokes rise off the canvas. Other images taken under ultraviolet light show a pigment line outlining the head.

The near topographical marks in *Head of a Black Woman* make literal the construction of sight at work. The use of brushwork telegraphed the act of perception. The marks direct the gaze, as if diagramming the intense investment in growing questions of the day about how race shapes vision.

While *Head of a Black Woman* has yet to be addressed in the literature on Duveneck, other period documents reveal his interest in the depiction of black figures. Consider a group portrait in which the artist poses with his students and a model the year he began to teach in Cincinnati (Figure 3.4). Standing at the left next to a painting on an easel, Duveneck flanks the work with a group of white men and woman, only a few of whom are staring at the camera. Most gaze either at the painting or at each other, bucking a frontal gaze convention. In the foreground is a black man who seems to be the class model, based on the portrait on the easel. He slumps. His left hand

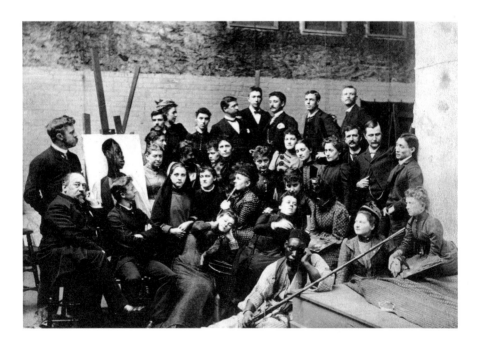

3.4. *Frank Duveneck (standing at left) and Class on Third Floor of Cincinnati Art Museum,* ca. 1890, photograph.

rests on his face as if resigned. He holds what appears to be a rifle in his right, calling attention to the casual lean of his body against the wooden platform on which he likely sat or stood before the class. His figure is a stark contrast to the man shown in the easel painting—head upright and proud. He now diagrams his separation from the group as he sits on the floor, the figure lowest to the ground. The variance in posture and tone between the portrait on the canvas and his body language in the photograph is so stark that one wonders, per Denise Murrell's excavation of the unexamined histories of black models in the context of French imperialism, how exactly this model has been seen.[34]

Duveneck was working during a period when the rare portrayal of dignified black subjects in print and in paint was contested in the United States. The decision by Winslow Homer—America's most prominent painter by the turn of the twentieth century—to do much the same resulted in a threat against his life.[35] To leave *Head of a Black Woman* out of the literature on Duveneck's work raises unaddressed questions about the artist's understanding about the marriage of his technical aesthetic with racial assessment in the period.

In the late nineteenth and early twentieth centuries, Duveneck's process of turning perception into part of his composition was, in many appraisals of his work, reduced to a mere technical feat at best. As the founder of the Archives of American Art, Edgar Preston Richardson, wrote in a typical mid-twentieth-century assessment: "As his life unrolled, it became evident that although he had a new palette and brushstroke and a new way of painting a posed model, he had nothing very much to say beyond this technique."[36] Early on, this bravura, vitalist style had earned Duveneck acclaim, yet over time, some critics saw technical dexterity instead of creativity. The comment that "he was a technician and not an artist" typified the damning critique of the Whitney Museum of American Art's 1938 Duveneck exhibition, published in the *New York Sun*. "The America of his day needed [Duveneck's] insistence on technique" is the pregnant final sentence of the entry on the painter in the 1935 edition of *Art in America: A Complete Survey*, written by the first director of the Museum of Modern Art, Alfred Barr, and Holger Cahill.[37]

At a moment of heightened focus on eugenics and social assessment, Duveneck's technique was singled out for acclaim. In 1915, at the Panama-Pacific International Exposition in San Francisco, he received a special medal of honor for his contribution to American painting and, in particular, his technical innovations.[38] Duveneck was one of ten artists who had

entire galleries dedicated to their work at the exposition. He showed works that included thirty oil paintings and thirteen etchings. He also served on the Panama-Pacific Exposition's International Jury of Awards. Despite being ineligible for an award due to his jury position, the support for his work had been so great that one was granted to him anyway two weeks after the exposition. What had prompted the belated embrace, after such earlier disquietude, among American, largely white, critics?

World's fairs during this period mounted forceful displays shaped by eugenics, a popular social philosophy focused on perceived goals of racial betterment. Indeed, as Matthew Frye Jacobson has argued, the 1915 Panama-Pacific International Exposition framed eugenics and racial discourse as "representation," even though it was a political ideology tied with immigration and the broader project of white supremacy. "Like anthropology, eugenics was a genre of representation, which served up the world's peoples and made them 'known' according to an established body of scientific principles—the Serb is a savage, the Gypsy is lawless, the Italian is excitable, the Bulgarians stolid, the Slav is careless and given to fits of cruelty."[39] The exposition distributed such ideas through exhibitions such as those found in the Race Betterment Congress booth and the US Department of Labor booth, which aimed to show both "race deterioration" and "the possibility of race improvement."[40]

The fair's fine art displays, to which Duveneck contributed and acted as juror, became part of a larger complex of the distribution of these ideas. As Emma Acker argues, the "core message" of the fair was to relay "the perceived superiority of Anglo-Saxon culture and justification for its dominion over other races and nations," and this message was reinforced by the fine arts displays. While "the contents" of the art displays "were not necessarily tied to these themes," Acker notes, "the display at the Palace of Fine Arts—in terms of its conception, organization, layout, marketing, and critical reception—further reinforced the nationalist and imperialist thrusts of the Exposition." The installations drew force by "highlighting the American art on view as proof of the cultural apotheosis of the United States over Europe, and as a symbol of and justification for the forward march of its empire."[41]

The fair was held in California, which just six years earlier had passed a sterilization law for those considered to be so-called deviant from societal norms—the very "ragamuffins," as Burns terms it, that had so startled Duveneck's public when he made unidealized character studies the subject of his 1870s work. Two years before the fair, twelve US states had passed sterilization laws.[42] By the turn of the twentieth century, the scrutiny and

assessment in social life had taken on firmer scaffolding that supported what was becoming a massive, popular movement. We can see the origins of it through the rumination, discomfort, and ultimate embrace of Duveneck's chosen subjects and the assessment evident through his tenebrist compositional style.

Alongside the work of assessment for immigration policy, eugenics ideals were funneled through culture—from pedagogical approaches to visual representation in print, on stages, and through exhibition display.[43] The term "eugenics," coined by British natural scientist Francis Galton in 1883, became a widely popularized ideology focused on measurement and assessment for which nineteenth-century scientific racism was critical. The tactics of eugenics—legal, social, and medical—focused on "breeding," sterilization, and restrictive immigration. The tactics were also, crucially, visual.

Eugenics was supported by a coalition of leaders, educators, Supreme Court justices, social reformers, and scientists—Oliver Wendell Holmes, John D. Rockefeller, Alexander Graham Bell, and Theodore Roosevelt among them—all focused on a so-called science of heredity as a means for so-called social improvement, guided by an ideal of perfected racial whiteness. Today, pathbreaking research has started to expose the fuller, unvarnished history of the cultural uptake of eugenics, revealing it as far more commonplace in the pedagogy, cultural mores, and practices of social life in the United States than has been understood. This new scholarship is vital work that underscores the importance of events—from pedagogy to social visits to the history of museum collections and displays—for understanding the contextual history and impact of eugenics.[44] By the turn of the twentieth century, the scrutiny and assessment in racialized social life took on more concrete scaffolding, supporting what was becoming a massive, popular eugenics movement in the United States.

Mounted at the start of 1915 the Panama-California Exposition, the World's Fair held in San Diego, which ran for two years, included anthropology exhibits read by journalists as "established scientific proof of human evolution and the superiority of white America." While figurative drawings compared racial types, sculptural busts laid out the great chain of being, and drawings and sculptures created a "racial record" to reinforce the idea (Figures 3.5 and 3.6).[45] The exhibits designed by Aleš Hrdlička and laid out in the Science of Man building were meant to show objective knowledge.

Eugenics mandated comparative vision. What is striking is how reliant the anthropological exhibit is on the medium of the arts—from drawings to sculpture—to present seemingly objective data, and how heavily

3.5. "Ontogeny," Room 2, Physical Anthropology Exhibit, Science of Man Building, Panama-California Exposition, San Diego (1915–1916).

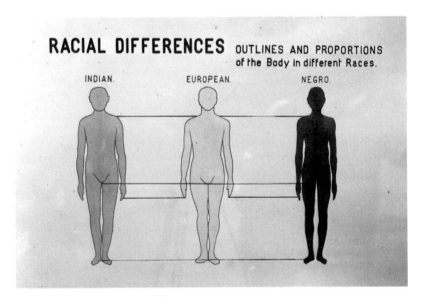

3.6. "Racial Differences," Room 3, Physical Anthropology Exhibit, Science of Man Building, Panama-California Exposition, San Diego (1915–1916).

design was used to place at the center of the exhibit models of the "'thoroughbred' white American."[46] Busts and waist-length figures set in a narrative told through sketches and sculptures were crafted by none other than Frank Micka, an assistant to Gutzon Borglum, who would go on to sculpt Mount Rushmore and Georgia's Stone Mountain dedicated to the Confederacy.

Visual culture functioned as racial propaganda. The intention for the didactic exhibitions was to guide the eye, an act of "instruction," a lesson in what Woodrow Wilson would consider of paramount importance for racial governance—learning how to see.

To date, the context surrounding Duveneck's *A Circassian* has not included the history of racial science or eugenics and the cultural scrutiny it brought about, despite how crucial this context was in the early twentieth century when his work was publicly revived at one of the major world's fairs. Scholars have primarily asked about whether the painting *A Circassian* was an example of burgeoning technical, painterly innovation in need of reassessment, or whether it showed the artist trafficking in Orientalist exotic figures.[47] Dombrowski, for example, adroitly prompts us to reconsider the "conceptual and practical stakes concerning both the techniques and critical languages of Duveneck's art of the 1870s that have been buried over time."[48] Can we more capaciously assemble the context surrounding Duveneck's work?

We can see the stakes of Duveneck's *A Circassian* from Alice Sturgis Hooper. She was invested in the success of the museum as a forum for civic discourse and exchanged letters frequently with the museum director. Along with her sister Anne, Hooper gave the institution its first painting, *Elijah in the Desert,* by Washington Allston, which entered the collection in 1870 (before the museum had a building), along with works by John La Farge.[49] Later, she loaned the museum J. M. W. Turner's 1840 painting *Slave Ship* (*Slavers Throwing Overboard the Dead and Dying, Typhoon Coming On*), which depicted the atrocities of the slave trade, as part of a tradition of complex negotiations that reconciled art with civic humanism. In her public writing for *The Nation,* for example, Hooper considered how the display and presentation of art could contribute to what she called a "new art movement."[50]

Hooper's conceptualization of the role of art in civic life informs our understanding of the context of *A Circassian,* yet grasping this has been

impossible because the historical record and provenance about Duve-
neck's painting for some time had scrambled the biography of "Miss" Alice
Sturgis Hooper with that of Alice Mason Hooper, the wife of Alice Sturgis
Hooper's brother William Sturgis Hooper.[51] Alice Mason Hooper would
marry US Senator Charles Sumner after William Hooper's death, but the
two quickly divorced and she left for Europe in scandal after having an affair.
Although Alice Sturgis Hooper was always referred to as "Miss" in corre-
spondence with the MFA, this salacious history and the name confusion
erroneously became part of her life narrative. This has resulted in over-
looking the significance of writings by the young collector, who died just a
few years after donating the Duveneck. Instead, what has been written
about Alice Sturgis Hooper largely comes from fiction, namely Michelle
Cliff's novel *Free Enterprise*, which includes a pivotal scene of Hooper dis-
playing Turner's painting in her Boston home.[52] There is little scholarship
about Hooper's actual life beyond her role in bringing the celebrated
Turner painting to the public's view in the United States.

Alice S. Hooper's writing in *The Nation* on art and politics was often crit-
ical about the state of American society in the 1860s and 1870s. Her articles
offer context for why she aimed to collect and display work with what she
referred to as an "elevating message," a near-mantra for her collecting.[53] The
year 1876 marked a pivotal shift for Hooper and her brother-in-law, Thornton
Kirkland Lothrop.[54] In a series of well-argued and extensive pieces about
women's suffrage, Hooper wrote that "the present condition of society is
far from being well enough to be let alone," indicating the mind of a col-
lector who understood culture to be an especially effective form of political
persuasion.[55] In 1876, Lothrop, who had not only defended fugitive slaves
but also prosecuted slave traders, retired from practicing law and would go
on to join the boards of Boston institutions, including the Museum of Fine
Arts, which opened on July 4, 1876.

Hooper purchased *A Circassian* just months before her acquisition of
Turner's *Slave Ship*. It would be impossible to discuss the history of repre-
sentations of slavery without a mention of Turner's work. "If I were reduced
to rest Turner's immortality upon any single work, I should choose this,"
said John Ruskin, the first owner of the painting.[56] He ultimately sold it; he
found its key compositional feature too difficult to view daily—a single
brown leg and arms surrounded by a shoal of fish in a rough sea under a
white-gold sunset (Figure 3.7). In fact, as Paul Gilroy notes, Ruskin left the

3.7. J. M. W. Turner, *Slave Ship (Slavers Throwing Overboard the Dead and Dying, Typhoon Coming On)*, 1840, oil on canvas, 35 3/4 × 48 in.

mention of the ship as a slave vessel to a footnote in *Modern Painters*.[57] As scholars including Marcus Wood and Cheryl Finley have discussed, the painting is now widely known to depict the actions of the slave ship *Zong*'s commander, who threw 133 sick enslaved Africans overboard en route to Jamaica in 1781 so the insurers would bear the cost of their lives. Ruskin felt that the painting should be in North America. There are no public records, to my knowledge, of Hooper's views on the Turner *Slave Ship* painting. Yet it is worth noting that Hooper purchased the work in late December 1876 for ten thousand dollars, at the time the highest price ever paid in the United States for a European picture—and notably one about the history of slavery.

The museum-going American public first experienced Turner's painting by reading Ruskin's *Modern Painters,* which was in the libraries of Frederick Douglass, Henry Adams, and his wife, Marian "Clover" Hooper Adams, a cousin of Alice Hooper. The book was so widely read that *Slave Ship* was already famous when it was shown in the Museum of Fine Arts in 1877. Viewers eager to compare the actual painting to what they had read or heard crowded the museum as a copy of Ruskin's text lay on each chair surrounding the work in the museum's Great Hall. Hooper bequeathed the Turner to her nephew William Sturgis Hooper Lothrop. He would take possession of it in 1890, when he graduated from Harvard in the same class as W. E. B. Du Bois; he then sold it to the museum in 1899.

The reception history of Turner's *Slave Ship,* which involved not outright denial of its subject matter but refusals to perceive what was depicted, echoes the kind of silence and confusion that surrounded *A Circassian.* When *Slave Ship* was on view at the MFA, a seven-part letter series in the *Boston Evening Transcript* centered on denials about the plausibility of its scene. There were many contortions of description and sight required to see the work as simply about the sea, as many insisted it was. It took until 1990 for any art historian to treat the Turner painting within the context of abolition, beginning with Albert Boime's scholarship.[58] Here we start to arrive at a corollary to Toni Morrison's argument in *Playing in the Dark*—the compounding, conspicuous silences about black presences in works of literature or culture can indicate a suppressed recognition of a latent racial discourse.[59] There is an analogous significance in the silence in art criticism about paintings of racial whiteness as a signal not of a non-response but of a much deeper recognition.

Turner's work challenged legibility.[60] It did not offer a clear moralizing narrative for Reconstruction-era and mid-Victorian audiences on either side of the Atlantic that would have allowed the abolitionist market to transform it into engravings to be sold around the globe. The canvas is nearly bifurcated by the white-gold sun—the ship on the left and the leg in the right in sharp focus in the extreme foreground—which critics such as William Thackeray saw as a compositional error. The reception of the painting was equally bifurcated.[61] "What is there to admire in this painting?" asked *Harper's Magazine*'s article in 1880, a satire about black life in which a character named Hieronymus Pop "tumbled down all in a heap, looking somehow like Turner's Slave Ship as one stumpy leg protruded from a wreck of red flannel and ruffled petticoats."[62] Mark Twain, who called the work a "manifest impossibility—that is to say, a lie," would frame it in a comic

style, saying that "it reminded him of a tortoise-shell cat having a fit in a platter of tomatoes."[63] Twain's use of humor is not merely a tactic of distraction but of declamation, a way to communicate that one is not seeing what is right in front of one's eyes, an example of how comic traditions have been used as a racialized tactic of dismissal, one that, as scholars including Glenda Carpio, Richard Powell, and Rebecca Wanzo have assiduously examined, catalyzed traditions of black satire as a bulwark from such offenses.[64] The episteme of race was predicated on what was seen and then disavowed.

After *A Circassian* had been in Hooper's possession for a few months, she came to feel it had an importance beyond Duveneck's career. She contacted museum director Martin Brimmer, writing on the assumption that Brimmer had "probably seen" *A Circassian* on display from August through September 1875 in Boston at the Doll & Richards Gallery, a comment suggesting the widespread awareness of his paintings at the time. Duveneck had just created a sensation in Boston with two exhibitions of his work from his time in Munich.[65] In *The Nation, Atlantic Monthly,* and Boston's dailies, reviewers lavished attention on many of the paintings. Henry James, who based fictional characters on Duveneck in novels, reviewed the artist's exhibited work with nearly ecstatic praise in *The Nation* in 1875.[66] Although James offered either a close analysis or mention of the paintings, he omitted *A Circassian.*[67]

Yet when Hooper wrote "Whatever Duveneck may do in the future, this picture seems to me to have a permanent value of its own," she did not refer to the subject matter as in any way obscure. Her language is resolute and undeterred as she explains choosing it as a gift to the MFA, Boston. She did not rest her case on Duveneck's importance to the annals of American art. The artist was at the start of his career. In fact, his reception in Boston was a surprise; he had struggled to find patronage in Cincinnati upon his return from Munich in 1873 but found exuberant support from influential artist William Morris Hunt, merchant Herman Geopper, and others. The value of *A Circassian* beyond Duveneck's career is unstated but implied in Hooper's next line, in which she argues it would be fitting if the work could "find a place in a public collection." The painting went on display soon after in the museum's exhibition of contemporary art.[68]

Hooper's agenda and the sale of the Turner painting raise questions about how *A Circassian* was regarded while on display at the MFA, Boston from the 1870s through the end of the nineteenth century, and suggestively alludes to

the value of *A Circassian* for racial discourse. Curator Julie Aronson notes that "social consciousness may have drawn Hooper to *Slave Ship* and *A Circassian* as portrayals of subjugated people." Aronson goes on to question whether the "presence and impactful scale of Duveneck's pensive soldier and the nuances of the painted surface" led her to purchase the work for the museum.[69] Yet how was the "presence" of this Circassian soldier read at the time?

In the United States, as we have seen, the Caucasus conflict was not reported on as a foreign news story alone, but one that also implicated racial negotiations on American soil. In the meantime, while Duveneck painted *A Circassian,* Karl Marx had catalyzed a Circassian craze in Munich. Marx celebrated the prowess of Circassian fighters. He admired them as "freedom fighters courageously battling Russian imperialism."[70] Aronson and Elliot Bostwick Davis, former chair of the Art of the Americas department at Boston's MFA, noted this development abroad, citing the "prolonged campaign" during which "Russians had forced the Circassians to abandon their homelands in the northern Caucasus, a campaign mostly complete by 1864."[71] Yet this preoccupation also permeated local US discourse when the painting was exhibited.

The specificity of the painting's title referenced what a nineteenth-century viewer would have known about its Janus reality—that while natural science had once designated Circassians as the purest of what had been touted as the most beautiful racial type, because they came from the so-called regional homeland of the "white" race, this was now being called into question. Coverage of the Caucasus uprisings in the late 1870s and lectures by George Kennan had exposed that nearly all the assertions Johann Friedrich Blumenbach had made about Circassians—from their supposed exemplary whiteness and laudable beauty to their antiquity-rooted heritage— were false or contested.

Even when soon-to-be president Theodore Roosevelt was carrying around Edmond Demolins's book *Anglo-Saxon Superiority* while he was navy commander and the Progressive era became focused on eugenics, concerns about the Caucasus lingered.[72] As we have seen, the interest and deployment of the Anglo-Saxon ideal that took hold and intensified in the United States largely in the 1850s has obscured this history of the lingering interest in the Caucasus.[73] The decade was filled with change, from admiring the physical prowess of the Circassian as a human ideal to seeing the region of the Caucasus as an unintelligible image of racial diversity. The region that

had once grounded the idea of white racial superiority became more than a discarded term; it was a disavowed relic, a revenant that returned like a haunting in American life.

These concerns matter. The idea of the Caucasus was used as bedrock for legal decisions that buried the contradictions of racial science in ways that had material consequences in public life. Racial adjudication became the foundation of socio-political order.[74]

At the turn of the twentieth century, visual adjudication would even enter the courtroom as a residual posture of racial science. For example, in the famous 1925 *Rhinelander v. Rhinelander* case in New York state, Leonard Rhinelander sued his wife, Alice Jones, on the grounds that she lied about being a white woman when she had black ancestry. The accusation about racial passing was made more unusual because New York did not prohibit interracial marriage.[75] Coerced partial exposure became the principal evidence in the court proceedings—Jones was forced into "unveiling . . . parts of the body unexposed to sunlight," as historian Elizabeth M. Smith-Pryor recounts.[76] Yet images alone were not enough to offer proof of Rhinelander's cognizance of his wife's mixed-race status.

Visual assessment itself, more than the judgments deduced from a visual object such as a photograph, became the trusted mode of judgment in offering evidence in the arena of law. Rhinelander's own photographs of Jones in an intimate pose—lying in a nightgown with a plunging neckline, in a hotel-room bed before they were married—were unpersuasive. To prove that she was not white, the photographs of his wife had to be married to something more: an interrogative gaze in the courtroom, specifically the jury room.

In the *Rhinelander v. Rhinelander* trial, the jury room became the site of an uncanny update to the photography studio in the never-ending project to accommodate the fictions of scientific racism. (The courtroom was deemed too public and, hence, embarrassing as a location for the unveiling.) The court stenographer recounted that Jones went to the lavatory and returned crying, wearing only underwear and a long coat that she let down at her lawyer's direction. There Jones sat, "the upper portion of her body, as far down as the breast was exposed." She then was instructed to show the jury her legs up to the knee. The justices, attorneys, stenographer, jury, and her husband all took part in the visual display. Jones turned from subject to object through a forcible presentation of her body; Justice Joseph

Morschauser insisted on calling her body "it" several times during the case.[77] Jones's lawyer admitted her unrobed body parts into evidence—principally "her upper body and lower limbs," areas less affected by sunlight and therefore closer to her natural state—to prove that her race was undeniable in private even if obscured in public. This act of coerced undressing, and specifically partial undress, was a continuation of the precise visual language of race and property that had been on display in Zealy's photographs more than a century earlier.[78]

Jones was "partly disrobed," stated the report by many outlets, including the *New York Evening Standard,* which ran an image that depicted what differentiated the act from being solely a display of nakedness—the directive to partially undress. In the image, Lee Parsons Davis, Jones's lawyer, points directly at her, his arm a horizontal line, a conceptual ruler that marks the boundary between a portrait of nudity and one of an insistent gaze. While no photographers were allowed in the courtroom, newspapers ran photo collages to replicate the act of partial disrobing. The *New York Evening Graphic* ran a composograph, a composite of actual photographs affixed to staged bodies—a strategy apparent in the attendees' illogical gazes, which are averted from Jones and toward the corners of the room, perhaps in a wished-for measure of decency. Jones is shown with one hand covering her face and the other arm covering her breasts, with the armhole of her slip resting on her hip.

The partially exposed body offered for examination—Jones's partially nude form—cued the act of racial adjudication. The court ruled for Jones, determining that her skin color in the less sun-struck areas proved that her husband must have known that she was of mixed race before the marriage, and that she had therefore not attempted to pass as white. She received a lump-sum payment and monthly support, in return for dropping any claim to the Rhinelander family estate.

What the courts came to rely on, common knowledge to determine if someone was Caucasian or not, was conditioned by cultural forms of all kinds, from the Barnum Circassian Beauty performances to wrestling with the significance of Duveneck's painting of a figure from the region installed in a museum. Cultural events—from displays to paintings such as Turner's *Slave Ship* and *A Circassian* to performances to jury room practices—together helped forge a shift from vision to assessment that lent stability to an ideology that rested on false foundations.

The response to Duveneck's paintings—the strain on adjudication that it prompted—was vivid and bodily. Consider the response to a painting that

has been framed as "a new and important painting by Duveneck" and a "significant milestone in Duveneck's growing reputation": *Oriental Boy* (1876), later renamed *The Turkish Page* (Figure 3.8). The work compositionally centers on a young boy with a basin of fruit feeding a cockatoo and went on view in New York at the National Academy of Design and later in Boston alongside William Merritt Chase's version of the same scene.[79] It was initially praised as Duveneck's most "complete" picture. "None has withheld his admiration of its prodigious strength," a review began, describing that nevertheless "all feel a vexation which they do not wholly understand. It has the air of telling a story, of disguising a pathos in which we wish to believe."[80]

But *The Turkish Page* caused a frustrating ambivalence for many of its white critics. "It shows what claims to be an Oriental youth feeding with fruit a cockatoo," one critic from the *Boston Daily Advertiser* stated, yet closer inspection made viewers wonder if he was presenting the truth or a fiction. "Mr. Duveneck takes pains to make us see his boy is no Oriental," the critic argued. "The white and beautifully painted flesh belong not to that land of sunshine, and his hands, brown not with sunshine but dirt, shows that his breast has not been long out of the clothes of Europe." By October of 1877,

3.8. Frank Duveneck, *The Turkish Page*, 1876, oil on canvas, 42 × 58 1/4 in.

one review of *The Turkish Page,* then on display for a second time at Doll & Richards Gallery in Boston, said bluntly after praise, "*[b]ut the picture is too well known* to admit of further discussion," since it had been so "talked about in this city."[81] Works that fall into the genre of Orientalism largely create and narrate racialized and gendered difference between the so-called Orient and the West. Duveneck had collapsed the boundaries, bringing the "imaginative geography" of the Middle East and North Africa closer to home.[82]

The painting was criticized for a refusal to adhere to the boundary lines that demarcated the region and the newly constructed category of whiteness. The boy in the painting, it was clear to its nineteenth-century viewers, was likely white, a fact thinly veiled by compositional inconsistencies. Duveneck had made no attempt to inflect the contrast between the darker shade of the boy's face and his light body—one painted a gleaming white, and his face a ruddy tan, as critics noted. This boy, it became clear, was a model, a white American boy posing. The fruit in the basin was being eaten by a cockatoo, while the emaciated boy seems not to want it. His pathos seemed too studied, perhaps deceptive.[83] As Linda Nochlin has argued, it is impossible to discuss works influenced by Orientalism "without some attempt to clarify *whose* reality we are talking about." Duveneck had shifted the convention from whiteness being present only as the "necessarily controlling gaze," as Nochlin put it in her discussion of Orientalism, to making a white figure an actual subject in the work.[84]

As Shawn Michelle Smith argues, Henry James's 1892 short story "The Real Thing" typifies the role of nineteenth-century paintings in the construction of racial types and class-based identities in white middle-class society.[85] The narrative revolves around an artist who needs to choose from two sets of models for sketches to illustrate his novel. He is after individuals whose identities disappear such that they inhabit that of another. In the story, the artist begins working with an unlikely pair, "The Monarchs," a married couple of blue-blooded aristocracy now impoverished. Finding no other employment, their skill is being "the *real* thing." But this becomes the problem. Mrs. Monarch could not inhabit other identities; her husband was no better. They are so obdurately aristocratic that they cannot take on another guise. "I placed her in every conceivable position, but she managed to obliterate their differences." "She was the real thing," James writes, "but always the same thing."[86] The artist fires the Monarchs. He ultimately chooses a second pair—an Italian immigrant, Oronte and Miss Churm, an East London native—because they "could represent everything."[87]

Understanding the full context of *A Circassian* involves more than the history of Orientalism. Certainly, the Orientalist craze is one of the reasons that Duveneck's painting of figures from the Middle East and North Africa attracted attention. In a twenty-first-century display, the MFA, Boston showed *A Circassian* with figurative works by William Rimmer, Elihu Vedder (*Lazarus Rising from the Tomb*, 1899, and *Nude*, 1890), and John Paul Selinger (*The Water Seller*, 1878). The soldier in Duveneck's *A Circassian* is typical of the discursive ideology of Orientalism—his body is relaxed, not primed for any impending action, his mind alert with a reverie of another kind. The figure's clothes are indexes of place—his fur hat is specific to the Caucasus, for example—yet his open shirt gives way to a body being exposed, as if an invitation to appraisal unusual for a portrait of a soldier. Orientalism, as defined by Said, created an imaginative geography through which fictional ideas became objective, and identities were fashioned as hegemonic, binary polarities couched in the language of culture, distance, and custom. The discourse became mapped onto geography; as Said put it, "racism is spatially as well as socially constructed."[88]

Yet a fixation on Orientalism alone as a means through which to understand the response to *A Circassian* overlooks three key features of representation in the nineteenth century. It does not engage with the negotiated cleavage between racial whiteness, as in "Caucasian" identity and representations of the Caucasus, taking place in the nineteenth century in the public sphere. It fails to contextually consider the legal engagement with what was deemed to be Caucasian at the time that focused juridical attention on representations of the Caucasus region. Finally, the focus on Orientalism alone to engage with this painting obscures a more direct political interest in conflict in the Caucasus, and the genre of the citizen soldier monuments commissioned during, and to a greater extent after, the American Civil War.

Common Soldier Monuments after the Civil War

While *A Circassian* was on display in Boston, monuments to an invariably white, common soldier were being erected both locally and in civic squares around the nation. Commemorating Emancipation had created a new figure in public sculpture—the common soldier, not the "hero" but specifically and deliberately the white citizen soldier. By the mid-1870s, towns and cities in and around Boston were receiving their first common soldier

monuments, just as the same question of corporeal legibility was coming into play with Duveneck's paintings. The year 1876 marked the opening of the Centennial Exhibition in Philadelphia, a time when the country was shoring up a sense of collective self-representation in the midst of the Reconstruction era. The image of the white soldier took on an emblematic significance: to both represent and ignite a sense of civic duty to a federal government that had recently been torn apart, and to reify a social regime of embedded, enforced, racial hierarchies.

The question became what form of representation would make the ideal of whiteness legible.[89] The standard look of a common soldier monument—alert, proud, composed, and capable—was not meant to be a "portrait, but rather an ideal figure," as one unnamed journalist put it in the proceedings of a monument dedication.[90] As a result, the standardization of the monuments—a single, white male soldier at parade rest atop a plinth—recapitulated racial hierarchies to create a representative type.[91] Yet in some cases, locals would lampoon the inaccuracy of a facial likeness, questioning whether it was truly representative of whiteness. So went the blunt critique by the head of a drive to erect a black soldier monument in Rochester, New York, in 1894: the writer claimed not just that the common soldier failed to represent all who fought in the war, but also that the features were distinctly "Irish and German," so not (yet) "white."[92]

What is likely the first common soldier monument was, in fact, cast in Munich's Royal Foundry in 1865 and designed by Randolph Rogers for Cincinnati, Ohio—*The Sentinel* or *Soldier of the Line.* It was installed when Duveneck was still living there.[93] The son of German émigrés, Duveneck grew up in Cincinnati, whose population by 1870 was nearly 30 percent German immigrants. Rogers would continue producing in this vein, working abroad while sending back to the United States citizen soldier monuments such as the *Michigan Soldiers and Sailors Monument,* dedicated in 1869 in Detroit but not erected until 1872, and ones in Gettysburg and Rhode Island. When Duveneck would create his own sculptures—busts of Harvard University President Charles William Eliot and Ralph Waldo Emerson, for example, and later an effigy of his late wife, Elizabeth Boott Duveneck—he would return to the Cincinnati enclave for advice from sculptors.

The common soldier monument is so familiar today that it is easy to forget that in 1870s America it was a new artistic form. What it had in common with the photographic genre of, most often, tintypes of military service was the focus on a single infantry soldier at parade rest. By the mid-1870s, Massachusetts towns and cities in and around Boston were

receiving their first common soldier monuments. The Roxbury Soldier monument had already gone up in 1867, as had the Jamaica Plain monument in 1871, along with the Charlestown Civil War memorial in 1872. Perhaps the largest of them all in Boston, Martin Milmore's *Soldiers and Sailors Monument* on Flagstaff Hill in Boston Common, had its cornerstone laid in September 1871 (Figure 3.9). The majority of monuments were erected in the 1880s, but in New England, many were installed just a decade after the war. Augustus Saint-Gaudens's relief sculpture *Robert Gould Shaw and the 54th Regiment Memorial,* which looms large in Boston and in cultural memory, for example, would not come about until 1897, although calls for it began in the 1870s.

Discussions about how to create the look of a representational soldier (that is, a racially "white soldier"), an effort fueled by Southern retrenchment and investment in the Lost Cause narrative, accompanied the installation of these highly reproduced sculptures, as Savage assiduously outlines in *Standing Soldiers, Kneeling Slaves.*[94] These objects were not just in city centers, but "even in tiny hamlets that had never before seen a single public statue."[95] The difficulty of giving soldiers a "good death" due to the violent nature of combat, as deftly explored by Drew Gilpin Faust, is one reason for the rush to sculptural memorialization.[96] The common soldier

3.9. Martin Milmore, *Maquette of Union soldier for Roxbury Soldiers' Monument and other sculptures at the studio of Martin Milmore in Boston, Massachusetts,* ca. 1867, albumen photographic print on stereo card.

monument quickly became popular because it was fashioned to be more than a memorial to honor the fallen soldier; it was crafted to emblematize both the implied look of the veteran to be honored and a framework of racialized citizenship.

Black soldiers did not appear on these common soldier monuments. There are a few (or even partial) exceptions, such as the *Robert Gould Shaw and the 54th Regiment Memorial* of 1895, which honors black soldiers while instantiating racial hierarchies in its composition, but none are general war memorials. This statistic is perhaps easier to understand knowing that before the 1860s, the only figure of a black man in bronze was John Quincy Adams Ward's *The Freedman* (1863). It is small, just two feet tall, and it appeared in New York after the signing of the Emancipation Proclamation (Figure 3.10). Some critics suggested that it become a public monument, even one that would be placed in the Capitol. This would have been the first monument to an African American man on the nation's soil. It was never erected.[97]

The face of the common or citizen soldier monument would remain white, and it proliferated as the ideal citizen type at a time when the legal definition of citizenship expanded such that racial whiteness was no longer a prerequisite. The repetitive use of a generic, standardized soldier frustrated cultural patrons who felt that it flattened artistic industry. Yet the practice would continue through the early twentieth century, spawning the Union and Confederate memorials in our public spaces today. The symbol became so "universal" for both the North and the South that, as Dell Upton argued, "statues wearing the uniform of the wrong side" were accidentally delivered by monument manufacturers.[98]

The standard look of a common soldier monument was meant to align a newly consolidating idea of racial whiteness with citizenship and civic duty at a time when this was being challenged. "Physiognomists tell us that no two faces are alike, yet here is a face that will answer for hundreds of young men who went forth to die in defense of their country's flags," stated a newspaper report about the Launt Thompson *Soldier Monument* dedicated in 1872 in Pittsfield, Massachusetts. Even so, some lampooned the accuracy of the facial likeness, questioning whether it was representative of whiteness at all.

There are documented cases of local challenges to this equation of racial whiteness with citizenship. In the end, these campaigns failed. They did succeed, however, in erecting a statue of Douglass in 1897—the first freestanding public statue of a black man in the United States.[99]

3.10. John Quincy Adams Ward, *The Freedman*, 1863 (cast 1891), bronze.

As late as 1900, a Confederate soldier monument in Elberton, Georgia, was taken down because the features looked "too Yankee." As Sarah Beetham details, "a mob attacked the statue in the middle of the night and brought it to the ground, breaking it into several pieces. The next day, the towns-people buried it where it lay, facedown as a traitor to the Confederacy."[100] The work was replaced by a statue produced by the Monumental Bronze Company, known for its ability to churn out a figurative type called the "American soldier" for Union citizen soldier monuments. Starting in World War I, these companies would largely take on more work as munitions and armaments providers, but they would continue producing figurative sculptures as well—engaging in a domestic battle of another kind.

It is a history of insistent assembly. This exact same white model, Carol Grissom's study has shown, eventually produced in the cheaper material of zinc, would be commissioned over eighty-five times and sent to more than twenty states.[101] The development of large firms such as the Connecticut Monumental Bronze Company, the Muldoon Monument Company, and the Ames Manufacturing Company allowed for the replication and dissemination of this distinct figure throughout the United States, one of many examples of the codification of racial types and hierarchies in forms of capitalist industry.

One of the few representations of a seated, resigned military figure is an engraving by the influential satirist Thomas Nast that was published in *Harper's Weekly* and as a broadside supplement to the *Cincinnati Gazette*. In the image, *Patience on a Monument* (1868), citing Shakespeare's *Twelfth Night*, a black soldier, resting with a rifle, chains broken at his feet, sits atop the inscribed obelisk in a posture of both resignation, contemplation, and mourning. At the base of the statue are his murdered wife and children. The man's posture is of utter disempowerment relative to the upright stance of a contrapposto white infantry soldier. Violence pervades the backdrop—fires set to a colored orphanage, a reference to the arson during the New York Draft Riots, and a fire set to a Freeman's school by cloaked figures. A sign on the hat of one states "KKK." Underneath Nast's figure, on the obelisk, is a list of the horrors born of white supremacy and slavery. It begins "the whipping-post," "hunted down with blood-hounds," "slavery for years," and "the auction block—husband and wife, parent and child, brother and sister sold apart," and continues, enumerating instances of violence against African Americans (Figure 3.11).[102]

As Richard Powell states in his landmark study of the centrality of black visuality to the art of satire, Nast "combined scathing caricatures of politicians and social policies with polemical declaration and combative subheadings" that were so pervasive in print media they "irrevocably set the template and tenor in American editorial cartoons for more than a century."[103] Nast's 1868 *Harper's Weekly* cartoon "This Is a White Man's Government" shows the artist's gruesome ability to translate through bodily posture the denigration of black life on American ground. In this work, a body of a black man, planted face down on the ground, gazing up for aid, is under the heels of three men—a caricatured Irishman, a man at center wearing a buckle with the initials CSA on his belt in reference to the Confederacy, and at right, the New York governor Horatio Seymour, holding money representing graft. As Nell Painter argued, the caption is only "half-ironic."[104] Nast's

3.11. Thomas Nast, "Patience on a Monument," *Supplement, Cincinnati Gazette.*

choice of a seated, resigned figure for the caricature shows an understanding of the visual template of the new figurative, racial emblem just developing in the United States.

Yet in the midst of this discourse on immigration, eugenics, public symbols, and visual scrutiny brought about by Jim Crow rule, leaders still looked to the embattled Caucasus region, chipping away at hardened fictions. For example, when Duveneck's work was acquired by the MFA, Boston and displayed in subsequent decades, the first American to travel the entire length of the Caucasus between the Black and Caspian Seas, George Kennan, was laying bare the fictitious racial image projected onto the region. His writing, lectures, and robust speaking circuit made him one of the most

popular lecturers in the United States in the nineteenth century.[105] The impact of his speeches would contribute to the shift in what the courts would call the common knowledge that came from this transformation in racial assessment.

A Circassian went on view at the Museum of Fine Arts, Boston, in 1876, 1877, and later in 1886, when there was still demand for Kennan's popular lecture on the "Mountains and Mountaineers of the Caucasus." (Douglass was also lecturing in Boston at the time and likely picked up his copy of the MFA, Boston exhibition catalogue then.) In the Bay State capital, Kennan gave over six lectures in 1890 in one month alone, including a talk about the Caucasus at Tremont Temple organized under the auspices of the Press Club. He lectured about the Caucasus in late October before leaving for Bridgeport, Connecticut, and Springfield, Massachusetts, only to return to Boston for another talk a week later.

Thousands would come out for Kennan's tales of the Caucasus and his lectures about Russia and Siberia. He drew audiences that filled venues as large as Chicago's Central Music Hall.[106] Although his beginnings were modest—he began in Ohio with an audience of just four people—by 1900 he was on a two-hundred-city lecture tour. The schedule was so grueling that he would sometimes faint on stage due to what he called his "helter skelter" travels. His schedule in 1899 and 1900 included stops in Atlanta, Augusta, Birmingham, Boston, Brooklyn, and Buffalo, with more than one lecture offered in some cities. Advertisements for his Boston lectures began with the word "KENNAN!" followed by his lecture titles in smaller print, telegraphing his popularity. By 1895, his talks were advertised with just his name in all capital letters followed by a period or exclamation point.

Kennan's presentations revealed the deception at work in the Caucasus region's constructed image. He had left to travel in the Caucasus in 1870, having quit "a desk job in Ohio" for employment with the Russian-American Telegraph company to build an overland telegraph from the United States to Europe, via Siberia and the Bering Strait. The trip was ultimately a failed mission because the undersea Atlantic Cable obviated the need for an overland telegraph. Yet the journey made him curious to explore more, so he set out a second time to explore the postdiluvian biblical homeland. While preparing to visit the Caucasus, he studied works by others, such as the travel account of James Bell, the British merchant who supported Circassian independence and wrote *Journal of a Residence in Circassia*. Kennan tried to familiarize himself with the "literary Caucasus," the images conjured by famed Russian poets and authors such as Pushkin, Lermontov, and Tol-

stoy.[107] As Kennan put it, during his trip he wanted to "be a simple observer in the great world of God," yet while there he witnessed a "kaleidoscope of ethnic groups" instead of the expected homeland of racial whiteness.[108]

When Kennan returned to tell audiences what he had learned about the Caucasus, he was the first in the tradition of published travelers to the area to make his thesis explicitly racial. Before Kennan made it far into his lecture, he would discuss the "ethnological types" in the Caucasus—their habits, their customary laws, and the legend of the resistance leader Shamil. His audience was acutely aware that the region played a role in racial categories. One journalist described his topic and "graphic descriptions" as "the Caucasus, that interesting mountain region lying between Europe and Asia, which has given its name to one branch of the human family." What the audience took away from Kennan's lectures was either that the men and women of the Caucasus were not the "forefathers of the Caucasian race" or, if they were, that they were a living "fossil" in a state of "arrested development."[109]

Kennan capitalized on the confusion about how to assemble a view of the Caucasus, turning the region into an object in need of contemplation. Instead of taking on each claim about the Caucasian race, he insisted on seeing them anew. He emphasized that the Caucasians were a "people," not a "race," arguing that the Caucasus "comprises representatives of many races, and yet belongs, as a whole, to none of them. It is a heterogeneous collection of miscellaneous elements."[110] He also consistently presented the region as Muslim, fracturing the allusions that had equated Shamil with a Christian saint.

He put the confusion about the region best in his lecture and article for the journal of the American Geographical Society in New York in 1875 after he returned from traveling there: "And in thinking of the Caucasians we must remember that the Caucasian mountaineers as a whole are made up of fragments of almost every race and people in Europe and Western Asia. How such a heterogeneous collection of the tatters, ends, and odd bits of humanity ever blended into one coherent and consistent whole I don't know; but there they are, offering problems to ethnologists which will be hard to solve."[111]

While the term Caucasian was still being debated in the courts, Kennan dared to speak loudly about the fabricated, constructed image of the region. His observations were not always accurate. That is, in part, the point. Kennan's lectures exposed that a new language was necessary to describe how to see the Caucasus region as anything but racially white. Kennan,

a relative of the statesman George F. Kennan, became one of the main out-
lets through which US newspapers obtained direct reports about the
Caucasus and Slavic regions at large. By the time of his death in 1924, his
lectures and publications had made him the "chief intellectual link between
America, Europe, and Russia for fifty years."[112] His lectures show him
straining to dispel the myths that had turned the Caucasus into a near
fictive site. Their popularity demonstrated that the Caucasus had thwarted
visual assembly, which in turn helped to upend the region's importance for
the foundations of racial formation in the United States.

To View *A Circassian*

Imagine seeing Duveneck's painting *A Circassian* at the Museum of Fine
Arts, Boston, in the nineteenth century. Consider a viewer such as, poten-
tially, Frederick Douglass looking at a copy of a museum catalogue from 1886
when the painting was on view. (The museum would print many catalogues
each year; this is the only copy of an MFA, Boston catalogue Douglass had
in his collection). The response to Duveneck's *A Circassian* was an ideolog-
ical carrier of more than just the history of Orientalism. It also conveyed
the history of racial formation catalyzed by immigration debates, the popu-
larization of eugenics, legal challenges, and the scrutiny these cases brought
to the Caucasus region.

In 1919, the title of *A Circassian* changed. Duveneck had died that year,
and records show that the MFA, Boston, along with other institutions,
changed its listing of the painting's title to *Caucasian Soldier*, a title it would
keep through America's period of segregation in the 1940s all the way until
the 1990s. Curators in the early 2020s labored assiduously to explain the
reason for the title change. The paper trail at the museum does not offer a
direct explanation. The work had been listed as *A Study for a Circassian*
during the first year it went on display, but "A Study" was dropped in sub-
sequent showings, repositioning it less as an academic painting made during
Duveneck's time at school and more as one created for the public. After 1919,
the museum used the title *Caucasian Soldier* in an exhibition catalogue.
In 1924, it was published as *Caucasian Soldier* in *The Metropolitan Museum
of Art Bulletin*.[113] This new title appeared in some of the authoritative
American scholarship and biographies on the artist and again in major
exhibitions.[114] It was still called *Caucasian Soldier* as late as 1989 at a show
at the Danforth Museum of Art and in museum records. The addition of

the noun *Soldier* moved it out of the realm of racial typology and into a specific past.

Ultimately, in 2010, the curators changed the title back to Duveneck's original. It had been known as *A Circassian* for fifty years, even in the *Encyclopedia Americana*. There is no extant documentation to indicate why the title was changed back.[115] The original shift in title had not been sanctioned when Duveneck was alive. After combing the records, the consensus was that there was no "smoking gun" to be found.[116]

The silence in the archive about something as significant for a museum as the title of a painting, especially a painting that was among the first it acquired, is an example of the submerged visual regime under discussion. The history was seen. There was an awareness of the Caucasian War. There was enough consideration of this moment that it warranted a formal change.

The absence of any paper trail suggests an unstated deliberation. The very fact that there need not be any documentation for such a change speaks to the "common knowledge" about the Caucasus. By the time of the change in title in 1919, interest in the white common soldier monument had peaked with early twentieth-century anniversary celebrations of the Civil War. Immigration and legal cases had intensified readings of racial science and the history surrounding racial whiteness. Given the timing, the construction of the new title is not a surprise. For Duveneck's painting, the term "Circassian" had become a relic of nineteenth-century debate. It had given way to the term "Caucasian," making the painting much more commonplace and legible.

There are countless examples of name changes—with paintings, with tagging conventions in archives—that indicate a recognition subsequently disavowed. This is a national practice; for example, works once titled Caucasian were often altered in archives of all kinds.

This kind of editing has, in fact, changed the very history of the production of knowledge. These changes in nomenclature, however warranted and advisable, make the history less discoverable and, as archivist Dorothy Berry has argued, more difficult to surface.[117] While I do not mean to advocate for always keeping original titles, eliminating them from view in scholarship, and allowing this kind of rigorous questioning to rest only in the more protected parts of institutions, puts enormous responsibility on scholars, curators, museum leaders, and others to not compound the discursive silencing it has brought about.

Understanding the context surrounding Duveneck's painting allows for an unsilencing. A crucial task of the historian is to hold together narratives

as a constellation. Instead, *A Circassian* has been suspended at what Arthur Danto would call "facing curves," a point at which histories "touch . . . and then swing forever in different directions."[118] The response to *A Circassian* offers an opportunity to understand *why* it is so crucial to examine, excavate, and contextualize racialized culture; it presents us with what has been lost without this perspective.

I write this at a productive inflection point when disciplines and fields of all kinds are beginning an honest evaluation of the marriage of racial construction and vision. This work has been ignited by cultural flashpoints. The Capitol riot on January 6, 2021, was one. It propelled, for example, curator Gail Levin to reconsider her past work on American painter Edward Hopper. She began "investigating and documenting parallels between what we today call white nationalism and the nationalistic wave in the United States in the 1920s and 1930s, when the first museum devoted to American art was founded in New York." The results are a clear-eyed assessment to challenge the disavowal about the language of white racial dominance. Levin reflects on the framework surrounding the praise of Hopper's work as "Anglo-Saxon," a response to the artist's oeuvre in the preceding decades. "I propose that it is time to investigate and understand that the original promotion of Hopper's art—by the artist himself, by his champions, and by institutions—had racist underpinnings," she writes.[119] Institutions at large have begun to consider how terms—from titles of works to wall labels—contribute to epistemological production.[120] The complex and largely forgotten history and fantasy of the Caucasus reveals that the processual role of the Anglo-Saxon fixation is merely one of the underexplored frameworks to include in these developing examinations.

What must be examined is not only the work of art and culture, but also the silences history has concealed. Much of the work is about, as Hartman has argued, a "struggle with and against constraints and silences imposed by the nature of the archive—the system that governs the appearance of statements and generates social meaning." The context surrounding *A Circassian* offers a vivid sense of what is meant by this "system"—not merely the system of records, labels, scholarship, but also the system that has not accounted for the shape of absences that live in the archives through shifts within statements down to a title that go unaccounted for, unexamined, and unaddressed.[121]

When I first saw *A Circassian* at the MFA, I noticed that installed just a few feet from it, divided by a doorway, was the realist painting by Warren and

Lucia Prosperi, *Museum Epiphany III* (2012). The picture prompts questions about how viewers make sense of what is before their eyes (Figure 3.12). The composition centers a young white girl and her mother, both in white shift dresses, looking up to gaze at a gleaming white marble sculpture: Randolph Rogers's life-size sculpture *Nydia, the Blind Girl of Pompeii* (1856), once a widely popular work based on the novel *The Last Days of Pompeii* (1834) by Lord Edward Bulwer-Lytton. Rogers's work depicts a young girl groping mid-pace to find a path out of ruin, reliant not on sight but hearing alone. It is one of many works of idealized sculpture, part of the social movements of sentimentalism or "true womanhood" that refuted or affirmed moralizing ideals drawn from literature and the Bible. These works also constructed notions of idealized white womanhood and the construction of gender, operating as what Nathaniel Hawthorne called "sermons in stone."[122] The scale and height of the sculpture dominates the frame. Yet the uniform white of the dresses and sculpture and the close rhyme of their pleats make the mother and daughter's clothing almost indistinguishable from the finely chiseled folds in the marble, suggesting that they share a mutually constitutive connection—that the social world and the world of culture are inextricably bound.

3.12. Warren Prosperi and collaborator Lucia Prosperi, *Museum Epiphany III,* 2012, oil on canvas, 52 × 35 in.

Displayed within an installation of paintings in the American wing, it becomes clear that *Museum Epiphany III* is, in fact, a representation of the actual room at the Museum of Fine Arts, Boston, a trompe l'oeil painting that replicates what the viewer is doing at the precise moment, staring at sculptures and paintings, the same ones reproduced in this work.[123] In the painting, however, are all white viewers in the act of assessing the paintings and sculptures before them, in various states of contemplation—hands clasped at the back, a torso leaning forward to examine a painting, hands folded across a chest. Compositionally prominent is the act of looking itself. By installing this Prosperi painting of gazing at paintings and sculptures, the curators seem to ask a precise, incisive, question: how were these works once seen and how might we view them now?

Kirsten Pai Buick is one of many scholars who makes explicit the "terrible silence" in the visual arts "around what these narratives actually enshrine," which she describes as "the history of the visual cultures of White racial formation." She also is transparent about the need to correct for it in her teaching of American art history and, by extension, asks us to consider how museum galleries themselves function to educate, challenge, and perpetuate civic and racial narratives about who counts and who belongs in US society.[124] Yet the point here is not so much to discuss actors and institutional intentions. The aim here is to consider the structural frameworks that naturalize these silences.

In 2020, I returned to the MFA to study *A Circassian* again. I noticed that the curators had installed Kehinde Wiley's *John, 1st Baron Byron* (2013) at the entrance to the gallery (Figure 3.13). In Wiley's hands, a painting by William Dobson of a white man and English cavalier, Baron Byron, now centers instead a young anonymous black man dressed in a bright blue t-shirt and jeans, mimicking Byron's insistently upright posture. His figure is surrounded with a flourish of vibrant, neon green floral and muted yellow vined filigree enveloping the figure framed by a bright red backdrop. The figure's left hand, dramatized by a pop of light on his muscular bicep, gestures off frame. At the entrance to the gallery where Duveneck's painting hangs, it appears as both a beckoning and a genteel signal of ownership, giving the viewer permission, as it were, to enter.

As I stepped back to get a picture of the Duveneck and Wiley paintings juxtaposed, another set of visitors, a man and a woman, stepped into the frame and I overheard them speaking about Wiley's painting. At first, their

3.13. View of Kehinde Wiley, *John, 1st Baron Byron,* 2013, and Frank Duveneck, *A Circassian,* 1876, in the New American Wing of the Museum of Fine Arts, Boston.

conversation seemed intimate, so I smiled and pointed my camera away from them. Then the man pointed at the label identifying Wiley's painting and said to the woman, cocking his head:

"The original painting is of a white man. America. This is ridiculous. Why is this painting here?" he said, gesturing to the room, walking into the gallery with the Duveneck painting. He was getting agitated. We were the only three people in the gallery at that moment.

His comments struck me enough that I froze.

"Why is this painting here?" he repeated, looking at the Wiley painting. His companion turned to take one last look at the painting, visibly confused, and they walked away.

For that museum visitor, Wiley's work was more than just out of place. The man's repeated question—"Why is this painting here?"—suggests that a fundamental narrative about racial hierarchy was being disrupted.

If it was once possible to discuss vision and visual culture as if somehow sealed off from racial formation, it is not any longer. In the 1990s, a methodological shift occurred as scholars including but not limited to Martin A. Berger, Maurice Berger, Kirsten Pai Buick, Eddie Chambers, Hal Foster, Édouard Glissant, Kellie Jones, Nicholas Mirzoeff, W. J. T. Mitchell, Toni Morrison, Richard Powell, Michele Wallace, and Deborah Willis began to focus on the polemics, process, and construction of vision, absence, and opacity in the history of racial formation and social power.[125] Throughout the deft critiques of vision in modernity as "contested terrain," the term vision stays relatively intact.[126] When one fully integrates the history of race and aesthetics into our understanding of modernity, we see that racial formation had put what Arthur Danto called "interpretive pressures" on contemporary viewing far earlier than has been understood.[127]

Treating works of art in their full context means expanding what we mean by "seeing race" to treat vision analytically, as a process of assembly, and to consider its blind spots. In the case of Duveneck, it would mean asking: What narratives did viewers have in mind that led to such silence about a painting that would go on to such acclaim? What concern made critics try to puzzle out whether the figures in his paintings were models?

In 2005, art historian Martin A. Berger made a bold argument about the underexplored relationship between visual representation and the construction of whiteness specifically in the second half of the nineteenth century in the United States. Berger maintained that scholarship on visual culture had participated in "an endless feedback loop" of interpretation where media and texts "containing only white people—or containing no white figures at all—have nothing to say about race."[128] Berger took on the daunting task of pointing out that American Studies and art history were forged in a culture unattuned to "European-American whiteness." Building on scholarship in the then burgeoning field of whiteness studies, he focused on the reception and construction of visual representation that seem "removed from racial concerns," to prove that they were animated by them. He moved away from the idea of whiteness as a constructed identity, describing it instead as a structuring force of vision. While not a critique of formalism, it did call into question what tools art historians use when what is in front of the eye

is not "readily seen," not "self-evident" but instead conditioned by historical and social context."[129]

In the years since Berger's scholarship, what has emerged is an increased focus on the interpenetration of whiteness as a marked racial category, one residing within the broader history of racial construction and its role in understanding the development of modernism in America and the global south. Scholars in art history and visual studies have recently taken a more critical approach to analyzing how visuality operates as a filter of racial ideology connected to the construction of whiteness as a marked racial category within the broader history of racial construction in the United States.[130] In a prior period, it was feasible to study the construction of vision without any acknowledgment of the structuring logic of race on sight. Now scholars have imbricated the polemics, process, and construction of vision, absence, and opacity into the history of racial formation and social power.[131] Yet what has not shifted within this accumulated discourse is the nineteenth-century negotiation of the visual representation of whiteness as part of the understudied transnational project relating specifically to the Black Sea region.

Silences should no longer hold back warranted interventions and critique. I write at a time when the very ideals that framed the basis of the discipline of art history—an equation of whiteness with the height of aesthetic skill—have been called into question. "A beautiful body will be all the more beautiful the whiter it is," proclaimed Johann Winckelmann, widely considered to be the founder of art history, instantiating ideals about aesthetic quality that rested on racial observation.[132] Aesthetics were marshaled to create, solidify, and naturalize the structure of racial hierarchies that we still live with today. Aesthetic judgment took on the character of authority in upholding the racial discourses of domination in American life, then became divorced from it.

A rupture between the study of racial construction and aesthetics was *required* for naturalizing the construction of race itself. While racial science tracts used art objects elevated to the status of the classical human ideal such as the Apollo Belvedere—a work Winckelmann made famous—as a cognate for whiteness, after this moment, the field of art history would long adopt the approach that representation lets us see race, yet there was little consideration about how aesthetics became a social tactic to turn subjective argument into fact. In the arts, we are only starting to address how this conditioned way of seeing meant that epistemology—creating knowledge about the observed world—defined ontology, the lived experiences shaped by it.

The project of modernity requires that we understand how race transformed what we call vision. Jonathan Crary has argued that the nineteenth century saw the redefined status of the observer as institutions and technologies of seeing centered the body as the locus of new practices.[133] Yet the terms spectator, which Crary rejects, and observer, which he chose, are not sufficient to describe what happened to perception in the context of racial life.[134] This moment in history was one when the marriage of race and modernity shifted vision itself, turning observers into adjudicants and so forcing them to determine how what they were seeing conformed to learned, received, and textual narratives about racial global order.[135]

The response to Duveneck's *A Circassian* telegraphs the need for a more expansive understanding of racial construction in the United States that extends beyond the circum-Atlantic to the Black Sea region. What is remarkable about *A Circassian*, perhaps Alice Sturgis Hooper meant, was that it not only showed the start of Duveneck's *alla prima* conceptual innovation but also emblematized the complex, racialized act of unseeing the Caucasus region as the unstated subject of his work.

This submerged history of racial adjudication goes well beyond the context of the Duveneck painting. The silencing around this history was conditioned not only by the visual culture that narrativized the Caucasus region, but also by how it became hidden in order to fashion what only seemed to be empirical evidence to support white supremacy. We glimpse this in the history of how maps and atlases were used as requisite tools of instruction in schools across the United States. It is made vivid in considering how pedagogy itself—through the teaching of global history—became the training grounds to unsee the fictions that have justified racial ideologies in American life.

4

Negative Assembly

Mapping Racial Regimes and the
Cartography of Liberation

In a photograph taken circa 1899 by Frances Benjamin Johnston, a teacher and students stand or sit on three rows of benches largely staring at miniature globes. A chalk drawing of North America hovers behind the students on the blackboard of an adjoining room. A young man stands pointing to another blackboard with a simple chalk drawing of the earth orbiting the sun. Directly beneath this diagram the teacher sits at a cloth-covered desk, her hand resting on the pages of an open atlas. The continent of Africa is visible on the small globe next to the atlas, bisected by a metal meridian. A single student in the back row stares not at the globe before her, but directly ahead at the teacher, perhaps deep in thought about how to see her surrounding world (Figure 4.1).

This photograph, *Geography: Studying the Seasons,* was commissioned as part of a larger suite of images to promote the pedagogy of Hampton Normal and Agricultural Institute in Virginia for black and, for a period, Native students. Such teaching was championed by white philanthropists and critiqued by leaders such as W. E. B. Du Bois for having a pedagogical philosophy so accommodationist it "practically accepted the alleged inferiority of the Negro races."[1] Johnston's photographs were taken during the racial nadir when social and political challenges to racial hierarchies of Reconstruction were blunted by the entrenchment of racial oppression in Jim Crow America.[2] Each image finds force in the ability to capture activity as if frozen, "as calm as 'a fly in amber,'" as if an index of the labor required to fix and

4.1. Frances Benjamin Johnston, *Geography: Studying the Seasons,* from the *Hampton Album,* 1899–1900, platinum print. The Museum of Modern Art, New York, Gift of Lincoln Kirstein, 859.1965.63.

naturalize racial hierarchies in the United States.[3] Yet the stillness of the photograph is in sharp contrast to the dynamism of what was being taught. These classes made mapping a crucial site of propaganda in the ongoing work to cement the logic of white racial supremacy, and later, to challenge it.

For years, I looked at this image and imagined the lives of these women and men—many of them training to be teachers—who experienced the transformation of white racial supremacy into a curriculum-based fact. Racial dominance had so deeply structured the composition and textual narratives of common maps and atlases during this period in the United States that teaching geography required instructing black and indigenous students about their so-called subordinate place in the racial hierarchy, limiting their perspective of the true activities taking place in the world.

A study of mapmaking at the turn of the twentieth century exposes the extensive work of *negation* done to thwart doubt about the legitimacy of

racial hierarchy and the regime of white racial supremacy. It reveals a wide-spread tactic of *omission* to solidify narratives of white racial dominance. An excision of details, ideas, and historical materials—a negative assembly—blocked scrutiny of the foundations of white racial supremacy and the legitimacy of the racial order it secured.[4] Central to the project of racial hierarchy has long been an overlooked, enduring pattern of negative evidence to solidify narratives of racial hierarchy.

Negative sight—born of learning to unsee the unstable foundations of white racial supremacy—transformed vision into an act of continual racial assessment. This taught, conditioned, and naturalized mode of negative assembly stabilized racial discernment in American life and enabled the narrative solidity of racial myths. The legacy of this practice catalyzed a form of resistance—cartographic and otherwise—that has become foundational to liberation practices today. Erasure has been a crucial component of the maintenance of racial hierarchies in the United States.

I was in the Map Collection reading room of the New York Public Library when I first noticed the pattern that pointed to the evidence: by the 1890s, the Caucasus region and its peoples shown in maps began slipping off popular atlases in the United States. Any supposedly factual, geographic basis for the term Caucasian for racial whiteness by then had been revealed to be a fiction—an invention that had created the foundation of racial ideology and hierarchy. As this revelation came to light, details about the region began dropping away in societal discourse, in law, and even on maps and atlases of the world. As we will see, maps became anti-chorographic; once prominently displayed, the details about this place, the supposed demographic origin for racial whiteness, had a steadily diminished presence on maps starting around the turn of the twentieth century when it no longer contained explanatory power regarding racial science. It would have been common, year after year, to read in a popular geography textbook or an atlas, "By far the largest and most civilized of the four divisions of mankind is the *white* or *Caucasian race*," and that its "leaders now dominate the world," and then, in later versions, to see the comment, "Their original home is not known."[5]

What remained in the geography teaching manuals and the most popular, standard atlases distributed in the United States were figurative and cultural narratives about the Caucasian ideal that would prove critical for shoring up racial hierarchies and ideology.[6] The dynamism about the Caucasus on maps had emerged in the 1880s and 1890s when the oppressive logic of Jim

Crow rule became a compensatory measure to nullify the Confederacy's defeat, block Reconstruction, and maintain the racial regime that slavery had helped to secure.[7] These decades were also a period when, we are told, the idea of the Caucasus, with all its contradictions, started to be ignored, repudiated, and then finally overturned as a stable, racial reference.

These facts are not unrelated. Media of all kinds aimed to cement white supremacist ideology. Domestic racial violence, including extrajudicial lynching supported by municipal governments, instantiated Jim Crow rule. It is during this period, Henry Louis Gates, Jr. argues, that "white supremacist ideology, especially as it was transmuted into powerful new forms of media, poisoned the American imagination in ways that have long outlasted the circumstances of its origin."[8] Yet from the 1880s through the turn of the twentieth century, tactics of racial domination began to have the critical feature of erasure, of negative assembly.[9]

Sight became a form of racial sculpture; vision became a knife excising what no longer served the stability of racial hierarchy. Negative assembly enabled the narrative solidity of racial myths.

Excisions in mapmaking at the turn of the twentieth century in the United States reveal how society grappled with the incoherence of the foundation of racial hierarchy. The narrative of the Caucasus had been destabilized in the context of scientific racism, but remained a reference point for the public. Maps, from atlases to teachers' manuals for geography classes, can transform our understanding of how these developments hardened foundations of racial ideology on fractured ground and altered the work of seeing in racial life at large.

Benedict Anderson has argued that the map, the census, and the museum together are a central framework for a consideration of nationhood. Each are "institutions of power that all changed their form and function as the colonized zones entered the age of mechanical reproduction" and "imagined its dominion—the nature of the human beings it ruled, the geography of its domain, and the legitimacy of its ancestry."[10] The production of knowledge and narratives by museums, along with the work of the census and the courts, as researched by scholars including Melissa Nobles and Ian Haney López, shaped the construction of race in American life.[11] If print culture allowed for "imagined communities" among those who would never meet, as Anderson argues, the disappearance of the Caucasus from maps allowed for the creation of shared communities of racial supremacy to become, in effect, the implied *universal* community.[12]

This underexplored history reveals why W. E. B. Du Bois would famously innovate the very *form* of maps for social science methods—both as a model for his award-winning display at the 1900 Paris Exposition about progress in black life and as a touchstone for his rhetorical claims in his 1910 essay "The Souls of White Folk." Du Bois's approach reflects how pervasive and essential atlases and mapping were for adjudicating race for the public. His work modeled the use of maps as weapons to push back against the ruling logic of white supremacist ideology and the burgeoning racial data regime that, as scholars including Autumn Womack and Aldon Morris detail, was developing at the turn of the twentieth century.[13]

Du Bois mobilized the form of maps to explode the racial myths they secured. His engagement with maps shows more than a critical awareness of the data visualization tactics of social science. Rather, Du Bois demonstrated a striking fluency with the repertoire of aesthetics that served as political, racialized propaganda in American life.

Negative assembly—excisions to prevent a reckoning with the fictions of racial hierarchy—is pervasive today. We see it in legacies of mapmaking maneuvers in the Jim Crow era, such as district gerrymandering, carceral geography, red-lining real estate policies, and white flight, as deftly discussed by scholars including Ruth Wilson Gilmore and Richard Rothstein.[14] The tactics of negation, of deliberate excision, are also found in attacks on critical race theory in our own time. It is these practices that Fred Moten has called "incorporative exclusion"—racial inclusion in social life made possible because of specific prohibitions and regulations based on deliberate omissions.[15] By examining the design, compositional variation, and pedagogical use of early twentieth-century world maps, with careful attention to how the Caucasus was taught, one can locate precisely their origins as racialized weapons in the United States. Scrutinizing geography taught in schools, and the maps distributed during that era through atlases, does more than evince their foundational use as tools for figurative assessment and racial domination.[16] It reveals negative assembly as a central, structural feature for the maintenance of racial hierarchies in American life.

One may look at Johnston's photograph and conclude that the unexamined pattern in US mapping and visual racial assembly should not matter given the standard sociohistorical account of racial formation in the United States.[17] De jure and de facto segregation would harden as Jim Crow rule

was legalized in *Plessy v. Ferguson* (1896). The violence of the segregationist order would become so oppressive, with racial lines so deeply entrenched, that this observation about mapping the Caucasus could pass without remark. Historians have also emphasized that at the turn of the twentieth century, the term Caucasian as the racial category of whiteness had been replaced by a focus on the Anglo-Saxon or Aryan ideal.[18] William Z. Ripley's influential *Races of Europe* (1899), a "definitive" source for nearly twenty-five years, would salute the Anglo-Saxon model as the root ancestry of white Americans, a fixation that had emerged over a century through writings by Thomas Jefferson and Ralph Waldo Emerson.[19]

Yet the place of the Caucasus on maps at the turn of the twentieth century, including those taught at Hampton, offer a glimpse of the crucial transformation in visual assembly that is entirely absent from the standard historical account. Visual images and visual regimes appear, at best, as illustrations of change rather than active agents. The stakes here are higher. They concern not merely the status of white racial formation, but also the formation of racial assessment as a ubiquitous practice—disguised as merely seeing, looking, and observing. Such assessment was required to secure and later, crucially, to challenge oppressive racial hierarchies in the United States. We have seen how the Caucasus as an actual region and as a presence in the American imagination became two separate things entirely. Maps offer a window into how this was done.

Geography teachers' manuals—popular, standard texts used in schools around the nation—offer unequivocal evidence not only of a blunt insistence on white racial dominance in these classes, but also of the reliance on strategic negation to maintain the rationale for these racial hierarchies in the postbellum period and Jim Crow era. Teaching manuals contain clear evidence: narrative scripts—a repertoire of codified, repeated narratives—used in classrooms to circumvent the lack of foundations for the ideology of white supremacy. These scripts would shield the Caucasus from examination even when, after the Caucasian War, it was revealed to be anything but a racially white region. As a portrait of the actual demography of the Caucasus emerged after the Caucasian War, it turned the Black Sea region into both a foundational and disavowed geography central for racial assembly in the United States.

Yet these maps evade the search pathways of the archives. A literal request for maps of the Caucasus in a library led to only a narrow set of objects though the collection contained more. I needed to examine the full set of material that emerged in the wake of this cut-and-paste operation to

see the submersion of the term so foundational to US racial formation. The difficulty of this labor in the archive, to say nothing of how rarely we consider omissions as significant, creates a problem for how we understand history.

The absence of any writing on these maps, too, is curious. At the turn of the twentieth century, there was widespread social interest in mapping spurred on by imperialism, increased internationalism, incursions onto Indigenous lands, and the new US Census inclusion of maps.[20] This interest was amplified by an early spatial consciousness brought about by the visual surveillance required for the regulation of slavery.[21] Yet there is "strangely—an inverse relationship between the proliferation of atlases in American culture and the level of critical attention paid to them," Susan Schulten notes.[22] In the midst of this period of burgeoning and then waning cartographic literacy, the compositional variation of atlases and maps positioned the Caucasus as an increasingly disavowed region for racial assembly and white supremacy in the United States.

Scholars such as Michel-Rolph Trouillot, Michel Foucault, and Édouard Glissant have claimed that modernity required a "geography of imagination" and a presentation of "the legitimacy of the West as the universal unmarked."[23] An exhaustive study of atlases and academic geography in the nineteenth century shows that what aided the legitimacy of this locus were the increasingly elusive references to the Caucasus, the region once identified as the origin site of racial whiteness. The "white mythology" of universality, as Jacques Derrida argued, is one that "assembles" cultures.[24] Mapmaking's practice of deracinating details became central to the conceptual operation of white mythmaking at the foundation of racial hierarchy. It shaped discursive regimes that legitimated colonialism and imperial conquest through both assertion and negation. Framed, produced, and sold as objective, empirical information about the world, US atlases reveal what had to be excised for racial regimes and hierarchies to remain intact.

A study of mapping registers that the complex development from sight to assessment was nearly inescapable in racialized social life in the United States. Paul C. Taylor has examined the instability we see in this period derived from "the wider problematic of racial formation under white supremacy."[25] Reading racial assembly through the lens of Stuart Hall, Taylor posits that "assembly is the mode of inquiry that allows us to see and account for the coherence of the configuration without glossing over the respects in which it remains, in a sense, incoherent."[26] A key operational

tactic of assembly, however, was negation—what was hidden and kept out of sight.

What else makes this specific form of visual culture—mapping—so important for this investigation? There are two additional reasons. First, the social production of maps and their material transitions—updates, edits, and other revisions—make them laboratorial sites through which to trace notions and actions often not yet contained in the secondary literature about racialized geographies.[27] This is, in part, due to the urgent stakes of their production. Even changes in reproductive technologies played a role here. In a race to capture the market, mapmakers using the cheaper, US-pioneered technique of wax engraving aimed to outdo each other with how much information their compositions could present. Competition for market share was telegraphed through the atlas titles. Cram's version, for example, was bombastic in its proclamation of its superiority as the *Unrivaled Atlas*, literally cramming information into its products—maps, histograms, pictograms, but also visual treatises that turned it into a "Bureau of Information" utilized by the federal government.[28] Based on the gazetteer model, the production of maps offered an encyclopedic index of regional facts, including racial demography.[29] When viewed over decades, their design and production technique show definitive transformations, a near sequential glimpse of shifting views about racial formation.

Most significantly, studying maps from the turn of the twentieth century exposes the "conceptual filing error" in the archives that thwarts our ability to *see* the evacuation of the Caucasus as a racial touchstone in US maps. Daniel Immerwahr, for example, has traced what fell off the continental United States "logo map" during the age of imperialism. The logo map depicted the United States bound by land north and south and by oceans east and west. The problem with the logo map, he writes, is that "it isn't right. Its shape doesn't match the countries' legal borders." It excluded territories such as the Philippines, Guam, American Samoa, and the Panama Canal, to say nothing of Hawai'i, Alaska, the US Virgin Islands, and Puerto Rico. Omissions of imperial territories on the map allow envisioning a republic without consideration of its colonial history. The geographies of occupied territories are out of sight. The maps not only leave off the nearly nineteen million people who lived in these US territories— which, if framed in terms of size of empires, was "at the time of Pearl Harbor, the fifth largest in the world"—but, in so doing, also make it harder

to file, sort, and identify images of US imperialism.[30] A similar dynamic occurred in my research.

As I found maps of the Caucasus in the New York Public Library (NYPL) Map Division, one of the most robust set of holdings of maps in the United States, I came to realize I was looking at negative evidence—maps that showed what happened when the region fell off US atlases in the wake of the Caucasian War and, in turn, became a concept in the American imagination. On maps from Italy, France, and the United Kingdom, the Caucasus was first described as a geographic region—a mountainous range between the Black, Azov, and Caspian Seas—but then emerged as a geopolitical area. By Arthur Tsutsiev's account, in these European atlases, the frontiers and imperial conflicts between Persia and the Ottoman and Russian empires created a heightened, detailed focus on the region. Forced resettlements, relocations, and various administrative reforms became mapped with increasing intricacy.[31] Yet in the United States, maps of the Caucasus became embedded in atlases not only as a chorographic region but also as a figurative, racial ideal—what W. J. T. Mitchell and Nicole Fleetwood refer to as "a racial icon," which, Mitchell argues, is "not simply something to be seen, but itself a framework for seeing through."[32] This transition and the framework it disclosed was impossible to grasp without looking at nearly all the atlases produced in a particular time period.

I remember the day when NYPL Map Division librarian Ian Fowler looked at the material I had located and said, "I see what you're researching now." He graciously brought out what seemed to be most of the library's US atlases, geography textbooks, and teacher manuals for the decades in question, including items I could not have found in the library catalog.[33] As I worked through the maps and geography textbooks that were taught in then-segregated schools, I thought of what Katherine McKittrick has called the "corporeal and affective labor" of black liberation practices.[34] My initial interest had not changed. I had just realized that there was no way to narrow the requests further.[35] The process of research had shifted my own conceptual filing system, along with my understanding of the breadth of focus required to examine this history.

Extractive conditions of colonialism and imperialism were not only focused on mining lands, slavery, and forcing migrations; details of geographies on maps had to be excised to support the larger project of racial formation as well.[36] Writers and scholars focused on the geography brought together by the extractive logic of these conditions have often coalesced on the term Black Atlantic. Defined by Robert Farris Thompson and further

developed by Paul Gilroy, "Black Atlantic" indexes the cultures of displace-ment and reconstitution brought together by the flows of slavery and im-perialism in the Atlantic world.

Maps of the Black Sea area during this period show that racial regimes were crucially supported by extractive logic in the symbolic terrain as well. The patterns in mapmaking history disclose a vital, interlocking relation-ship between the history of visualization and racial regimes. We have seen the shift from vision to assessment telegraphed in photographs, perfor-mances, and museum collections. The composition and instructional use of maps signals how this development impacted worlds including and be-yond the arts and its related institutions and social spheres.

The tactic of negative assembly and racial disavowal—the insistence on *not* seeing conflicting details about the Caucasus region as the foundation of white racial dominance—became a key discursive feature in the transfor-mation of vision in the modern age.

Conceptual Filing Error: Mapping Race in the United States

I had not planned to study maps. I was preparing for a trip to the Caucasus region for additional research, and following a trail left by Woodrow Wilson when he requested an image of women from the area. The trip meant going to places that were not showing up on maps I could easily find online—drives toward Anaklia and Abkhazia, the heart of Circassia. To trace the shifts in the assembly of maps of the region methodically, I started looking for US atlases from the 1870s that included the Caucasus. These would have circulated during the same period when P. T. Barnum's Circassian Beauties were still on the performance circuit.

I opened an atlas from 1876, *Black's General Atlas of the World,* and saw an ethnographic map with a torso of a Circassian woman representing the pinnacle of humankind. This map by cartographer and well-known Scot-tish engraver John Bartholomew was one of the first pages in the atlas, just after a Mercator projection of the world spread over two pages. In a car-touche on the lower left of this map of the human races were fine-lined engravings of the busts of ethnic types grouped under the headings "Cau-casian," "Mongolian," "Malay," "Negro," and "American"—the fivefold representation of the "principal varieties of mankind."[37] The Circassian's image is the apex, centered within the top row, as a bust with flowing hair

underneath a capped headdress and a high-necked top of an imperial style. A legend at the top of the map identifies the color-coded regions. In small cursive letters the words "Caucasian" and "Georgian" appear over the mountain range between the Black and Caspian seas. In large, block letters above the contours of Western Europe are the words "CAUCASIAN RACE" (Figure 4.2).

The appearance of Circassian figures on maps and in geography teaching manuals through the mid- to late nineteenth century signals a fixation on the Caucasus region in public life that was more widespread than has been previously understood. *Black's General Atlas* was circulating just as Frank Duveneck's painting *A Circassian* (1870) became one of the first works to enter the collection of the Museum of Fine Arts, Boston. Around the same time, the philanthropic Hooper family had, in fact, created the Harvard University endowment that helped establish the Department of Geology, the parent discipline of geography. Samuel Hooper, father of Alice Sturgis Hooper, who gifted the Duveneck painting to the Boston museum, gave Harvard $50,000 in 1865 for this purpose. The Sturgis Hooper Professor of Geology was named after his son, William Sturgis Hooper Lothrop, who would graduate in the same Harvard class as W. E. B. Du Bois.

Atlases and geography textbooks from the period were filled with details about the Caucasus region, even quizzing students on the mountain ranges separating Circassia and Georgia. A geography manual produced by the Confederacy, for example, *A Geography for Beginners,* published in Richmond, Virginia, contained lore about racial whiteness and Circassia specifically. It also contained a section on "Caucasia," with detailed descriptions of the beauty of both Georgian and Circassian women as part of this "handsome race."[38]

Cartography became an increasingly vital form of racial assessment, even after the Civil War. Maps were commissioned and integrated into the census of 1872 for the first time by the influential statistician Francis Amasa Walker. The racial and ethnic composition of the United States became a central feature of this census, which centered on the effects of both Emancipation and immigration, counting free black Americans and a wide range of ethnic groups for the first time. It institutionalized the outsized role that measurement through mapped lines, via the Mason-Dixon line, had already played in American racial life. Walker, an ardent nativist, would go on to call immigrants from southern and eastern Europe "beaten men from beaten races; representing the worst failures of the struggles for existence."[39] Drawing from the US Census, he produced a report for mass consumption

4.2. "Ethnographical Chart of the World Shewing the Distribution and Varieties of the Human Race," *Black's General Atlas of the World* (Edinburgh: Adam and Charles Black, 1876).

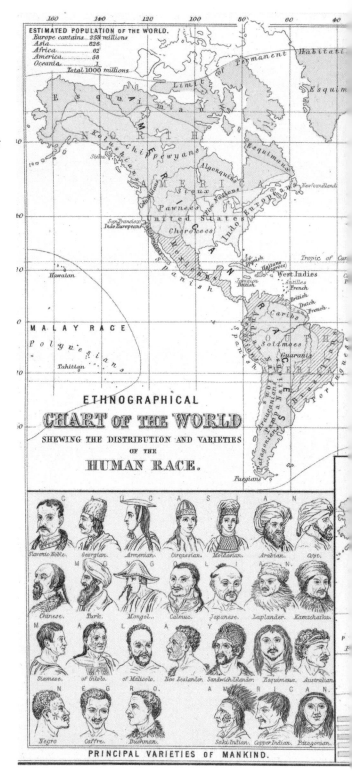

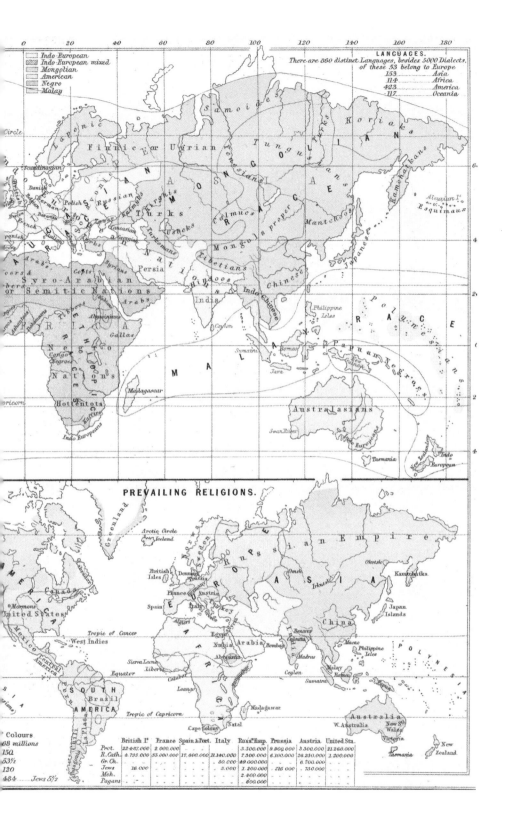

that was published in the 1874 *Statistical Atlas of the United States Based on the Results of the Ninth Census.* The precision of these maps announced them as an increasingly central site for the production of knowledge about racial and ethnic classification during the decades of demographic upheaval at the end of the nineteenth century. Maps would shape the grammar and logic of governance for racial reconciliation.

As maps and atlases began to assume an authoritative position in federal governance, however, atlases from the 1890s excised figurative details about the Caucasus region. In *The Scribner-Black Atlas of the World* from 1890, for example, the Circassian figures were among those edited out of the ethnographic chart (Figure 4.3).[40] The map engraving now showed one type to represent a "Caucasian"—a bust of a white man, with straight, coiffed hair, a moustache, and an aquiline nose, dressed in a modern suit and tie. In a cartouche at the bottom left of the map, the "Caucasian" figure hovers at the center of the presentation of humankind with four other figures, labeled "Malay," "Mongolian," "Negro," and "N. American Indian."[41] Profiled, but slightly askew, the Caucasian is scaled as the largest figure of them all.

Maps betray the compositional efforts to cover up the fractured foundations of racial hierarchy and white racial supremacy that emerged at the turn of the twentieth century. The critical operation was deletion. Engraving techniques magnified the labor and expense that went into making these changes. Scribner-Black used lithography, not cerography, which was an early form of engraving developed by Sidney Edwards Morse, brother of Samuel Morse, inventor of the telegraph and son of the famed cartographer Jedidiah Morse. Although similar in some ways to the process of etching, cerography additionally engaged a process known as electrotyping. An incised wax-coated plate was dipped in a solution of copper sulphate and attached to a battery. The charge encouraged the copper in the solution to fill the plate's etched lines, allowing for the wax to serve as a molding medium to produce a relief-printing surface. The plate could then be put through a "common press," producing high-quality images on less expensive paper and so allowing for mass production.[42]

Like many European mapmakers, Scribner-Black had not switched to this cheaper, nimbler model of cerography. The wax engraving process accounted for up to 75 percent of all maps sold in the United States between 1840 and 1950.[43] This also led to an overabundance of information that became the "notorious trademark of American maps."[44] Though marketed in the United States, Scribner-Black's atlas was printed in Edinburgh and, like many European mapmakers, it used copperplate engraving, the intaglio

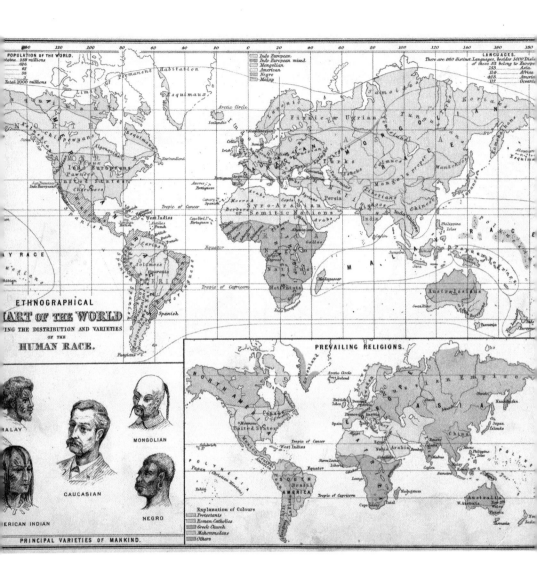

4.3. "Ethnographical Chart of the World Shewing the Distribution and Varieties of the Human Race," in *The Scribner-Black Atlas of the World: Embracing the Latest Discoveries, New Boundaries, and Other Changes: Accompanied by a Geographical Introduction and Indexes* (New York: Charles Scribner's Sons, 1901).

process that required highly skilled engravers, making any change deliberate, laborious, and costly. The edits to the Scribner-Black atlas, given that it was still using lithography and not wax engraving, telegraphed the urgent need to ensure that atlases could keep pace with societal and racial comprehension about the region at large.

The instability in American racial formation drove print innovation. New figurative templates emerged in atlases. Figures were redesigned. New diagrams were cut out. Excisions on maps would continue.[45] Atlases beyond those produced by Scribner-Black deleted details about the Caucasus's geography and demography, such as renderings of Circassian figures—the purported apex of the Caucasian type. Consider the *People's Illustrated and Descriptive Family Atlas of the World* from 1885, produced by George F. Cram & Company, one of the largest mapmakers in the United States (Figure 4.4). Within this atlas, with an embossed cover of gold letters on black leather, was a figurative racial scheme. At top center a man labeled "European" is dressed in a three-piece suit and necktie, his hand resting on the word "Caucasian" for emphasis, with the term rounded as if an entryway sign.

Given the standard account of racial formation, it is striking that the Caucasian scheme would contain not one but *two* Circassians—a "Circassian Chief" and a "Circassian Girl," the only woman in the diagram. Within this racial banner is a "Greek" man on the left and on the right a more schematically rendered "Circassian Chief" in a simple button-down shirt and jacket. The three men are framed in a circle, with the Circassian and the Greek figures flanking the European man. To the right in this image is a diagram of a "Chinaman," evidence of the negotiations about the contours of the definition of the term Caucasian in the 1880s.[46] The central figures rest atop a quadrant with figures of the four other racial types listed as "Mongolian," "Malay," "Ethiopean," and "American."[47]

This racial diagram organized by the ideology of white racial supremacy was so deeply nestled within the volume that I almost flipped past it. The "Types of the Races of Man" diagram was integrated into the standard atlas, listed on the page across from, significantly, a map of "England & Wales." This was preceded by pages with maps of Scotland, Ireland, Sweden and Norway, Holland and Belgium, and other countries in Western Europe. Set against a symbol of Anglo-Saxon geography, the arrangement signaled the dynamism in the structure of racial ideologies while retaining the idea of the Caucasus.

The figurative chart of racial hierarchies acquired heightened authority through the process of engraving. Near uniformly vertical lines left from the

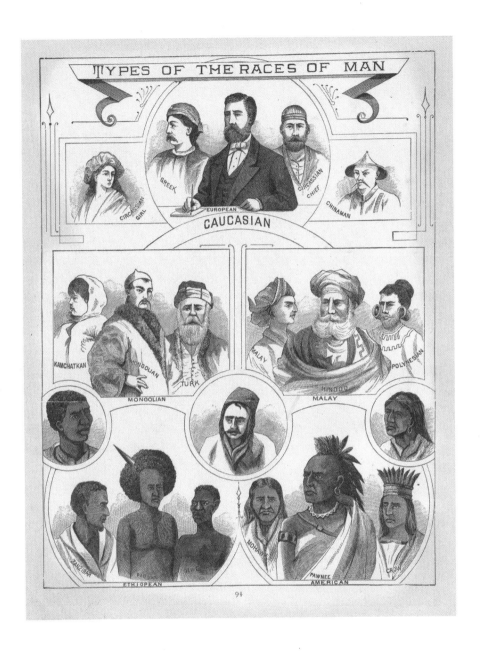

4.4. "Types of the Races of Man," in *The People's Illustrated and Descriptive Family Atlas of the World Indexed*, 7th ed. (Chicago: People's Publishing Co., 1885).

reserve of the wood engraving process signal ascension. Spear-tipped lines bracket the Caucasian figures and point upward, framing them as the apex of this schematic order. The exceptions are the engraving of a Papuan man rendered with circular forms on his bare chest, suggestive of a permanent tattoo, and the rendering of the hair of the Ethiopian figures. The engraving decisions underscored that this diagram was a declaration of hierarchy.

By 1891, Circassian figures had been removed entirely from *Cram's Unrivaled* atlas.[48] Instead, the frontmatter presented a fivefold figurative template as the opening of the section on "man" and a discussion of industry around the world. This diagram was engraved by William H. Van Ingen & Henry M. Synder, known for supplying illustrations for antislavery publications, children's books, and travel narratives.[49] The same diagram appeared in other common geography textbooks such as *A System of Modern Geography* by S. Augustus Mitchell and the *National Standard Atlas of the World*.[50] Cram's maps also represented the increased ease in amended or eliminated information that became possible with the shift in techniques from copperplate to wax engraving and was one of the pioneers of the technique along with Rand McNally.[51]

Now the pared-down races of man were juxtaposed with a schematic rendering of spheres representing planets (Figure 4.5). "The civilized nations are nearly all Caucasian," the text states before launching into a discussion about the "four classes" of civilization "engaged in agriculture, manufacture, [and] commerce," which "have established systems of education, and have reached the highest perfection."[52] The rhyme between racial types and celestial bodies, the most vast spatial framework imaginable, suggested that the order and hierarchy they represent—with the Caucasian type centered—was as inviolable and totalizing as the gravitational arrangement of the solar system. Figurative cartouches emerged as a frame through which to understand racial ideology. The Caucasus, first centralized as a geography in popular atlases, now became a floating, figurative concept.[53]

The pervasive pattern of excision was easy to miss. To work around the conceptual filing error, I had to look at, essentially, all the maps produced in the United States in the library's collection that would have been circulating during a specific period. Most importantly, I needed to put pressure on a punctuated moment in the archives—the period in which the Caucasus became, in effect, a relic, a retained fiction. I needed to know in advance what period in history to examine. As Walter Benjamin has argued, in the production of history, "every image of the past that is not recognized by

CLIMATE.—By the climate is meant the heat or cold moisture or dryness of the atmosphere. Climate may depend upon several circumstances, as distance from the equator, height above sea level, distance from the ocean, and the direction of the prevailing winds.

The hottest parts of the earth are the lowland plains of the Torrid zone, more particularly such as are far inland, or are near sandy desert

SIZE OF PLANETS.

regions. The coldest parts are those of the Frigid zones, or places near those zones, and unprotected from the icy winds. The mountain regions and plateaus between the tropics enjoy a perpetual spring, the heat being modified by the elevation. Lofty mountains everywhere are perpetually covered with snow. Ocean currents, as the Gulf stream, affect the climate of different countries. The western parts of Europe and North America are much warmer than other countries in the same latitude, on this account. Ocean winds communicate to the land the even temperature of the ocean, and transport the moisture exhaled from its surface to the interior of the continents, where it falls in the form of rain, dew, snow, etc. Mountains condense the vapors of the atmosphere. Hence, elevated regions or those near mountain ranges generally receive the most rain. More rain, however, falls on the coast regions than in the interior, and in tropical than in temperate countries. Climate is also greatly affected by the kind of soil and the extent of vegetation. The removal of forests renders the climate of a country warmer. The healthfulness of a climate depends chiefly upon its freedom from the noxious gases which arise from the decay of vegetable and animal matter.

The three kingdoms of nature are the mineral, vegetable and animal. Minerals—in regard to their uses to mankind, comprise three classes—force-producing minerals, industrial metals and building stones. The chief and most abundant force-producing mineral is coal. It is of vegetable origin and has been found in nearly every country in the world, both in lowland and highland. The leading industrial metals include iron, copper, nickel, zinc, gold and silver. Granite, marble and sandstone are the most valuable building stones.

VEGETATION.—The vegetable productions of the earth vary with the climate. It is most luxuriant in tropical countries, where the most important productions are yams, bananas, plantains, bread-fruit, cassava, sago, cocoa-nuts, and the cacao or cocoa tree. Many delicious fruits are also produced in the Torrid zone—such as pine-apples, oranges, lemons and citrons. The Temperate zones are the regions of the grape vine, the potato and of various grains, and of the beech, maple, oak and pine trees. In the Frigid zones trees dwindle into mere shrubs, and in the regions of perpetual snow no vegetation exists except a few minute plants that grow upon the surface of the snow. In ascending from the base of mountains and table-lands, the same changes in the character of vegetation are found as in going toward the poles; so that a tropical mountain of great elevation, possesses the climate and many of the productions of every zone.

ANIMALS.—The character of the animals which inhabit the earth varies with the climate and vegetation.

In the Torrid zone are found the largest, strongest, and most ferocious land animals. A great variety of birds, and vast numbers of dangerous reptiles and troublesome insects, are also found in this zone. The birds, fishes, insects, serpents, and many of the wild beasts, are adorned with the most brilliant and beautiful colors. In the temperate regions are the buffalo, bear, deer, wolf, fox, and wild-cat. Reptiles and insects become fewer, smaller, and less troublesome. The birds have not so gorgeous a plumage, but they are more melodious. In the Polar regions, the animals have a less brilliant color. There are no reptiles, and but few insects. In ascending from the base of tropical mountains, the same changes of animal life are found that are observed in passing from the equator to the poles.

RACES OF MEN.

MAN.—Whatever may be the conceits and fancies of the present age, it is generally admitted that man in his first estate was a savage of the lowest type. The annals of primeval man do not follow out any line of

4.5. "The Earth," in George F. Cram Company, *Cram's Unrivaled Atlas of the World, Indexed* (New York: C. P. Gray, 1891).

the present as one of its own concerns threatens to disappear irretrievably."[54] One such disappearance—the erasure of details about the Caucasus—exists in this corpus of maps.

In isolation, these map cartouches and atlases could seem unremarkable, just more examples of the declamation of racial ideologies in epistemological production. After all, the hierarchy of this racial ideology was part of the landscape of visual culture, framed, as Paul Gilroy notes, as a constitutive element of "racialised reason."[55] Yet variations in the figuration on maps produced in the 1880s and 1890s—even before the influx of immigrants from eastern and southern Europe that would redefine racial whiteness—telegraph a sustained tension in the boundaries of race set out by scientific racism, emergent ideas about ethnicity, and social definitions of the contours of racial formation evolving in the United States.

I began to understand the stakes of this pattern of excision and the instability it excavates when I examined a little-studied aspect of mapping—the scripted instruction for teaching geography in schools in the United States. Academic geography became part of a complex of journalism, educational textbook distribution, and the arena of visual culture that together shored up an idea of the Caucasus as conceptually divorced from its actual history. What allows us to see the shifts in racial adjudication is the connection between the methods of teaching geography and the instantiation of racial domination during Jim Crow rule.

Racial Scripts: Figuring and Geography in US Schools

Consider the larger suite of photographs by Johnston of the Hampton school, one of many series the photographer took for the segregated school systems. These images captured evidence of instructional scripts to instantiate racial domination. Johnston had already trained her camera on Washington, DC schools in 1899. She would later photograph the Carlisle Indian School for Native American instruction in 1901 as well as the Tuskegee Institute in 1902 and 1906.[56] Legend has it that she gained experience from George Eastman, who gave her one of his first cameras after he established the Eastman Kodak company in 1888. She trained with Thomas W. Smilie, the first official photographer and curator of photographs at the Smithsonian Institution, and became the official photographer for the World's Columbian Exposition in 1893. The Hampton Album garnered the grand prix at the 1900 Paris Exposition and is the work for which the photographer is best known.

Among the suite of Johnston's photographs from the Hampton Album is *Geography. Class in Current Events* (1899–1900), which visually narrates a near sequential presentation of what geography instruction aimed to do when read from right to left—to progress students from learning to individual assessment to embodied knowledge. In the photograph, a geography class for young men at Hampton is splayed out before the viewer as if a model of success, the didactic aim of geography pedagogy. A teacher appears with her head tilted downward as she reads from a book, perhaps an atlas or a geography teaching manual. At the center, students gather around her and stare at territories of the world set in relief through a sand model.[57] Two students huddle as if conferring while looking at a globe with the North and South American continents facing the viewer. Bookending them is a single man seated at a desk, pen in hand, reading a publication, presumably an atlas, opened fully (Figure 4.6).

Key for understanding the racialized nature of geography instruction at Hampton and elsewhere are the cursive, underlined words written in chalk

4.6. Frances Benjamin Johnston. *Geography. Class in Current Events*, 1899–1900, platinum print. The Museum of Modern Art, New York, Gift of Lincoln Kirstein, 859.1965.64.

on the blackboard above him: "Current Events" and "South Africa," with a line below listing regions and territories. The geography class takes place during the Boer War, at a time when Jim Crow segregation was beginning to inform the creation of the South African system of apartheid. Yet it antedates the fraught comparative analysis between South Africa and the United States drawn by Hendrik Verwoerd, the "architect of apartheid."[58]

Listing the specific country of South Africa on the classroom blackboard is striking given that US world atlases were overwhelmingly localized, far more than was the case for other countries. In the United States, the early teaching of geography, as developed via Jean-Jacques Rousseau, Emma Willard, and William Woodbridge, had a centrifugal method, first centered on the home, then the local landscape, and finally moving out toward the world.[59] The image tacitly demonstrates the intentionality of each lesson to instantiate the marriage of geography and racial hierarchies in a global context.[60]

Another photograph by Johnston, *At the Museum, Fourth Grade* (1900), shows how the lessons moved from geographical features to bodily assessment.[61] The picture, published in a book on geography instruction for a series she co-produced on educational practices in Washington, DC, shows students standing with their teacher, peering into an exhibit case housing a diorama of a Native man making crafts, sitting with his face cast downward. A visit to a natural history museum can make this encounter seem a commonplace scene today—cultures subjugated by settler colonialism and territorial violence are frequently presented for the presumptive museum-going public. Particularly striking here, however, is the intensity of the assessment telegraphed by the children and teacher, who crowd very close around the diorama, with some of the children's faces pressed against the glass (Figure 4.7). Was this mere childlike curiosity, or was it born of the kind of skeptical vision that Michael Leja argues defined sight at the turn of the twentieth century? Here Leja points to the density of displays at world's fairs and in the practices of photography that suggested a lack of ease in reading social identities with certainty.[62] But was skepticism central to the method of assessment taught through the study of geography to engage with the racialized world? Does this mode of observation suggest an entitlement to inspect, and a presumption of dominance? And how did the teachers navigate the fractured image of the foundation of white supremacy when teaching about the Caucasus, if at all?

What were the students being taught in the geography classes Johnston photographed? None other than Booker T. Washington recalled how Native

4.7. Frances Benjamin Johnston, *At the Museum, Fourth Grade*, 1900.
Photomechanical print (halftone).

students at Hampton would critique how geography classes characterized
them. When the unit turned to the five races of man, Washington recounted
hearing students murmuring to each other "Who is red man?" and "I am
not red."[63] At the end of the lesson, he recalled another Native student
repeating the word "savages," as if resigned, processing what Sylvia Wynter
would call his "narratively condemned status" at the hands of US textbooks
and curricula. This history contributes to what Mishuana Goeman has called
the urgent need of "(re)mapping" from a Native perspective.[64] These events
were not isolated.

 Washington's anecdote prompts the question: what else was said by stu-
dents about the racial narratives on the atlases? As maps became a prime
site for the development of racial assessment and judgment, the very or-
dering of the world through geographic education became a necessary
target of critique for many humanist projects.

 Teaching geography became a form of "figuring"—a nineteenth century
term for the tactical method for racial assessment and calculation about the

surrounding world that emerged in the antebellum period. Consider the language of abolitionist William Lloyd Garrison, who decried the marriage of calculations, mapping, and the forcible migration of black and indigenous populations in the early republic. "I know it is easy to make calculations. I know it is an old maxim that 'figures cannot lie,'" he wrote in his 1832 *Thoughts on African Colonization,* arguing that "I very well know, too, that our philanthropic arithmeticians are prodigiously fond of FIGURING . . . Give them a slate and pencil, and in fifteen minutes they will clear the continent of every black skin; and, if desired, throw in the Indians to boot."[65] Garrison here slides between figuring as an arithmetic calculation and figuring as a vision of violent social order. This figuring was part of the calculation of "removal," as Samantha Seeley has deftly considered in the context of Indigenous history.[66] Writing in the wake of the Indian Removal Act of 1830, Garrison's comments speak to the tight relationship between cartographic vision and ideologies of racial supremacy.

We hear echoes of this tactic of assessment through figuring, map study, and removal by Woodrow Wilson. While looking at maps as commander-in-chief with British prime minister David Lloyd George at the end of World War I, Wilson recalled his days studying geography as a boy and how "puzzling" it was to consider "all of the unknown country west of the Mississippi." "The contrast is very striking to my mind," Wilson said of that "boyhood" geography class in the 1860s and his work in "following out these maps" as he governed.[67] Wilson's use of the term "following out" indicates the epistemic, directional work of mapping, and offers an example of how the legacy of early teaching of US geography influenced global policy.

Figuring would marry the data-driven interest in racial demography, classification, and spatial regimes that emerged in the wake of increased attention to changes in the US racial order. What drove this acute interest in geographic literacy beginning in the antebellum period were three factors: territorial violence in the United States, changes in demography precipitated by immigration and migration in the wake of the end of slavery, and a focus on environmental determinism—the neo-Lamarckian belief that climate correlated with objective human characteristics.[68] The nation's most prominent geographer at the time, Daniel Coit Gilman, would stress this new importance of maps in an 1871 address at the American Geographic and Statistical Society. He argued that maps were increasingly crucial tools whose focus in composition and production had shifted from "boundaries, locations, or topography" to the "social environment."[69] Figuring was

central for this burgeoning practice of assessment in racialized, geographic literacy.

To teach geography was to contour lines of racial sight. It became an exercise in where to look, and how. Scripts and visual lessons from academic geography are key for understanding how a complex negotiation about racial hierarchies—a tessellation between narratives to determine racial identity—became commonplace, daily, and urgent. Geography teaching manuals had instructors use near-dramaturgical lines of prepared dialogue with students to standardize observations about race.

In these scripts found in geography teaching manuals, often startling in their stark transmission of the racial bias of the era, we see an emphasis on the full repertoire of visualization—from observation and imagination to recollection and scripted, performative display—in order to teach students to make evaluative statements about the world. As a popular elementary geography textbook emphasized: "there is scarcely an important lesson in geography" that does not "[call] for the splendid constructive power of imagination."[70] (The term "constructive imagination" is one Wilson used in his discussions about the vision necessary for the segregationist modern age.) However, what was framed as merely the quality of reverie, the imagination, was in fact a tactic for sustaining taught narratives about the racialized world. Critical for this were discourses centered around figuring and the idea of the Caucasus.

Consider the atlases used in the nation's schools produced by author, publisher, and inventor Levi W. Yaggy. In 1888, school superintendents, the US Department of the Interior, and the National Education Association, then led by Harvard president Charles Eliot, lauded the inclusion of Yaggy atlases in American schools as a pedagogical improvement.[71] The delivery of Yaggy atlases and maps were part of the collective effort to develop the instruction of geography, which was then a central component of secondary education and foundational for teaching literacy. In many states, to teach required competency in geography instruction.[72] In rural schools without a library, Yaggy's maps, including one showing the distribution of the five races of man on the globe, were seen as invaluable.[73] Though it may be impossible to say what atlas is open on the teacher's desk in the 1899 Johnston photograph, the Hampton curriculum reveals that its teachers were using textbooks including *Geography* by Alexis Everett Frye, along with textbooks by Ralph Tarr, Frank McMurry, and Henry Gannett, and crucially, maps by Yaggy.[74]

Teaching about the Caucasus and white racial superiority was couched as an exercise in selective observation in Yaggy's geography lesson plans. Immediately after instructing the students about the geology of the earth, for example, comes instruction about racial classification. This discussion centers on Yaggy's 1887 map *The Five Zones, Showing in a Graphic Manner the Climates, Peoples, Industries & Productions of the Earth* (Figure 4.8).

Teachers were directed to first discuss the Caucasian race, "the group just above the center of the map."[75] (There has been no discussion of the Caucasus as a geographic region thus far in the lesson.) Under the banner "Caucasian," spotlit in white (from the reserve of the printing process), five figures are placed at the center of the page, nearly at the center of the globe, striated according to the central torrid zone, the temperate climatic zones, and the two frigid zones.

Every race except Caucasian has been lifted off the planet, and nested, floating, at the corners of the page on Yaggy's map. The teacher is instructed to tell students: "They are the most handsome, active, wise and powerful people in the world. Their color is white, the shape of the head round or oval; hair soft and of various colors."

The script then states that the teacher should tell students, "The first race is the Caucasian. The Caucasian people are spread over a large part of the Earth." The students are not told where Caucasians are. Co-opting the logic of colonialist language, they are told what Caucasians are doing— spreading over the world with presumptive ease. Yaggy's large climatic chart—distributed through its Chicago-based school-supply company and hung in schools—telegraphed this spread. The regime of racial ideology is color coded. Light blue indicates the extent of Caucasian distribution in northern Africa, South Africa, eastern and southern parts of the United States, and the edges of the continents of South America and Australia (Figure 4.9).

The teacher is asked to conclude the lesson with a memorization exercise about Caucasians. "It will help to remember these different features if I write them on the blackboard," the instructor states. Memorization was a key feature of nineteenth-century pedagogy, as Ruth Elson has noted in her study of more than a thousand of the most popular textbooks of the period.[76] "In all but the most experimental schools of the time the child was generally required to memorize such characteristics as the rank of each race in the accepted racial hierarchy."[77] Yaggy's instructional manuals for teachers

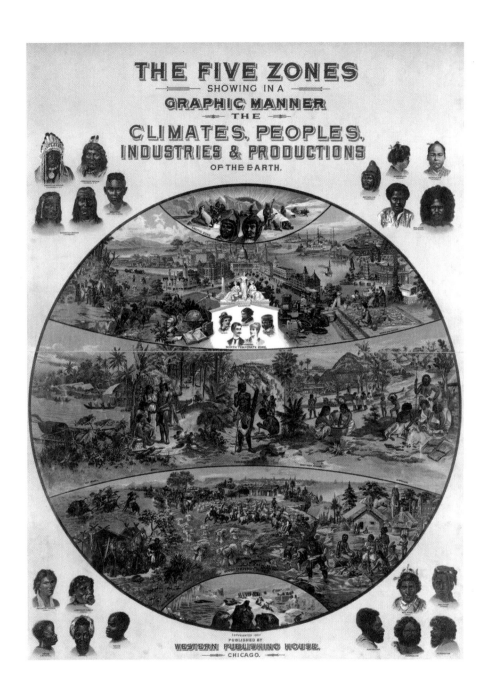

4.8. L. W. Yaggy, "The Five Zones Showing in a Graphic Manner the Climates, Peoples, Industries & Productions of the Earth," in *Yaggy's Geographical Study Comprising Physical, Political, Geological, and Astronomical Geography* (Chicago: Western, 1887).

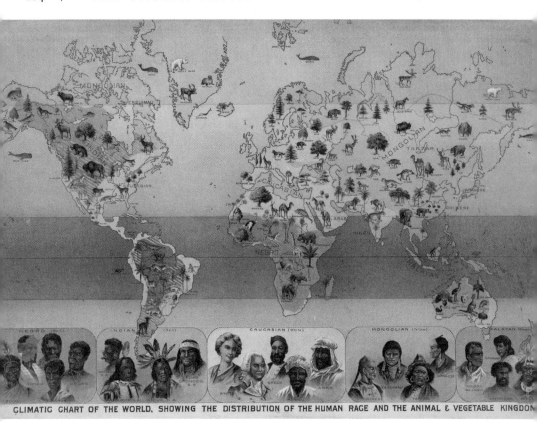

CLIMATIC CHART OF THE WORLD, SHOWING THE DISTRIBUTION OF THE HUMAN RACE AND THE ANIMAL & VEGETABLE KINGDOM

4.9. L. W. Yaggy, "Climatic Chart of the World. Showing the Distribution of the Human Race and the Animal & Vegetable Kingdoms," from *Yaggy's Geographical Portfolio* (Chicago: School Supply Co./C. F. Rassweiler & Co., 1893).

show that the narrative scripts—the discursive, evaluative method for geography lessons—naturalized racial, evaluative judgment.

The casual description of supremacy differs from the instruction that immediately follows about other races. In the exercises, students are introduced to geographies from Russia to Western Europe with the framing statement, "Caucasians live here," followed by lessons largely about continents with only a few countries differentiated, a pattern replicated in many maps from the period.[78] (There is a lesson on "Asia" and one on "Africa," for example.) For Native groups, teachers are instructed to say nothing about where they live now, save the genocide-dodging statement: "Before the white people came to this country, it was the Indian's home." There is no indication of where they are physically located. The teacher's omission of this history resettles the land. In the section on the "Negro," the teacher

states, "These people mostly live in Africa. There are, however, quite a number in our country."[79]

At this point, the instructions indicate to stop and ask: "How many of you have seen a Negro?"[80] In no other case is the teacher instructed to do this. In the construction of the question are normative claims about who has the right to look, and who should be rendered as a human subject. Here the embedded presumption is that the normative race of the American student—the observer—is white. By not using the word "met," but "seen," the question frames a "Negro" as an object of inspection, and forever "elsewhere (on the margin, the underside, outside the normal)."[81]

After the show of hands about who "has seen a Negro," the teacher does not immediately discuss their features, as the lesson plan called for in other cases. "They first came to this country as slaves," the teacher says before launching into a description of "the Negro," referring to the map. The manual instructs teachers to "make all exercises of this kind conversational, simple, and familiar," leading to the reading of figures in what Allan Sekula considered both an "analytic and synthetic" interpretative mode.[82] In these lessons, casual comments by students were codified as objective knowledge about social development, race, and society.[83] This very casualness of the script was part of how education "socialized" students to accept racial domination, as Wynter terms it, saluting educator Carter G. Woodson.[84]

In subsequent decades, none other than author, psychiatrist, and activist Frantz Fanon would centralize a near inverse of the question "How many of you have seen a Negro?" in *Black Skin, White Masks* (1951), his landmark critique of the structures of racial oppression, visuality, and domination under colonialism. In it, Fanon meditates on a time when a young white boy pointed to him on the train and said, "Look, a Negro!"[85] The boy stated it three times. Fanon had done nothing but sit there. "I made no secret of my amusement," he writes. But then the boy utters, "Mama, see the Negro! I'm frightened!" After he "throws himself into his mother's arms," he exclaims that Fanon, described with a racial epithet, is "going to eat me up." "Scared! Scared!" he wrote, reflecting on the event. "Now they were beginning to be scared of me. I wanted to kill myself laughing, but laughter had become out of the question."

The moment, Fanon notes, is a critical one of subject formation for both him and the white boy. It typifies how what Fanon calls the "white gaze" has the capacity to fix subjects, making them "overdetermined from the outside."[86] Scholars including Gavin Arnall, Homi Bhabha, Achille Mbembe,

and David Scott have framed developments catalyzed by globalization as a prompt to reconsider Fanon's seminal arguments.[87] Fanon's focus on the gaze, and his "'image' of colonialism" cannot be understood, however, without consideration of a prior moment when figuring registered a transformation of vision into assessment.[88]

The question in the Yaggy textbook, "How many of you have seen a Negro?" constructs the reproduced, collective gaze that Fanon seeks to dislodge. The teacher's prompt is a precursor to presumed agreement. The students are being invited not to recall a memory, but to create one.

The teacher's invitation is not to scan a figure, but *to figure*—to assess how a "Negro" was to be seen. The meaning of these maps was "processual" and "constantly reaffirmed."[89] The transformation of vision into assessment and the creation of racial hierarchies were correlative acts.

These were not rare atlases. They were pervasive. The vast adoption of Yaggy school atlases throughout the United States deserves emphasis here. Counties in Delaware, Illinois, Michigan, Minnesota, Mississippi, Nevada, New York, North Dakota, Pennsylvania, South Carolina, Utah, and Wisconsin, among many other states, all purchased these atlases for classroom instruction in the 1890s.[90] These acquisitions were supported and promoted as a curricular improvement by the federal government. Between the Spanish-American War and World War II, there was no federal governmental agency dedicated to producing atlases, so what it chose to supply to schools takes on heightened significance. These expenditures quantify the conditioning and reproduction of racial hierarchies in classrooms throughout the United States.

It is easy to stay fixated on how breathtakingly stark the shift is from pedagogy to propaganda in these geography lessons. This sort of indoctrination is benignly labeled. It is simply called an "exercise."[91]

As poet Terrance Hayes wrote, *"Never mistake what it looks like / for what it is."*[92] These maps only look like ordinary school displays. What they became were tools of ideological conditioning about the so-called order of the racial world.

Cartography scholarship makes the point that maps are subjective (the distortions of continent sizes through the commonly used Mercator projection are a good example); instructional geography pedagogy makes the more acute point that they were, indeed, part of the history of racial propaganda. I use the term propaganda deliberately as it would become used by leaders such as W. E. B. Du Bois to reference media—and he meant nearly

all media—that could both manipulate and convince a group that an ideology was the truth. The scripted instruction in schools of the increasingly requisite subject of geography betrays its intentional use to support the ideology of racial domination under the guise of conveying information about the world. As Trouillot reminds us, many "first history lessons" come "through media that have not been subjected to the standards set by peer review, university presses, or doctoral committees."[93] Yet these maps came with the very authority of such reviews, supported by the federal government as they were, and, as we will see, mounted as public displays at institutions such as Harvard University.

The ideology of racial supremacy that was being taught in many US geography textbooks is indisputable when one considers the compositional figurative regimes that developed and consolidated ideas about white supremacy, studied by Donald Yacovone.[94] These messages were part of what David Roediger calls, via the language of Du Bois, "the wages of whiteness."[95] As Elson notes, racial ideology was "latent in all the schoolbooks, in stories, descriptions, even arithmetic problems, and most important of all in the Geographies."[96] These texts also became part of what Alexander G. Weheliye notes was the "continual visual reinforcement" required to continue the project of racialization.[97] In spatial design, compositional emphasis, and textual narratives, maps not only modeled the reifying racist hierarchy of savagery—consider how the African diaspora and civilization were defined by "rational, liberal, and moral Europeans (and their Northern American descendants)"—but also would cement it as a natural feature of the social terrain.[98]

What geography instructional texts in the nineteenth century objectively show is a blunt, consistent engagement year after year with ideologies of white superiority, so much so that one wonders how it was even possible to teach some geography textbooks in segregated schools for black and Native students.[99] For example, the text of a popular 1901 geography teacher's manual by Tarr and McMurry states in the section on the "Distribution of Races" that

> the leaders are the whites who, having learned the use of ships in exploring distant lands, have spread with a rapidity never seen before. Also, being more advanced than the others, the white races have readily conquered the weaker people and taken their lands from them. They now dominate the world (see Fig. 60), the only division that has held

out against them being the Mongolians, whose very numbers have in large measure served to protect them.[100]

This statement is repeated from 1901 through the 1917 version of the textbook, with only slight modification: it becomes emphasized with italics, and placed farther back within the textbook. The main shift was changing the line from "now dominate the world" to "*rule almost* the whole world."[101] It is a fixation on even a slightly diminished ability to claim racial power. That it is registered in these textbooks over the years indicates the precarity about the stability of assembly based on white racial dominance.

The review section concludes with a series of questions about racial types intended to reinforce the school lesson. The final question makes the main point of the exercise clear: "To what extent are the Caucasians leaders among the races? Give reasons."[102]

However sophisticated our contemporary discussions about the history of cartography, however well understood they have become as a social formation, however clear it is to us now that the standard Mercator projection of the world is structured around a Euro-American centric view that distorts proportions, one thing is clear: these maps were promoted and used as *objective* tools. In the classroom, in society, and in scholarship, they were disseminated as essential information for the public. As Wynter put it in her analysis of US textbook history, the effect was "that of inducing the White students to believe that their ancestors had done everything worth doing in . . . the past, and at the same time, to induce the Black students to believe that their ancestors had done nothing worth doing."[103]

It would have been common, as Jarvis R. Givens notes in his landmark study of black pedagogy, for the high-school social studies textbook formally adopted by the state of Louisiana by the 1930s, Henry Elson's *Modern Times and the Living Past,* to open with the following frame: "Almost the entire book will be devoted to the doings of the Caucasian race," or more specifically, "at least nine tenths of the book must be given to an account of the Indo-European branch of the race, as the Indo-Europeans have dominated the world for the past 2500 years."[104] (Not only are the peoples of the Caucasus not white, but a vast majority of the languages of the Caucasus are not Indo-European.[105]) The variation, transformation, and compositional decisions of these maps and geography teaching manuals in the nineteenth and turn of the twentieth century, under the guise of teaching skills of "description" and observation, shaped cultural attitudes and racial beliefs about the world.

Teaching Negative Assembly

These maps are not surprising in their blunt figurative recapitulations of racial hierarchies, but in how they expose attempts to mask and overcome doubt. They instructed readers on where *not* to look. Atlases and geography textbooks circulating in the United States were filled with narratives of disavowal about the relevance of the Caucasus region as a geography for racial formation.

For example, in the Ralph Tarr and Frank McMurry textbook *Geographies, Third Book: Europe and Other Continents with Review of North America* (1901), one of the earliest to incorporate human geography, students were taught, "By far the largest and most civilized of the four divisions of mankind is the *white* or *Caucasian race*," yet the text also included an offkey refrain, "Their original home is not known. Some believe it to have been in the plateau of central Asia, others in the northern part of Africa."[106]

This line about not knowing the "original home" of the Caucasian race warrants scrutiny because it was repeated in these textbooks and home atlases for over seventeen years.[107] For some, the foundational idea of the Caucasus at a time of white supremacist rule and ideology became what Toni Morrison might have called "a kind of Procrustean bed, an intellectual trap, because it's such an attractive portrait that it encourages what ought to be eliminated."[108]

At the turn of the twentieth century, US geography textbooks muted details about the Caucasus that would undermine the foundations of racial domination. Consider the *Universal Cyclopaedia and Atlas* from 1902 that negotiated this fraught narrative in the backmatter. There it states that the word "Caucasian" was "an epithet somewhat loosely applied to the principle white races of mankind," explaining that "Circassians and Georgians dwelling at the foot of Mt. Caucasus have been taken as the type of the Caucasian race and suggested the name . . . But the inhabitants of the Caucasus, so long held to be types of the European variety, are now by some excluded from it altogether, and classed with the Mongols."[109] These experiments in US mapmaking record the public attempts to sort out the dual tracks of thought about this region, as both an imagined regionally specific territory and a ruptured symbol of racial hierarchy.

By the 1920s there would be a near complete disavowal of the significance of the Caucasus region on US maps. "As shown on the map, the Caucasus region is a veritable linguistic Babel," stated the *Teacher's Manual for the Webster-Knowlton-Hazen European History Maps* from 1923. The text

continued: "The Caucasus has been spoken of as an island in the sea of history. As a consequence of numberless raids and invasions of the plains below, it became a place of refuge, and its high, isolated valleys contain the residue of a great number of peoples."[110] After *United States v. Bhagat Singh Thind* (1923), in which the United States sued to reverse a 1920 decision in the district court for Oregon that effectively conferred whiteness on an Indian man, the Supreme Court would disregard the history of racial science as it related to the Caucasus that had allowed it. "Many of the people of Asia are Caucasians," stated a popular geography teachers' manual for Jacques W. Redway's *The New Basis of Geography* (1907), mirroring the process of being worked out in court cases that permeated atlases.[111]

So thoroughgoing was this disavowal that when the Caucasus region appeared in specialized geographical knowledge exams in US schools, the outcry made the news. Geography became a college entrance requirement at Harvard University in 1893 and part of secondary-school entrance exams in the early twentieth century. During this period, as a larger proportion of the population began attending secondary school, and as eugenics developed, school exams, made popular by Carl Campbell Brigham, became increasingly important.[112] In 1912, for example, parents criticized such grammar-school exam questions as "Where is the country called Caucasus?" and "When was the public school system started in the United States?" for being too difficult. Other questions, such as, "If the Caucasus mountains should be removed from the face of the earth, what effect would it have on the Caspian Sea?" were considered "too advanced and ludicrous."[113] The comment and public outcry registers discomfort. It begs the question, what was "ludicrous" about a test for schoolchildren focused on the Caucasus geography that had inaugurated the very idea of white racial supremacy? What cultural shift in vision had allowed for such ease in unseeing this heterogeneous region?

Objects have their mobility written out of their histories; so, too, do foundational terms such as Caucasian. Narratives on these maps and atlases changed in their figurative description of Caucasians—as in actual Caucasians, from the region—they lifted specifics about them off the maps altogether. Maps, as an arcade of malleable forms, show how the use of the term Caucasian was predicated on details being removed from analysis. In the context of mobility, Jennifer Roberts has made the case that studies of art and visual culture, following Pierre Bourdieu's urging, should attend to the legibility of transmission registered on the physicality and composition of

objects.[114] In much the same way, mapping the Caucasus—with shifting figurative icons, with narratives of revision and disavowal—exposes the traveling life of a component of racial ideology.[115] The very composition and contents of these historic US atlases detail the labor required to move the Caucasus from remaining an idea ungrounded in racial science to an established public discourse.

A series of paintings titled *Black Sea Composite,* by artist and historian Nell Painter—who joins artists such as Radcliffe Bailey, Frank Bowling, Mark Bradford, Yinka Shonibare, and Faith Ringgold in taking up aspects of mapping in dialogue with the field of critical cartography—urges a unique reconsideration of the mobile foundations of racial difference and the shift in vision it required.[116] Each painting by Painter shows a map centered on the Black Sea region, this critical, unseen part of the racial imagination in the United States. The region was also part of the boundaries of what Halford Mackinder called the "Heartland Theory." In a presentation to the Royal Geographical Society in 1904, he argued that control of Russia, Eastern Europe, and Central Asia would mean control of the "pivot" point of global politics.[117] Painter's insistent and metronomic return to the Black Sea region in her paintings stand in for the unarticulated narrative revision to this geo-conceptual site.

Painter's *Black Sea* series focuses our gaze on the Caucasus region as a conceptual map, making this little-known history plain (Figure 4.10). In one painting, she places at the center of the Black Sea Jamaica, nestled between Crimea and Puerto Rico, which abuts a relocated New Orleans and Dominican Republic, to show us the re-networked associations that complicated the region's image. Painter has obliterated the names of the towns and tributaries with narratives about the region as if to declare that our perceptions of it determined our historical access to the geography. It is a work that recalls how the mental picture had been composed and challenged until there was little intelligible connection between the term "Caucasian" and the idea of whiteness. To change Americans' views in this way required that this geographic region, once a well-known part of American culture, be effectively erased from the public imagination as a cultural feature that had shaped racial life.

Painter's *Black Sea Composite 7* (2012) signals the confusion, erasure, and caprice about the region—confusion over the Caucasus region's geographic details, erasure from some of the most standard histories, and caprice about how to depict its ties to racial life after it came to represent an exploded myth (Figure 4.11). Painter symbolically erases the Caucasus in the series by first meticulously marking the drawing with an eraser, lifting

4.10. Nell Painter, *Black Sea Composite Map 5 Circassians Frequently Sell*, from the series *Odalisque Atlas*, 2012.

4.11. Nell Painter, *Black Sea Composite 7*, from the series *Odalisque Atlas*, 2012.

graphite off the yupo paper, a polypropylene material, and then laying down a whitewash of milky acrylic over the graphite. The marks double as directional lines: journeys made, forgotten, honored, and disavowed. The words "Jamaica" and "Puerto Rico," for example, are barely perceptible in the middle of the Black Sea. What remains visible are traces of a confused geography, perceived through a series of translucent brushstrokes over a faintly legible ground. The cotton-candy colors, devoid of narrative, suggest not only an irreverence for the associations of place and nationality in the Caucasus in the dominant American imagination, but a sense of whimsy.

Each painting dramatizes how human hands have contoured the mental image of this region in the United States. Within the literal white paint washes are near-cursive black lines representing boundaries and tributaries that doubled as handwritten marks. However disconnected and ultimately incoherent the Caucasus demography became, it was a palimpsest of various states of racial formation. It became a tabula rasa, a blank screen for projections. No matter how many other terms arose, such as Anglo-Saxon, this region remained a keystone, a settlement site, a foundation for racial formation.

The claim of a collective "amnesia" regarding the fact that "today's Caucasians had ever been anything other than a single, biologically unified, and consanguine racial group," as Matthew Frye Jacobson has argued, must be reconsidered in light of this evidence.[118] This amnesia—in fact, a conditioned unseeing—is a crucial part of Jacobson's important three-part analysis of the long history of racial whiteness between 1790 and 1965 in the United States. The fulcrum of the argument is the transformation between the 1840s and the 1920s from a period of "variegated whiteness" to a period in which the idea of a "Caucasian" race became an umbrella category for many ethnic groups previously excluded from this definition, after waves of European immigration.[119] A collective will to unsee this earlier history of fracture around the idea of the Caucasus allowed it to remain a category with a normative claim to racial superiority in the social sphere.

This amnesia was not a "forgetting" about the false ground of white racial supremacy. It was a consistent conditioning to not look. The visual regime instantiated by racial formation was not only shored up by what Nicholas Mirzoeff calls "the right to look," citing the governance of racial surveillance that emerged during slavery, but the right to *refuse* to look at the fractured ground on which the foundations of racial hierarchy rest.[120]

This refusal is what defined the form of racial understanding that Sylvia Wynter argues shaped our "inner eyes" in the wake of representational regimes perpetuated on maps and in textbooks.[121] It extends to what Toni Morrison argues is an ambient practice of deliberately unseeing others. This is to say nothing of the violence stemming from perceptions shaped by hardened stereotypes that run throughout the history of racial formation in the United States.[122]

There are rare moments when we have been jolted enough collectively to see just how well conditioned this figuring and disavowal of the Caucasus region—a negative assembly—was for the burgeoning form of racial adjudication. It is why, for example, during the manhunt after the 2013 Boston Marathon bombing, the description of brothers Dzhokhar and Tamerlan Tsarnaev as "dark Caucasians"—they were from the Caucasus—was largely unintelligible to the American public. Entire articles were penned about whether this meant that the public would see them as white. "Are the Tsarnaev Brothers White?" ran the *Salon* headline. "Is the Defendant White or Not?" was the headline in the *New York Times*.[123] By the twentieth century, the mental picture had been created, shored up by racial science, and then challenged to such an extent that there was little intelligible connection between the term "Caucasian" and the Caucasus region at all. This "amnesia" about the fractured foundations of the idea of the Caucasus was not an aberration but a critical feature of the maintenance of racial ideologies.

George Lipsitz has described whiteness as the "unmarked category against which difference is constructed," such that "whiteness never has to speak its name, never has to acknowledge its rule as an organizing principle in social and cultural relations."[124] This idea was, we now know, a mirage.[125] Maps and geography lessons diagram the throughgoing ways in which racial whiteness was explicitly referenced as the reigning organizing principle for global economic, political, and social development. Before it could become "unmarked," it needed to be intentionally excised and disavowed. Negative assembly was a pervasive, enduring way to stabilize racial hierarchy even as the foundations began to erode. It made the Caucasus in the racial imaginary a malleable framework for the maintenance of racial order.

What has been framed as a "forgetting" of the foundational instability of racial construction was, in fact, part of a history of visual conditioning. This work—the "disciplining" of the American eye, as Matthew Pratt Guterl has argued—was not informed solely by the rampant dissemination of stereotypes in newspapers and by trenchant racist caricatures.[126] Instead,

as a sequential study of maps of the Caucasus region makes clear, it also involved unseeing—eliminating through studied disregard what destabilized racial assessment in public life.

"Fugitive Pedagogy"

The pattern of negative assembly underscores why mapping, particularly in black liberation practices, has been an urgent, vital tactic of narrative correction. It is not incidental, for example, that Carter G. Woodson, known as the founder of both the Association for the Study of Negro Life and History (ASNLH) and Black History Month (through the launch of Negro History Week) began his riposte, *The Mis-Education of the Negro* (1933), with a statement about the study of geography. This groundbreaking critique of formal and social education starts with a reflection on both the history of racial domination and cartographic practices.[127]

Geography teaching manuals, read through the lens of the representations of the Caucasus, underscore the need for insurgent resistance, or what Jarvis R. Givens, inspired by Woodson's work, has aptly termed "fugitive pedagogy"—a structured set of covert tactics, approaches, and strategies by black educators to resist the conditioning of oppressive racial regimes. The underexplored marriage of racial formation and geography instruction offers a practical sense of what Givens means by fugitive pedagogy as "a schooling project set against *the entire order of things*," a "plot against the current configuration of the modern world" conditioned by "*the arrangement of the human species.*"[128] This resistance is rooted in the disruptive modalities of flight and fugitivity to seek out black American pedagogical interventions.[129] It was a necessity. The criminalization of black literacy, beginning with the Slave Codes of 1740, ultimately included both free and enslaved black people by 1800 in South Carolina, for example. These practices extended to the criminalization of "black learning" and education that integrated a history of the black experience.[130]

As part of a widespread movement to combat "antiblack curricular violence," textbooks by black teachers such as Edward Johnson's 1890 *A School History of the Negro Race in America, from 1619 to 1890* and Leila Amos Pendleton's *A Narrative of the Negro* would target and correct narratives in geography textbooks about people of African descent.[131] These efforts included black-educator-led workshops, formalized in 1915 in the months leading up to Woodson's founding of ASNLH, designed to correct the

distortions within disciplines. The teaching of geography, as late as the 1960s, was on the agenda.[132]

The focus on racial adjudication and geography also helps us understand why W. E. B. Du Bois included the form of maps in his contribution to the American Negro Exhibit at the 1900 Exposition Universelle in Paris, which earned him the gold medal "for his role as 'collaborator' and 'compiler' of materials for the exhibit."[133] Building off his empirically driven social survey analysis in *The Philadelphia Negro* (1899), Du Bois worked with a team of Atlanta University students to craft an installation of photographs, maps, books, and data visualizations.[134] Through the method of a case study, the installation functioned as a counternarrative for the presentation of the over-looked economic, social, and educational achievements of black life and progress on the world stage. His contribution to the American Negro Exhibit, *The Georgia Negro: A Social Study*, began with a progressive disclosure, sequentially revealing information to the audience.[135] It opened with a map.

The stakes and scope of the project drove the enthusiasm of the dedicated team; Du Bois worked himself to the point of "nervous prostration."[136] For the first time, the Paris Exposition, which attracted 50 million people, would include a show about black life in the main exhibition hall. Planned in collaboration with Thomas J. Calloway, the 1895 commissioner of the Atlanta Exposition, and Daniel Murray, librarian at the Library of Congress, the American Negro Exhibit had ten objectives distilled down to, as Du Bois put it, "an honest straightforward exhibit of a small nation of people, picturing their life and development without apology or gloss, and above all made by themselves."[137] Booker T. Washington personally wrote to President William McKinley for funding, resulting in an allocation of $15,000. Du Bois would examine everything from the value of household and kitchen furniture to the progress in black living since the abolition of slavery just one generation earlier.

Du Bois prepared for the Paris Exposition with a clear tenet: scholarship produced as a "calm, cool, and detached scientist" alone would not do for a country where the consequences of white supremacy were perilous.[138] One of the definitive experiences of his life and career had occurred that year on April 24 when he heard about the dismembered body of Sam Hose, who had been lynched in Coweta County, Georgia. When Du Bois learned that Hose's severed knuckles and toes were on display at a meat market on Mitchell Street in Atlanta—a warning that radiated like sonar the might of white supremacist rule—he was on his way to the Atlanta *Constitution* with

a letter of introduction to editor Joel Chandler Harris.[139] He turned around and went back to Atlanta University. The experience, Du Bois wrote, had "broken in upon my world and eventually disrupted it." At a time when "Negroes were lynched, murdered and starved," a focus on data alone would not suffice. It was not, Du Bois realized, "axiomatic that the world wanted to learn the truth."[140]

One month after this event, on May 24, Du Bois's son, Burghardt, died at two years old from diphtheria, a condition that could likely have been treated if they had been on the other side of the Mason-Dixon line. Du Bois and his wife, Nina, would not bury their son in Georgia. They traveled back to Great Barrington, Massachusetts.

Du Bois's work took on new urgency. He began a sustained engagement with organizing and activism while remaining committed to the work of social science. His twin aims created a double-barreled, forceful approach to tackling propaganda, which came in the form of something as seemingly innocuous as the formal composition of a map.

A global map on a twenty-two by twenty-eight-inch plate opens *The Georgia Negro: A Social Study* (Figure 4.12). The map centralizes the "routes of the African slave trade" in a gradient of shades from black to yellow. Black lines connect the coast of West Africa to ports in Portugal, Brazil, Santo Domingo, and, noted with two vectors, the US South. Structuring a Mercator map with the "Negro" as protagonist rebuked the established conventions of cartography.

Du Bois's project was a discursive counterstatement. It insisted on the presence and future of black life, situating black achievement as commensurate with that of any other "nation of people." The concluding statement, written in block letters at the bottom of the page, "The problem of the 20th century is the problem of the color-line," presaged the centrality of this project to Du Bois's seminal work, *The Souls of Black Folk*, published three years later.[141]

Just as students were learning about white dominance around the globe in triumphant fashion, with white supremacy presented as the natural order of the social world through Yaggy's geography maps and textbooks, Du Bois opened *The Georgia Negro* with a cartographic design that made explicit dynamics of power that the regime of racial hierarchies had omitted. His charts centered black progress. Using the rhetoric of mapping as the epigraph to the study offered Du Bois a key register through which to situate black life as a "relational" condition born of the global power dynamics of settler colonialism, imperialism, and the "afterlife of slavery."[142]

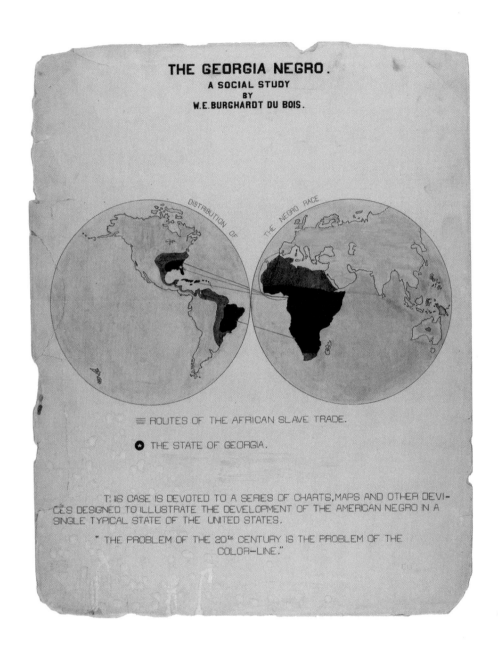

4.12. W. E. B. Du Bois, *The Georgia Negro. A Social Study by W. E. Burghardt Du Bois,* 1900, drawing (ink and watercolor), 28 × 22 in.

He identified the social forces of racial dominance that thwarted it as well, citing incidences of "lynching" and "Ku-Kluxism," and even displaying three volumes of Georgia's Black Codes.[143] Du Bois's installation included the effects of white supremacist rule as a form of rebuke of the ideology telegraphed in the cartographic discourse in the United States.

The problem was not just stereotype; it was excision. It is worth pausing here to note that just years before, in 1894, Frederick Douglass commented on the deleterious effects of keeping black Americans off the world stage at major exhibitions such as the World's Columbian Exposition. In his speech "Lessons of the Hour," delivered a year before his death, Douglass critiqued the World's Fair's elimination of the "American Negro" in the "assembled" display:

> Here were Japanese, Sudanese, Chinese, Cingalese, Syrians, Persians, Tunisians, Algerians, Egyptians, East Indians, Laplanders, Esquimaux, and as if to shame the educated negro of America, the Dahomeyans were there to exhibit their barbarism, and increase American contempt for the negro intellect. All classes and conditions were there save the educated negro.

This is a "silence," he argued, "that speaks louder than words." Negative assembly, Douglass maintained, was on the world stage:

> It says to the world that colored people of America are deemed by America not within the compass for American law and American civilization. It says to the lynchers and mobocrats of the South, go on in your hellish work of negro persecution. What you do to their bodies, we do to their souls.

Du Bois would now make black Americans central through visual strategy.[144]

With the 1900 Paris Exposition, Du Bois's intervention in geography and mapping as a tool of social science signaled his study of a shift in the tactics of racial assessment. How do we understand the "cartographic, geographic, and historical implications of Du Bois's 'color line' used first in the Georgia Study"? Mabel O. Wilson asks.[145] Cartography as an arena of contestation shaped Du Bois's political and educational life.[146]

Du Bois would have been familiar with the teaching of geography from his experience as a schoolteacher in rural Tennessee, where proficiency in the subject was a requirement of all licensed instructors. (In 1887, he had

scored seventh highest on the Nashville teacher examination.)[147] Tennessee state superintendent records from the period show districts buying maps in large quantities. In 1891, for example, the cost of new globes and maps in the state's schools was about the same as that spent on erecting new school-houses that year.[148]

The use of maps in the US Census was also well known to Du Bois, who had, after all, been commissioned by the census to analyze its data—data he drew on for the Paris Exposition installation.[149] A range of factors—the rapid expansion of the railways during the Industrial Revolution, eth-noracial concerns that created demand for US boundary surveys, and the imperialism of the Spanish-American War—increased demand for the explanatory power of mapping, to which the US Census responded by making greater use of maps as tools of racial analysis and demography. Finally, Du Bois's landmark sociological portrait, *The Philadelphia Negro,* relied on his own use of maps to study the demography of the city's seventh ward, which was densely settled by African Americans.[150]

The composition and installation of global, county, and state maps com-piled by Du Bois and his Atlanta University student collaborators were important not just because they represented an infographic innovation. Scholars including Aldon Morris and Alexander G. Weheliye have offered deft analyses of how Du Bois's 1900 exhibition launched a critique of the dominant methods of deploying social science statistics just as Frederick Hoffman's widely influential book, *Race Traits and Tendencies of the Amer-ican Negro* (1896), predicted the gradual decline and elimination of African Americans.[151] Hoffman worked as a statistician for the Prudential Insurance Company, which also exhibited at the 1900 Paris Exposition and would later give the charts to Harvard as instructional tools.[152] What has been left out of the discourse on Du Bois's maps is that the visual idioms he employed as a sociologist went beyond a focus on data, accounting, and enumeration to include engagement with the highly *visual* repertoire of maps.[153]

Consider that within years of Du Bois's award-winning exhibition, col-lections and pedagogy at Harvard University would frame Henry Gannett's 1900 US Census map through the rhetoric of racial domination. By 1903, a map showing the distribution of the black population in the United States, now in the collection of the Harvard Art Museums, was mounted on gray matboard with the header printed in black letters, *Extent of the Negro Problem: Social Conditions, United States Census of 1900, Composition and Dis-tribution of Population* (Figure 4.13). The title could be a citation of Booker T. Washington's anthology, *The Negro Problem,* published that year, which

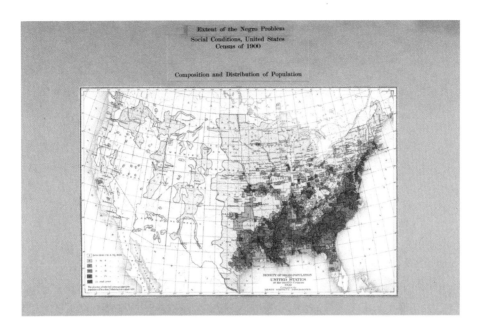

4.13. *Extent of the Negro Problem. Social Conditions, United States Census of 1900. Composition and Distribution of Population.*

included an essay by Du Bois. Yet the insistence on a new title for the map—one carefully cut and pasted on, despite the presence of one already printed directly in the cartouche by the US Census Office—conveys their use for explicit training in how to see in a society fashioned by racial hierarchies. The term "Negro Problem" was "a crafty invention," as Frederick Douglass noted years earlier in his 1894 speech, just before his death, because it not only "puts upon a race a work which belongs to the nation," but serves to "awaken and increase a deep-seated prejudice at once." It was an extension of the "old trick of misnaming things."[154]

The map with this new title, *Extent of the Negro Problem,* was used by Francis Greenwood Peabody for widespread instruction at Harvard on social reform movements.[155] Peabody, the Plummer Professor of Christian Morals from 1886 to 1913 and brother-in-law of Charles Eliot, president of Harvard University for forty years, acquired the map as part of a collection of objects by expending a great deal of financial and political capital.[156] The collection—totaling nearly 10,000 objects, over 4,500 photographs, and 1,500 illustrations, charts, and graphs—became a cornerstone of his teaching in the Department of Social Ethics, which was later absorbed into the new Department of Sociology.[157] Peabody's secularization of the curriculum by

abolishing compulsory prayer was replaced by an Eliot-backed focus on the social gospel—developing moral leadership in students through an explicit focus on social reform.[158] One of the meticulously classified reform efforts focused on "races."[159]

Du Bois took Peabody's class during his senior year.[160] At the height of the popularity of Peabody's courses, one out of four Harvard students would take his Social Ethics course.[161] David Levering Lewis emphasized that Peabody's influential teaching definitively shaped the social landscape at Harvard during Du Bois's undergraduate years.[162] In his course, students were "prodded to consider what the social classes owed each other and what the causes and social implications of extreme wealth were."[163] There were critiques of Peabody's pedagogy. Some colleagues and students argued that what was framed as inductive logic was, in fact, presumptive; students examined facts only to reaffirm prior held beliefs. A student of Peabody's summarized the criticism in the margins of his lecture notes: the approach led to "generalizations" that "depend on uncriticized and specious assumptions. His method is dogmatic deduction."[164] Despite these critiques of Social Museum collection teaching, a generation of students at Harvard and other universities had their intellectual formation shaped by Peabody's framing of objects like these maps.[165]

The *Extent of the Negro Problem* map was one of the objects in the Social Museum used for instruction at Harvard from 1907 until the early 1930s. The museum, housed initially on the second floor of Emerson Hall at the heart of Harvard's central campus, next to the Department of Philosophy, had as its mission to "collect the social experience of the world as material for university teaching."[166] Peabody designed the mounting procedure for the displays—titles on gray paper that matched the gray matboard, trimmed to a standard size—in order to present subjectively framed objects as standardized facts for students and the public (Figure 4.14).[167] Since Peabody's courses in Social Ethics used no standard textbook, the narrative headers he gave to the objects used in his instruction, borrowed by other instructors as well, acquired greater importance.[168]

The collection underscores the role of visuality and mapping for ideological persuasion, reflecting a dynamism in scientific methods for addressing social reform. "Not the ear, but the eye is the primary organ for scientific knowledge . . . To interpret nature, one must first of all see, touch, scrutinize, and analyze," Peabody wrote.[169] His statement indicates a consciousness of the shift in sight from observation to conditioned assessment during the period. A trustee of Hampton Institute for forty-six years,

4.14. Photographs in swing frames in Social Ethics Museum, Emerson Hall, Harvard University, ca. 1910.

Peabody acquired for the Social Museum largely visual material, including eighty-eight platinum prints by Frances Benjamin Johnston; work by Jessie Tarbox Beals and Lewis Hine, gifted by the Russell Sage Foundation; and charts from the Prudential Company.[170] This publicly accessible pedagogical collection was the first instructional museum of its kind in the United States.

The significance of the *Extent of the Negro Problem* map situates Du Bois's engagement with cartography as both an intervention in social science methods and a prescient riposte of the visual modes of instruction that would come to take root at Harvard. His project speaks to his investment in new qualitative methods not only as a sociologist and historian, as incisively reframed by Morris, but also as an educator invested in developing deliberately aesthetic and visual practices to counter the racial bias rooted in disciplinary formation. It also discloses the signal importance of the sphere of aesthetics and culture for social science methods, which made the 1900 Paris Exposition an especially effective location for such a rebuke. In fact, social economy pavilions, such as the Louisiana Purchase Exposition in St. Louis in 1904, were precisely where Peabody obtained his objects.

Exhibition displays developed for pavilions were part of the arena of public entertainment, as well as part of a new, authoritative set of teaching materials.[171]

By centering black subjects to highlight progress and achievement, Du Bois's 1900 *Georgia Negro* Exhibit was a cartographic refutation of geography's instructional pedagogy and the social discourse of figuring. The *Georgia Negro* map—produced the same year that Yaggy's maps were being formally adopted in US school curricula—contained no cartouches indicating the "races of man," as there were circulating in atlases. Absent is any feature centralizing whiteness. Instead, these maps were arranged next to photographs of black residents of Georgia by Thomas Askew and other black imagemakers from the American South.[172] The display of images not only offered a detailed presentation of the tone, texture, status, and image of black life left out of narratives by contorting racial stereotypes. This attention to black life on maps was also a spatial, social, and symbolic departure from the increasingly politicized use of mapping at large.

So much has been aptly made of these photographs by scholars, including Deborah Willis and Shawn Michelle Smith, that it is now easy to overlook their compositional singularity within the installation—they were placed directly next to maps, ones devoid of caricatured, figurative forms that supported ideals of racial domination (Figure 4.15).[173] To "see" black individuals, the exhibition seemed to say, one would have to view individuals as they actually are. In subsequent decades people would come to debate whether photographs could be viewed as transparent glimpses of social life. At the time, however, they functioned as invaluable data for counternarratives of refutation to assert an image of dignity, self-possession, advancement, and progress.[174]

Du Bois would later develop ideas about the importance of aesthetics for challenging racist propaganda being pumped into the media landscape through white supremacist rule. He published these ideas in his seminal essay "Criteria of Negro Art," which first appeared in *The Crisis* in 1926. (It was originally delivered as a speech for the Spingarn Medal Ceremony, honoring none other than Carter G. Woodson.) Du Bois seemed to argue against Alain Locke, the "dean" of the Harlem Renaissance, claiming instead that art for art's sake was not enough given the stakes of racial contestation in the United States.[175] Locke had done nothing short of transform the idea of the New Negro into a movement in the arts. Yet Du Bois's sense of the urgent imperative to counter myths of inferiority, racial caricatures, and the political realities of racial oppression and domination that had

4.15. Installation photograph of the Exhibit of the American Negro, Exposition Universelle, Paris, 1900.

hardened into perceived facts about black life led him to want more than artistic flowering alone.

Du Bois would argue that "all art is propaganda and ever must be."[176] He offered little room for equivocation when he explained, "I stand in utter shamelessness and say that whatever art I have for writing has been used always for propaganda for gaining the right of black folk to love and enjoy. I do not care a damn for any art that is not used for propaganda itself. But I do care when propaganda is confined to one side while the other is stripped and silent."[177] Du Bois took a nuanced view of propaganda. As Paul C. Taylor argues, propaganda for Du Bois, when framed as expressivist and contextual, was inseparable from the quest for truth.[178]

The use of maps in the American Negro Exhibit indicates Du Bois's thorough understanding of the repertoire of visual culture that marginalized black subjects for his data-driven analysis and his focus on racial propaganda. Philosopher Robert Gooding-Williams considers Du Bois's specific argument about "artistic propaganda" to be central to his work to "combat white supremacy and help to dismantle racial hierarchy." Gooding-Williams focuses on how Du Bois crafted a story about the "moral vice" of white supremacy by pointing to his choice of Albrecht Dürer's painting of the epiphany, *The Adoration of Kings* (1504), for the cover of *The Crisis* magazine issue containing Du Bois's short story "Jesus Christ in Georgia," which condemned the practice of lynching.[179] He argues that Du Bois did more than utilize Dürer's image as a figurative allusion connecting lynching to martyrdom. He crafted as the title page an engraving of the head of Jesus on the cross, looking down with sorrow on the photograph of a lynched man, to make the condemnation of lynching on moral grounds explicit.[180]

The trenchant analysis by Gooding-Williams of the juxtaposition of lynching and Dürer's crucifixion image is a reminder that Du Bois's act of centering black subjects as early as the 1900 *Georgia Negro* Exhibition was part of his rigorous study and knowledge of established conventions, canonical artworks, and pictorial codes of figurative power. Here I join Autumn Womack's incisive argument that racial data projects at the turn of the twentieth century were "undisciplined" in ways that cojoined "aesthetic innovation to social-scientific discourse," as we have seen from Barnum's performances to Eisenmann's photographs to maps of the so-called natural world.[181] This approach, cojoining the work of aesthetics as a form of data, occurred with more regularity, significance, and urgency in the early twentieth century than we have understood. The composition of maps in the *Georgia Negro* Exhibit indicates a foundational moment when Du Bois

marshaled his knowledge of aesthetics as a political weapon to intervene in even the mapping conventions that had stripped and silenced truthful accounts of the possibilities of black life.[182]

When Du Bois said, "I am given to understand that whiteness is the ownership of the earth forever and ever, Amen!" in his essay "The Souls of White Folk," it was not solely a rhetorical claim.[183] It was not hyperbole. One could read his project as an early example of what Henry Louis Gates, Jr. has called "signifying": Du Bois took the conveyance of facts commonly understood about racial dominance on widely circulating maps and positioned them as both sardonic (if not ludicrous) in the context of "The Souls of White Folk," as well as subjective (and incomplete) in the context of the Paris Exposition project.[184] As a sociologist, Du Bois was primed to critique the rhetorical structure of maps through his unique focus on "prejudice and racial attitudes," at a time when this approach, as Lawrence Bobo and Aldon Morris have deftly argued, was utterly absent from the world of empirical social science.[185] One wonders if these critiques ever entered discourse among students in Johnston's photograph of the Geography lesson at Hampton as they were learning how to map their place in the world and the universe itself (Figure 4.1).

Du Bois's statement about "ownership of the earth forever and ever, Amen," could be read as a send-up of the visual and textual narratives circulating in atlases. "The leaders are the whites, who . . . have spread with a rapidity never seen before" and "now dominate the world," stated the popular Tarr and McMurry geography textbooks.[186] This was one of countless examples of the scripted language of unequivocal racial dominance in atlases circulating in the United States at the time of the Paris Exposition—from Cram's to Yaggy's—that rhymed with Du Bois's sardonic statements.

Du Bois even published an expanded version of "The Souls of White Folk" in *Darkwater: Voices from within the Veil* (1920) and further critiqued the framework of maps structured by colonialism and white supremacy.[187] The essay's topic is rapacious imperialism and settler colonialism fed by the logic of white supremacy. Du Bois called it the seeming "duty of white Europe to divide up the darker world and administer it for Europe's good."[188] He structures his rhetorical device through the atlas, taking the reader on a roving tour of the world. To make his case that "the title to the universe claimed by White Folk is faulty," he describes what he has seen "down through the green waters, on the bottom of the world," and "in Central Park" and in "city after city" as he offers an account of civilizations

throughout the ages. Here, too, he is arguing against white supremacy not from the position of black subjectivity in the United States, but as a global *"fight for freedom"* that, he states in italics, *"black and brown and yellow men must and will make unless their oppression and humiliation and insult at the hands of the White World cease."*[189] When he uses terms such as "Dark World," it was not a metaphor alone. He was invoking the language used on the ostensibly objective atlases with their deliberate focus on white racial dominance around the globe.

Du Bois's *Georgia Negro* Exhibit was an indictment of the very real consequences of the narratives contained on atlases being passed off in schools as objective information about the world. Du Bois's version of the world map signaled that geographic narratives had prevented an accurate, fact-driven presentation of black life, distorting the "universal community" that Benedict Anderson would later argue maps and print culture created, and cementing whiteness as a default norm. The use of maps as data was limited by an antiblack worldview.

In *Black Reconstruction* (1935), Du Bois continues this critique of what I have called excision and negative assembly as it was used in the social sciences at large. In "The Propaganda of History," the aptly named final chapter, he argues that the use of natural science as the common model for history was insufficient and morally dangerous since it excised actions and interpretation. Du Bois cites Charles and Mary Beard's *The Rise of American Civilization*, because, as Gooding-Williams notes, it "treats the clash between north and south as if it were a clash between winds and waters."[190] Framing events as if just a part of "cosmic" law, the book leaves out the subjective actions of individual agents in the production of history. Here the geographic register was a key part of the discursive formation for his critique of history.

Excisions are a crucial tactic of propaganda and "more than mere omission," Du Bois argues. He offers examples—from works of history to his own text submitted to the Encyclopedia Britannica that was so doctored, with all Reconstruction history edited out, that he refused to let it be published. Du Bois asks, "Can all this be omitted and half suppressed in a treatise that calls itself scientific?" If the practice of omissions continues, he argues, "we must give up the idea of history either as a science or as an art using the results of science, and admit frankly that we are using a version of historic fact in order to influence and educate the new generation along the way as we wish." Du Bois presses for the creation of a new social-science framework for understanding history, not predicated on the tem-

plate of human events as natural events, but as created by subjective hands. "We shall never have a science of history until we have in our colleges men who regard the truth as more important than the defense of the white race," he concludes.[191] The geography repertoire familiar to Du Bois offers a sense of the reason for the urgency behind his request.

As a marker of how widespread the use of mapping became as a discursive tool for racial assessment, consider that as Du Bois crafted his installation, Winslow Homer, the most well-known American painter of the period, whom Alain Locke would salute for his portrayal in paint and print of black subjects with a rarely seen dignity, used the language of geography to doubly center black life in his painting *The Gulf Stream* (1899, reworked in 1906). The painting is in the collection of the Metropolitan Museum of Art, purchased after members of the National Academy in New York petitioned the museum to acquire it (Figure 4.16).[192] It had sparked controversy. In this landmark work, Homer placed a solitary, pensive black man in a small, dismasted, wooden ship on a turbulent sea. Gap-mouthed sharks circle below. A gray waterspout hovers near the horizon where a faint sliver of sunlight appears as a band. A dark line of ash-blue sea bisects the canvas connecting

4.16. Winslow Homer, *The Gulf Stream,* 1899 (reworked by 1906), oil on canvas, 28 1/8 × 49 1/8 in.

an impending storm to the precarious boat. A man, bare-chested, leans against a damaged gunwale, unperturbed. He gazes coolly, almost suspended from this context, sovereign.[193]

Art dealer Ronald Knoedler could not show the painting for long without asking Homer if there was an implied narrative in the composition. The work had prompted nervous laughter, silences, and mixed reviews when it first went on view in January 1900 at the Pennsylvania Academy of Fine Arts.[194] One potential buyer wanted to know how the viewer was meant to read the fate of the black man. The artist demurred, referring the audience instead to a famed geography expert. Homer told his dealer, "I regret very much that I have painted a picture that requires any description. The subject of this picture is comprised in *its title* & I will refer these inquisitive schoolmarms to Lieut. Maury," referring to oceanography expert Lieutenant Matthew Fontaine Maury, the author of the first geography bestsellers after the Civil War.[195] Maury, the founding superintendent of the naval observatory and a former Confederate Navy commander, was also widely known for issuing the "Washington map" that helped leaders to navigate sectional crises in the 1860s. His books were used in nearly five thousand Southern schools; his maps were on classroom walls. The title of Homer's painting came from Maury's landmark book, *The Physical Geography of the Sea* (1855). The book opened with a map of the Gulf Stream.

By referring his viewers to a geographer, Homer underscored that mapmaking had become a pervasive, legible language for discussions about racial life in the United States. His comment was in part a jocular attempt to avoid the topic that likely interested his public most—the fate of the black man surrounded by sharks in turbulent water and, by proxy, black lives cast into such precarious conditions on land in the United States. During the antebellum and Civil War period, artists used Northern and Southern compositional ordinals to telegraph aspirations, concerns, and allegories about the conflict brought about by slavery and settler colonialism.[196] Disrupting that impulse, Homer's painting instead insisted on a release from locational certainty. In *The Gulf Stream,* his compositional emphasis is on the suspension of being stranded—on uncertainty *as* location. He forced his viewers to wrestle with the social instability and racial contestation that gave rise to the innovations in atlases.

Homer's sardonic answer also gestures to societal familiarity with mapping during this period of imperialism's "oceanic frontiers"—when the United States annexed Hawai'i and American Samoa, the Philippines, Puerto Rico, and Guam, and occupied Cuba during the Spanish-American War.[197] In fact, when the Metropolitan Museum of Art mounted a Homer

exhibition with *The Gulf Stream* as the centerpiece, it nodded to this history with an unusual installation design. At the center of the entrance to the show was a gigantic cutout gray frame from which one could telescopically view Homer's painting hanging in a subsequent room. To the right was a huge map by Maury of the Atlantic Gulf Stream current that flows from the Caribbean to the Arctic. It is equivalent to the scale of the cutaway shape. It dwarfed the viewers, dominating the entire visual field. To enter the show, one had to first study the map (Figure 4.17).

I propose that the confusion about the Caucasus had dismasted racial discourse and left it stranded, in search of new ground. Du Bois, like Homer, had used mapping to disclose, challenge, and contemplate the future of black living. Du Bois's cartographic focus, installation form, and rhetorical style were indebted to omissions in the template of the atlas at the turn of the twentieth century. He signaled what Homer's painting *The Gulf Stream* conveys: cartography had become a racial language.

In the history of cartography and the field of critical cartography, there have been debates around a false binary about whether maps were "increasingly

4.17. Winslow Homer, *Crosscurrents* exhibition, Metropolitan Museum of Art, New York, 2022.

accurate" or "born of political agendas."[198] Yet these incisive debates have obscured our understanding of the force and deliberation behind the construction of these maps during this period of instantiating racial hierarchy in the United States. As atlases incorporated figurative racial templates, their compositions became tools for a racialized agenda in social, political, and economic life.

Racial domination is a spatial project, as McKittrick notes.[199] The burgeoning field of black geography has been at the vanguard of understanding visual regimes through exploring the history of geographic and spatial epistemologies.[200] Recently, there has been increasing attention on a "war of imagery" regarding racialized life in the United States.[201] These discussions generally center three fulcrum moments: the use of images to define stereotypes through slavery and Jim Crow rule; critical debates about art versus propaganda that emerged during the Harlem Renaissance; and the current shared public consumption of racial stereotypes in a landscape dominated by antiblack violence. The marriage of race and aesthetics has been such a site of agency and resistance that, as bell hooks argues, "the history of black liberation movements in the United States could be characterized as a struggle over images as much as a struggle for rights, for equal access."[202] When hooks concludes her seminal essay "In Our Glory: Photography and Black Life" by mentioning that "the walls of pictures" in homes "were indeed *maps*," she pinpoints the need to more broadly understand the range and impact of the visual in the context of ever politicized racial life.[203] How seemingly empirical maps were compositionally tailored to reflect the racial literacy that was developing in the United States is an underexplored area of early US internationalism and racial politics.[204]

Indeed, even with this heightened focus on the visual, not only have maps fallen out of the search pathways of the archive; the history of mapping has also dropped out of incisive conversations about the role of visuality in the deep history of racial formation in the United States. By "deep history" I do not refer to the more recent attention paid to the history of mapping within racial justice, environmental history, urban planning, and literary studies.[205] Instead, I mean the intertwined US repertoire of mapmaking—surrounding the "object" of the map—in which we see the start of the history of elision and exclusion in heavily used atlases and school textbooks.[206] This elision in scholarship has occurred in part because work on educational textbooks often pulls up short of an explicit focus on the visual culture these texts contain. This is further complicated by another disciplinary tension in the arts between what is deemed the province of visual

culture and what should be the subject matter of art history, which has historically limited the scope of visual material as an object of study.[207] This work of sidestepping the history of maps as part of the history of race and visuality was made easier, too, as geography as a discipline came under fire in the twentieth century.[208]

Du Bois's 1900 project underscores that understanding the visual logic of mapmaking and its specific repertoire is key for grasping how the creation of racial narratives were passed off as knowledge in the social sciences. Geography as an emphatically visual form of measurement became a vital method of measuring social life in the United States.

Examining the excisions in constructing racial narratives called to mind Toni Morrison's preface with "all the things I have seen" in *The Black Book,* in which she listed the "*New York Caucasian* newspaper." She included it alongside "the scarred back of Gordon the Slave, the Draft Riots, darky tunes, and merchants distorting my face to sell thread, soap, shoe polish, coconut."[209] She cited it ahead of the images and events we more commonly associate with overt symbols of entrenched antiblack violence and its related stereotypes. At the start of each issue of the *New-York Caucasian,* also called the "White Man's Newspaper," the pro-slavery publication stated that it "stood" firmly for "WHITE SUPREMACY, a defense of the rights and welfare of the Producing and Working Classes, now imperiled by the doctrine of Negro Equality."[210] On the banner was printed the motto, "'I hold that this Government was made on the WHITE BASIS, by WHITE MEN, for the Benefit of WHITE MEN and THEIR PROSPERITY FOREVER.'" (Figure 4.18). The reach of this New York City–based newspaper was vast; that it found subscribers even in California was a topic of concern during the Civil War.[211]

I had seen *The New-York Caucasian* newspaper that Morrison flagged early on in my research. Seeing it framed in her volume prompted me to revisit it. I learned that this newspaper was housed prominently in a building on Nassau Street, just a block from where Cram's maps would be produced during and directly following the Civil War. It was being published just blocks from where Charles Eisenmann had photographed the Circassian Beauties, those conceptual riddles of a racially figurative display. The newspaper was also close to P. T. Barnum's American Museum, where the Beauties were first shown.[212] It was one of many newspapers based in New York City's "Printing House Square" near City Hall. It was hardly tucked away—it was

4.18. *New-York (Weekly) Caucasian*, January 18, 1862.

instead housed by the proprietors of the *Day Book* in a building where the name of the paper was printed in large block-text, visible for blocks around.

Morrison's publication of *The Black Book* was a way to address the conceptual filing error in the visual archives on race that still prevents a full view of the distortions produced by racial ideologies in visual culture. Published in 1973, it is a landmark compilation of images, texts, articles, photographs, and newspaper headlines—a veritable record of racial contestation in the United States. (It was while creating this volume, as Hilton Als notes, that Morrison discovered the story of Margaret Garner, a mother who chose to murder her own children rather than let them return to slavery, which became the basis of her novel *Beloved*.) It is an archeological map, offering markers for excavations. It left directions for stories that should never be forgotten, excised, kept out of sight.

Morrison's volume is an exhortation to take stock of what has fallen out of view but has, nevertheless, conditioned and contoured the shape of the world in which we live. *The Black Book* is a prompt to be attentive to the silences shaped by our archives and human hands.[213] In the context of oppressive racial hierarchies, what is excluded—deleted, left off the record—is often as important as what is made explicit.

How would our analysis of the history of the interpenetration of racial formation and visuality change if we considered the excisions of the Black Sea region in maps circulating in the United States? It would expose the developing form of assessment that relied on negative evidence to reify oppressive racial hierarchies. It is a transformation not captured by the study of eugenics or the development of the New Negro movement alone. What emerged in the 1890s through maps in the age of imperialism, resistance to Reconstruction, and the instantiation of Jim Crow rule was a collective training—daily, mundane, pervasive—in how to see the racialized world.

We have learned to see around the lack of evidence for the foundational idea of racial hierarchies. What we have come to live with is a form of seeing so deeply rooted in contextual cues that another word—negative assembly—is required to describe what, precisely, it is and what it has cost us.

Tracing the representation of the Black Sea region through negative assembly allows us to rethink the modes in which race and modernity are mutually constituted, calling our attention to how history works through negation.[214] The fact that racial domination and ideology were secured not only by norms and laws in the representational democracy of the United States but also by narratives steadied by excisions is critical for understanding how a polity reconciled laws based on the groundlessness of racial supremacy.

Even the debates over teaching critical race theory that came to a head in 2020 offer a reminder of how negation, excision, and negative assembly have constructed history in the United States. By 2022, legislation in over seventeen states had blocked the teaching of what is labeled critical race theory or programs that support it. At the time of writing, *Education Week* maintains that more than forty-two states have "introduced bills or taken other steps that would restrict teaching critical race theory or limit how teachers can discuss racism and sexism."[215] Critical race theory is a framework developed out of the possibilities and limits of critical legal studies—through the work of scholars including Derrick Bell, Kimberlé Crenshaw, Richard Delgado, Alan Freeman, Mari Matsude, Patricia Williams, and cultural historians in Black Studies. It aims to identify the structural forms through which laws and institutions perpetuate socially constructed racial hierarchies. It began with a question about the backlash to the civil rights movement. It exposed the presumption of race neutrality and the basis for "seemingly race-neutral exclusion" in the law.[216] "The gap between words and reality in the American project—that is what critical race theory is, where it lies," Imani Perry told Jelani Cobb.[217] Yet through this legislation,

the term has been distorted into a national catchphrase to mean any form of teaching about racial formation or racial ideology in US history from elementary school to college. The legislation has resulted in bans that PEN America has argued amount to "educational gag orders" targeting the First Amendment.[218]

The most historically cohesive way to understand the critical race theory debate is not through the lens of censorship in the classroom, but as an extension of tactical excisions that have been foundational to crafting racial history. The conflict about teaching critical race theory is predicated on the history of negative assembly. That is, the legislation redeploys a template long used in teaching America's racialized history: strategic subtraction.

Beyond critical race theory, this logic of negation even permeated racially motivated spatial policies such as gerrymandering. The foundation of gerrymandering is geographic excision. It is a process entirely reliant on mapping. The aim is to diminish the effect of some voters—often minority voters—on the outcome of an election. The practice takes several forms: "cracking" groups of minority voters throughout other districts to dilute voting power and "packing" minority voters into supermajority districts where a dissenting vote has negligible power.[219] The egregious extent of these practices is, many argue, unique to the United States, and has helped maintain racial hierarchies of power through the logic of negation.

Negative assembly is a maximalist framework. It is found in the logic of structural racism that functions through denied access and eliminated resources. We see it from the elimination of access to resources and rights to the denial of basic protections from harmful environmental toxins due to race-based institutional decisions and policies. We saw it in the response to mandated integration—the elimination of resources such that protests over racially integrated public swimming pools meant that these facilities were closed entirely. Resistance to desegregation meant strategic subtraction and white flight.

Negative assembly is a widespread durable tactic of historical production that we have failed to fully address. This account of mapping and the history of negative evidence it exposes aims to offer a conceptual foundation for future analysis of frameworks used to record, archive, and teach the history of racial formation in the United States. This history of material excisions has been foundational to maintain concepts of racial hierarchies in American life.

These maps of the Caucasus should not be dismissed as simply a relic of the ideology of white racial supremacy without considering the impact they

had on the students they instructed, and what it gave rise to that we still live with today. It is here that a crucial model of archival imaginings created by Saidiya Hartman—"critical fabulation"—along with vital counternarratives to resist "the tyranny of 'the archive'" as Annette Gordon-Reed puts it, can allow us to imagine how formative and devastating this history must have been to learn and how much this legacy persisted.[220] I began with a photograph of students at Hampton. I return to it now as a prompt to consider the real consequences this history had on lives.

Imagine, if you have not already, how impossible the once required course of geography would have been for many black educators to teach. Resistance was necessary. It was led by Woodson and the teachers he inspired. It was exemplified by Du Bois's landmark installation and leadership. Together, these efforts created the foundations of Givens's "fugitive pedagogy." It offers a reminder of the clarity and significance of Spillers and Wynter's claim that the methodological project of Black Studies has been central for defining, expanding, and critiquing the concept of the human in the history of Western modernism.[221]

Lessons in geography made white supremacy seem as natural as the forces that govern the air. Mapping spatialized racial dominance. Mapmaking, tailored to the US market at the turn of the twentieth century, did not just mirror the instantiation of racial hierarchies and white supremacist language of the day. It helped to create it.

Geography teaching nearly mandated the critical, on-the-spot curricular resistance by black educators as well as Native and black students' challenges to its distortions and negative assembly despite the consequences. It is what made Roscoe C. Bruce, a superintendent of black schools in Washington, DC, write to his superiors with the plaintive, rhetorical cry: "Can it be that all the generals, all the statesmen, all the men of letters were white men?"[222] Here he echoes a question that thought leader and bibliophile Arturo Schomburg and educator Albert N. D. Brooks would ask about the work of institutions.[223] It is why a young student in 1934 who found himself in a Hampton, Virginia, social studies class studying a "Let's Go Traveling Map" dared to ask in class, "May we study ourselves, too?"[224]

It is why, in 1926, my grandfather, Shadrach Emmanuel Lee, then attending eleventh grade in a New York City public high school, asked why the school's textbooks omitted mention of excellence and achievement by any other race but white Americans. His history teacher said that black

Americans, in particular, had done nothing to merit inclusion. He continued to ask the question in class. For his so-called impertinence at refusing to accept the answer, he was expelled. Negative assembly became a pervasive tactic to shore up narratives that justified white dominance.

The language of geographic and colonialist dominance fills the discourse of white nationalist and supremacist groups even today. At times, lines that seem lifted from maps and atlases discussed in this chapter emerge in publications by American white nationalist and supremacist groups such as New Century Foundation. As one example, expressions about the white man's "instinctual . . . proclivity to expand and conquer" were common in its publication *American Renaissance*.[225] This is to say nothing of the language of the Great Replacement theory central to white nationalism's stance with its claims that there is "a systematic, global effort to replace white, European people with nonwhite, foreign populations." (These ideas are now believed by a substantial swath of the American body politic, according to a study conducted by the Southern Poverty Law Center.[226]) This focus on demography, this fixation on fears and threats to white racial dominance, uses the language of figuring and negation in geography to naturalize discussions of racialized violence. The rhetoric has gone far beyond the teaching of geography, beyond pedagogy, beyond the history of scientific racism.

I mention this history to say that the deft discussion of "worldmaking" practices that takes place in anticolonial regimes is not only a metaphor.[227] The ongoing, countervailing framework of geographic, racial dominance still reigns in the strain of white nationalist politics in the United States and beyond. Negative assembly became a narrative, worldmaking tactic for the survival of racial oppression. It served to block doubt about the fractured foundations of racial ideology. It became a normalized strategy for political persuasion about the future direction of the United States. It is part of the history of epistemic injustice.

The social reproduction of this racial regime of excision took place through a fixation on racial detailing. The language of detail would become a key part of racial domination during a period of segregation at the end of World War I. To understand it requires probing the broader reasons behind President Woodrow Wilson's decision to ask his military commander to investigate the so-called legendary beauty of the women from the Caucasus.

5

The Unseen Dream

Racial Detailing and the Legacy of
Federal Segregation in the United States

In 1913, twenty-nine-year-old Swan Marshall Kendrick arrived in Washington, DC, assessed the landscape, and knew "sure as fate" that he was "bound to win."[1] He worked hard as a federal clerk and felt confident. "The money is sure, sick or well, as long as I live," he wrote, "and promotion, while slow, reasonably certain, and fine prospects of an old-age pension being established at least before I would need it."[2] It was a month before President Woodrow Wilson's inauguration. After Wilson had been in office, Kendrick's tone had changed. He now had a horror of being "buried" in Washington. Despite his ease early on about his career prospects in the federal government, he came to believe that his "chances for advancement" were "absolutely negligible."[3]

Kendrick continually assessed the political terrain. He had no choice. He was courting Ruby Moyse, a schoolteacher who lived in his hometown of Greenville, Mississippi, and hoped she would move to be with him (Figure 5.1). Their lives were split apart by the Great Migration, the northbound movement for opportunity and flight from racial terror and the limitations of Jim Crow rule. To assure her and her family of his "prospects of success," he had to reveal his thoughts on his employment and future in the nation's capital.[4] Kendrick wrote vivid, eloquent letters to Moyse constantly, sometimes twice a day. "When you write," she asked, "please make it a newspaper and tell me all that you did and all you saw and all you heard."[5] He began calling his letters "Ruby's Weekly," and later they became a

5.1. *A (left).* Swan M. Kendrick, undated. *B (right).* Ruby Moyse, ca. 1915.

"private edition of the Saturday Morning Post, of which my unworthy self is editor, business manager and mailing clerk."[6] After some time had passed, worried that Moyse would lose faith in him, he explained that he was not waiting to ask to marry her out of some desire to "get rich" first; instead it was just not "fair to any girl to wait on me."[7] He continued: it is "not that I dislike the city, but the limitations . . . As soon as I can get fare and a few shekels, I see myself leaving."[8]

By August 1913, just months after Wilson took office, Kendrick had tracked the changes happening in his department and planned a move to Central or South America for better employment options. He did not speak Spanish, but would learn.[9] At this point, he was not "satisfied" to "live in the rut" that his "acquaintances seem to be" given the pervasive nature of Jim Crow rule.[10] "I want the opportunity for self-realization," he wrote. He was willing to fail so long as he could not "blame it on the 'white folks.'"

He gave no indication that his skills were in question. He was in demand as an educator. He had been offered a job at Fisk University, but had turned

it down before his optimism turned to a warranted fatalism by the noose of segregation.[11] All told, he would consider "electrical engineering, chickens, truck farming," and "dairying" as professions.[12] These were his dreams, an inner "redress" to sustain life where he was cut off for advancement at every turn.[13] The beginnings of de facto segregation were implemented during President William Howard Taft's administration, but there had been little expectation of the total federalization of the Jim Crow policy to come.

Soon after Kendrick began work in the Wilson administration, he wrote to Moyse offering to send her as a birthday present *The Crisis* along with *The Souls of Black Folk* by W. E. B. Du Bois. It was not the romantic gesture one might expect, but it was necessary to fortify any life they might live together. After some time in Washington, DC, Kendrick saw the battleground for racial contestation as "a cause which is the greatest since the anti-slavery crusade of Garrison and Phillips."[14] He felt that federal segregation had brought them to a precipice:

> The whole range of subjects supposed to be covered by the 13th, 14th and 15th Amendments of the Constitution is going to be threashed [*sic*] out during the next 50 years, I believe; the plain truth is that we are farther from Emancipation in this the 50th Anniversary thereof, than we were when the Proclamation was signed.[15]

He argued that "especially during these past 25 years we've gotten so used to being insulted and humiliated that we are really surprised when treated like gentleman and ladies. Things are not going to stay that way, of course."[16] He explained, "I try hard not to be a fanatic on this eternal race question, but the position in which we find ourselves in this 'land of the free' is certainly one that I can't help thinking about a great deal."[17]

By 1915, he confessed to Moyse that he had started to go hungry during the day while working in the Ordnance Department of the War Department, a state preferable to eating under segregated conditions. The cafeteria for his federal government office effectively no longer serviced black workers, who had to go to the kitchen door "where there is no one" to take an order "but the cook, and usually he is at the counter until all white employees have been served." Some brought lunch from home and ate in or right outside of segregated bathrooms to remain undisturbed.[18]

In 1919, Kendrick was confronted by a guard when he used a washroom that, he was told, was now for whites only. He decided to leave government service. He stayed on until 1921, when he left to become a dairy farmer in

Hampton, New Jersey, while Moyse, whom he had married in April 1916, worked as a schoolteacher in Downingtown, Pennsylvania. It was difficult work, but he refused to be "downhearted," he wrote in January 1922.[19] Within six months, he had contracted a fatal infection from the livestock. He died in August 1923.

The record Kendrick left as one of the few black civil servants in the Wilson administration is invaluable, and devastating. Taken together, his writings—erudite, impassioned, incisive, and clear—comprise a rare eye-witness account of the Wilsonian era. It outlines the period shift in vision to racial detailing. It urges a fundamental reconsideration of the tactics required to combat racial domination in the United States.

A central force that secured racial dominance in the United States was the use of racial detailing—assembling seemingly small, procedural features to constitute a totalizing and inhumane regime. Oppressive granularity made segregation and its legacy difficult to study, never mind uproot. Wilson would become known for implementing federal segregation, but his archives reveal that what sustained it—what made it so brutal and en-trenched—was a visual regime of racial detailing that aimed to obscure racial injustice.

We live with the legible practice of racial profiling—assessment filtered through brutal stereotypes and narratives—but what preceded it was racial detailing. Both are practices of racial domination within bureaucracies and other structures of power, and both have legacies in our current social and political worlds and roots in the history of aesthetics. Race created a "period eye" through segregation. The concept of a period eye describes an evaluative culture of viewing commerce: art and goods.[20] Yet, as Simon Gikandi has noted, the foundational role and "afterlife" of slavery that commodified and trafficked human beings as objects extended this evalua-tive mode to the dynamics of racialized societies.[21] Developing vision into an evaluative method for racial regimes required trained perception on the detail.[22]

After years as a federal clerk, Kendrick saw it: the Wilson administration would shape a regime of racial domination by the force of a mass composi-tion of innumerable details, impenetrable all at once, not through speech, declaration, or outright policy decree. Wilson was initially silent about his allowance of federal segregation—a deliberate omission, a form of negative assembly. It was necessary to enact an unspeakable injustice through this "second segregation" that symbolized the Jim Crow nation's hollow

commitment to equity and freedom.[23] The segregation that has lingered in neighborhoods and schools is the result of not only "white flight," discriminatory banking practices such as "redlining," or real estate agencies deterring black families from particular neighborhoods, but also racial detailing.

Details, from signs to markers, became the scale that determined the firm contours of racial dominance. Constructing this system of racial injustice was in keeping with a developing theory of vision and governance of the day and with the study of administration. Wilson argued that it was critical for racialized modern life.

Through Wilson, federal segregation was both inaugurated and unseen at the same time. It is a duality mirrored in his legacy: his achievements have also come alongside an easy disregard of exercised, policy-framing racism of a kind that was, as the renowned constitutional scholar and Princeton University president Christopher L. Eisgruber put it, "significant and consequential even by the standards of his own time." The racism of Woodrow Wilson, a former president of Princeton and a winner of the Nobel Peace Prize, was so influential that the university could no longer bear his name as a model and inspiration: it de-named both the Wilson School of Public and International Affairs and a residential college. Wilson was not a figure such as "say, John C. Calhoun or Robert E. Lee, whose fame derives from their defenses of the Confederacy and slavery," Eisgruber noted, and explained that "Princeton honored Wilson not because of, but without regard to or perhaps even in ignorance of, his racism. That, however, is ultimately the problem." That model, he continued, is "part of an America that has too often disregarded, ignored, or excused racism, allowing the persistence of systems that discriminate against Black people."[24] What Eisgruber cited is not only a conditioned American practice of learning to see and unsee racial conflict, but also a form of civic vision that, as we will see, Wilson's regime itself worked to instantiate.

Kendrick had not been wrong in looking to Washington, DC for opportunity. Before Wilson's administration, cultural leaders from Langston Hughes to Du Bois considered it a site with rare prospects. "It's the capital, and you had more chances for things," said one resident, Velma Davis, about Washington before Wilson's presidency. "Jim Crow was there, but it was still no South to us."[25] The district's equality laws had been enforceable enough to stop attempts at statutory segregation.[26] Hughes recalled in 1927 that "As long as I have been colored I have heard of Washington society," reflecting

on Black Washington.[27] The image of three generations of the Frederick Douglass family—Douglass, his daughter Rosetta Sprague, and her daughter—stretched out in front of two homes that he consolidated exemplifies this sense of promise (Figure 5.2). The family's placement on either end of the two adjacent houses underscores their ownership and rightful claim to the capital's public space.[28]

While the promise created by black middle-class Washington was not exemplary of life for most black Americans in the nation's capital, the symbolic image of black clerks in the federal government upheld a signal claim to equality and a belief in the possibilities for mobility and advancement in the United States.[29] The civil service exam-based system of entry, begun in 1883, made education an elevator to opportunities. Before Du Bois would write *The Souls of Black Folk*, he outlined the many triumphs of black life over racial domination through a display at the renowned 1900 Paris Exposition. He included panels that saluted black American US government clerks in his gold-medal-winning exhibition (Figure 5.3).

Wilson's administration purged black clerks from the federal government. Of the seventeen black clerks appointed by the previous Taft administration, Wilson would dismiss fifteen. Further research has found that this number may have been higher.[30] Even when clerks did rise in station, they were often "promoted to racial isolation."[31] For black clerks, stagnation

5.2. Frederick Douglass standing in front of his home at 320 A Street NE, Washington, DC, 1876.

5.3. "Government Clerks. Have received appointment as Clerks in Civil Service Departments [in the] United States Government through Competitive Examinations." One of three charts prepared by W. E. B. Du Bois for the 1900 Exhibit of the American Negro, Exposition Universelle, Paris, to show the economic and social progress of African Americans since Emancipation.

became common even during a period when the *Civil Service Advocate* reported on the good prospects for work and "need for bodies." For example, census clerk Lucretia Mott Kelly went from 1893 to 1919 without any increase in pay. Frederick Douglass's son Charles R. Douglass was one of many who went ten years or more without an increase in salary while working at the Department of the Interior. By the end of Wilson's administration, only four black clerks who had been promoted went beyond the Class 1 clerkship, just above the level of sub-clerk. None would enter the upward ranks that came with supervisory roles.[32]

Wilson institutionalized racial segregation in the federal government for the first time without a bold declaration. The president would not speak plainly about his inauguration of federal policies of racial domination. It came as a surprise to civil clerks and leaders such as Du Bois, who had even left the Socialist Party to support Wilson's first presidential campaign, and to the nearly 100,000 African Americans who left the Republican Party to vote for the New Jersey Democrat. Du Bois did not believe that Wilson "admires Negroes" and admitted that "his promises" were "disconcertingly vague," but argued that he was the best candidate for progress.[33] When Wilson, the first Southerner elected president after the Civil War, defeated former president Theodore Roosevelt and incumbent president William Taft in the presidential election, Du Bois had been hopeful about what his presidency could do for Black America. He considered it "a momentous occasion," for all, "to the colored people, to the white South and to the nation." In 1916, Wilson sought reelection. Du Bois then made his revised view clear, in italics, for the readers of *The Crisis: "No intelligent Negro can vote for Woodrow Wilson."*[34]

Wilson was silent in the face of lynchings and racial violence. He spoke about racial terror only once in a public speech. In the summer of 1919, Washington, DC's race riots were so "murderous," with much of the violence occurring within a mile of the White House, that James Weldon Johnson, field secretary of the National Association for the Advancement of Colored People (NAACP), would refer to those months as the "Red Summer."[35] That Wilson instituted federal segregation and remained silent in the face of racial terror meant, as Du Bois put it, that the ways in which black Americans were "oppressed, killed, ruined, robbed, and debased" was not only "uncondemned by millions of their white fellow citizens," but "unrebuked by the President of the United States."[36] Wilson's papers are so devoid of any mention of federal segregation that one could think it never happened at all.

When confronted about the federal segregation that occurred during his administration, Wilson would cloak it. He argued that what was being called segregation was, in fact, a benevolent design to reduce racial conflict. He employed this approach even as president of Princeton University. During his tenure, he did more than refuse to admit black students. He cited a precedent that the school had never allowed black students to enroll when, in fact, it had. As other universities were admitting black students, Wilson "had letters distributed to all black applicants informing them that Princeton enjoyed a large Southern enrollment and that black students would feel out of place," making the school "perhaps the only great Northern university that excluded Negro students."[37]

In Washington, alongside his landmark New Freedom platform of progressive reforms, including the creation of the Federal Reserve, the modern income tax, and antitrust law, Wilson's first term witnessed a rash of measures put forth by Southern congressional Democrats amounting to "'the greatest flood of bills proposing discriminatory legislation against Negroes' ever to come before Congress."[38] The targets ranged from the Fifteenth Amendment to miscegenation, which became a felony in Washington, DC. Yet federal segregation itself began without being declared outright. This omission left leaders grasping at shards to find proof of a directive behind the clearly growing system of racial domination in the highest seat of power in the land.

The hidden nature of the oppressive rules of federal segregation—cutting off merited life paths—now mandated careful, detailed adjudication. Some obstacles were plainly there. Many were out of sight. "Careers suddenly slowed down, like rivers reaching their muddy deltas," Eric S. Yellin writes.[39] By 1914, job applications in the Civil Service Commission required identification photographs—a tactic that only supported segregation—and promotions that did come were no longer accompanied by higher station.[40]

Signs indicating segregation in government buildings were rare; many were removed as part of the "token efforts" to reduce the appearance of Jim Crow in the capital. Such measures kept the system in the shadows—present, but undeclared.[41] In most cases, once racial-caste working arrangements were set, signs were not required or taken down. One of the very few images depicting their use in a federal building is of a Public Health Service Dispensary that includes segregated waiting area signs with, ironically, two black employees, as if staged, standing in the "white men's waiting room" (Figure 5.4). The image telegraphed the change to come.

5.4. Group of federal employees waiting for treatment at the Public Health Service Dispensary #32, which has recently been opened for the exclusive benefit of government workers, ca. 1909–1932.

The Wilson administration made segregation obdurate and hard to see.[42] With impersonal language and privately held visual maps, there was no handbook to destroy, no one policy to tear down to eliminate federal segregation. The NAACP halted its segregation protests within a few years to focus on the more overt violence of lynching. The logic of implementing federal segregation through this attention to impersonal details had rendered it impervious to critics because it was upheld by a system of mental mapping, held together by minute cues.

One of the most vivid examples comes from the experience of Assistant Secretary of the Treasury Charles S. Hamlin, who came to Washington, DC in March 1914 unaware that segregation was happening in his own department. Hamlin was opposed to segregation. A Boston Democrat, he had been "advised that segregation because of color would not be permitted by the dept."[43] It was being implemented anyway, but Hamlin could deduce it only from a maze of correspondence, denials, and deflections.

To prove that federal segregation was taking place required new skills of detailed assessment. Kendrick exemplified this work as a core constituent of the NAACP, eventually becoming secretary of the DC branch led by Archibald "Archie" Grimké. He acted as an informant to substantiate civil rights abuses that could not be confirmed without an eyewitness report. Even his personal exchanges with Moyse expose the blunt force leveled at black ambition, the havoc the need for constant attention to detail and assessment could wreak on one's interior life, and the strength required to handle negotiations and appeasement in the face of white supremacist rule. The skills of careful observation—a fixation on detailed interpretation—were becoming necessary counterinsurgent means of resisting hardened racial hierarchy in the United States. A failure to marshal these skills was measured by the specific devastation it brought to black citizens' lives.

Federal segregation was initiated not by sweeping law, but via a detail-driven visual regime that laid out the most minutely specific directions to administer the unspeakable—a totalizing biopolitical racial decree. Cabinet-level officials used private diaries, and only rarely public correspondence, to map out a patchwork policy that segregated federal offices. Where indeterminately raced women could sit in the Treasury Department, for example, preoccupied leaders even though there were only three out of hundreds.

The hidden force of racial detailing matched the piercing violence of the era. It appears virtually mapped out in 1918 by the popular photographer Arthur Mole who gathered 21,000 men on the military grounds of Camp Sherman in Ohio to create a portrait of Wilson (Figure 5.5). To construct the image, one of the many he made to extol American democracy and nationalism, Mole built towers nearly eighty feet high and placed his design on his eleven-by-fourteen-inch camera glass. With a megaphone, he then directed his assistants, with the aid of his collaborator John Thomas, to mark the outline on the ground, picking up a white flag to communicate when they were out of vocal range.[44] It took weeks to sort the location of each individual, all of whom were white in the then segregated army. The orchestration of details with such exactitude was demanding. Eight thousand men in dark green uniforms were needed to create Wilson's hair above the part. A raft of men formed the eyeglasses.[45]

The image is an American *Leviathan*. Mole evokes the most famous European emblem of political life, the image that visually summarized Thomas Hobbes's concept of sovereign political power as the creation of

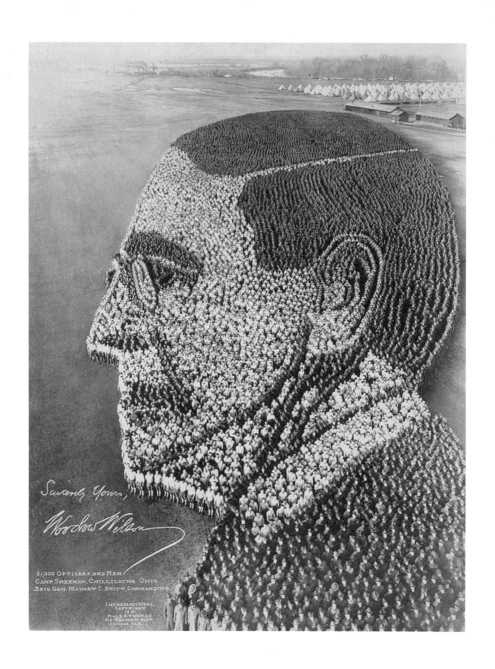

5.5. Arthur S. Mole, *Sincerely Yours, Woodrow Wilson 21,000 Officers and Men, Camp Sherman, Chillicothe, Ohio, Brig. Gen. Mathew C. Smith, Commanding,* 1918, gelatin silver print, sheet 14 × 11 in.

contractual collective will. Published as the frontispiece to Hobbes's *Leviathan* (1651), an engraving by Abraham Bosse shows a disappearing mass of bodies, representing "the people," which form a huge body: Leviathan, the sea monster of biblical and apocalyptic lore. Hobbes makes this creature into a metaphor of the state in the shape of its awesome sovereign power. A colossal "automaton," due to its being an artificial person produced and enlivened by its subjects, the state leaves no space for dissent. All are one. Most significant here is Hobbes's prediction that the tactics of representational political regimes would become visually oriented.[46] Mole rendered his image of Wilson as a sovereign figurehead through perceptual distortions. Individuals appear as mere dots to render a legible image of political will, with each soldier holding his position for hours. The very act of creating Mole's image hints at the force of interpretation required to both structure and challenge racial dominance and the legacy of segregationist rule.

Mole would construct widely popular portraits—including *The Living American Flag* (1917), *Human Statue of Liberty* (1918), and *The Human U.S. Shield* (1918)—each comprised of up to thirty thousand white men in the segregated army and navy corps, each meant to be a symbol of and consent to American patriotism. Mole and Thomas became so popular that they "very nearly persuaded the American armed services to permit them to cross the Atlantic so as to shoot the most massive living portrait ever assembled: a clock marking the eleventh hour, portrayed by the *entirety* of the American armed forces stationed in Europe."[47] The photographs were not simply propaganda. Their compositions outlined the brutal precision of civic sight necessary to sustain US nationalism.[48]

The history of unseeing that segregation required is so pervasive that it even impacts the telling of Mole's own history. In all of the probing scholarship on Mole, the popular photographer of symbolic civic life, any discussion of racial segregation is completely absent. It is a particularly confusing omission given that the images are of monoliths, and an alarming one given that Mole emigrated to the United States and lived in the religious community of Zion City, Illinois, founded by a faith healer, John Dowie, who believed that the Anglo-Saxon race was favored by God.[49]

In July 1913, just after his inauguration, Wilson addressed a crowd of Civil War veterans at the fiftieth anniversary of the battlefield of Gettysburg, Pennsylvania, in an event that anticipated the exacting design of federal segregation. When Wilson addressed the crowd, he crafted their collective portrait. "Look around you upon the field of Gettysburg! Picture the array, the fierce heats and agony of battle, column hurled against column, battery

bellowing to battery!"[50] Yet his address was given to a deliberately incomplete gathering of the Blue and Gray. For although more than two million dollars in federal and state funding had been secured to ensure that any Union and Confederate veterans could travel to attend, as David Blight notes, there was "no space . . . for surviving black veterans."[51]

I first realized that Wilson's focus on detailed vision had been overlooked as a force for racial federal policy when I considered his odd request for information about the look of women from the Caucasus region in 1919. Race riots and massacres erupted that year as black soldiers returned from war with a pride that affronted the order of white supremacist rule. Among this violence was a mob attack in 1919 on black soldiers in Washington, DC, and a massacre of an estimated eight hundred men, women, and children in Elaine, Arkansas, after black farmers sought pay equity. Labor unrest dominated the work of legislators—the war had increased union membership and protests for higher wages had led to major strikes throughout the nation.

Amid these riots and strikes, Wilson, the internationalist president, was also focused on the site of another siege: the Caucasus. Turks and Tartars joined to fight Armenians; the United States considered arming Armenian troops. British troops withdrew from the Caucasus and the conflict seemed to be one that only the United States could address. Armenians were among the peoples, including Kurds, Koreans, Georgians, Syrians, and Lebanese, who were clamoring for self-determination.[52] The US Supreme Court would soon rule in *United States v. Cartozian* (1925) that Armenians should be designated as white, at a time when many immigrants were negotiating their place in the umbrella of racial whiteness in the United States.

Wilson's concern about the "self-determination" or independence of stateless and non-Western groups after World War I forced him to take the same fine-grained approach to studying the world that he had developed in studying racialized life in the United States.[53] In the postwar settlement, Wilson aimed to position "international sovereignty and equality" not as "a prize to be won or a privilege to be earned but a basic right that any nation could claim."[54] He was concerned about such "unorganized" people (as he referred to them), because they "have no political standing in Europe."[55] His papers reveal that he was concerned with peoples who, he said, are "of our own blood," a perspective for the maintenance of a racial order that created the framework for his domestic policies at home.[56]

Long before he became president, Wilson had connected his theory of governance to figuring—calculating a composite image of the nation through detail to assemble and reify a racial hierarchy of global order. The first Southerner elected president after the Civil War would argue as a scholar in widely influential texts that a new kind of sight had to be developed for the modern era. He entered the White House focused on a new way of seeing to shape modern, racially based governance in the segregationist age.

Wilson not only published, researched, and taught the history of American politics. His celebrated book *Congressional Government* (1885) also established his expertise on what he would call the philosophy of American governance. Writing was not a parallel pursuit to his political career, but a means through which to achieve it.[57] Wilson's books were influential; Du Bois, for example, would teach from Wilson's popular textbook *The State* (1889) at Atlanta University.[58] Yet governance, Wilson would argue, required something unexpected. Well before his time as governor of New Jersey and president of Princeton University, his letters to Ellen Axson, an artist, eventually his wife, reveal a life spent focused on visuality and representation that shaped his approach to his writings on governance and his understanding of representational democracy. His archive makes explicit the critical role of vision in the management and maintenance of racial order, a role that has a legacy in the tactics of racial domination today.

The Wilson administration offers a case study of how the history of racial detailing structured racial hierarchy in the United States. The managerial process systemized a way to seem to address racial contestation without enacting demonstrable steps toward justice. Federal segregation institutionalized unseeing. To detail can also mean to clean; the federal government in the Wilsonian era cleaned house of black ambition. In the context of security and surveillance, to be detailed is also to be pinned down, tracked, and accounted for with limited free mobility. As the national interest in eugenics heightened a fixation on race and physiognomy, visual detail became part of the everyday language of assessment, governance, and power.

Contesting racial segregation during this period required what Wilson's War Department clerk, Freeman Henry Morris Murray, understood: careful interpretation that could match the piercing detail of federal segregation. Murray, working in the federal government at the same time as Kendrick, was a black political agent and a cofounder of the Niagara Movement

5.6. Group portrait of members of the second meeting of the Niagara Movement in 1906 held in Harpers Ferry, West Virginia. W. E. B. Du Bois is seated. Standing behind him are *(left to right)* J. R. Clifford, L. M. Hershaw, and F. H. M. Murray.

alongside Du Bois and J. R. Clifford, the first black attorney in West Virginia.[59] Murray was chair of planning the group's second meeting at Harpers Ferry to honor the anniversary of John Brown's raid (Figure 5.6). He was also a senior editor of *The Horizon: A Journal of the Color Line* (another precursor to *The Crisis*).

Alongside this work, Murray was also an art historian, the first to publish scholarship on race, visual representation, and public space in the United States.[60] Each of these roles informed the other. His work with black progressive organizations, while serving as a civil servant in the segregated administration, mandated his focus on representation as a political weapon.

Murray, along with Kendrick, grasped what other leaders had not: if Wilson structured the system of federal segregation as a visual regime, combatting it would require reading the social landscape with unprecedented

care. Murray is now largely known for his scholarship in *Emancipation and the Freed in American Sculpture: A Study in Interpretation* (1916), published by his family-owned Washington, DC printing press. It is one of the first studies on race and aesthetics in the United States.[61] Yet the full scope of the political ground of his focus on interpretation—writing while a government clerk—remains largely divorced from the scholarship honoring his landmark, understudied contributions.

Murray's archives include a clipping from the writing of Woodrow Wilson—an article excerpted from *A History of the American People*, published in the *Washington Herald*—that indicates how central politics were to his writing. In the article, Wilson had omitted key details about the Civil War. He distorted the history of slavery, describing it, for example, as a system where "great gangs of cheery negroes worked in the fields, planted and reaped and gathered."[62] Placed in Murray's papers directly after the draft of his manuscript, Wilson's article, marked up in ink, is nearly the only newspaper clipping that survives in his files.

Murray was pointing to the need for a gear shift, a change in the intensity of assessment necessary for citizens faced with racial domination. His work also explains what prompted Du Bois's landmark focus on the role of propaganda in America's history of racial contestation. Du Bois's idea is a central touchstone of any discussion about race and representation, and has been long framed as emerging from his debate with Alain Locke, as I discussed in Chapter 4. Yet what has been overlooked is that Du Bois's work on propaganda was also part of the work about truth and representation that Murray had urged him to complete years earlier. Murray, that is, had an unheralded role in one of the most vital discussions about the marriage of race, representation, and politics in the United States.

What drove Murray's interest was excision.[63] What was missing, he saw, were solutions to racial inequity. As he explained to the readership of *The Horizon*, which he edited with Du Bois, resisting Jim Crow rule meant processing the racial arena with attention to the finite event, to discern patterns. It also meant being inundated with discrete examples of outright racial domination. He itemized a representative list:

> Scarcely a week goes by that our newspapers do not carry one or more stories concerning it: someone has trouble on an interstate bus; someone refuses to move and is arrested; someone complains of being put off a conveyance for refusing to move or to take a certain seat; someone sues for being moved in, put off, or refused transportation in, some vehicle on land, water, or in the air. Then there are cases

arising from segregation at lectures, theaters, concerts, church conventions, in and at public and semi-public institutions, celebrations and functions; separation in college dormitories, in public schools and so on ad infinitum.

Murray was after resolutions. He noticed that few were ever mentioned after such incidents. There is nearly always "a failure to state how it ended, or what was done about it," he wrote. "Occasionally we read that someone got nominal damages or compromised a case; but as a rule we do not hear anything concerning the final outcome of the letters and protests or the appeals in suits, except those that go to the higher courts which we usually lose, finally—de jure, de facto or by default."[64]

He found resolution to racial injustice in detailed interpretation. The US landscape was filled with symbols of racial domination. What was needed was careful consideration of why they remained. Symbols that let segregation continue—from the hidden details to the massive monuments set on courthouse lawns—could not be ignored. Murray would marshal tools from a seemingly unrelated field—the arts—for resistance to racial domination, just as Wilson had done to instantiate it.

Wilson's papers, Hamlin's diary, Kendrick's letters, and Murray's research—the archives of two federal executives and of two clerks—offer a picture of how the visual operations of racial detailing were critical for stabilizing racial oppression. Racial hierarchies and political order were co-produced in the United States. This correlation required a sustained transformation of visuality as a tool of accounting. After the Civil War, the absence of a clear line of racial demarcation made constant, visual judgment necessary to reinforce the unjust laws that defined racial boundaries.[65] This transformation of vision into detailed assessment shaped federal policy and ideals of nationalism in modern life.

Studies on the relationships between detail, visuality, and race in the Progressive Era have long focused on immigration and an expanded definition of what constituted racial whiteness. Before 1924, Ellis Island was the largest immigration station in the United States, a place where US immigrants were, as if individuals in a Mole photograph, sorted, tagged, and moved. In Edwin Levick's photograph *The Pens at Ellis Island, Registry Room . . .* rows of immigrants sit in pens, cordoned off, part of the in-between state after arrival and before landing in Battery Park and beginning a new life (Figure 5.7).

5.7. Edwin Levick, *The Pens at Ellis Island, Registry Room (or Great Hall). These People Have Passed the First Mental Inspection*, 1902–1913, photograph.

The white bars in the photograph seem to superimpose a grid on the seated immigrants in order to assess their place within humanity. The act of sorting is diagrammed in the photograph's compartmentalized, aerial perspective.

During the immigration process, visual tactics became part of national policy. Officials would create a "List of Races or People" based on visual cues—dress, features—that would define their immigrant status. This focus on details was an extension of the era's broader interest in figurative measurement born of eugenics and bureaucratic management.

Yet detailed visual interpretation also became a way to counter rights-based assaults. Consider the work of photographer James Van Der Zee during World War I. For many, Van Der Zee has been seen mainly as a portrait photographer working during the height of the Harlem Renaissance in a practice that spanned over sixty years. Yet his images countered Wilson and Mole's portrait of the nation, an approach exemplified in the photograph of black soldiers from the 369th Infantry Regiment from New York City (known as the Harlem Hellfighters) returning from war (Figure 5.8). The prowess and courage of these men in the face of segregation became a

5.8. James Van Der Zee, *369th Infantry Regiment, Harlem Hellfighters*, ca. 1916, gelatin silver print.

symbol, a rebuke to the segregationist age. On the left, Van Der Zee's composition included the word "Dyeing"—the white letters stenciled on a sign for a dye shop indicating what the words on the upper right make plain—this is a funeral, a ritual to honor a life. In isolation, Van Der Zee's images can seem to be mainly an invaluable index of black life. Instead, his understudied corpus of over twenty thousand pictures represents an aesthetic challenge.[66] Through a fixation on detail, he would insert, for the record, those who were being left out.

This underexplored focus on the visual politics of detail reveals the depth of the data crisis brought on by racial conflict in the United States at the turn of the twentieth century.[67] This history of race and aesthetics is not simply an extension of the focus on detail in the history of punishment discussed by Michel Foucault.[68] As Autumn Womack has deftly argued, there was an epistemic change in the very definition of data during this period as visuality was wed to social science technologies to capture the dynamism of black living.[69] The force of racial dominance expanded the very definition of data to include aesthetic projects.[70] Data regimes took on a new "regulatory grammar" found in forms from the photograph, to innovations

in film, to Du Bois's landmark 1900 Paris Exposition display.[71] The transformation in racial data made interpretation—of films such as *Birth of a Nation,* and monuments writ large—the province of all.

This history of racial detailing registers a long-standing shift in the weaponization of vision in the history of racial formation. In the twentieth century, detailed interpretation became tightly conscripted to racial politics. Detail-driven interpretation—as Wilson implemented, and Kendrick and Murray observed—took on an outsized significance in structuring racial inequity in American life. It later became central to the means to contest it.

Wilson and The Constructive Imagination

On November 6, 1913, Swan Marshall Kendrick and Freeman Henry Morris Murray left a meeting with President Wilson to protest segregation. They had gone with the firebrand Boston *Guardian* journalist William Monroe Trotter, who led the meeting, along with a delegation from the National Independent Political League (NIPL), which included J. R. Clifford and Ida B. Wells-Barnett. The meeting had made one thing plain: Wilson denied that segregation took place due to a directive by the federal government. "There is no policy on the part of the administration looking to segregation," Wilson claimed. Kendrick left the meeting unconvinced. "Whether anything will come out of it or not no one knows, except, perhaps, the president," he said.[72]

Murray was there again at the famous follow-up a year later at the White House, on November 12, 1914, which finally exposed that Wilson knew segregation was being implemented by his administration. "He was so constantly dodging the issue, pretending at times that he did not know that there was segregation, and succeeding in so mystifying the matter that even some good white people, and good friends of ours still felt that the thing was done, but not with his approval," Reverend Francis J. Grimké told his congregation in Washington on Thanksgiving day. After the meeting weeks earlier had revealed it, he said, "the truth has at last come out."[73]

Wilson's method was largely successful in obscuring the full effect of his racial policies from history—until now. He is a president locked in the American imagination as progressive, as an internationalist, but not as a Robert E. Lee, not even as an Andrew Johnson, who oversaw the dismantling of Reconstruction. While he largely succeeded in preserving his image

as a crusader for justice, Wilson could not obscure the truth of his positions from black leaders like Du Bois, Kendrick, Murray, and others who lived through the stark realities of his injustices in real time. He could not hide them from Trotter, who caused Wilson to lose his temper in their second meeting, leading to his expulsion from the White House. These men lived the history that others denied. Their testimony was ultimately silenced; the evidence of their experiences rendered unvisible.

Biographies of Wilson have treated his racism mainly as an odious feature consistent with the biases and traditions of the time. Early biographer Arthur S. Link, for example, recounts that the president's cabinet secretaries recalled Wilson telling "darky stories" during meetings.[74] Patricia O'Toole's deft research unearths that Wilson was the son of a clerk in the Confederate Presbyterian church, a breakaway sect founded after the national Presbyterians decried slavery, who signed the church's foundational document. "We are profoundly persuaded that the African race in the midst of us can never be elevated in the scale of being," it stated.[75] O'Toole notes that Wilson even opposed the use of the term "racial equality" in the preamble to the League of Nations proposed by the Japanese delegation.[76] There is little discussion of his engagement with any efforts toward racial equity, even in a biography with the title *The Moralist: Woodrow Wilson and the World He Made.*[77] It's not surprising, as Link also framed his racism as commonplace: "Wilson was a liberal white supremacist like so many northern academic people of his day," he notes.[78] As Eisgruber reminded us after Princeton's years-long deliberations about Wilson's legacy, this perspective has been shown to be only partly true.

What these biographies leave out is crucial for our modern-day understanding of racial conflict: Wilson modeled a lasting representational regime that let the unspeakable govern racial life without outright decree, eroding the commitment to equity in the United States through bureaucracy. The model of the Wilson administration was not simply one of denials and obfuscation. The bureaucracy of racial detailing crafted statements of racial injustice that were unutterable any other way.

From Wilson's perspective, how to see in racialized American society had been clear. His writing made it explicit: in his eyes, black Americans in the South were "children still."[79] During Reconstruction, the period just after Emancipation, he argued that the South had become dominated by

a vast "laboring, landless, homeless class," once slaves, now free; un-practiced in liberty, unschooled in self-control; never sobered by the discipline of self-support, never established in any habit of prudence; excited by a freedom they did not understand, exalted by false hopes; bewildered and without leaders, and yet insolent and aggressive; sick of work, covetous of pleasure—a host of dusky children ultimately put out of school.[80]

What masked Wilson's blunt views—and what made the intention to seg-regate the federal government so hard to prove—was that the language of rational management and mechanical efficiency both obscured a direct dis-cussion of racial conflict and politics and became the means to create racial discourse via proxy, couched in oblique terms.[81] Industrial capitalism brought a focus on efficient management at the end of the nineteenth century. The chief examiner of what ailed bureaucracy was German soci-ologist and political economist Max Weber. "Friction," he argued, was the problem.[82] The regulation of time and labor would aid the efficiency of in-dustrial capitalism and, as Supreme Court justice Louis Brandeis would state, democracy itself.[83]

The language of rational management operationalized the disregard of racial conflict. As leaders began to use the terms "friction" and "racial friction" to stand in for racial conflict, injustice at the heart of the nation's capital became framed as just an example of "colliding interests." Racism was cast as an impersonal dynamic of physics, as natural as the weather, a tactic that, Du Bois argued, allowed racial politics to be omitted in the writing of history. This approach was also found in school curricula down to common school maps and atlases. Forceful euphemisms were used continually, by everyone from Treasury Secretary William McAdoo to Navy Secretary Joseph Daniels to individuals in everyday exchanges.

Friction was the main reason given to Alain Locke, for example, by his real estate agent to explain why an apartment he wanted to rent in Wash-ington, DC remained empty after the declaration of war. The building had to remain segregated—"all white or all colored"—even though the block was racially integrated. Since a "white tenant is still on the first [floor] flat and will be there till about the 1st of August," the realtor explained to Locke, black "tenants cannot go in, to avoid friction, until Aug. 1."[84]

The mechanical language of rational management had achieved a rhetor-ical reversal: the problem was not racial injustice, but "friction" itself and

those—African Americans—who were creating it. According to this reversed logic, Wilson could tell Trotter that "segregation is not humiliating but a benefit" intended to eliminate friction, and that it "ought to be so regarded by you gentlemen."[85] Segregation was rationalized as a "neutral solvent rather than an act of discrimination" since efficiency, not justice, was the aim.[86] It meant that Wilson could both cloak racial injustice in this language of efficiency and insist that African Americans had created the need for segregation in the first place.[87]

Wilson did more than use the language of friction; he was largely responsible for urging the very study of government administration and civil service bureaucracy because of America's racialized democracy. Wilson wrote his way into history with his theories of governance. He told his then fiancée, Ellen Axson, "I want to contribute to our literature what no American has ever contributed."[88] The first US president to hold a doctorate, Wilson approached his political life as a researcher. After conferring with his advisers, he would often retreat to write and read for such lengthy periods that some worried he would impair his relationships in Washington. When not in meetings, he was in quiet deliberation, as he liked it, "studying maps & reports of experts."[89]

Before he even held office, Wilson wrote about political administration in his widely influential 1887 text "The Study of Administration," making the case for forms of efficiency that could "destroy all wearing friction."[90] Political scientists had focused on the "*constitution* of government" and "the nature of the state" whereas he observed that no one wrote about administration. It meant, he argued, that "we do not study the art of governing: we govern."[91] Wilson would do both.

Long overlooked is the racial thesis behind Wilson's urgent need to separate "administration" from "*politics*" in federal government and civil service.[92] The studies about bureaucratic reforms that had so gripped political scientists were from a history of "foreign races," which meant that these reforms must be "adapted" to meet conditions in the United States. He continued: "we must Americanize it, and that not formally, in language merely, but radically, in thought, principle, and aim as well. It must learn our constitutions by heart; must get the bureaucratic fever out of its veins; must inhale much free American air." Popular sovereignty made organizing in a democracy cumbersome since America's racial and ethnic demography made it a place he characterized as having more "unphilosophical bulk of mankind" than anywhere on the globe, where "one must influence minds cast in every mould of race."[93] Government administration in these condi-

tions had to be free of the demands of politics, he rationalized, which would create a cover for the segregation to come. To say that "slavery" had "diverted us" helped to explain the lack of innovation in US governmental administration, he argued.[94] He stressed that politics should not be allowed to manipulate the bureaucratic workings of offices, which mandated new forms of attention. Scholars have long cited the division Wilson advocated without, to my knowledge, referencing the foundational discussion of racial demography that preceded it just sentences earlier.[95]

In an underexamined essay, "The Study of Politics," Wilson relates that what was needed in bureaucracy was not just efficiency, but also a new way of seeing the world that focused on detail—the foundational scale for assessment in the modern racialized world. The study of politics is not more important than "a constructive imagination and a poet's eye for the detail of human incident," he contended. In fact, for the "student of politics" these skills, he argued, are equally important as "ripe scholarship in history and jurisprudence."[96] He developed the idea further as the essay peels off to explain how to make a mass of data comprehensible as part of the political economy. "The economist must become a literary artist and bring his discoveries home to our imaginations—make these innumerable details" into "a concentrated fire upon the central citadels of men's understandings."[97]

His writing had a peculiar accent on the tidbit, what he calls "some apparently trivial outlying detail which contains the very secret" of politics at large. This, he maintained, is what the political economist is after. These details range from "whose photographs are most frequently to be seen on the walls" to "what books are oftenest" on shelves in homes, to "some piquant gossip about [a] legislator" that could be missed "without the least suspicion that it epitomizes a whole scheme of government."[98]

Curiously, Wilson's reference point for these ideas was not another political theorist, but the study of representation. The twenty-eighth president had first developed this idea about detailed vision for governance in an early lecture, "Mere Literature," borne of his frustration with a tendency to dismiss the arts as unworthy of serious consideration. Scholars have argued that it was primarily a speech-turned-essay that laid out Wilson's educational philosophy, focused more on humanism than on embracing developing technology.[99] It was also, in part, a dig at Wilson's father, who had warned him not to choose a "mere literary career such as you seem to dream about now and then."[100]

Wilson made his argument primarily through visual analogy. To make his point about politics, he referenced ideas about reconstructive history from

the field of archeology. He argued that a mere fragment, such as a "torso" from Rome, was able to "paint that ancient life with the materials that will render it lifelike,—the materials of the constructive imagination." What this approach allowed for is the ability to piece together a world when only fragments were available. By the end of his life, the phrase "constructive imagination" would come up in a profile on Wilson himself.[101] While his article was critiqued for giving "almost too free a rein to his imagination," it did not dissuade him from elaborating on the idea in his studies of government.[102]

In his "Address on the Nature of History" for the 1904 Saint Louis Universal Exposition, Wilson, who had been invited to deliver a speech on any topic, focused on an idea by art historian John Ruskin as the anchor for his thesis, summarized by Ruskin's argument that "Great nations write their autobiographies in three manuscripts,—[sic] the book of their deeds, the book of their words, and the book of their art." It is only then that Wilson moves to discuss government itself, before turning back to reflecting on Theodor Mommsen's archeological *The History of Rome*, which he praises as he did nearly two decades earlier. Here he acknowledges that what he is saying is "radical," but makes a case for how to "build scattered hints into systems, and see a long national history singly and as a whole."[103] Governmental administration, Wilson laid out, required the precise, detailed vision of Arthur Mole.

Wilson gestures toward the work of vision in the rollback against Reconstruction. This period would "obliterate any trace of the marvelous gains made by the freedpeople," as Henry Louis Gates, Jr. puts it, by making unseeing both conditioned and commonplace.[104] We tend to discuss racial ideology through visual evidence—the signs of segregation, the stereotypes that circulated in media. Yet what is left unconsidered is the qualitative shift in vision required to sustain this racial nadir. One had to find a way to tame those details undermining the grand narrative that black Americans deserved their place in the white supremacist order.

Just as Frederick Douglass had a landmark interest in visuality at the end of the Civil War, Wilson was writing, just a decade later, about the work of visuality for holding to a totalizing worldview of racial and social hierarchy. What stabilized judgment in administration and politics, Wilson argued, was the very mode of seeing that could only be understood through culture in modern life.

Detail had become tied to a new form of racial accounting, a new form of knowing, an epistemological production of the world. The drive of the imperial project was to control knowledge, to affirm a social order predicated on racial caste. The question about how details could aid, not challenge, knowledge occupied writers and thinkers from Henry David Thoreau to Henry James, Oliver Wendell Holmes, and painter Frederic Edwin Church, "the nation's first artistic celebrity."[105] The central question, as Thoreau reflected, is how details become more than "information," and instead part of a coherent vision not "marked" and challenged "by discontinuity and difference."[106] Details made seeing objective and conferred new agency.[107]

Wilson's papers and letters telegraph his interest in the act of seeing as much as representation. This interest appears in an early letter from his father Joseph Ruggles Wilson about Ellen Axson going on a trip to Chicago to visit the World's Fair in 1893. He is sure that Wilson's wife would enjoy seeing it because, he wrote, she "know[s] *how.*"[108]

It continued innocently enough. His thoughts seemed to come out largely through his detailed correspondence with Axson, who was training to be an artist during their courtship. He corresponded with her almost daily, often about his ardent love for her, his love of art and, later, his interest in the debates about literature and archeology.[109] He would send her copies of art books, such as Philip Gilbert Hamerton's *The Graphic Arts* (1882), and wrote about art so extensively to her—his love of Ruskin, appreciation of the Walters' collection and more—that he said, only half in jest: "It's sad to think what the world has lost by my not being an artist, is'nt it? [*sic*]."[110]

Just after they got engaged, Axson left to study in New York City at the Art Students League while he was in graduate school at Johns Hopkins University, and Wilson was fascinated by the races of the models she would draw from life in her art classes. She told him about a black model she described as a "'darkie'—not *very* dark however . . . with the most remarkable Pre-Raphaelite hair" as she wondered about the criteria for choosing models. She noted that she had a range of individuals—from a "French Canadian" model to a "famous old Algerian model," along with a "most villainous looking creature" who "looked as though he might be cursing us all the time."[111]

Wilson would write about how he traveled to give lectures and made judgments based on the faces of his audience. "I have scanned the features of the men I see daily at the University" to the point where they seemed "to *fade,*" he wrote. The next year, in the summer of 1894, he lectured at the Plymouth School, where there were students in attendance from colleges including Harvard, Cornell, Wellesley, Vassar, and the University of Georgia.

He longed for a "new *type*" of face in each scan. "It is the study of the characters which the forms suggest, rather than of the forms themselves, that influence me," he emphasized.[112] Eugenics influenced his everyday exchange.

As a scholar, Wilson's interests turned to figuring—studying the nation and its new racial and ethnic composition through photographs, particularly the work of the journalist and Danish immigrant Jacob Riis's *How the Other Half Lives* (1890). This is the recollection of Ernest Poole, a former student of Wilson's at Princeton, and a Pulitzer Prize–winning journalist who would go on to direct a communications arm of Wilson's administration, the Foreign Press Bureau of the Committee on Public Information (CPI). Created by executive order in 1917, the bureau included a Division of Pictures that allowed images to serve an official policy function to support Wilson's program. Poole had been so affected by the introduction to Riis's work that after graduation he moved to New York City's Lower East Side and became a settlement worker to advocate for integrated services for immigrant families. In 1905, Poole went to the Caucasus on the Black Sea. He considered himself to be living through "another Civil War" created from the intolerable conditions of racial violence in America. So he went to the Caucasus region to finally see life on this mountainous line between Europe and Asia. "What took hold on me from the start," Poole said, was "How to picture it? That was my job."[113]

Wilson's writing had coincided with a broad shift in epistemic inquiry in modernity—how to arrive at knowledge of the world itself. Visual entertainments of the day, from humbugs such as P. T. Barnum's Circassian Beauties to Riis's famed photographs, challenged the presumed accuracy of vision.[114] Wilson had come to understand that detail fixation could also be harnessed to create certainty, stability, and racial order. The period of rational management during the Progressive era was born not only of challenges of industrial capitalism, but also of racial politics.

Mapping Federal Segregation

Federal segregation was mapped by executive officials as if a picture made out of fragments and presented as a diagram for understanding the racialized world. The diary of Assistant Secretary of the Treasury Charles Hamlin is the unwritten handbook for how the Jim Crow regime permeated the federal government without bold decree. Hamlin had learned that Wilson

would not agree to a blanket policy about segregation; he would only approve details. In discussions with Wilson, Hamlin noted in his diary that Wilson asked that his rules not be put in writing, only communicated verbally.[115]

Hamlin was forced to arrange details, hidden in documents rarely seen, to shore up racial boundaries. Given the fires that destroyed the Post Office records, a large employer of African Americans in Washington, DC, as well as the reluctance of many government leaders to put in writing their thoughts on policy changes about segregation, the Treasury Department records constitute a rare opportunity to see what this meant for the scope and process of planning federal segregation. Spanning five stories on five acres, the Treasury also employed many African Americans working in the government.

Hamlin requested the following five principles for Treasury governance be conveyed to Wilson:

1. Justice to all.
2. No notices on toilet rooms.
3. No discrimination in promotions.
4. No discrimination in work rooms.
5. No partitions in dressing rooms.

Hamlin shared these items and wrote in his diary that William Gibbs McAdoo, secretary of the Treasury, reviewed them, but would not write down "justice to all."[116] McAdoo, who was also the president's son-in-law and future general counsel of *Birth of a Nation* director D. W. Griffith's production company, United Artists, would take only the other four items to the president for consideration. Hamlin said, reflecting on the meeting, "later in the day he said he had gone over the matter with the President who sheepishly approved the above general rules which were to be given to [Joseph] Ralph verbally." There was another caveat. "As to rule 4 it was distinctly understood" that the department leaders were "given discretion in individual cases to arrange as far as possible w. out open clash, so that *individual* dissatisfaction could be met by reassignment."[117]

Hamlin had tried to bar segregation in his new department, but was stopped by McAdoo. Hamlin would instead issue orders to "obscure" segregation. There would be "No partitions in dressing rooms" and "no notices in toilet rooms" and "no discrimination in work rooms" as examples. He was not permitted to ban segregation entirely.[118]

To instantiate segregation in the Treasury, Hamlin could not point to a public policy, but relied on figuring—mentally diagramming the racial choreography of physical spaces in the office, then noting it in his private diary. In "the postage stamp perforating room," he wrote, there were "150 women of whom 40 were colored. Each machine requires 2 women. Of these, 30 machines are manned entirely by white girls and 10 machines by colored girls. There is no isolation, however, are all near together."[119] In his diary, we have an example of how "bodies and material objects become data," as Womack and Khalil Muhammad argue, and an early example of the "racial data revolution" that came out of the concern for the so-called Negro Problem.[120] These diaries from the Wilson administration are governance maps of the federal segregationist regime.

Hamlin's entries arranged the racial landscape of the US Treasury with meticulous, nervous precision. Black and white women sat alongside each other in the Surface Printing Division, he noted. No black workers were in the Lumbering Division where money was printed, but they were amply represented in the rag laundry, stables, and plate printing area. His diary of detailed observation of everyday life had become a mode of racial accounting, evidence of what Katherine McKittrick would call a "violent arithmetic."[121]

Hamlin itemized the increasing instances of segregation that he witnessed in his diary—a running log of his shock at the administration of the department—as if speaking to a private audience, as if there was no one else to tell. Despite denials, Hamlin noticed "there was segregation . . . even in writing of letters." Typically, "letters were addressed 'Sir' or 'Madam' and signed 'Respectfully yours,'" yet he noticed that when they were "addressed to colored employees the words 'Sir' and 'Madam' and . . . 'Respectfully yours'—were omitted." He logged it in his diary. "Since writing above," he stated, he found that his predecessor made it a custom to always omit the salutations if he knew that the recipient even outside of the White House was a "colored man or woman." Hamlin jotted down that he "Also learned" his predecessor "would never let a colored person sit down in his presence, except once when a colored auditor called on him and that it disturbed him greatly."[122]

The design of the new departmental building made clear what he hadn't been told. He found out that segregation would be implemented in his department only when the director of the Bureau of Engraving and Printing, Joseph Ralph, sent him a memo apologizing that his work on the new plant led to "a very embarrassing situation": they had "overlooked" the need to have separate "toilets and dressing rooms for the colored employe[e]s."[123]

Hamlin learned that one of the last acts of Secretary Treasury John Skelton Williams had been to "remove all colored employees now having desks" in a particular room, and put them all "into the corridors" and "keep them there."[124]

Hamlin spent a great deal of time wondering how three racially indeterminant women would move within the offices. What could be done about female employees "of mixed blood but to all appearances absolutely white"?[125] By his count, there were only three women out of 3,800 who fit this description. Would they consent to going to the colored side of a partition, a proposal for the workrooms suggested by Ralph in 1914? Hamlin sensed that these three women would "bitterly object," as he wrote in his diary, and decided to not erect the partition.[126] With hidden entries, Hamlin regulated the visual geography of racial hierarchy within his office without legislation. After excavating its guiding map, he stored it in diaries, in the mind.

Other departments also contended with the question of how to manage figures of racial refusal. For example, national activist Mary Church Terrell, the first president of the landmark National Association of Colored Women who led the fight to end segregation in restaurants in Washington, DC, recounted how brutally difficult it was to maintain the managerial regime in the Census Bureau. While she worked in this department as a government clerk, she saw "Colored women so fair that they had been assigned to sections set aside exclusively for white women" being "pounced upon," "snatched," and "removed" to "the room to which 'they belonged.'"[127] One day, she saw such a scene "repeated half a dozen times." This is not a story of the consequences of deliberate racial passing. One of the women, Terrell recounts, told her about the examination she underwent by the officer running her section, asking about her parents' racial status. When he asked, "aren't you a colored woman?" as she was so fair, the woman replied, "Yes, I am, I've never denied it."

"Don't you know it was not customary to put white and colored people together in Washington?" he asked.

"No, I was not aware that was the case," she said. "Before I came here, I heard that in some of the departments the two races sat together, so I did not know that by remaining in the room to which I was assigned I was violating some hard and fast rule . . . I am sorry I had to be publicly humiliated to learn this fact."[128]

The very presence of a handful of women whose bodies could not be assessed and read tied the color line in a knot. One woman being racially

unregulated in the sea of humanity had been enough to send Florida Congressman Frank Clark, who sponsored a streetcar-segregation bill in Congress, "straight to the White House." A "fair-haired, blue-eyed octoroon" had taunted him by saying: "I can go into any gathering in churches, theaters, or anywhere else you go," and then did exactly that.[129] In February 1915, this one woman tangling racial lines had "terrorized" him.

Figures who refused racial categories in this system of racial mapping disturbed federal segregation's racial plot in bureaucratic management. The unclear boundaries of segregated space were a physical reminder of the fabricated fact of racial lines. That could be one woman in Washington's public space, three women out of 3,800 workers in the Treasury Department, or an imagined woman from the Caucasus whose image was not yet mapped, determined, or fully known.

Interpretation as Countermeasure

During his time in the Wilson administration, Kendrick saw that two forces were required for racial contestation at the turn of the twentieth century—mass organizing and detailed interpretation. At first, Kendrick focused on large, bold gestures to make change; "mass meetings," for example. He attended several. As he told Moyse, in "Washington people can't vote, you know, and the mass meeting is the only means we have of letting public men, congressmen, etc. know what we think about things."[130] These more overt protests of racial domination are well known. They created part of the foundations of the political strategy of the NAACP, an organization that proved an effective eminent public mediator for cases of racial discrimination, alongside, for a time, Trotter's National Independent Political League.

Yet winning the battles against racial oppression often required a more painstaking approach. Instead of attacking a central policy, one was forced to marshal every single example of a demotion without explanation—a job being "abolished" despite the clerk's excellent service and lack of redundancy, for example—all in an attempt to make the discrimination plain. Archibald Grimké, the Boston attorney and president of the NAACP's Washington, DC Bureau who protested the federal policy of discrimination, realized that effectively combating it meant attending to its pointillist structure, one infraction at a time.

Since the map that controlled the policy of federal segregation was hidden, visual reports were key. Eyewitness accounts by government

workers poured into the office corroborating what was known but denied. The NAACP initiated physical tours of government offices. Assessing political changes from close range became invaluable data to combat unannounced, yet pervasive federal segregation. Those who offered information to counter White House denials of segregation as a federal policy took on a great risk. Kendrick was one of them. Grimké would frequently contact government officials, such as Hamlin, with "what amounted to laundry lists of complaints and grievances."[131] It is just one example of the oblique angle leaders were forced to run in order to make any direct progress.

The mechanistic nature of the procedure—the need to provide a racial mapping of injustices—was grating. Grimké's diplomatic experience had prepared him for this cloaked work, but the administration's tactic of assembling a mountain of barriers and practices, with no public policy of segregation on the books, was unnerving. "What I want is a human feeling toward these people," he finally let out at the House Select Committee on Reform in the Civil Service, the only black employee to testify.[132] The language of racial detailing had done its dehumanizing work.

Kendrick spent his final years, the last years of Wilson's presidency, anticipating the pointillist labor that would be required to combat this dehumanizing violence, to resee the unseen. When not at the War Department or the NAACP office, he analyzed articles and writing as part of The Correspondents' Club, which organized to combat "all efforts in public or private, by speech or writings, to misrepresent, defame, or discredit our race" as well as "to note with equal promptness every favorable comment upon the achievements or character of our race, every generous defense of our rights, and every helpful suggestion for our guidance."[133] The members wrote carefully crafted letters to authors, organizations, and editorial boards. They hoped others would join their efforts.

Kendrick's aim was to magnify the public's conditioned, unexamined fatal acceptance of racial inequity. He began extensive letter-writing campaigns in well-known, mainstream publications of all kinds, tackling instances of representational injustice with missives sent to countless editors, authors, publishers, and stores. For example, on January 22, 1919, he wrote to the Red Cross Magazine to call attention to an article about the US Army that had used a picture of a man of African descent to represent "colored people as a species of clown." He continued, "It seems to me that a magazine whose sole purpose and reason for existence is the development of humanitarian

ideas should realize that we do not promote humanitarianism by fostering contempt or ridicule of our fellowmen, though they be black."[134]

Soon thereafter, on February 23, 1919, he wrote to Samuel G. Blythe of the *Saturday Evening Post* about the racial epithets in the "otherwise excellent collection of war anecdotes." At the time, it was not only "the nation's most popular periodical," but one that was a mouthpiece for nativism and anti-immigrant racism for nearly fifty years.[135] "In every story relating to a colored man, with possibly two exceptions," he argued, "there was in it that tendency to make of every colored man a sort of clown which intelligent colored people so thoroughly detest."[136]

He would also write to M. A. Donahue & Co. that year about a Mother Goose nursery rhyme book that to his surprise contained racial epithets. He described reading the book with his wife to their children: "Mother Goose rhymes, so far as we could recall, have always been free of objectionable features. You can imagine our feeling of disgust, therefore, when in turning the pages for the eager eyes of two little brown babies, we came upon some half dozen pages of which the enclosed is a sample." Even "the New Century dictionary," he continued, defined the epithet as a "'vulgar and opprobrious" term.[137] He wrote to the store selling the book, Woodward & Lothrop on 11th and F street in Washington, DC, that same day.

The store wrote back explaining that his complaint about the book was "the first one we have ever received . . . in nearly sixty years," but Kendrick's work got the rhyme changed. M. A. Donahue himself wrote that despite being able to "justify having printed this rhyme as it was originally written," they would now revise it.

> Now that you have drawn our attention and emphasized the offense that might perhaps justifiably be taken, we have concluded to change the rhyme and wherever the word "negro / nigger" appears, we will substitute the word "black," which we believe will be free of any taint of objection. If you can suggest a better word than "black" that would fill in, we would be glad to entertain it and include it in our future editions."[138]

This illustrated children's book is but one example of how Jim Crow rule extended far beyond government practices, but pervaded visual culture to its core, making such examples commonplace during the era.

Kendrick insisted on contributing to a dream that he would never live out. His letters were posted with the same frequency with which he had

written to his wife during their courtship. On January 17, 1917, he wrote to an editor at the *Washington Post* about distortions in the paper. He stated:

> I am inclosing herewith a clipping from the Washington Post of last Thursday morning, the 11th, and would respectfully ask the authority upon which you base the statements embodied therein . . . The disposition to charge colored people with all sorts of infractions of the law, to single them out as special subjects of criticism on every possible occasion, to make capital out of the faults of the few to the detriment of the many, to indict an entire race for the sins of a few of its members, has long been the chief stock in trade of a certain species of southern politician, but it is a distinct disappointment to find such sentiments emanating from one of whom the public has a right to expect a great deal better.[139]

He also wrote notes praising instances of fair, fact-driven, thoughtful writing, such as Ray Stannard Baker's writing in *The World's Work.* "It requires courage of a sort quite different from the ordinary for a popular writer to present facts as you did to a public," he wrote, "which prefers by far the sort of history taught by 'Birth of a Nation.'"[140] (Baker had written about the need for justice both at home and abroad at a time during World War I, when such a view was rarely seen in print.) Kendrick would also praise an author at the *Metropolitan Magazine* for the "spirit of fairness and candor" in their article about black soldiers during World War I.[141]

Kendrick's letters were part of a strategy used by early civil rights workers to combat discrimination. His pointillist approach would anticipate Du Bois's attempt years later, at the end of World War I, to document the injustice he learned black soldiers had experienced, and how it had been hidden in letters, undisclosed, and obscured. In 1919, Du Bois would find his way to the front to hear firsthand from black troops in the 92nd and 93rd Divisions. There he received letters exposing the clandestine nature of racial domination in the US Army, as Chad L. Williams painstakingly recounts. He read one that "bluntly revealed the United States Army's attempt to indoctrinate their French counterparts with the rules of American racism." He stated that French officers needed to have an "exact idea of the situation of Negros in the United States," including their status as an "inferior being" and sexual tendencies that made black men a "constant menace," advising that they refrain from "'spoiling' the Negroes." Du Bois recalled reading the memo. "I read it and sat very still."[142]

Du Bois returned to the United States on a mission to use *The Crisis* to amass the full set of experiences of black soldiers returning from war and to write a book on the topic. He offered an impassioned plea to those who had put their lives on the line for their country: "Will every Negro officer and soldier who reads these documents make himself a committee of one to see that the Editor of THE CRISIS receives documents, diaries and information such as will enable THE CRISIS history of the war to be complete, true, and unanswerable?"[143] Documenting this history of discrimination and segregation became the unfinished project of his life.

Kendrick's exquisite letters conveying his trials make vivid what has gone missing from the history of racial formation in the United States. Detailed interpretation—exacting and labored—became a political force and tool. The work required to unsee this totalizing regime and legacy would become a weapon.

During Wilson's administration, the American landscape was receiving its first monuments to Emancipation, and with it, the contrasting narratives that made interpretation a national crisis. The Lincoln Memorial was under construction. Georgia's Stone Mountain was dedicated to the Confederacy in 1915 and set on the world's largest piece of granite, three miles at its circumference and just over six hundred acres. Its carved figures of Jefferson Davis and Generals Robert E. Lee and Thomas "Stonewall" Jackson measure three acres across and nearly four hundred feet off the ground. The mass could support so much stone harvesting starting in the 1880s that the stairs of the East Wing of the U.S. Capitol are made with its granite, as are many courthouses and post offices across the country (Figure 5.9).[144]

One of the highest exponents of the fatal dangers of white supremacy, the Ku Klux Klan, enervated in the late 1880s, found its resurgence at the top of Stone Mountain on Thanksgiving night in 1915. Members of the Klan burned crosses at the summit in a fiery display of white supremacist rule, deliberately in advance of the Atlanta screening of D. W. Griffith's film *Birth of a Nation*.[145] The landmark sensation of a film was a blatantly racist narrative complete with countless myths about black ignorance, brutality, and venality that positioned Reconstruction as a failure after the Civil War and the Ku Klux Klan as the saving grace of the United States. This domestic terrorist organization, so vital to the history of white supremacy, the "single most dangerous domestic terror threat in our homeland," as President Joe Biden has noted, was making a critical statement only recently understood:

5.9. Stone Mountain, near Atlanta, Georgia.

culture and symbols were not just a bludgeoning weapon to assert power in public, but also a means to declare the unspeakable truth.[146]

In the history of segregation and the Progressive era, it is now common to focus on bold symbols of white supremacy and how they emerged, in policy and stone, to honor the Confederate Lost Cause, which gained full force at the turn of the twentieth century.[147] Yet Murray wrote at a time in history when influential cultural critics such as Robert Musil would observe how state-commissioned monuments, seemingly hypervisible—bold, declarative, prominent—in the end became invisible. Despite their ubiquity, these public works are often largely unnoticed and unremarkable.[148] These claims did not fully apply to the United States. As silence became policy and unseeing became conditioned, public works about racial politics had to warrant our attention.

The practice of unseeing the fractured foundation of racial dominance created a crucial legacy of indirection, a practice of speaking about racial life by proxy. It has meant that signs, symbols, and markers have had an

outsized role and significance in constructing distinct narratives about national belonging and racial exclusion in American life. In a country built on equality and freedom and unspeakable forms of inhumanity and bondage, visuality and representation have long been vital to articulating the direction of representational democracy itself.

After his meeting with Wilson, Murray saw it too, and decided to draft a project about interpretation—something was being left out of the conversation that would endure longer than any changes in the White House.[149] An activist, he had also been a full-time civil servant in the federal administration since 1884. Nearing the end of his service, he noticed what few others would. Accounting for, and countering, the injustices of American racial policy now required more than law, more than norms, because they were being perpetuated not simply by the bold signs of Jim Crow rule, but also by subtle ones instantiated in ubiquitous misrepresentations in culture at large.

By 1916, Murray was working as a clerk in Wilson's administration and would publish the widely influential, first interpretative study of racial representation in the United States. His book was not a detour from his political work but exemplified his insight that seemingly aesthetic concerns both managed and obscured racial politics. He understood how the visual could convey the unspeakable. Murray aimed for a wide readership for his work. Among other publishing houses, he sent his manuscript to Macmillan Company. "They did not seem to want it," he said of his efforts. He would publish it himself.[150]

Murray anticipated that detailed interpretation would move out of the confines of the desks of art historians, critics, artists, and collectors and into the laps of political leaders, judges, businessmen, and educators—all in an effort to maintain federal segregation. Consider the response to *Birth of a Nation*, which Wilson screened at the White House in 1915, just as Murray was writing his book. Part of the film was not only based on *The Clansman*, a book written by a Johns Hopkins classmate and friend of Wilson's, Thomas Dixon; the film also included intertitles drawn from Wilson's 1902 publication *A History of the American People*.

Birth of a Nation—and the efforts to keep the film in theaters while pacifying protestors—intensified and broadened public consciousness around interpretation as a political force. Two days after the film premiered in Boston, the city's mayor held a meeting to suggest precise edits that would

allow the film to run. Charles Fleischer, a prominent rabbi based in Boston, requested statistics at the end of the film that would present "vital facts of the negro's real progress since emancipation," and Griffith agreed to include new elements to the film that would seem to many as "astonishing facts and figures" about "negro advancement."[151] There was also an appendix to the film, *The New Era*, composed of footage from Hampton Institute's *Making Negro Lives Count* series. Hampton trustees had approved it. *Birth of a Nation* ran with this new ending in Boston's Tremont Theater by April 21, 1915, after its premiere in February of that year in Los Angeles.[152] Civic discussions assessed whether *Birth of a Nation*—"harmful and vicious" as well as "libelous" about black life—could possibly be made palatable through precisely calibrated revisions.

To explain why *Birth of a Nation* was banned in Ohio, the chairman of the state's Board of Censors offered the kind of granular analysis that spilled over into civic critiques of all kinds. While "there are a few scenes on the end of the last reel of said film that show the colored race in a favorable light," he wrote, the effect was "similar to forcing a very nauseating concoction down the throat of a man and then giving him a grain of sugar to take the taste out of his mouth."[153] Echoing this focus on precision, Leslie Pinckney Hill, principal of the landmark black educational institution the Cheyney Training School for Teachers in Pennsylvania, noted that "there might be a scintilla of good connected with the show," in reference to the new addition of the Hampton images at the end. Still, she concluded, "nobody thinks of this when one considers the world of evil which it brings upon us all."[154] The urgent question became whether the new additions could possibly be enough to counter the film's degrading stereotypes.

Assessment focused on fine calibrations to the narrative of *Birth of a Nation*. Boston mayor James Michael Curley, for example, requested the removal of particular lines in the film, with William Monroe Trotter chiming in as simply wanting more of Curley's requests incorporated.[155] Labor leader Eugene V. Debs was one who found this conciliatory approach exasperating. He wrote in frustration about "the chief commercial statistics exhibited at the close of the play to show the progress made by the colored race" and argued that it was just "a weak attempt to excuse the wanton insults heaped upon the race."[156]

The response to *Birth of a Nation* shows that details mattered, and too few had changed. Most critics argued that efforts to counter the overriding narrative of racial domination in the film had failed.[157] Protests over the film would bolster the sense of urgency to enact change through policy measures.

In 1918, for example, Republican Missouri congressman Leonidas C. Dyer would introduce in the House an antilynching bill that built on the painstaking, pioneering work of the crusader journalist Ida B. Wells-Barnett, and earlier attempts to get Congress to pass antilynching legislation.[158] The furor over the detailed misrepresentation of black people in *Birth of a Nation* is one example that fueled Murray's belief that politics and aesthetics were irrevocably fused on the racialized grounds of the United States.[159]

Murray's book begins by addressing silences. He focuses on the conflict at the seat of federal power—the Capitol's reflection of the tension between slavery and freedom. After an analysis of one of the most well-known works of American sculpture central for the discourse on slavery in the United States, Hiram Powers's *Greek Slave,* he cues the reader to omissions. He focuses on a single term, "white silence," a line at the end of Elizabeth Barrett Browning's poem inscribed on the sculpture itself, what he calls "a scathing—and I think, sarcastic—arraignment of Powers' American countrymen for maintaining slavery here." His aim was to analyze not only the messages sent through representation, but also "what they leave unsaid."[160]

After taking the reader on a tour of monuments, he arrives at his main point: the lack of "adequate representation" of Emancipation constitutes a significant problem for the racial depiction of figures in the United States.[161] He then takes his reader on a second tour of works by major figures such as sculptor Meta Vaux Warrick Fuller, whose oeuvre modeled new possibilities—the accurate portrayal of denigrated black lives.

Murray called for a specific form of interpretation: "careful" and "perspicacious." He emphasized, "we can hardly press" its importance of such a form of interpretation "too strongly."[162] He stressed that the force of details has an outsized impact on the messages of works of art. "It is not out and out caricature—bad as its effects may be and sometimes are—that needs to give us the most concern," Murray wrote. "But it is the lethal poison—often only a suggestion; sometimes the mere breath of an insinuation—which lurks in art, particularly in what purports to be serious historic art."[163] What it demanded was observation as a civic skill. "I am convinced that, for Black Folk—in America, at least—this is of paramount importance."[164]

By 1909, Murray had been identified as a progressive leader. He would join the American Negro Academy, entering with Carter G. Woodson and

Arturo Schomburg, after five years of entreaties.[165] His blunt, frank style would cost him allies, but offered him a singular vision. He found a way to steward the movement with a focus on cultural forms. Yet his perspective about the merger of aesthetics, politics, race, and interpretation would take decades, if not nearly a century, to be understood.

Murray's method of writing modeled the form of racial detailing he thought was critical for seeing during segregation—and he managed to complete the book while continuing his work as a federal clerk. He wrote to the librarian in New London, Connecticut, asking how, exactly, they have honored the soldiers on the Colored Soldiers memorial he heard had been erected on Gorton Hill. "What I seek to know is, what sort of recognition have these colored soldiers (and the others) on this monument? Is it sculptural (reliefs or figures) or is it in the form of inscription showing names—the colored being listed with the rest?"[166]

He wrote boldly to the foundry on West 27th Street in New York City that produced the statue he found listed "in the Catalogue of the Art of the Panama-Pacific Exposition" with the title "the 'Nigger.'" He asked to see a picture of it. He noted that he knew it was now owned by Mrs. Harry Payne Whitney (Gertrude Vanderbilt Whitney). This work is now in the collection of the Whitney Museum of American Art, with the new title, *Ethiopian*, part of the history of renaming, discussed earlier, that structurally, however inadvertently, silences such histories. Murray also wrote to famed artist Daniel Chester French in an extended exchange about his sculpture personifying "Africa" installed in front of the Custom House in New York City. She is rendered as if "dozing, napping," her right arm on the rendering of the head of a sphinx, her left arm on a rousing lion.[167] Murray urged an expanded focus on the tactic of detailing being used to cement racial dominance. He aimed to ensure that the expendability of black life was not reflected in a damning omission of representation in public life. The landscape of culture would become an interpretive training ground for understanding the tactics and full scope of the political weapons used to enforce Jim Crow rule.

Early drafts of Murray's book show his frustration that Du Bois himself had not made this argument about the force and power of detailed interpretation and representation. In the early twentieth century, Du Bois was the most influential scholar, critic, and thought leader in Black America, and Murray had the opportunity to identify any blind spots in his colleague's work as his editor at *The Horizon*.[168] Murray was disappointed in what he

saw as Du Bois's "pitifully inadequate" focus on visuality in the journal *The Negro's Progress in Fifty Years,* where Du Bois's essay contained only two sentences on the topic of race and visual representation. To omit any rigorous discussion of visual representation—of the symbols, signs, and markers erected to instantiate Jim Crow rule and to declaim it—was, Murray argued, "a golden opportunity lost," for Du Bois and for the nation.[169] Murray was not about to lose that opportunity completely. There were fatal consequences for ceding the ground of interpretation given the pervasive symbols and propaganda of white supremacist rule.

At the time, Du Bois had, of course, gestured toward the need to require careful visual interpretation to contest segregation. Du Bois had experimented with the idea in a work of speculative fiction, *The Princess Steel* (1908–1910), originally titled *The Megascope.* The plot centered on the wonder of a machine that presents the "Great Near"—the view that aggregates details. Du Bois described these details as the "always present but usually invisible structures . . . that shape the organization of society." The machine is the invention of a black sociologist, Professor Hannibal Johnson, whose megascope looks at data gathered over "200 years." The story, which revolves around how to make sense of a horde of details streaming across centuries, remained in his papers, unpublished.[170]

Du Bois had also created new forms of interpretive scrutiny of the American social and political economy in this racial nadir in his award-winning Paris 1900 Exposition. As discussed earlier, the display consisting of charts, books, maps, and photographs created with his students at Atlanta University examined everything from the value of household and kitchen furniture to the "rise of the negroes from slavery to freedom in one generation." The show began with a map, a sendup of the narratives of white racial supremacy. Du Bois included photographs of black Americans in Georgia along with unusual, innovative charts, a mode of data visualization that let him visually describe and measure progress. Each tackled a racial stereotype: black intellectual capacity; black fertility; "black progress" defined by business, home, and land ownership; and more.

Today, the aim of data visualization is to make information legible at a glance, but the charts in Du Bois's display repudiate that scheme. Each prevents data from being interpreted too quickly. Each forces the viewer to decelerate to understand the demands on black life. It was, he emphasized, a display of progress "made by African Americans *in spite of* the machinery of white supremacist culture, policy, and law that surrounded them."[171] To make that clear required the gearshift Murray had articulated.

Consider the chart showing the value of black property held by African Americans in Georgia. He includes on the graph paper the words "Kukluxism," "lynching," and "political unrest," as if to create a more vivid, more fully representational, picture of the physical terrain by including the social landscape for the property holders (Figure 5.10). It was not enough to chart the change in prosperity. Du Bois's data portraits were not only innovative in their design, but also reflected the burgeoning forms of detailed interpretation necessary to understand modernity and progress in American political life.[172]

Du Bois anticipated that marrying hard data to deeply engaging visual presentations could be a weapon to combat hardening racial boundaries. Yet Murray argued that Du Bois, as one of the few who could impact public discourse, had not gone far enough.

This critical history has been lost in part due to Murray's decision not to call out Du Bois, one of the foremost thought leaders in the United States, by name. He refers to Du Bois only as "the man generally regarded as the leading literary man of the race in America." It was as far as he would go. Murray had been advised by sculptor Warrick Fuller and former Atlanta University president Horace Bumstead to cut down the opening section of his book where he openly critiqued Du Bois. Murray, who had fallen out with Du Bois, protested at first, but ultimately followed their advice.[173]

Yet Murray's views on the civic function of racial aesthetics would have been impossible for Du Bois to ignore. Du Bois owned a copy of Murray's *Emancipation and the Freed in American Sculpture*. It remained in his personal library for decades.[174] Murray's book was seen as landmark during an era when critical debates about the "New Negro aesthetic" were taking place, as proclaimed in the *Washington Bee*, the city's nationally respected weekly focused on black life. Murray himself was in high demand as a speaker. In 1923, he gave a speech surveying racial representation in the United States at the American Negro Academy (ANA), the same night as the annual speech by Arturo Schomburg.[175] The day before, Alain Locke had given a talk on his journey to Egypt as a member of the ANA. Having traveled for the meeting, Locke was likely to have been in attendance for Murray's presentation, especially since Locke would serve on the executive committee of the academy. The president of the academy years earlier was John Wesley Cromwell, a good friend of Locke's who had also written the introduction to Murray's book.[176]

Murray had chosen the wrong target in Du Bois, but by 1916, he could not have known that the right interlocutor was instead forming in the young

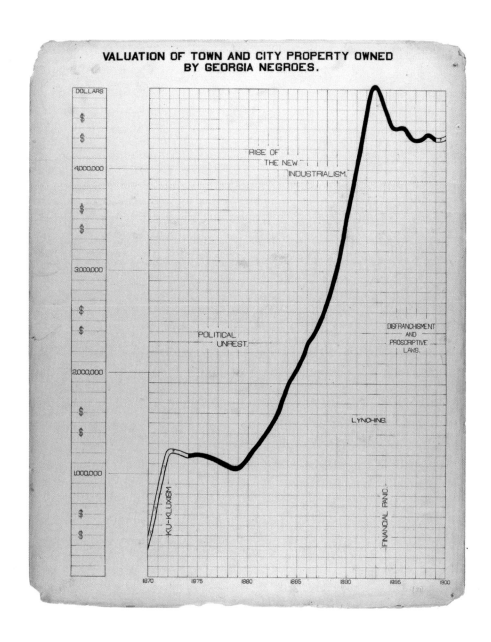

5.10. W. E. B. Du Bois, "Valuation of Town and City Property Owned by Georgia Negroes," in *The Georgia Negro*, Paris Exposition Universelle, 1900, ink and watercolor, 28 × 22 in.

Locke. Well before Du Bois wrote his famous 1926 essay "The Criteria of Negro Art," he had delivered an unpublished lecture at Wilberforce about his tour of "The Art and Art Galleries of Modern Europe." In it, he focused exclusively on non-black art and beauty in the surrounding world.[177] By 1924, Locke would become the "renaissance architect of Black culture," after the publication of the *New Negro* anthology and with it the community, momentum, and vision for the cultural flowering that indelibly rooted black aesthetics and modernism.[178]

Murray's book *Emancipation and the Freed in American Sculpture* is now seen as constituting the headwaters of the study of race and aesthetics. One of the posthumous reviews by Richard J. Powell, writing as editor-in-chief of *Art Bulletin,* offered an incisive retrospective account that telegraphs the foundational impact of Murray's "ahead of its time and even visionary" work nearly a century later.[179]

Yet the long unheralded significance of Murray's work requires no less than a full reconsideration of what truly prompted Du Bois's interest in the art-versus-propaganda debate about race and representation, what influences propelled Du Bois's cultural leadership, and the full scope of the tactics of cultural resistance during segregation. Scholars such as David Levering Lewis have framed Murray emphatically as a "Du Boisian loyalist."[180] He was, but only for a time. The idea of Murray's productive break with Du Bois's thinking and cultural leadership has not been fully considered, to say nothing of Murray's foundational role in the discourse on race, representation, and propaganda in the United States.

By the time Du Bois penned his speech about the force of propaganda, discussed earlier, he had lived out the hope of Murray's argument. At that point, Murray had fallen out of prominence. He was leading the *Washington Tribune* newspaper, which would thrive even through the Great Depression, but was also attending to health issues and was not frequently on the public stage.[181]

Racial Detailing as Protest

The kind of racial detailing and interpretation that Murray argued was a critical weapon of exposure would continue and make plain even one of the most horrific acts of Jim Crow rule: lynching. Public lynchings during this period were governed by the same principle of composite sight—an aesthetics of expulsion. As Bryan Stevenson and Sherrilyn Ifill have argued,

lynchings were not isolated incidents, but deliberate acts tolerated, supported, and frequently photographed by state and federal officials to reinforce a racial hierarchy. Until 1952—the first year to pass with no record of lynchings in the United States—these acts were extrajudicial, distinct from mob violence or hangings that follow a criminal trial.[182] They were a form of domestic terrorism carried out with impunity.

The NAACP's anti-lynching campaign addressed how conditioned unseeing governed the nation. For years, each day after a lynching took place, a flag proclaiming "A Man Was Lynched Yesterday" hung over the organization's headquarters on 69 Fifth Avenue in New York City (Figure 5.11). Its capitalized block-type letters were a call to force the public to pay attention to a particular group of citizens, using a script that rhymed with the routine, near mechanical dehumanization of killing men, women, and children. The flag transformed each murdered human being into an icon in the sky, a counter-veneration.

Unseeing had so desensitized the nation to the terror and violence that advertisements for lynchings could run casually in main city newspapers.

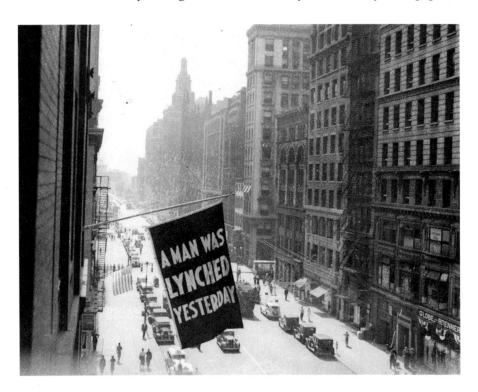

5.11. *Flag, announcing lynching, flown from the window of the NAACP headquarters on 69 Fifth Ave., New York City,* 1936. Photograph print (gelatin silver). Visual materials from the National Association for the Advancement of Colored People Records.

Consider the announcement in the Jackson, Mississippi *Daily News* of June 26, 1919, trumpeting the lynching of John Hartfield as if a popular entertainment in headlines from New York to New Orleans (Figure 5.12). Lynchings were public spectacles, organized with tacit or explicit municipal support. Mississippi Governor Theodore Bilbo told *Jackson Daily News* reporters that he was "powerless" to stop the lynching, but that "a committee of Ellisville citizens" had been "appointed to make the necessary arrangements."[183] Hartfield, who had been accused of assaulting a white woman, had been shot during the manhunt that lasted eleven days and, after receiving medical treatment for his shoulder, was scheduled to be burned alive at 5 P.M. The timing meant that the newspapers that day could offer promotion for the event. As many as ten thousand people attended. His fingers were amputated, passed around the crowd. He was shot after he was lynched. Postcards of the event sold for twenty cents.[184] The countless images of lynching that circulated—detailing "the hellish work of negro persecution," as Frederick Douglass would call it; a practice that "had assumed all the functions of civil authority"—would make clear how immune the country had become to the inhumanity of racial terror.

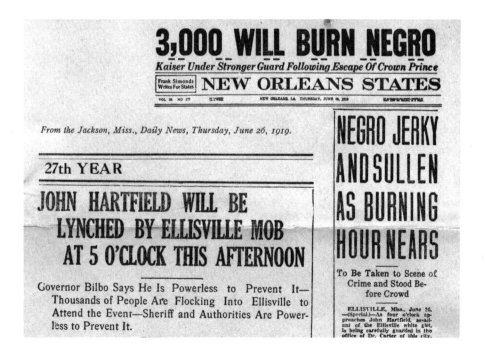

5.12. "John Hartfield Will Be Lynched by Ellisville Mob at 5 O'Clock This Afternoon," *New Orleans States*, June 26, 1919.

Appeals to Wilson's White House to stem the tide of racial terror were met with pregnant silence. Wilson would give letters he received to Attorney General A. Mitchell Palmer, who answered by appealing to state's rights, a code to permit the practice to continue: "The law, as laid down by the Supreme Court of the United States, is to effect that lynching is a crime which can be dealt with only by the State authorities and over which the Federal Government has no jurisdiction." His letter would include the defense of the precedent: "See *Hodges v. United States*."[185] It was not a misstatement. Lynching had become a states' rights issue. But to have the highest legal authority in the country, alongside the president, use both silence and a reference to a legal case shows the degree to which racism had inured leadership from even recognizing that citizens were being murdered, as entertainment at picnics and as public spectacles, literally in broad daylight.

The history of detailing translated into counter-visual tactics for one of the most significant events in the early civil rights movement: the Silent Protest Parade of July 28, 1917. Conceived by James Weldon Johnson and organized by leadership of the NAACP, including Du Bois, this public rebuke of lynching featured nearly ten thousand black Americans marching in total silence down the main thoroughfare of Fifth Avenue in New York City, with women and children wearing white to emphasize their dignity and nobility, and men following in somber dark suits. Placards indicated the pointillist aesthetics at work. "The First Blood for American Independence Was Shed by a Negro Crispus Attucks," one sign read. The replication of a phalanx of whiteness and the decision to spotlight granular facts—as if to counter the aesthetics of Arthur Mole—demonstrates how critical this strategy of racial detailing was both for deploying the regime of racial domination and for repudiating it. A letter from the parade organizers to President Woodrow Wilson only emphasized this tactic of racial accounting. It emphasized the exact number—2,867—who were known to have been lynched by 1917 (new research suggests even more were killed). The letter pressed on, using precise numbers to bring home the personal, unjust nature of the horror and counter the efforts to dehumanize black citizens: "less than a half dozen persons of the tens of thousands involved have received any punishment whatsoever for these crimes, and not a single one has been punished for murder."[186] The document's details were a countermeasure to the attention to precise fragments that had eased the dehumanization of black life (Figure 5.13).

It has fallen to cultural workers and representational tactics to use racial detailing to force a focus on the unstated second injustice behind lynching—a

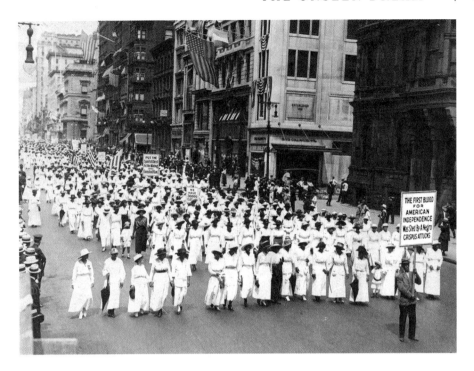

5.13. Underwood & Underwood, *Silent Protest Parade in New York [City] against the East St. Louis Riots*, 1917, photographic print.

corrosive, willful unseeing of this history, and a disregard for any culpability for the act of racial terror, a fact telegraphed in the image of a lynching itself. Artist Kerry James Marshall tackled this history in his 2002 work reflecting on the double lynching of two black men, Thomas Shipp and Abram Smith, in Marion, Indiana in 1930. A mob had taken the men out of the county jail. A crowd of up to an estimated ten thousand had witnessed their killing, their bodies hung from trees. After the murders, crowd members cut off parts of the men's bodies to keep with them as souvenirs. When schoolteacher Abel Meeropol saw the picture, taken by Lawrence Beitler, cropped here, he wrote the plaintive song "Strange Fruit," made popular by Billie Holiday (Figure 5.14).

Lynchings were not complete without their photographic staging that turned human beings into objects, dehumanized dots within the landscape. The often public event of a lynching was meant to exert civic control, as was the strategic distribution of photographs of the horror, commissioned by municipal officers as postcards and mailed to black leaders such as Ida B.

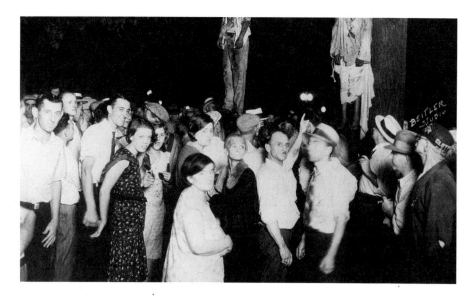

5.14. Lawrence Beitler, view of the lynching of Thomas Shipp and Abram Smith at Marion, Indiana, August 7, 1930, "by parties unknown" *(detail)*.

Wells-Barnett as a second act of terror.[187] The events conformed to a particular template, expelling one body or more with impunity in the midst of a phalanx of homogeneity. The demand for such photographs was startling, and Beitler worked for days to meet it, with his daughter recounting that "It wasn't unusual for one person to order a thousand at a time."[188]

Marshall noticed that the lynching photograph telegraphed a visual rule of unseeing. "Everyone in the photograph is an accessory to a double murder, everyone who was present," Marshall said flatly to the camera when interviewed about the unspeakable tragedy of the source photograph and his painting.[189] Yet, he noticed, each person in the crowd seemed to gaze insouciantly, casually back at the camera even as they stood surrounding the lynched men hanging from trees. It was as if, Marshall states, they knew their presence in the image would be unseen, viewed but then disregarded as accessories to murder.

Marshall used the regime of racial detailing as a form of critique to dramatize this fact (Figure 5.15). In three inkjet prints, he muted the photograph of the lynching so it was reduced to a faint white. Yet in each, he has left one woman's image unaltered, framed with a superimposed locket. The triptych of three portraits shows these figures spotlit from the whitewashed source image. Like lockets, like heirlooms, willful unseeing is also passed

down—and with it, the need to understand this history of racial detailing to combat it.

By the 1960s, the civil rights movement roared into American conscious-ness because of the power of cultural actions—protests, organizing, and documentation from photographs to media—to get people to see what had for too long been obscured and rendered invisible. Wilson took refuge in the shadows before this collective work began. At the time, during the Pro-gressive era, leaders had only just begun to understand the force of the re-gime of racial detailing, of the constructive imagination he had unleashed as a policymaking force for racial inequity. We are starting to realize now that what they were battling was not just outright racial injustice, but also the tactics used to enact it and then render it unvisible to the public at large, seen and then unseen.

This history of racial detailing allows for a reconsideration of the roots of the early foundations of the civil rights movement and the full contestation of the legacy of federal segregation. It shifts our focus from landmark dates—from the founding of the NAACP to the launch of the Freedom Rides of 1947 and the work of mass organizing—to see the unheralded tactics of resistance. The work of giving voice to the unheard took place through more than demonstrable movements of resistance and protests. It included—required—addressing unseeing. It focused on details and eyewitness ac-counts in order to counteract the shift in vision that racial domination had brought about.

In February 2019, after nearly a hundred years of failed attempts, Con-gress passed legislation to make lynching a federal hate crime. It was the first time that federal legislation condemned the use of violence and racial terror that had so long sustained racial inequity, shining a light backward to illuminate the work not only of Ida B. Wells-Barnett, but also of the Ken-dricks, the Murrays, and the cultural workers who had forced the country to see the unvisible. It would take until 1941 for segregation to be outlawed by President Roosevelt's Executive Order 8801, but by then, the shift in vi-sion had taken hold and practices of segregation had become so common-place. During this period, one young photographer, Gordon Parks, would come to Washington, DC to work for the federal government's Farm Secu-rity Administration (FSA) project, which put a face to the depth of suffering during the Great Depression, creating pictures to support the agricultural loans, housing projects, and conservation efforts aimed to combat it. The

5.15. *A (above)*. Kerry James Marshall, *Heirlooms & Accessories,* 2002. Three inkjet prints on paper in wooden artist's frames with rhinestones, 57×54 1 / 4×3 in. (57×54 1 / 4×3 in. with frame), and *B (detail, right)*.

trove of over 165,000 prints from the FSA–Office of War Information Collection, a portrait of the country from the Great Depression through World War II, is the greatest collection in photographic history. Republicans wanted it shut down and succeeded in 1942.

It is against the backdrop of segregation, specifically in Washington, DC, that Parks transformed the very model of documentary photography and the role of images as weapons in the long civil rights movement. His central question: How could he get people to see past the unseen, to overcome the near studied, practiced disregard that had ossified in the racial stratigraphy of American society? His aim was to get a viewer to "have some human feeling for these people," as Grimké would say, expressing frustration at the inability to move past the mechanical language, denials, and obfuscation of federal segregation.[190]

Parks had come to Washington inspired, but within a day his elation, like Kendrick's, had turned to disbelief and then determined outrage. Born in Fort Scott, Kansas, having lived in Minnesota and Chicago, he saw nothing but the principle of equality and justice when he arrived in the nation's capital. He looked at "The White House, the Capitol and all the great buildings wherein great men had helped shape the destinies of the world" and hoped to "borrow from their tradition."[191] He walked with confidence into the office at Fourteenth and Independence Avenues.

He met with the head of the Farm Security Administration, Roy Stryker—the ringleader of the agency's band of roving photographers from Dorothea Lange to Ben Shahn and Arthur Rothstein—who promptly took away Parks's cameras, a Rolleiflex and a Speed Graphic, and locked them in a closet during their first meeting.

"You won't be needing those for a few days," he told Parks.

Stryker instead asked him to experience Washington, DC, to "walk the city. Get to know it," and perhaps most importantly, attempt to buy a few things. After a few days of this, he wanted Parks to report back.

Parks's entire worldview changed. He went to a drugstore to get breakfast and was denied. He tried to see a movie. Same thing. He tried to buy a coat at a department store and was told, when someone finally helped him, that the store didn't have his size. They never asked what his size was. This led to a "ridiculous" stand-off between Parks and the retail staff. Parks sat on the couch. No one would help him try on a single coat or look for his size. The manager came to speak with Parks, but would not help him try on clothes.

"Such discrimination in Washington D.C., the nation's capital," was, he wrote, "hard to believe."[192] Parks said of his experience in 1942 that "discrimination and bigotry were worse there than any place I had yet seen."[193]

He went back to Stryker sooner than he imagined, eager for his cameras. After their conversation, Parks wrestled with how to craft a way to convey visually the paradox of this injustice—to unsilence it.

Vibrating throughout the story was Parks's experience of the kind of segregation and Jim Crow rule he did not expect, the kind Kendrick did not foresee could be possible in the nation's capital, the kind Murray fought to make visible through visual analysis—a disbelief about the unseen. Stryker had locked the young photographer's camera away at first to make a point—that anything Parks had imagined he might do with his camera before coming to Washington, DC would not work until he had witnessed it for himself. New tactics, a new visual strategy, were needed. Parks would, as Stryker urged, "think it out constructively," as if echoing Woodrow Wilson's chosen term, to find a way to undermine, with a new intentional force, the construction of the regime.

Parks found a model through a now iconic image, *American Gothic* (1942), a portrait of Ella Watson who worked cleaning the notary public offices. She stands holding the tools of her trade, a mop and broom, in front of an American flag. Her polka-dotted dress, with one button missing and another broken, rhymes with the flag's stars as if a reminder of the heralded dots in the landscape of the United States. Parks had met Watson one night at the start of her shift that ended at 2:30 A.M. He learned of her strength and resolve: her father had been murdered by a lynch mob. Her husband had been killed just before her daughter was born. She was, as her great-great granddaughter would relate, a "Proverbs 31 woman" who wouldn't abide being idle, but whose life was built by "all that her hands have done."[194] Here, as photographer LaToya Ruby Frazier, a contemporary heir to Parks, explains, Ella Watson stands "in front of the American flag in a society, a nation, a government that doesn't recognize her as a full human being" (Figure 5.16*A, left*).[195]

Parks's *American Gothic,* when set against Mole's larger collective portraits, makes vivid the critical work of racial detailing as an act of political resistance in the wake of the second founding of the United States and the long legacy of reconstruction after the Civil War (Figure 5.16*A, B, left and right*). If one aim of the American Civil War "was to replace the sentiment of section with the sentiment of nation," as Louis Menand has argued, an

5.16. *A (left)*. Gordon Parks, "*American Gothic*," *Washington, D.C.*, 1942, Harvard Art Museums/Fogg Museum, Transfer from the Carpenter Center for the Visual Arts, Beinecke Fund, © Gordon Parks Foundation, Photo President and Fellows of Harvard College, 2.2002.1000, gelatin silver print, 13 3 / 16 × 9 5 / 8 in. *B (right)*. Arthur S. Mole and John D. Thomas, *The Human U.S. Shield*, 1918, gelatin silver print, 12 13 / 16 × 10 3 / 8 in. The Museum of Modern Art, Gift of Ronald A. Kurtz, 351.1994.

THE HUMAN U.S. SHIELD
30,000 OFFICERS AND MEN
CAMP CUSTER, BATTLE CREEK, MICH.
BRIG. GEN. HOWARD L. LAUBACH COMMANDING.

1918
MOLE & THOMAS
315 MEDINAH BLDG.
CHICAGO, ILL.

effect of America's involvement in World War I was the attempt to conflate the concept of nationalism with racial whiteness.[196] Mole's widely hailed work constructed a collective portrait of the United States with a precision that reflected the rigid hierarchy of racial difference and a reliance on detail that became the means through which it was done. Parks shows what it would take to undo it—the same penetrating insistence that guided Murray's work and Kendrick's painstaking letter-writing campaign, both calling attention to those narratives honoring black life that were being left out.

Given Parks's work, it is perhaps no surprise that, in 1947, he would photograph Dr. Kenneth Clark and Dr. Mamie Clark's study known as "the doll test" showing the psychological impact of this racial inequality, which became key evidence in the *Brown v. Board of Education* Supreme Court decision that would help outlaw segregation. Parks's work helped the public to forsake a studied disregard for inequality—an unseen truth long denied. If representation had become a "weapon," as Parks argued, it was because it harnessed the power of interpretation that Murray, that Kendrick, that Marshall knew was critical to address injustice and inequity in American racial life. When seen in the context of Murray and Kendrick's labors, it becomes clear that Parks was not only working within an aesthetic tradition of documentary photography. He was one of many civic actors who saw politics as conditioned by a cauterizing visual regime of interpretation that had come to pervade civic life.

After Swan Marshall Kendrick died, his daughter, Charlotte Swan Kendrick Brooks, worked alongside her son Joseph Kendrick Brooks to self-publish a biography of her ancestors. It is now in the Library of Congress, ensuring that the unseen will not be unheard. Much of the manuscript is crafted from the letters between her parents. We also have this family history due to the perseverance of Kendrick's sister, Hattie D. Kendrick, who worked at age ninety-five to record the family's lineage, and of Ruby Moyse Kendrick, who saved her letters with Swan Marshall Kendrick for sixty years. Kendrick's sister would go on to work in a middle school and file a suit against the Cairo Board of Education in 1941 that was won by Thurgood Marshall, then chief counsel for the NAACP.[197] The Kendrick-Brooks family history, along with Murray's work, models not only the precise, painstaking work of the long civil rights struggle, but is a testament to the force of the racial detailing that obscured the forms of racial domination we seek to undo.

"The ancestors deserve to know that their struggles were not in vain; that their hopes and dreams for their children and their children's children have

in very large part been realized, and will continue to be realized," Charlotte Swan Kendrick Brooks wrote in the preface to her biography. "The descendants will learn at least partially from this story what the people of their own blood have lived through and suffered, and that they were strong, competent, persistent and enduring, loving people who deserved much better than slavery, disfranchisement and—worst of all—the lies told to conceal their humanity, intelligence and courage."[198]

The conditioned unseeing common in Wilson's administration did not arrive at the turn of the twentieth and twenty-first centuries. It was part of a fundamental transformation of vision that emerged in the nineteenth century in order for racial domination to survive. We do not "see," but as Wilson put it, have so "learned how" to unsee the fractured foundations of racial domination such that it is nearly second nature.

Wilson never did or could receive a report about the look of women from the Caucasus region. He had asked for the report to be delivered in person. He suffered a stroke shortly afterward. Yet there was nothing lost at that point by not seeing images of the actual Caucasus region in the United States. Racial domination had created a shared language to both legitimate and unsee the false foundations of racial hierarchy, one naturalized to become part of the everyday circuits of vision in American life.

We have not been told about the fictions underlying the logic of racial domination; we have been conditioned not to see them. We have been trained to ignore them as the regime of racial hierarchy was stabilized through a history of negative assembly, erasure, and racial detailing. These practices have served to mask the fictions that supported racial domination, once codified into law, but still present today. These tactics find force precisely because they are so common to racialized norms in the United States that they are easy to miss.

A visual racial regime accommodated unspeakable fictions at the basis of racial supremacy. Racial supremacy in the United States was built on more than stereotype, and to undo the damage will require more than redemptive images. The unseen truth of silencing and racial detailing to secure racial domination is cloaked in the very roots of modern American culture. There is an invective, a near epistemic violence, to the silence around this history. For far too long, the tactics employed to naturalize the reproduction of fictions beneath our racial order have masked the foundational lie that Kendrick Brooks exposed: there was never any basis for asserting the superiority of any American racial group over another at all.

Epilogue

It Takes So Long to See

I was not expecting to stand just feet from Woodrow Wilson's tomb and memorial on the ground floor of Washington National Cathedral. I had come to see a new commission that the church was set to unveil: stained glass windows and tablets by artist Kerry James Marshall and poet Elizabeth Alexander to replace those dedicated to Confederate generals Thomas "Stonewall" Jackson and Robert E. Lee that had remained for seventy years. Wilson's tomb had been deliberately installed beneath these stained-glass windows, which had been erected years earlier through a gift from the United Daughters of the Confederacy (UDC). After being invited to speak about the new commission, I had asked for a tour and then noticed what had gone unmentioned in all the reporting: Wilson's memorial would now be directly next to the new Marshall windows and Alexander tablet. Joined by an open-air arched passageway, they are porous to each other, connected through place and time.

Wilson is the only president buried at Washington National Cathedral. His sarcophagus and cenotaph are in the nave next to the pews for worship. The church was built by an act of Congress and deliberately set on the highest point in the area as a house of prayer for all people. Initially, Wilson was buried one floor below ground in Bethlehem Chapel. More than three decades later, he was raised to the main-floor level and given his own bay with three windows designed by Ervin Bossányi portraying allegories of God's blessing, forgiveness, and destroyed peace.

In the 1950s the cathedral's dean, the Very Rev. Francis B. Sayre Jr., oversaw both the installation of the Confederate windows and the prominent placement of Wilson's tomb in the nave dedicated one hundred years after his birth. Sayre was also Wilson's grandson. Years earlier, Rev. Canon Merritt F. Williams had advocated for the windows, rejecting a proposal from the UDC for a bronze plaque to honor Lee in the crypt. "Only a memorial commensurate with General Lee's position among the nation's great men would be acceptable to the cathedral," he said.[1] The date of dedication in 1956 was chosen to coincide with the national UDC convention (Figure E.1.*B*).

The cathedral's pulpit was also the site of Martin Luther King Jr.'s final Sunday sermon on March 31, 1968, days ahead of his prophetic "Mountaintop" speech before he was assassinated. That day, King spoke from the cathedral's pulpit ahead of his Poor People's Campaign, pressing the conscience of the congregation with the moral outrage of poverty. On April 5, just a week later, over four thousand would come to the cathedral for his memorial service.

Yet Sayre would also speak to the very causes that had brought King to the cathedral, turning it into an arena for civil rights discussions during

E.1. *A (left)*. Stained glass window *(detail)*, *Now and Forever*, designed by Kerry James Marshall. National Cathedral. *B (right)*. President Woodrow Wilson's tomb, National Cathedral *(detail)*.

his tenure. Months before the dedication of the Confederate generals' bay and windows, Sayre had delivered a speech critiquing segregation while advocating for equality and a presidential commission on human rights, published in the *Washington Post*. It was a space that uncloaked the same histories of racial violence and conflict in American life for which Wilson had shown such studied and conditioned disregard.

The killing in June 2015 of nine black worshipers at Mother Emanuel AME Church in Charleston, South Carolina, carried out by a white supremacist who had previously posed for photographs with guns and the Confederate flag, prompted cathedral dean Gary Hall to reconsider the stained glass windows honoring the Confederate so-called Lost Cause. The irony of windows dedicated to unseeing the violent past was too much to ignore.

The new commission by artist Marshall and poet Alexander would be not only next to Wilson's memorial bay. It was also adjacent to one that honors Andrew W. Mellon. The Mellon memorial was dedicated in 1952 also by Sayre and the Right Rev. Angus Dun. Beyond being renowned for her poetry, Alexander became president in 2018 of the Andrew W. Mellon Foundation. It was an accident of destiny.

Together, Marshall and Alexander's commission and Wilson's grave constitute an American triptych. They symbolize the forces—culture and civic society—through which we revise the narratives about who counts and who belongs in American life.

"It takes so long for us to see," the cathedral's Rev. Canon Leonard L. Hamlin said after a long silence as we stood looking at the new windows with the tomb beside them. "Time has brought us to this point," he added, turning to me. "It is easy to go to one side or the other, but the center point, that tension, that's where we go to find answers and learn about ourselves."

I had nearly missed the memorial bay for Wilson. To see it, I had to move up close, shift my vantage point, and stay aware of the full detail that surrounded me, not just what might be of interest for my current task. Because the works are all in a row, side by side, to see them all together I also had to stand back to view it at a distance. To notice that the three were together took curiosity, patience, effort, and time.

It takes so long for us to see. I thought of the canon's words as I went back to my hotel, turned on the television, and saw the January 6 hearings. The

focus of the House select committee investigation that year was getting the public to believe that what we saw—over two thousand violent rioters attacking the US Capitol in 2021 to prevent the peaceful transfer of power, incited by the then sitting president—was what we saw.

We are in the midst of a crisis of regard in the United States, amidst our triumphs. Our persistent unwillingness to see each other has put pressure on the operation of vision itself. We have shaped our own self-portrait, we have transformed what *is,* through omissions and negations. We have had debates about monuments and markers—even stained glass windows— because we know the facts of what they were meant to do.

The contradictions at the country's founding—the tension between slavery and freedom, between equality and a commitment to the fabrication that upheld racial dominance—have played out nowhere more than in the visual realm. They have made vision—the work of seeing the full truth in this extraordinary history—the crucible of American democracy. In the United States, the history of unseeing is so pervasive that it takes will and work to acknowledge what is right before our eyes. As King said that day from the pulpit, "human progress never rolls in on the wheels of inevitability," but comes from "tireless efforts," which include those on display in the cathedral by Alexander, by Marshall.

It took years to understand the larger stakes behind Wilson's request for a closer look at people in the Caucasus region. When I thought this research was finally complete, I prepared to give a talk on New York University's campus. Four individuals arrived at the lecture hall early. They sat silently in the front rows of the narrow classroom, looking less curious than determined, as if I were going to begin the presentation at any moment. I told them that I would not be starting for about thirty minutes. They said they would go out for coffee and come back. They returned to their seats and watched me with the same air of inspection. After a few minutes into my opening remarks, I began speaking about the Caucasian War and the history of the Caucasus region's image in the United States. Surprisingly, they appeared more at ease. Their arms unfolded, one whispered to another, and they began to relax.

It turned out that the group were all descendants of Circassians from the Caucasus. They lived in New Jersey, part of the Circassian diaspora that spans Iran to the United States. They had been tracking my research online for notices of upcoming talks. My book seemed to wrest the history of their region from the predominance of its associations with racial science. They

were aware of the gulf between their own history and how the image of the Caucasus had been used for centuries to support racial ideology.

I was stunned when, at the end of my lecture, they gave me the first of two gifts: a large green and gold Circassian flag. The other gift would arrive by mail later at my office. It was a flash drive. I held my breath slightly before opening it. After all, the book was nearly done. On the drive was every primary document they had found about the history of their homeland of Circassia from the Library of Congress and the British Foreign Office. Multiple folders held documents separated into categories—maps, articles, notices about Barnum's Circassian Beauties, atlases that had circulated in American homes. I pored over the contents of the flash drive for months. The physical gift was so tiny, whereas the contents were a trove I had worked to amass for more than ten years. Here were many of the same articles and maps I had found while excavating this history. The meaning of these files—the preciousness of them, the way in which they had been passed down from one leader in the community to another—lingered with me, imparting an urgency to convey the stakes of our failure to see this history anew.

There was a time when American society glimpsed the Caucasus and could see the fault lines of race, the fictions underneath the entire structure of racial categorization and racial domination. This is a forgotten history that consists of more than the moment when Americans saw the region, rendered it unvisible, and pressed on. It exposes the creation of a foundation for racial hierarchy as if a photograph with no true negative, no stable referent to be found.

What has been traced in this book is an untold history that many have refused to see, and some thought unworthy of seeing. The story of race in America can only be told while being attuned to the precise consideration of information that falls off the edges of our vision. It requires attention to the nuance, to the shard, to representations, as much as to recasting the history of racial formation we think we know. By not paying attention to what has been silenced, and left out of sight, we have created a racial regime of adjudication that is so devastating that it is perhaps only possible to see, to withstand, to take in one fragment of assembly at a time.

To examine this history is to expose how we have learned *not* to see the fictions that legitimated racial injustice and inequity. The work of revision—of re-seeing—must continue. For where we once blocked our rightful view of each other, we now have the means to construct windows. The question is whether we still have the will.

NOTES

Introduction

1. Serene Jones, "Ferguson Decision Reveals the Brutality of Racism," *Time,* November 25, 2014.
2. By assembly I am thinking of the framework created in Paul C. Taylor, *Black Is Beautiful: A Philosophy of Black Aesthetics* (Chichester, UK: Wiley Blackwell, 2016).
3. Henry Louis Gates, Jr., *Stony the Road: Reconstruction, White Supremacy, and the Rise of Jim Crow* (New York: Penguin, 2019), 37.
4. The Caucasian racial category had come about from the work of Johann Friedrich Blumenbach, who inaugurated the Caucasus as the homeland of whiteness in 1795. See Johann Friedrich Blumenbach and John Hunter, *The Anthropological Treatise of Johann Friedrich Blumenbach and the Inaugural Dissertation of John Hunter, M.D. on the Varieties of Man* (London: Anthropological Society, 1865). This tract located the Caucasus region more generally as the homeland of white racial purity for three reasons: skull symmetry, beauty, and antiquity-rooted heritage and biblical lore. Historians have maintained that Blumenbach borrowed the term "Caucasian" from his colleague and rival Christoph Meiners (1747–1810) without citing him. Blumenbach glossed the term "Caucasian" by referencing not Meiners, but a travel account by Jean Chardin. Meiners, who taught with Blumenbach at the University of Göttingen in 1776, had devised a two-category racial system comprised of the Tartars—the Caucasian and the Mongolian. Johann Friedrich Blumenbach, *On the Natural Variety of Mankind,* quoting Chardin, *Travels of Sir John Chardin,* vol. 1, 171, in *The Anthropological Treatise of Johann Friedrich Blumenbach,* ed. and trans. Thomas Bendyshe (London: Anthropological Society, 1865), 269. Among the foundational texts on the history of Blumenbach vis-à-vis the construction of racial whiteness are David Bindman, *Ape to Apollo: Aesthetics and the Idea of Race in the 18th Century* (Ithaca, NY: Cornell University Press, 2002); Matthew Frye Jacobson, *Whiteness of a Different*

Color: European Immigrants and the Alchemy of Race (Cambridge, MA: Harvard University Press, 1998); and Nell Irvin Painter, *The History of White People* (New York: W. W. Norton, 2010).

5. As David Bindman notes, what we now term racial science is a nineteenth-century development that began in the seventeenth and eighteenth centuries as an investigation of what was termed "human variety." Bindman, *Ape to Apollo*, 11-13. Toni Morrison offers a blunt assessment of the twinned nature of the interpenetration of the Enlightenment and scientific racism; see Morrison, "The Site of Memory," in *Inventing the Truth: The Art and Craft of Memoir*, ed. William Zinsser (Boston: Maringer, 1998), 189.

6. The Caucasian War as one stage in the longer colonial conquest of the region has been studied extensively and is the constitutive foundation for understanding the Chechen conflict of the twentieth and twenty-first centuries. See Thomas Barrett, "Southern Living (in Captivity): The Caucasus in Russian Popular Culture," *Journal of Popular Culture* 31, no. 4 (Spring 1998): 75-93; Moshe Gammer, *Muslim Resistance to the Tsar: Shamil and the Conquest of Chechnia and Daghestan* (London: Taylor & Francis, 2003); Moshe Gammer, "Nationalism and History: Rewriting the Chechen National Past," in *Secession, History and the Social Sciences*, ed. Bruno Coppieters and Michel Huysseune (Brussels: VUB Brussels University Press, 2002), 117-140; Amjad Jaimoukha, *The Circassians: A Handbook* (New York: Routledge, 2001); Austin Jersild, *Orientalism and Empire: The North Caucasus Mountain Peoples and the Georgian Frontier, 1845-1917* (Montreal: McGill-Queens University Press, 2002); Rebecca Gould, *Writers & Rebels: The Literature of Insurgency in the Caucasus* (New Haven, CT: Yale University Press, 2016), 26; Michael Kemper, "Khālidiyya Networks in Daghestan and the Question of Jihād," *Die Welt des Islams* 42, no. 1 (2002): 41-71. See also Yo'av Karny, *Highlanders: A Journey to the Caucasus in Quest of Memory* (New York: Macmillan, 2000); Charles King, *The Ghost of Freedom: A History of the Caucasus* (New York: Oxford University Press, 2008); Walter Richmond, *The Circassian Genocide* (New Brunswick, NJ: Rutgers University Press, 2013); and Bruce Baum, *The Rise and Fall of the Caucasian Race: A Political History of Racial Identity* (New York: New York University Press, 2006). For a photographic reflection on the history of the Caucasian conflict, see Thomas Dworzak, *Kavkaz* (Amsterdam: Schilt, 2010).

7. Michel-Rolph Trouillot, *Silencing the Past: Power and the Production of History* (Boston: Beacon Press, 1995), 7.

8. Beyond Henry Louis Gates, Jr., *Stony the Road*, a few of the key texts on visuality and racial stereotype in the United States include Lee D. Baker, *From Savage to Negro: Anthropology and the Construction of Race, 1896-1954* (Berkeley: University of California Press, 1998); Donald Bogle, *Toms, Coons, Mulattoes, Mammies, and Bucks: An Interpretive History of Blacks in American Films* (New York: Bloomsbury Academic, 2016); Richard Dyer, *The Matter of Images: Essays on Representation* (London: Routledge, 1993); Richard Powell,

Going There: Black Visual Satire (New Haven, CT: Yale University Press in association with the Hutchins Center for African & African American Research, 2020); Michelle Wallace, *Dark Designs and Visual Culture* (Durham, NC: Duke University Press, 2004).

9. Ivan S. Golovin, *The Caucasus* (London: Trubner & Co., 1854), 57, 74–75.

10. As I discuss in Chapter 1, the level of interest in Shamil is registered by the number of books that emerged about the leader, particularly during the height of the Crimean War.

11. Drew Gilpin Faust, *This Republic of Suffering: Death and the American Civil War* (New York: Vintage, 2008), xi; Jersild, *Orientalism and Empire*, 12.

12. While the idea of the Caucasus is extensively documented in the context of the Russian Empire, commensurate examinations in the United States do not currently exist. Similarly, while the engagement with Shamil in the United States is an understudied topic, the literature on the reception of Shamil in the Russian-Soviet and European context is vast. See Jersild, *Orientalism and Empire*, esp. chapter 6. A few key texts include Aida Azouqa, *The Circassians in the Imperial Discourse of Pushkin, Lermontov and Tolstoy* (Amman: The Deanship, 2004); Thomas Barrett, "The Remaking of the Lion of the Dagestan: Shamil in Captivity," *Russian Review* 53 (1994): 353–366; Gammer, *Muslim Resistance to the Tsar;* Gammer, "The Imam and the Lord: An Unpublished Letter from Shamil to the British Ambassador in Constantinople," *Israel Oriental Studies* 13 (1993); Gammer, "Nationalism and History"; Anna Zelkina, *In Quest for God and Freedom: The Sufi Response to the Russian Advance in the North Caucasus* (New York: New York University Press, 2000); Leila Aboulela, *The Kindness of Enemies* (New York: Grove Press, 2015).

13. James McCune Smith, "Introduction to *My Bondage and My Freedom* (1855)," in *Douglass in His Own Time: A Bibliographical Chronicle of His Life, Drawn from Recollections, Interviews, and Memoirs by Family, Friends, and Associates*, ed. John Ernest (Iowa City: University of Iowa Press, 2014), 105–119.

14. Charles Mills, "White Ignorance," in *Race and Epistemologies of Ignorance*, ed. Shannon Sullivan and Nancy Tuana (Albany: State University of New York Press, 2007), 13–38; Miranda Fricker, *Epistemic Injustice: Power and the Ethics of Knowing* (New York: Oxford University Press, 2007). Also see Charles Mills, "Ideology," in *The Routledge Handbook of Epistemic Injustice* (New York: Routledge, 2017), 100–111. Many scholars have shown how white racial formation was constructed as a category of social power and, as Cheryl Harris has shown, a form of property to be protected. A key aspect of the production of race was, as Richard Dyer and others have argued, to maintain whiteness as an unmarked category. See Dyer, *White;* George Lipsitz, "The Possessive Investment in Whiteness: Racialized Social Democracy and the 'White' Problem in American Studies," *American Quarterly* 47, no. 5 (1995): 369;

Cheryl Harris, "Whiteness as Property," *Harvard Law Review* 106, no. 8 (June 1993): 1707–1791; Sara Ahmed, "A Phenomenology of Whiteness," *Feminist Theory* 8, no. 2 (2007): 149–168, and "Declarations of Whiteness: The Non-Performativity of Anti-Racism," *Borderlands* 3, no. 2 (2004). The scholarship on the construction of whiteness is vast and discussed throughout this book, particularly in Chapter 1, and includes: Reginald Horsman, *Race and Manifest Destiny: The Origins of American Racial Anglo-Saxonism* (Cambridge, MA: Harvard University Press, 1981); Noel Ignatiev, *How the Irish Became White* (New York: Routledge, 1995); Matthew Frye Jacobson, *Whiteness of a Different Color: European Immigrants and the Alchemy of Race* (Cambridge, MA: Harvard University Press, 1998); and Nicholas Mirzoeff, *White Sight: Visual Politics and Practices of Whiteness* (Cambridge, MA: MIT Press, 2023). On the pitfalls of the presumed invisibility of whiteness, see Adrienne Brown, *The Black Skyscraper: Architecture and the Perception of Race* (Baltimore, MD: Johns Hopkins University Press, 2017); Eva Cherniavsky, *Incorporations: Race, Nation, and the Body Politics of Capital* (Minneapolis: University of Minnesota Press, 2006); Hamilton Carroll, *Affirmative Reaction: New Formations of White Masculinity* (Durham, NC: Duke University Press, 2011); Robyn Wiegman, "Whiteness Studies and the Paradox of Particularity," *boundary* 2, no. 26.3 (Fall 1999): 115–150; and Claudia Rankine, "Brief Encounters with White Men," *New York Times Magazine,* July 21, 2019, 38.

15. We see lurches toward this consolidation of the term "Caucasian" with language in the 1911 Dillingham Commission's Report on Immigration, which invoked Blumenbach, endorsing his fivefold definition of race and compounding the use of Caucasian as a concept, not a visible, legible category. Jacobson notes that the *Dictionary on Races and Peoples* published by the Dillingham Commission stated that "Caucasian" would signify "all races, which, although dark in color or aberrant in other direction, are, when considered from all points of view, felt to be more like the whole race than like any of the other four races." Jacobson, *Whiteness of a Different Color,* 2, 79. For more on the Dillingham Commission, see Jacobson, *Barbarian Virtues: The United States Encounters Foreign Peoples at Home and Abroad, 1876–1917* (New York: Hill and Wang, 2000); Katherine Benton-Cohen, *Inventing the Immigration Problem: The Dillingham Commission and Its Legacy* (Cambridge, MA: Harvard University Press, 2018).

16. Jacobson, *Whiteness of a Different Color,* 135.

17. Ian Haney López, *White by Law: The Legal Construction of Race* (New York: New York University Press, 1996), 3.

18. Haney López, *White by Law,* 5. The first case in which common knowledge was used as the foundation for the verdict was the 1878 *In re Ah Yup* federal district court case. It was not until 1909 that the courts were in conflict about whether racial science or common knowledge should prevail, with answers

solidified in 1922 and 1923 with two Supreme Court cases, *Takao Ozawa v. United States* and *United States v. Bhagat Singh Thind*. Haney López, *White by Law*, 3–5.

19. The absurdity of the situation is particularly stark given that after 1870, naturalization was also available by petitioning the courts to be seen as black. See Haney López, *White by Law*, 2, 31–36.

20. Kaja Silverman's landmark text *The Subject of Semiotics* introduces the idea of sutures as both a cinematic tactic and a conceptual approach that art and cultural historian Nicole Fleetwood takes up as a means of understanding the artistic process of digital assemblage—of making visible "gaps, erasures, and ellipses of dominant visual narratives and their underlying ideology of spectatorship" in the context of black aesthetics. Kaja Silverman, *The Subject of Semiotics* (New York: Oxford University Press, 1983); Nicole R. Fleetwood, *Troubling Vision: Performance, Visuality, and Blackness* (Chicago: University of Chicago Press, 2011), 6, 179.

21. As I discuss at length in Chapter 1, there is literature about this history, but mainly in Russian and oral traditions maintained in writing in the indigenous languages of the Caucasus—as well as in Turkish, Georgian, and more. Some of the most extensive accounts include Walter Richmond, *The Circassian Genocide;* and Nicolas Griffin, *Caucasus: A Journey to the Land between Christianity and Islam* (Chicago: University of Chicago Press, 2001). For more on the formation of the diaspora fashioned from the migrancy of those in the northern Caucasus in Jordan, see Vladimir Hamed-Troyansky, "Circassian Refugees and the Making of Amman, 1878–1914," *International Journal of Middle East Studies* 49 (2017): 605–623; and Vladimir Hamed-Troyansky, *Empire of Refugees: North Caucasian Muslims and the Late Ottoman State* (Redwood City, CA: Stanford University Press, 2024). The 2014 Sochi Olympics, held on a site integral to the study of Circassian genocide and exile, exposed how little this history is known by the public. See Amie Ferris-Rotman, "Russian Olympics Clouded by Nineteenth-Century Deaths," *Reuters*, March 21, 2010; Thomas Grove, "Genocide Claims Complicate Russian Olympic Plans," *Reuters*, October 13, 2011; "Georgia Plans 'Circassian Genocide Memorial,'" *Civil Georgia* (Tbilisi), July 29, 2011; Maja Catic, "Circassians and the Politics of Genocide Recognition," *Europe-Asia Studies* 67, no. 10, special section, "Family, Health, and Reproduction in Russia and Ukraine—in the Intersection between the Private and the Public" (December 2015): 1685–1708. While I include these references here, again, this book focuses on the limited extent to which this history was known in the United States.

22. Neal Ascherson, *Black Sea* (London: Jonathan Cape, 1995). A methodological parallel: Michel-Rolph Trouillot observes that in Eric Hobsbawm's *The Age of Revolution: 1789–1843*, the Haitian Revolution never appears. See Michel-Trouillot, *Silencing the Past*, especially chapter 4.

23. Toni Morrison, *Playing in the Dark: Whiteness in the Literary Imagination* (Cambridge, MA: Harvard University Press, 1992), 6, 46.

24. W. J. T. Mitchell, *Seeing through Race* (Cambridge, MA: Harvard University Press, 2012), 13.

25. From the first use of the term "visuality" by Thomas Carlyle, who invented the word to mean a privileged perspective on history, the term has meant more than seeing; rather, a privileged regime of making meaning. Here I am thinking of Fred Moten on the "hegemony of the visual." See Fred Moten, "Sound in Florescence: Cecil Taylor's Floating Garden," in *Sound States*, ed. Adalaide Morris (Chapel Hill: University of North Carolina Press, 1997).

26. *Congressional Globe*, 41st Cong., 2nd sess., 3607; Eric Foner, *The Second Founding: How the Civil War and Reconstruction Remade the Constitution* (New York: W. W. Norton, 2019).

27. Foner, *Second Founding*, xx.

28. Here I'm thinking of, as one example, Jason Frank's meditation on Douglass's "political poetics." See Jason Frank, *Constituent Moments: Enacting the People in Early Revolutionary America* (Durham, NC: Duke University Press, 2010), 211. While there is not room to discuss it further here, it is worth noting that Douglass's idea of thought pictures has resonances with Kant's formulation of the principles of mind, one being "the faculty of presenting aesthetic ideas" by which he meant the ability to, as Arthur Danto put it, use "experience" to "carry us beyond experience." See Danto, *What Art Is* (New Haven, CT: Yale University Press, 2013), 123-124.

29. I have discussed this concept in Sarah Lewis, "Editor's Note," *Vision & Justice* (New York: Aperture, 2016), 11-14. Once a magazine issue, this has now been released as a book.

30. See John Stauffer, Zoe Trodd, and Celeste-Marie Bernier, *Picturing Frederick Douglass: An Illustrated Biography of the Nineteenth Century's Most Photographed Man* (New York: Liveright, 2015). All of Douglass's speeches about pictures are reproduced in this volume, making it an invaluable publication, while of course they also remain in the holdings of the Library of Congress. Also see Frederick Douglass, "Pictures and Progress," in John W. Blassingame, ed., *The Frederick Douglass Papers*, series 1: *Speeches, Debates, and Interviews*, vol. 3: *1855-1863* (New Haven, CT: Yale University Press, 1985); Henry Louis Gates, Jr., "Frederick Douglass's Camera Obscura: Representing the Antislave 'Clothed and in Their Own Form,'" *Critical Inquiry* 42, no. 1 (Autumn 2015): 31-60; Laura Wexler, "'A More Perfect Likeness': Frederick Douglass and the Image of the Nation," in *Pictures and Progress: Early Photography and the Making of African American Identity*, ed. Maurice O. Wallace and Shawn Michelle Smith (Durham, NC: Duke University Press, 2012), 18-40; Ginger Hill, "'Rightly Viewed': Theorizations of Self in Frederick Douglass's Lectures on Pictures," in *Pictures and Progress*, 41-82; and Robin Kelsey, "Pictorialism as Theory," in *Picturing*, ed. Rachael Z. DeLue

(Chicago: Terra Foundation for American Art and University of Chicago Press, 2016), 186–204. I also have discussed these speeches by Douglass in Sarah Lewis, *The Rise: Creativity, the Gift of Failure, and the Search for Mastery* (New York: Simon & Schuster, 2014) and Lewis, "Editor's Note."

31. Sean Ross Meehan, *Mediating American Autobiography: Photography in Emerson, Thoreau, Douglass, and Whitman* (Columbia: University of Missouri Press, 2008), 154.

32. The listing of the purchase of photograph is in the Frederick Douglass Jr. account book from September 20, 1880, to October 4, 1884: on February 18, 1882, he purchased "photographs" for two hundred. This scrapbook is in the Walter O. Evans Collection. I was grateful to be able to see this years ago, prior to its acquisition by the Beinecke Rare Books and Manuscript Library at Yale University. Also see Frederick Douglass's last will and testament for his request to leave pictures and a portrait to his wife and daughter in Will Book, vol. 57, 178–179, Surrogate's Court, Monroe County Courthouse, Rochester, NY.

33. Interview with Aleksandra Kvakhadze, September 2019, Tbilisi, Georgia.

34. See Jacobson, *Whiteness of a Different Color*, 11; Trouillot, *Silencing the Past*, 26–27, 73. The idea of the "un-visible" is in reference to Ralph Ellison in *Invisible Man* (New York: Random House, 1952), xv, as well as a framework used by Krista Thompson to discuss the politics of visibility within African diasporic practices. See Thompson, *Shine: The Visual Economy of Light in African Diasporic Aesthetic Practice* (Durham, NC: Duke University Press, 2015), 39–40; and Thompson, "A Sidelong Glance: The Practice of African Diaspora Art History in the United States," *Art Journal* (Fall 2011): 19. For a discussion of the "aesthetics of opacity," see Édouard Glissant, "For Opacity," in *Over Here: International Perspectives on Art and Culture*, ed. Gerardo Mosquera and Jean Fisher (New York: New Museum of Contemporary Art, 2004); and Glissant, *Poetics of Relation*, trans. Betsy Wing (Ann Arbor: University of Michigan Press, 1997).

35. Isabel Wilkerson, *Caste: The Origins of Our Discontents* (New York: Random House: 2020), 66.

1. Ungrounding

1. Oliver Wardrop to Margrethe Wardrop, October 6, 1919, Oliver Wardrop Papers, Bodleian Library, Oxford University. See also Oliver Wardrop, *The Kingdom of Georgia: Notes of Travel in a Land of Women, Wine and Song* (London: Sampson Low, Maston, Seale & Rivington, 1888), vii. The papers of Major General James G. Harbord indicate that he had received instructions in August to deliver his report "in person to the President." See Frank McCoy, Chief of Staff, to James G. Harbord, August 13, 1919, box 8: Armenian

Mission, 1919, James G. Harbord Papers, 1886–1938, Library of Congress. Wilson would suffer a stroke on October 2, 1919; it is not clear that he ever received Harbord's report about the Caucasus women.

2. Erez Manela, *The Wilsonian Moment: Self Determination and the International Origins of Anticolonial Nationalism* (Oxford: Oxford University Press, 2007). The first use of this term was in February 1918.

3. Manela, "'Peoples of Many Races': The World beyond Europe in the Wilsonian Imagination," in *Jefferson, Lincoln, and Wilson: The American Dilemma of Race and Democracy*, ed. John Milton Cooper and Thomas Knock (Charlottesville: University of Virginia Press, 2010), 184.

4. "The Armenian Spirit in Art," *Fine Arts Journal* (September 1919); Antony Anderson, "Hovsep Pushman: An Appreciation," *The International Studio* 61, no. 242 (April 1917).

5. Letter from Mrs. H. Pushman to Mr. Vikrey (1917), The President Woodrow Wilson House archives.

6. Manela, *Wilsonian Moment,* 60; Manela, "Peoples of Many Races," 184–192.

7. Manela, *Wilsonian Moment,* 111.

8. In *The Papers of Woodrow Wilson* (hereafter *PWW*), ed. Arthur S. Link et al. (Princeton, NJ: Princeton University Press, 1966–1993), vol. 38, 539.

9. Wilson, *A Nonpartisan Address in Cincinnati*, in *PWW,* October 26, 1916, vol. 38, 539.

10. In fact, in one rare instance in July of 1918 when Wilson spoke out to denounce lynching, as we will see, he did so to underscore that such racial violence undermined the ability of the United States to project dominance in a global order. "A Statement to the American People, July 26, 1918 in *PWW,* vol. 49, 97–98; Manela, "Peoples of Many Races," 202.

11. Many intertitles about the emergence of white supremacy were excised from Wilson's own writing from volume 5 of *A History of the American People,* published in 1902. Michael Rogin, "The Sword Became a Flashing Vision: D. W. Griffith's *The Birth of a Nation,*" *Representations* 9 (1985): 150–195. The "Midnight" reference is from Adam Hochschild, *American Midnight: The Great War, A Violent Peace, and Democracy's Forgotten Crisis* (New York: Mariner Books, 2022).

12. Oliver Wardrop to Margrethe Wardrop, October 6, 1919, 2–3.

13. His title as high commissioner is consistent throughout the archives of the British Museum, National Archives, and National Parliamentary Library of Georgia, though he is also referred to as chief commissioner.

14. Oliver Wardrop to Margrethe Wardrop, November 3, 1919, and November 7, 1919, Oliver Wardrop Papers. Marjory is often used in publications, Margrethe is the name listed in the official papers at the Bodleian Library, Oxford University. Wardrop, *Kingdom of Georgia,* vii.

15. Wardrop, *Kingdom of Georgia,* vii.

16. Oliver Wardrop to Margrethe Wardrop, October 6, 1919, 2.

17. Edward M. House diary, entries for January 3 and 4, 1917, in *PWW*, vol. 40, 408–409, white is capitalized in the original; William B. Wilson to Ray S. Baker, September 17, 1932, Ray Stannard Baker Papers, box 117, reel 84, Library of Congress. In this memo recalling events from World War I, white and yellow are lowercase; Louis Menand, *The Metaphysical Club: A Story of Ideas in America* (New York: Farrar, Straus and Giroux, 2001), 67. The slippage between race and nation began with Immanuel Kant, who defined race as one category of "human variety" in his 1775 essay "On the Different Races of Mankind." Often the word "nation" was used instead of race; see David Bindman, *Ape to Apollo: Aesthetics and the Idea of Race in the 18th Century* (London: Reaktion, 2002), 16; A. Scott Berg, *Wilson* (New York: Berkley Books, 2013).

18. Menand, *Metaphysical Club*, 67.

19. This term Redemption, which Gates emphasizes is not known to most, was introduced to him in a course when William S. McFeely assigned Rayford W. Logan, *The Betrayal of the Negro: From Rutherford B. Hayes to Woodrow Wilson*. See Henry Louis Gates, Jr., *Stony the Road: Reconstruction, White Supremacy, and the Rise of Jim Crow* (New York: Penguin, 2019), xiii.

20. This has meant more than that the production of race, as Richard Dyer and others have argued, would need to maintain whiteness as an unmarked category. Richard Dyer, *The Matter of Images: Essays on Representation* (London: Routledge, 1993).

21. This comparative work was inspired in part by Peter Kolchin's comparative analysis of serfdom and slavery. See Peter Kolchin, *Unfree Labor: American Slavery and Russian Serfdom* (Cambridge, MA: Belknap Press of Harvard University Press, 1987). This book is deliberately not a foray into how the Caucasus region was received in Europe; there exists extensive research on the history and literature of the period from scholars including Moshe Gammer, Rebecca Ruth Gould, Charles King, Harsha Ram, and Walter Richmond. Beyond the works cited elsewhere in this chapter by Gammer, Gould, King, Ram, and Richmond, see Michael Kemper, "The Changing Images of Jihad Leaders: Shamil and Abd al-Qadir in Daghestani and Algerian Historical Writing," *Nova Religio: The Journal of Alternative and Emergent Religions* 11, no. 2 (2007): 28–58; Susan Layton, *Russian Literature and Empire: Conquest of the Caucasus from Pushkin to Tolstoy* (Cambridge: Cambridge University Press, 1995); Harsha Ram, *Prisoners of the Caucasus: Literary Myths and Media Representations of the Chechen Conflict* (Berkeley: Berkeley Program in Soviet and Post-Soviet Studies, 1999).

22. Barnum American Museum playbill, September 24, 1864, Harvard Theater Collection, Houghton Library, Harvard University. My research indicates that the first time the Circassian Beauty appeared on Barnum's American Museum playbills was on September 24, 1864. Scholars have previously been vague about exactly when the first Circassian Beauty debuted on Barnum's stage; Linda Frost dated it to "sometime in 1864." See Linda Frost, "The Circassian

Beauty and the Circassian Slave: Gender, Imperialism, and American Popular Entertainment," in *Freakery: Cultural Spectacles of the Extraordinary Body*, ed. Rosemarie Garland Thomson (New York: New York University Press, 1996), 249. See also Irvin Cemil Schick, *The Circassian Beauty* (London: Verso, 1999).

23. Zalumma Agra is alternatively spelled Zulamma and Zalumma in the vast constellation of Eisenmann Circassian Beauties.

24. "Barnum & Bailey Show Pays Salt Lake Visit," *Salt Lake City Telegram*, August 7, 1914, 7; "Amusements," *Daily Picayune*, December 11, 1868; *New York Herald*, May 3, 1870, 8; "Amusements," *Daily Evening Bulletin*, April 8, 1870, 3; "The Stage," *New Haven Evening Register*, November 21, 1878, 4; "Fondling Snakes, Diamond Rattlers Are Said to Make Good Pets When Handled Properly," *Biloxi Daily Herald*, February 19, 1902, 2.

25. One example of the use of hair in data collection of racial science is Louis Agassiz's Thayer expedition to Brazil. See Louis Agassiz and Elizabeth Agassiz, *A Journey in Brazil* (Boston: Ticknor and Fields, 1868); Louis Menand, *The Metaphysical Club* (New York: Farrar, Straus, and Giroux, 2001), 136. Hair was also a signifier of the protean quality of race. When the Ohio Representative and former Union Army colonel William Mungen stated in his 1867 address on the House floor, "We cannot legislate upon hair. We cannot call the previous question upon complexions. We cannot divide the House upon the matter of high cheekbones . . . the absurdities and contradictions in which we should find ourselves," he was not referring to just any racial group. He had begun by stating, "It is not the business of legislation to settle the comparative merits of races, and exalting the Circassian to put down the Mongol-Tartars." See "Mungen the Ethnologist," *New York Tribune*, July 13, 1867, 4. For commentary on this speech, see James Ford Rhodes, *History of the United States from the Compromise of 1850 to the Final Restoration of Home Rule in the South by 1877*, vol. 6 (New York: Macmillan, 1906), 39.

26. *The Daily Chronicle & Sentinel* (Augusta, GA), March 12, 1857. Benjamin Reiss, *The Showman and the Slave: Race, Death, and Barnum's America* (Cambridge, MA: Harvard University Press, 2001), 3.

27. *New York Herald-Tribune*, June 6, 1865, 3.

28. Kevin Young, *Bunk: The Rise of Hoaxes, Humbug, Plagiarists, Phonies, Post-Facts, and Fake News* (Minneapolis: Graywolf Press, 2017), 27.

29. Kevin Young, *Bunk*, esp. 4–44; James W. Cook, *The Arts of Deception: Playing with Fraud in the Age of Barnum* (Cambridge, MA: Harvard University Press, 2001).

30. Kobena Mercer, "Black Hair / Style Politics," *Black British Culture and Society: A Text Reader* (New York: Routledge, 2000), 11.

31. See Neil Harris, *Humbug: The Art of P. T. Barnum* (Chicago: University of Chicago Press, 1981).

32. Gates, *Stony the Road*, 14.

33. "Disastrous Fire," *New York Times,* July 14, 1865. In February 1865, Robert Kennedy was hanged for setting fire to the American Museum and a host of New York City hotels; see *New York Tribune,* November 26, 1864. See also James Trager, *The New York Chronology* (New York: HarperResource, 2003), 135; Nat Brandt, *The Man Who Tried to Burn New York* (New York: Syracuse University Press, 1986), 239; "Destruction of Barnum's Museum and Its Contents, *Daily Intelligencer* (Washington, DC), March 4, 1868, no. 17, 324, col D. *The Liberator* quoted the *New York Tribune* statement that "Barnum's Museum was fired by incendiaries in a half a dozen places simultaneously"; see *The Liberator,* August 4, 1865. See also Jeff Rosenheim, *Photography and the American Civil War* (New York: Metropolitan Museum of Art, 2013), 60-61.

34. Brandt, *Man Who Tried to Burn New York,* 14.

35. Lewis Carroll's *Alice's Adventures in Wonderland* (1865) included a "Caucasus Race" scene, performed at the suggestion of a dodo bird, with no clear starting point and culminating with all receiving some sort of rank and prize. Jennifer Brody has read it as an unwitting metaphor for the unstable foundations within the term Caucasian. Jennifer Brody, *Impossible Purities: Blackness, Femininity and Victorian Culture* (Durham, NC: Duke University Press, 1998), 5.

36. Johann Friedrich Blumenbach and John Hunter, *The Anthropological Treatise of Johann Friedrich Blumenbach and the Inaugural Dissertation of John Hunter, M.D. on the Varieties of Man* (London: Anthropological Society, 1865). See also Nell Painter, *The History of White People* (New York: W. W. Norton, 2010), 47.

37. Allison Blakely, *Russia and the Negro: Blacks in Russian History and Thought* (Washington DC: Howard University Press, 1986), 5-12; Festus Eribo, *In Search of Greatness: Russia's Communications with Africa and the World* (Westport, CT: Ablex, 2001), 1. "Batumi Negroes" is quoted in Eribo, *In Search of Greatness,* 274. Albert Parry, "Negroes in Russia," *Opportunity: The Journal of Negro Life* 3, no. 34 (October 1925): 306-307.

38. Frith Maier, "Introduction," in *Vagabond Life: The Caucasus Journals of George Kennan,* ed. Frith Maier (Seattle: University of Washington Press, 2003), 10.

39. It is not clear that this is the label Kennan gave the photograph.

40. Hughes had come to the region via Russia to take part in a failed film project, *Black and White,* a title that indicated the frame through which he came to see the southern Soviet republics themselves. Langston Hughes cited in Kate A. Baldwin, *Beyond the Color Line and the Iron Curtain: Reading Encounters between Black and Red, 1922–1963* (Durham, NC: Duke University Press, 2002), 95, 130, 133. Also see Gilmore, *Defying Dixie: The Radical Roots of Civil Rights, 1919–1950* (New York: W. W. Norton, 2008), 4, 167.

41. Baldwin, *Beyond the Color Line,* 115.

42. Langston Hughes, *Collected Works of Langston Hughes: Autobiography: I Wonder as I Wander,* vol. 14 (Columbia: University of Missouri Press, 2002), 113.

43. Hughes, "South to Samarkand," in Hughes, *Collected Works,* 137, 140-142.

44. Woodrow Wilson, *A History of the American People,* vol. 8 (New York: Harper and Bros., 1918).

45. Alexandre Dumas, *Adventures in Caucasia,* trans. A. E. Murch, 1st American ed. (Philadelphia: Chilton Books, 1962), vii.

46. As Painter notes, the site claimed to be the "mountains of Ararat" are not considered to be the Caucasus region but in present day Turkey. Nell Irvin Painter, *The History of White People* (New York: W. W. Norton, 2010), 3–4. Also see "Founded by Noah," *Duluth News Tribune,* August 11, 1912, 9.

47. Blumenbach's gloss of the term Caucasian referred to a seventeenth-century travel account by Jean Chardin, who was unreserved in his praise of the beauty of the women in Circassia in particular. Chardin was a French jeweler at the court of Louis XIV who narrated his trip through the Caucasus, an uncommon route for a travel account in the seventeenth century. The well-received publication of Chardin's travel account, which offered him great acclaim and entrance into the Royal Society in London, was one of the earliest documents that sent the idea of Caucasus women as supremely beautiful into circulation in the literary imaginary. See his *Journal du Voyage du Chevalier Chardin en Perse & aux Indes Orientales, par la Mer Noire & par la Colchide (The Travels of Sir John Chardin into Persia and the East Indies, 1673–1677)* (1686). See also Matthew Frye Jacobson, *Whiteness of a Different Color: European Immigrants and the Alchemy of Race* (Cambridge, MA: Harvard University Press, 1998); Reginald Horsman, *Race and Manifest Destiny;* Nell Irvin Painter, *History of White People;* David Roediger, *Wages of Whiteness: Race and the Making of the American Working Class* (London: Verso, 2018); and Theodore W. Allen, *The Invention of the White Race* (London: Verso, 2012), vols. 1 and 2.

48. The term, used for more reasons than phenotype alone, points to a long-standing racial division between the Russians and the Caucasians. See Bruce Baum, *The Rise and Fall of the Caucasian Race: A Political History of Racial Identity* (New York: New York University Press, 2006), 220.

49. Henry Louis Gates, Jr. and Andrew S. Curran, eds., *Who's Black and Why?: A Hidden Chapter from the Eighteenth-Century Invention of Race* (Cambridge, MA: Belknap Press of Harvard University Press, 2022), 40.

50. Blumenbach's first edition of the text in 1775 followed Linnaeus's four-fold scheme. By the second edition, however, he maintains that he had "more actively investigated the different nations of Eastern Asia and America, and, so to speak, looked at them more closely." The result was the five-group system.

51. Ian Haney López, *White by Law: The Legal Construction of Race* (New York: New York University Press, 1996), citing the case of *Takao Ozawa v. United States,* 6.

52. Painter, *History of White People,* 52.

53. "A Museum Returned. Mr. Theodore Thomas Impress of London Concerts," in *Cincinnati Commercial Tribune*, August 16, 1880, 2. See also the report about Zoe Meleke, shown in a dime museum in New Haven along with other curiosities. *New Haven Evening Register*, February 2, 1881, 4.

54. "A Museum Returned. Mr. Theodore Thomas Impress of London Concerts."

55. Michel-Rolph Trouillot, *Silencing the Past: Power and the Production of History* (Boston: Beacon Press, 2015), 82; Pierre Bourdieu, *Le sens pratique* (Paris: Minuit, 1980), 14. Here I reference Bourdieu's conceptualization of the idea via Trouillot, who argues that the unthinkable occurs not out of "ethical or political inclinations" but due to lack of conceptual frameworks, that is, due to "want of instruments of thought," whether they be "concepts, methods, techniques."

56. For more on the legacy of the gimmick after Barnum, see Sianne Ngai, *Theory of the Gimmick: Aesthetic Judgment and Capitalist Form* (Cambridge, MA: Belknap Press of Harvard University Press, 2020).

57. Here I am thinking of the expansive sense of the wake, as deftly outlined by Christina Shape, *In the Wake: On Blackness and Being* (Durham, NC: Duke University Press, 2016). Interest in the Caucasian War precipitating scrutiny of the region is not obvious if we follow traditional historical accounts. Britain had a strong interest in an independent Circassia and Caucasus; it would mean Russia could not expand into the Ottoman Empire and India. The Crimean War was just one part of this much larger struggle over political control of the Caucasus region, a response to concerns about what became known as the "Eastern Question: the question about the long, slow withdrawal of the Ottoman Empire" as well as "the fear of Russian imperial expansion." Stefanie Markovits, *The Crimean War in the British Imagination* (Cambridge: Cambridge University Press, 2009), 7.

58. "A Word about Museums," *The Nation*, July 27, 1865.

59. Linda Frost, *Never One Nation: Freaks, Savages, and Whiteness in U.S. Popular Culture, 1850–1877* (Minneapolis: University of Minnesota Press, 2005); Young, *Bunk*.

60. See Sander Gilman, "Black Bodies, White Bodies: Toward an Iconography of Female Sexuality in Late Nineteenth-Century Art, Medicine and Literature," *Critical Inquiry* 12 (Autumn 1985): 204–242.

61. Barnum's *Zoe Meleke: Biographical Sketch of the Circassian Girl* (1880), 3; Frost, "The Circassian Beauty and the Circassian Slave," 252. See also "Biographical Outline of the Beautiful Circassian Girl, Zobeide Luti, or 'Lady of Beauty,'" together with "A Brief Sketch of the Manners, Customs, and Inhabitants of Circassia" (New York: Barnum and Van Amburgh Museum and Menagerie Co., 1868), 3.

62. Susan Layton, *Russian Literature and Empire: Conquest of the Caucasus from Pushkin to Tolstoy* (Cambridge: Cambridge University Press, 1994); Rebecca

Gould, *Writers and Rebels: The Literature of Insurgency in the Caucasus* (New Haven, CT: Yale University Press, 2016).

63. Such narratives ranged from "The Fair Circassian" by Samuel Croxall (1759) to "The British Seraglio! Or the Fair Circassian," by A. Moor (1819) to Isaac Robert Cruikshank's "Persian Customs, Eunuchs Performing the Office of Lady's Maids, Dedicated to the Circassian Beauty" (1819). Circassians were in shows such as "The Revolt of the Harem" in 1851 at the Bowery Theater and "The Capture of the Circassian in the Desert" at Quick's Menagerie. See George C. D. Odell, *Annals of the New York Stage*, vol. 6: *1850–1857* (New York: Columbia University Press, 1931), 80. The Bowery Theater was managed by June, Titus, Anvegvine & Co., and Quick's Menagerie was managed by James M. June & Company. Edward W. Said, *Orientalism* (New York: Vintage, 1979). For more on photography and Orientalism, see Ali Behdad and Luke Gartlan, eds., *Photography's Orientalism: New Essays on Colonial Representation* (Los Angeles: The Getty Research Institute, 2013).

64. There were also attempts to distance the practice of white female slavery from associations with sub-Saharan slavery. Immanuel Kant would write of Circassian slaves a century earlier, "they seemed not to feel the tragedy of their condition;" see *Observations on the Feeling of the Beautiful and Sublime*, 1764. Similar comments appeared in print during the Civil War; see "National Academy of Design," *Pittsfield Sun*, April 25, 1861, 1.

65. Brooks, *Bodies in Dissent*, 19.

66. For an account of the connection between slavery in the Caucasus with the African slave trade, David Brion Davis assiduously details the historical connection between the white female slave trade associated with the Caucasus and the sub-Saharan African slave trade in *Inhuman Bondage: The Rise and Fall of Slavery in the New World* (New York: Oxford University Press, 2006).

67. The full history of slavery in the Caucasus is understudied. There have been comparisons between US slavery and Russian serfdom. Few comparable accounts exist to consider the conceptual resonance and challenge that white slavery had during the period of slavery and Emancipation in the United States. Narratives such as that of Leila (Saz) Hanimefendi recount atrocities and the different conditions for African and Circassian slaves in imperial harems of the Ottomans, while Halide Edib Adivar and Huda Sha'rawi, among others, offer accounts of growing up in homes with enslaved Circassians among those from Sudan and Ethiopia—a frequent template in which to encounter images of Circassians in representation. Some histories, Eve Troutt Powell argues, focus on "the forced migration of people from the Caucasus that dominated headlines," but largely in contexts outside the United States. See Eve Troutt Powell, *A Different Shade of Colonialism: Egypt, Great Britain, and the Mastery of the Sudan* (Berkeley: University of California Press, 2003).

Peter Kolchin, *Unfree Labor: American Slavery and Russian Serfdom* (Cambridge, MA: Belknap Press of Harvard University Press, 1987).

68. "Horrible Traffic in Circassian Women—Infanticide in Turkey," *New York Times*, August 6, 1856, 6.

69. François Marie Arouet de Voltaire, "Letter XI—On Inoculation," *Letters on the English, 1909–14*, available online at http://www.bartleby.com/34/2/11.html.

70. See "Humors of the Day," *Harper's Weekly* 6, no. 16 (1860): 371–372; George C. D. Odell, *Annals of the New York Stage*, vol. 6: *1850–1857*, 80.

71. Kirsten Buick, *Child of the Fire: Mary Edmonia Lewis and the Problem of Art History's Black and Indian Subject* (Durham, NC: Duke University Press, 2010).

72. See Martina Droth, "Mapping the Greek Slave," *Nineteenth-Century Art Worldwide* 15, no. 2 (Summer 2016), http://www.19thc-artworldwide.org /summer16/droth-on-mapping-the-greek-slave.

73. Charmaine A. Nelson, *The Color of Stone: Sculpting the Black Female Subject in Nineteenth-Century America* (Minneapolis: University of Minnesota Press, 2007); Martina Droth and Michael Hatt, "The Greek Slave by Hiram Powers: A Transatlantic Object," *Nineteenth-Century Art Worldwide* 15, no. 2 (Summer 2016), http://www.19thc-artworldwide.org/summer16/droth-hatt-intro-to-the -greek-slave-by-hiram-powers-a-transatlantic-object; Droth, "Mapping the Greek Slave"; Tanya Pohrt, "*The Greek Slave* on Tour in America," *Nineteenth-Century Art Worldwide*, ed. Martina Droth and Michael Hatt 15, no. 2 (Summer 2016): http://www.19thc-artworldwide.org/summer16/pohrt-on-the -greek-slave-on-tour-in-america; Cybèle T. Gontar, "'Robbed of his treasure': Hiram Powers, James Robb of New Orleans, and the 'Greek Slave' Controversy of 1848," *Nineteenth-Century Art Worldwide*, ed. Martina Droth and Michael Hatt 15, no. 2 (Summer 2016): https://www.19thc-artworldwide.org /summer16/gontar-on-hiram-powers-james-robb-the-greek-slave-controversy -of-1848; Joy S. Kasson, *Marble Queens and Captives: Women in Nineteenth-Century American Sculpture* (New Haven, CT: Yale University Press, 1990), 49; Charmaine A. Nelson, *Representing the Black Female Subject in Western Art* (New York: Routledge, 2010), 147–149; Brooks, *Bodies in Dissent*, 19.

74. Reverend Orville Dewey stated in a review that the statue was "clothed all over with sentiment, sheltered, protected by it from every profane eye." Dewey, "Mr. Powers' Statue," *Union Magazine of Literature and Art*, October 1847. As Tanya Pohrt notes, this was an early review, as Dewey had seen the work in Florence; it was recycled by Powers, who had it published in many newspapers. See Pohrt, "*The Greek Slave* on Tour in America." The tour agent, Minor K. Kellogg, a onetime friend of Powers, had traveled to Turkey and Georgia and had also created paintings of Circassians. For a review, see *Christian Inquirer* 1 (October 9, 1847): 20.

75. Freeman Henry Morris Murray, *Emancipation and the Freed in American Sculpture: A Study in Interpretation* (Washington, DC: Press of Murray Brothers,

1916), 3. Steven Nelson, "Emancipation and the Freed in American Sculpture: Race, Representation, and the Beginnings of African American History of Art," in *Art History and Its Institutions: Foundations of a Discipline*, ed. Elizabeth Mansfield (London: Routledge, 2002).

76. This version from 1866 is in the collection of the Brooklyn Museum. The manacle, Charmaine A. Nelson notes in the most extensive study of this work in the context of race and aesthetics, was a marker of the "symbolic transition" of the black body from "free to enslaved, human to commodity." See Vivien Green Fryd, "Reflections on Hiram Powers's *Greek Slave*," *Nineteenth-Century Art Worldwide* 15, no. 2 (Summer 2016), http://www.19thc -artworldwide.org/summer16/fryd-on-reflections-on-hiram-powers-greek -slave; Nelson, *Color of Stone*, 108–111.

77. Lisa Volpe, "Embodying the Octoroon: Abolitionist Performance at the London Crystal Palace, 1851," in a special issue of *Nineteenth-Century Art Worldwide*, ed. Martina Droth and Michael Hatt 15, no. 2 (Summer 2016): http://www.19thc-artworldwide.org/summer16/volpe-on-abolitionist -performance-at-the-london-crystal-palace-1851.

78. Kirk Savage, *Standing Soldiers, Kneeling Slaves: Race, War, and Monument in Nineteenth-Century America* (Princeton, NJ: Princeton University Press, 1997), 66.

79. Douglass, "Lecture on Pictures," Series: Speech, Article, and Book File—A, Frederick Douglass, Dated, Frederick Douglass Papers, Library of Congress, 5; David Blight, *Frederick Douglass's Civil War: Keeping Faith in Jubilee* (Baton Rouge: Louisiana State University Press, 1989), 113–115.

80. Quoted in Volpe, "Embodying the Octoroon." See also "The Great Exhibition," *Times* (London), March 17, 1851.

81. The Georgian skull came from Blumenbach's benefactor George Thomas, Baron von Asch, in St. Petersburg in 1793. His precise skull measurements, his *norma verticals*, were only part of what justified the skull's prime place. He explained about the Circassian: "I have taken the name of this variety from Mount Caucasus both because its neighborhood, and especially its southern slope, produces the most beautiful race of men." The word "beautiful" appears five times on one page to describe the "Caucasian" skull; he claimed that Circassians were the loveliest group of all. It was beauty, he made clear, that strengthened his case. See Painter, *History of White People*, 82.

82. Jean Chardin, *Journal du Voyage du Chevalier Chardin*. See Blumenbach and Hunter, *Anthropological Treatise*.

83. Gates and Curran, *Who's Black and Why?*

84. Immanuel Kant, *Observations on the Feeling of the Beautiful and Sublime*, trans. John T. Goldthwait (Berkeley: University of California Press, 1960), 89.

85. "The Circassians," *The Miscellany* (Trenton, NJ), July 15, 1805, 23. This article was published with slight variation for the *Connecticut Mirror* twenty years later in 1825, and again in 1827 in a Rhode Island newspaper. See "On Circas-

sian Women," *Connecticut Mirror*, October 3, 1825, 2; *Providence Patriot &
Columbian Phoenix*, December 26, 1827, 1. The *Connecticut Mirror* states "that
cannot be defined, but which exist, and necessarily constitutes beauty, since
all men render it homage." Also see advertisements in *Farmer's and Mechanic's
Almanac of 1875* (New York: John F. Henry, Curran & Co, 1875).

86. Charles King, "Imagining Circassia: David Urquhart and the Making of North
Caucasus Nationalism," *Russian Review* 66 (April 2007): 244.

87. *Springfield Weekly Republican*, August 10, 1867, 5; and *Republican Farmer*,
August 7, 1849, 3. "Circassian Balm," *Dakota Republican* (SD), January 11,
1868, 3.

88. *Baltimore Patriot*, November 23, 1829, 3; *The Times*, and *Hartford Advertiser*,
April 27, 1824, 3.

89. Charles King, "Zalumma Agra, the 'Star of the East,'" in *Russia's People of
Empire: Life Stories from Eurasia, 1500 to the Present*, ed. Stephen M. Norris
and Willard Sunderland (Bloomington: Indiana University Press, 2012),
129–130.

90. "A Would-Be Circassian Beauty," *New York Times*, December 17, 1884. Many
newspaper accounts documented the afterlives of these Circassian Beauty
performers. Examples include "Boston Dispatches," *Worcester Daily Spy*,
June 11, 1885, 1; "My Circassian Beauty: How I Became Acquainted with Her,"
Kansas City Star, May 21, 1899, 10.

91. Ivan S. Golovin, *The Caucasus* (London: Trubner & Co., 1854), 107.

92. It was a version of "'odic' triumphalism," as Harsha Ram terms it, consonant
with the Russian ecclesiastical and secular tradition of panegyric oratory. See
Harsha Ram, *The Imperial Sublime: A Russian Poetics of Empire* (Madison:
University of Wisconsin Press, 2003), 11.

93. Lesley Blanch, *Sabres of Paradise* (New York: Viking, 1960), 11. The British had
a substantial interest in Circassia's resistance to Russia's incursions into the
Ottoman Empire. The creation of the current Circassian flag of twelve gold
stars above three gold arrows on a green background was designed by a
British diplomat, David Urquhart. It remains the official flag of the homeland
of the Adyghe. As Oliver Bullough notes, a letter from "the people of Cir-
cassia" to Queen Victoria in April 1864 with expansive, spiraling copperplate
script operated as a visual clue about the alliance between the two countries,
the enormity of their suffering, and their unraveling stronghold on their
homeland at the time of the Circassian Beauty's debut on American stages.
See Oliver Bullough, *Let Our Fame Be Great: Journey among the Defiant Peoples
of the Caucasus* (New York: Basic Books, 2010), 102–103.

94. "Littell's Living Age," with an announcement for, "A Visit to Shamyl's Country
in 1870, by Edwin Ransom," *Lowell Daily Citizen and News*, February 3, 1873, 2.

95. *New York Herald*, October 11, 1857, 2.

96. Barnum in James T. Cook, ed., *The Colossal P. T. Barnum Reader: Nothing Else
Like It in the Universe* (Urbana: University of Illinois Press, 2015), 136. Barnum's

panegyric praise of the Circassian Beauties narrative also relates to oratory style found in the Russian tradition. Also see "Shamyl and the War in the Caucasus, Rendsberg," *The National Era*, September 28, 1854.

97. Thomas Bollinger, interview with the author, September 30, 2010. See also Lesley Blanch, *The Sabres of Paradise: Conquest and Vengeance in the Caucasus* (London: Tauris Parke Paperbacks, 2004), 52–53.

98. *New Hampshire Sentinel*, January 9, 1839, 3.

99. "Bloody Revenge of the Circassians," *Daily Delta* (New Orleans), September 9, 1862, 2.

100. "The Circassians," *Boston Daily Advertiser*, June 3, 1864, 1; "Foreign Summary," *Pacific Commercial Advertiser* (Honolulu), March 15, 1860, 3; "Circassian Exiles," *Dakota Weekly Union*, August 16, 1864.

101. "From Constantinople," *New York Tribune*, April 30, 1864, 9.

102. *The Constitution* (Middletown, CT), January 18, 1860, 2.

103. "From the National Gazette: Extract from Bishop Heber's Travels in India," *Eastern Argus* (Portland, ME), August 26, 1828, 1.

104. Kirill Rivkin, *Arms and Armor of Caucasus* (Edina, MN: Yamna Publishing, 2015); Stephen V. Grancsay, "A Gun from the Caucasus," *Metropolitan Museum of Art Bulletin* (September 1935): 173–174, figs. 1, 2.

105. For more on the internationalism that shaped Gardner's photographic work during the Civil War, see Makeda Best, *Elevate the Masses: Alexander Gardner, Photography, and Democracy in Nineteenth-Century America* (University Park: Pennsylvania State University Press, 2020).

106. The photograph is dated circa 1861, but there are no extant accounts of Barnum's Circassian Beauty appearing in New York before 1864. Brady was in New York in early 1864. In February, he photographed Lincoln in his Washington, DC studio, creating the image that would be engraved on the five-dollar bill. He returned to New York after April 1865, when he might have taken these photographs, including two images of Zalumma Agra's Circassian companion, Zobeide Luti, who came to Barnum's American Museum approximately a year after Agra debuted. Brady also delivered a lantern-slide lecture at Carnegie Hall in New York "consisting of lectures and reminiscence of the late War accompanied by views of photographs taken on the ground." See Roy Meredith, *Mr. Lincoln's Camera Man: Mathew B. Brady* (New York: Scribner's, 1946), 263. Zureby Hannum arrived at Barnum's American Museum in July 1865; see "The Circassian Family," *New York Daily Tribune*, July 21, 1865, 3. I have used the spelling Zalumma because it appears most often in both primary texts and scholarship.

107. Mary Panzer, *Mathew Brady and the Image of History* (Washington, DC: Smithsonian Books, 2004), 28; *Home Journal*, August 27, 1859, 1.

108. See Panzer, *Mathew Brady*, 1, 60–61.

109. The National Portrait Gallery in Washington, DC, located in the Old Patent Office Building, is just one block from where Brady's gallery in Washington

once stood. Brady's previous New York galleries were located at 205 Broadway, then at 359 Broadway (above Thompson's Saloon), next at 643 Broadway, and finally at 785 Broadway. See "A Broadway Valhalla: Opening of Brady's New Gallery," *American Journal of Photography and the Allied Arts & Sciences*, n.s. 3, no. 10 (October 15, 1860): 151-153.

110. Alan Trachtenberg, *Reading American Photographs: Images as History, Mathew Brady to Walker Evans* (New York: Hill and Wang, 1989), 40. The photographic studio and connected exhibition galleries were focal sites to both fashion and critique the truth during the antebellum period and the Civil War, and would be vital for sideshow performances. See Walter McDougall, *Throes of Democracy: The American Civil War Era, 1829-1877* (New York: Harper, 2008); Rachel Adams, *Sideshow U.S.A.: Freaks and the American Cultural Imagination* (Chicago: University of Chicago Press, 2001).

111. Oliver Wendell Holmes, "Doings of the Sunbeam," *Atlantic Monthly* (July 1863): 11. Holmes said this in reference to images taken by Alexander Gardner on behalf of Brady; the images were shown at Brady's gallery in 1862.

112. The War Department eventually acquired the negatives in 1875. See Panzer, *Mathew Brady*, 3, 13-14; Holmes, "Doings of the Sunbeam," 3.

113. Trachtenberg, *Reading American Photographs*, 91.

114. In 1860, Abraham Lincoln might have won New York State's vote, but he lost New York City by a margin of 30,000 votes. The draft riots of 1863 most violently exemplified the Civil War raging within the citizens of New York themselves. See Ernest McKay, *The Civil War and New York* (Syracuse, NY: Syracuse University Press, 1990), 18.

115. McKay, *Civil War*, 158; Trachtenberg, *Reading American Photographs*, 74.

116. "Brady's Photographs," *New York Times*, October 20, 1862, Mathew Brady Scrapbook, Brady/Handy Collection, Library of Congress.

117. The text that accompanied "A Burial Party" in *Gardner's Photographic Sketch Book of the War* (1866) confirmed such scenes: "The residents of that part of Virginia . . . allowed even the remains of those they considered enemies, to decay unnoticed where they fell." It echoed a battlefield report such as the one sent by Josiah Murphey of Nantucket, who stated that the deceased "remained where they had fallen for three days." James McPherson, *Battle Cry of Freedom: The Civil War Era* (New York: Oxford University Press, 1988), 544.

118. Drew Gilpin Faust, *This Republic of Suffering: Death and the American Civil War* (New York: Vintage, 2008), 66.

119. Faust, *This Republic of Suffering*, 62-63.

120. Quoted in Joseph Allan Frank and George A. Reaves, *Seeing The Elephant: Raw Recruits at the Battle of Shiloh* (New York: Greenwood, 1989), 107.

121. Gettysburg veteran quoted in Faust, *This Republic of Suffering*, 57.

122. *Boyd's Washington and Georgetown Directory, Contains Also a Business Directory of Washington, Georgetown, and Alexandria* (Washington, DC: A. Boyd, 1864), 330.

123. For concerns about "discolorations" and "the worst mishap," see Dr. G. H. Michel, "Discolorations," *The Casket* 37 (December 1912): 23; Karen Pomeroy Flood, "Contemplating Corpses: The Dead Body in American Culture, 1870–1920," PhD. diss., Harvard University, 2001. See also Robert W. Habenstein and William M. Lamers, *History of American Funeral Directing* (Milwaukee: Bulfin Printers, 1955), 330–334.

124. *The Casket: A Journal Devoted to the Interests of Funeral Directors* 31 (January 1906); Pomeroy Flood, "Contemplating Corpses," 223.

125. Flag designer James McFadden Gaston to Jefferson Davis. *Richmond Examiner,* March 29, 1862; Raphael P. Thian, *Illustrated Documentary History of the Flag and Seal of the Confederate States of America, 1861–1865* (Washington, DC, 1880), 39.

126. "The Flag of the Confederacy," *Charleston Mercury* (SC), March 6, 1862.

127. The Confederacy debated alternatives to what we know as the Confederate flag. Staunch Secessionist newspaper offices from Charleston, South Carolina to Richmond, Virginia functioned as galleries for citizens to view the designs.

128. See *Frank Leslie's Illustrated Newspaper* 24, no. 615 (July 13, 1867), 268; Jules Prown, "Winslow Homer in His Art," *Smithsonian Studies in American Art* 1, no. 1 (Spring 1987); Norman Bryson, *Vision and Painting* (London: Macmillan, 1983); Michael Ann Holly, "Vision and Revision in the History of Art," in *Theory between the Disciplines: Authority/Vision/Politics,* ed. Martin Kreisworth and Mark A. Cheetham (Ann Arbor: University of Michigan Press, 1990), 151–168.

129. Eleanor Jones Harvey, *The Civil War in American Art* (Washington, DC: Smithsonian American Art Museum; New Haven, CT: Yale University Press, 2012), 226.

130. Among her many observations here, Harvey notes that wheat was a crop that symbolized freedom in the United States, as well as, I would add, the enslaved labor required to produce it. Harvey, *Civil War in American Art,* 226.

131. See Nicolai Cikovsky, "A Harvest of Death: The Veteran in a New Field," *in Winslow Homer: Paintings of the Civil War,* ed. Marc Simpson (San Francisco: Bedford Arts for the Fine Arts Museums of San Francisco, 1988), 82–101. See also Nancy Rash, "A Note on Winslow Homer's 'Veteran in a New Field' and Union Victory," *American Art* 9, no. 2 (1995): 88–93; Christopher Kent Wilson, "Winslow Homer's *The Veteran in a New Field:* A Study of the Harvest Metaphor and Popular Culture," *American Art* 17, no. 4 (1985): 2–27; Natalie Spassky, "Winslow Homer at the Metropolitan Museum of Art," *Metropolitan Museum of Art Bulletin,* n.s. 2 (Spring 1982): 8–9; John Wilmerding, "Winslow Homer's Creative Process," *Antiques* 108 (November 1975): 965–971; and John Wilmerding, *Winslow Homer* (New York: Praeger, 1972), 47, 9.

132. The double valence of a work such as Homer's emerges as part of a widespread development. See Harvey, *Civil War in American Art.*

133. "The Circassians," *The Constitution* (Middletown, CT), October 12, 1864, 1.

134. Barnum in Cook, *Colossal P. T. Barnum Reader*, 136.

135. *North American* (Philadelphia), November 1853, 1.

136. Mackie, *Life of Schamyl*, 56; "A Word about Museums," *The Nation*, July 27, 1865; "The Seat of War," *St. Albans Messenger* (VT), October 23, 1876, 2. Ivan Golovin and J. Milton Mackie in the 1850s described the region's sublime beauty by invoking the river as a terrain-defining feature. See also Ivan S. Golovin, *The Caucasus* (London: Trubner & Co., 1854); Mackie book advertisement by John Jewett & Co. Advertisements, *The National Era*, January 24, 1856, 15; "Arrival of the Arabia. Three Days Later from Europe," *Daily Missouri Republican*, November 23, 1853, 2; *Daily Ohio Statesman*, November 22, 1853, 2; *The Barre Patriot* (MA), November 25, 1853, 2.

137. Barnum in Cook, *Colossal P. T. Barnum Reader*, 136.

138. There is no mention of Circassians in Neal Ascherson, *Black Sea* (London: Jonathan Cape, 1995).

139. Ascherson, *Black Sea*, 132. Some Circassians today still refute this apocryphal explanation with the oft-quoted retort: "Ah, now I understand. I give thee that little bird, take it," see Ascherson, *Black Sea*, 58.

140. Bullough, *Let Our Fame*, 9. Pioneering work by John F. Baddeley, Moshe Gammer, and Oliver Bullough, among others, has begun to reconstitute the history of the conflict in the Caucasus.

141. Sochi, location of the 2014 Winter Olympic Games, is a site that Circassians claim was the last stand of the Caucasian War. A group of Circassian diaspora organizations petitioned the International Olympic Committee (IOC) to not hold the games at this politically charged site. The IOC did not respond. When a Circassian Congress led by Murat Berzegov gathered documents to prove the circumstances and wrote to Russia's Duma for acknowledgment of the genocide, the Duma replied that the Circassians "do not appear on the list of . . . ethnic groups [that] underwent partial repression." See Bullough, *Let Our Fame*, 137. Just as the Armenian genocide was long denied but eventually recognized, the focus on Sochi prompted the Georgian parliament in May 2011 to recognize as genocide the forced emigration and massacre of Circassians by tsarist Russia. Weeks later, the Georgian government resolved to open a Caucasus memorial in 2012 in the village of Anaklia on the Black Sea coast. As a result, a nascent Circassian independence movement has taken hold. (Thus far, Russian officials have met with Circassian leaders, but have resisted all requests for acknowledgment of past crimes). See "Circassians genocie [*sic*] overshadows Sochi bid," *Reuters*, October 13, 2011; "Georgia Plans 'Circassian Genocide Memorial," *Civil Georgia* (Tbilisi), July 29, 2011.

142. Bullough, *Let Our Fame*, 108. See also W. E. D. Allen and Paul Muratoff, *Caucasian Battlefields: A History of the Wars on the Turco-Caucasian Border, 1828–1921* (Cambridge: Cambridge University Press, 1953).

143. A more direct translation of this title suggests that it could be more accurately described as "Abandonment of the aul by the mountaineers as Russian troops approach."

144. Claudio Saunt, *Unworthy Republic: The Dispossession of Native Americans and the Road to Indian Territory* (New York: W. W. Norton, 2020).

145. "The Last of the Circassians," *Deseret News,* July 6, 1864, 319.

146. George Leighton Ditson, *Circassia; or, A Tour to the Caucasus* (New York: Stringer & Townsend, 1850), 275.

147. "The Circassians," *True Flag* (Boston), December 3, 1859.

148. Laura Browder, *Slippery Characters: Ethnic Impersonators and American Identities* (Durham: University of North Carolina Press, 2000), 112. Thomas M. Barrett argues that American newspapers emphasized the "frontier process" dynamic in the Caucasus. Given the economic dependency of the Russian Cossacks on the region as well as the practice of nativization, the Russian Cossacks, he argued, functioned also as "settlers" in the Caucasus's native region. Thomas M. Barrett, "The Remaking of the Lion of the Dagestan: Shamil in Captivity," *Russian Review* 53, no. 3 (1994): 353–366.

149. Assimilation was bi-directional on this "frontier." There was a permeable line between the Caucasians led by Shamil and the Cossacks that made them defy the quarantine measures to facilitate the trade that the Russians, new to the region, desperately needed. Cossacks adopted the Caucasian lifestyle and practical systems despite being hired to attack Caucasians on imperial Russia's behalf.

150. Bullough, *Let Our Fame,* 108. Also See W. E. D. Allen and Paul Muratoff, *Caucasian Battlefields: A History of the Wars on the Turco-Caucasian Border, 1828–1921* (Cambridge: Cambridge University Press, 1953).

151. Sandwith to Gratz in *The Spectator* (quoted in *The Manchester Guardian,* August 2, 1862, 6).

152. K. H. Karpat, "Ottoman Immigration Politics and Settlement in Palestine," in *Settler Regimes in Africa and the Arab World: The Illusion of Endurance* (Wilmette, IL: Medina University Press International, 1974), 57–72.

153. Henri Troyat, *Pushkin,* trans. Nancy Amphoux (Garden City, NY: Doubleday, 1970), 361.

154. Austin Jersild, *Orientalism and Empire: North Caucasus Mountain Peoples and the Georgian Frontier, 1845–1917* (Montreal: Queen's University Press, 2003), 12; Main Staff of Caucasus Army, 1864, GVIARF (Russian Historical Society), f. 400, op. 1, 1864, d. 4736, Delo "Otchet po glavnomu shtabu o voennykh desitviiakh voisk Kavkazskoi armii," Emigration of natives of Kuban oblast to Turkey, l.61.

155. "Circassia Is Blotted from the Map," *New Haven Daily Palladium,* June 2, 1864, col. C.

156. "The Circassians," *Boston Daily Advertiser,* June 3, 1864, 1.

157. "The Circassian Exodus: Great Sufferings of the Circassians," *Farmer's Cabinet,* March 14, 1860, 1.

158. "The Circassian—Suffering and Death," *Albany Journal*, November 23, 1864, 2; Bullough, *Let Our Fame*, 103-111.

159. "The Rebel Forces—Lee and Johnston vs. Grant and Sherman, and the Mountain Region of East Tennessee," *New York Herald*, March 19, 1865.

160. E. B. Long and Barbara Long, *The Civil War Day by Day: An Almanac, 1861–1865* (New York: Doubleday, 1971).

161. "The War in the South-West Important from Tennessee. Columbus Not Evacuated. Gov. Harris Determined to Fight," *New York Daily Herald*, February 26, 1862, 8.

162. "Not Always," *Milwaukee Sentinel* (published as *Milwaukee Daily Sentinel*), March 8, 1865, 2. Here the term "fastnesses" references the nineteenth-century term for stronghold.

163. "Treason in Russia," *New Orleans Times*, June 26, 1865, 8. Other newspapers reported on the conflict in Circassia, including *Boston Daily Advertiser*, January 17, 1860, 1; "Latest News by Telegraph Arrival of the Teutonia," *The Constitution*, January 27, 1860, 3; *New York Tribune*, January 27, 1860, 2; "By Telegraph for the *Baltimore Sun*," *The Sun*, January 27, 1860, 2; "Latest News from Europe," *Daily State Gazette and Republican*, January 28, 1860, 2; "Additional and Later from Europe," *Daily Evening Bulletin*, February 20, 1860, 2.

164. "The Last of the Circassians," *Deseret News*, July 6, 1864, 319; Ursus Ferox, "One of the Blackest Pages in European History. Russian Ideas of Civilization," *Cincinnati Daily Gazette*, April 30, 1877, 2.

165. The Caucasian War was often considered a "Circassian struggle" in the nineteenth century, so much so that the *New York Herald* noted that it should be called a "Caucasian" struggle instead. See "Our St. Petersburg Correspondence: . . . An Ethnological Correction—The Caucassians [*sic*] Not Circassians, &c.," *New York Herald*, October 11, 1857, 2. Circassians (or "Cherkes") were part of the Adyghe group of the northwest Caucasus. This was not a "Circassian War," as it was often misnamed in the nineteenth century. In fact, the leader of the resistance in the Caucasus was the imam of the western-neighboring regions of Daghestan and Chechnya, though he also led the Circassians. Yet the pure valence of the term Circassian accorded by racial science turned it into a catchphrase for the people from the region as a whole. See Bullough, *Let Our Fame*.

166. See Liubov Kurtynova-D'Herlugnan, *The Tsar's Abolitionists: The Slave Trade in the Caucasus and Its Suppression* (Leiden: Brill, 2010).

167. "The Caucasus: Mr. George Kennan's Lecture on This Interesting Land," *Seattle Times*, February 19, 1893.

168. Jersild, *Orientalism and Empire*, 110. See Moshe Gammer, "Shamil and the Murid Movement, 1830–1859: An Attempt at a Comprehensive Bibliography," *Central Asian Survey* 10, nos. 1 and 2 (1991): 189–247. Indeed, even a Google n-gram search shows the increasing frequency of books about the figure published in English. See Barrett, "Remaking of the Lion," 366. Books on

Shamil include G. Bernier, *Les hôtes de Chamil* (Paris, 1854); N.a., *Ein Besuch bei Schamyl—Brief eins Preussen* (Berlin, 1855); Friedrich Martin von Boden-stedt, *Die Völker des Kaukasus und ihre freiheitskampfe gegen die Russen* (Berlin, 1855); Guillaume Depping, *Schamyl, le prophète du Caucase* (Paris, 1854); Golovin, *Caucasus;* August von Haxthausen, *The Tribes of the Caucasus. With an Account of Schamyl and the Murids,* trans. J. E. Taylor (London, 1855); Kenneth Mackenzie, *Shamil and Circassia* (London, 1854); John Mackie, *Life of Schamyl; and Narrative of the Circassian War of Independence against Russia* (Boston, 1856); Alexander Marlinsky (Bestoujev), *Esquisses Circassiannes—Esquisses sur le Caucase* (Paris, 1854); Xavier Marmier, *Du Danube au Caucase. Voyages et littérature* (Paris, 1854); John P. Morrel, *Russia and England: Their Strength and Weakness* (New York, 1854); Louis Moser, *The Caucasus and Its People* (London, 1856); Ludwig Moser, *Der Kaukasus, seine Volkerschaften, deren Kampfe etc., nebst einer Charakteristik Schamils* (Vienna, 1854); Laurence Oliphant, *The Russian Shores of the Black Sea* (New York, 1854); Oliphant, *The Trans-Caucasian Campaign of the Turkish Army under Omer Pasha* (Edinburgh, 1856); Thomas Peckett Prest, *Schamyl; or, The Wild Woman of Circassia. An Original Historical Romance* (London, 1856); N.a., *Shiamyl e la Guerra santa nell'Oriente del caucaso* (Milan, 1854); E. Spencer, *Turkey, Russia, Black Sea and Circassia* (London, 1854); René Gaspard Ernest Taillandier, *Allemagne et Russie; Études historiques et litteraires* (Paris, 1856); Edmond Texier, *Schamyl* (Paris, 1854); Horace Vernet, *Lettres intimes de M. Horace Vernet pendant son voyage en Russie, 1842–1843* (Paris, 1854); Vernet, *Schamyl als Feldherr, Sultan und Prophet des Kaukasus,* 2nd ed. (Leipzig, 1854); Friedrich Wagner, *Schamyl and Circassia,* ed. Kenneth R. H. Mackenzie (London, 1854); Vernet, *Sciamul, il profeta del Caucaso* (Florence, 1855); Frederick Wagner and F. Bodenstedt, *Shamil, the Sultan Warrior and Prophet of the Caucasus,* trans. Lascelles Wraxall (London, 1854); Maurice Wagner, *Travels in Persia, Georgia and Kurdistan* (London, 1855).

169. Leila Aboulela, *The Kindness of Enemies: A Novel* (New York: Grove, 2017).

170. Wilson, *History of the American People,* vol. 8.

171. Wilson, *History of the American People,* vol. 8, 249–250. See also *The Life and Letters of John Brown, Liberator of Kansas, and Martyr of Virginia,* ed. F. B. Sanborn (Boston: Roberts Brothers, 1885).

172. The play's American debut was in Boston. *Schamyl* debuted on November 20, 1854, at the National Theater, ran for a week billed as *Schamyl, The Hero of Circassia,* and starred an actor named Wm. Fleming. The New York debut was at the Metropolitan Theater on December 11, 1854. See Joseph N. Ireland, *Records of the New York Stage from 1750 to 1860,* vol. 2 (New York: T. H. Morrell, 1866), 746; George C. D. Odell, *Annals of the New York Stage,* vol. 7: *1857–1865* (New York: Columbia University Press, 1931), 233; "James R. Anderson," in T. Allston Brown, *History of the American Stage: Containing*

Biographical Sketches of Nearly Every Member of the Profession That Has Appeared on the American Stage, from 1733–1870 (New York: Dick and Fitzgerald, 1870); Gerald Bordman and Thomas S. Hischak, *The Oxford Companion to the American Theatre* (New York: Oxford University Press, 2004), 201; Allan Stuart Jackson, *The Standard Theater of Victorian England* (Cranbury, NJ: Associated University Presses, 1993), 102.

173. Jackson, *Standard Theater of Victorian England*, 101–102. Adapted from a French play by Anderson and William Markwell, the production was a "sensation drama" based on reporting about Shamil in US newspapers.

174. "All Sorts of Items," *Daily Evening Bulletin*, March 13, 1859, 1. It is likely that the "son of Schamyl" in the *Bulletin* was a professional or amateur impersonator. Shamil and his sons were captured in Gunib in late 1859 and never came to America.

175. Walt Whitman, "The Old Bowery: A Reminiscence of New York Plays and Acting Fifty Years Ago," *The Complete Prose Works of Walt Whitman*, vol. 3, ed. Richard Maurice Bucke et al. (New York: G. P. Putnam's Sons, 1902), 190. Later, on February 28, 1876, "Schamyl" would appear on American stages again in a play by Kate Fisher called *Schamyl; or, The Black Horse of the Caucasus*, put on at Wood's Museum and Menagerie in New York.

176. Bullough, *Let Our Fame*, 298.

177. In a letter about his visit in January 1864, on a tour in Europe, Aldridge describes the defeated hero as if a living tableau: "There is a decidedly benevolent expression in Schamyl's countenance, so much so indeed, that he looks more like a placid Patriarch of old than a famous mountain warrior. He is considerably above middle height; I should say full six feet when standing erect. He wore on his head a large white turban, with a small red crown and tassel, and just below it an encircling band of beautiful black lambskin." Bernth Lindfors, *Ira Aldridge: The Last Years, 1855–1867* (Rochester, NY: University of Rochester Press, 2015), 201.

178. See "Our St. Petersburg Correspondence: . . . An Ethnological Correction—The Caucassians [*sic*] Not Circassians, &c.," *New York Herald*, October 11, 1857, col. E, 2.

179. King, "Imagining Circassia," 243; "Circassia and the Circassians," *Penny Magazine*, April 14, 1838. Rebecca Ruth Gould is among the many scholars who write powerfully about how this combat of the Caucasian conflict lingered well into the twentieth century. See Gould, *Writers and Rebels*; "The Rebellion in Turkey: Speculations and Spasms of the Stock Exchange," *New York Herald*, September 20, 1875, 3.

180. "Revolt of the Mahamedans," *Daily Critic*, May 14, 1877, 7; "By Telegraph. Troops for Salt Lake. The Russians Crossing the Danube. The Mahamedan Insurrection," *Daily Critic*, May 15, 1877, 1.

181. Golovin, *Caucasus*, 30.

182. T. H. Huxley, "Schamyl, The Prophet-Warrior of the Caucasus," *Westminster Review* 61, n.s. 5 (1854): 480–519.

183. Dumas, *Adventures in Caucasia*, 62.

184. "Schamyl," *Fayetteville Observer*, September 25, 1854, col. A. The term "Circassian hair" also referred to a man's head of frizzy hair. See "Ruined His Business," *Grand Forks Daily Herald* (ND), September 4, 1891, 7. See Anne McClintock, *Imperial Leather: Race, Gender, and Sexuality in the Colonial Conquest* (London: Routledge, 1995); Timothy Barringer, "Images of Otherness and the Visual Product of Difference," in *The Victorians and Race*, ed. Shearer West (Aldershot, UK: Scholar's Press, 1995).

185. John F. Baddeley, *The Russian Conquest of the Caucasus* (New York: Longmans, Green, 1908), 249.

186. "Russian Ideas of Civilization: One of the Blackest Pages in European History," *Cincinnati Daily Gazette*, April 30, 1877, 2; "War in Asia: A Russian Military Expedition to Acquire Strategical Positions," *Philadelphia Inquirer*, May 12, 1877, 1; "The First Two Weeks of War: The First Shot of War Was Fired in Asia," *Jackson Citizen* (MS), May 15, 1877, 8.

187. Bullough, *Let Our Fame*, 307. The clicking sound in fact appears in Leo Tolstoy's *Prisoner of the Caucasus* (1870), where he describes the Caucasus men who captured the Russian hero as uncivilized through the same description: one Caucasus mountaineer, Abdul, spoke through a series of tongue clicks, which unnerved the protagonist Zhilin.

188. "Circassian Atrocities," *Daily Picayune* (New Orleans), July 28, 1876, 2; Bruce Grant, "The Good Russian Prisoner: Naturalizing Violence in the Caucasus Mountains," *Cultural Anthropology* 20 (2005): 39–67.

189. Matthew Frye Jacobson, *Whiteness of a Different Color*, 42.

190. "Circassian Soldiers Not so Bad as They Have Been Represented," *Territorial Enterprise* (Virginia City, NV), August 22, 1876.

191. See "Circassian Soldiers Not so Bad"; also "The Circassian Brigade," *Trenton State Gazette*, July 20, 1877.

192. Doris Sommer, *Foundational Fictions: The National Romances of Latin America* (Berkeley: University of California Press, 1991). See also Ann Laura Stoler, *Along the Archival Grain: Epistemic Anxieties and Colonial Common Sense* (Princeton, NJ: Princeton University Press, 2010), 6.

193. In archaeology and oceanography, sounding is a method meant to reveal what has been buried. *Soundings from the Atlantic*, the title of Oliver Wendell Holmes's mid-nineteenth-century treatise on the image at the start of the photographic age, reminds us that a sounding is not simply a turn of phrase.

194. Tina M. Campt, *Listening to Images* (Durham, NC: Duke University Press, 2017), 7. Also see Michael Gaudio, *Sound, Image, Silence: Art and the Aural Imagination in the Atlantic World* (Minneapolis: University of Minnesota Press, 2019).

2. Racial Adjudication

1. Sarah Lewis, *The Rise: Creativity, the Gift of Failure, and the Search for Mastery* (New York: Simon & Schuster, 2014), 90.

2. Frederick Douglass, "Pictures and Progress," in *The Frederick Douglass Papers*, ed. John W. Blassingame (hereafter *FDP*) (New Haven, CT: Yale University Press, 1985), ser. 1, vol. 3, 461. Douglass delivered another version of this speech at Wieting Hall in Syracuse, New York, on November 15, 1861. For the full transcript of these speeches, see John Stauffer, Celeste-Marie Bernier, and Zoe Trodd, *Picturing Frederick Douglass: An Illustrated Biography of the Nineteenth Century's Most Photographed American* (New York: Norton, 2015). Also see Henry Louis Gates, Jr., ed., *"Race," Writing, and Difference* (Chicago: University Press of Chicago Journals, Critical Inquiry series, 1992); Laura Wexler, "'A More Perfect Likeness': Frederick Douglass and the Image of the Nation," in *Pictures and Progress: Early Photography and the Making of African American Identity*, ed. Maurice O. Wallace and Shawn Michelle Smith, (Durham, NC: Duke University Press, 2012), 18–40; and Ginger Hill, "'Rightly Viewed': Theorizations of Self in Frederick Douglass's Lectures on Pictures," in *Pictures and Progress*, 41–82. I have discussed Frederick Douglass's speeches in Lewis, *Rise*.

3. Orlando Patterson, *Slavery and Social Death: A Comparative Study* (Cambridge, MA: Harvard University Press, 2018).

4. Douglass, "The Claims of the Negro Ethnologically Considered," in *The Portable Frederick Douglass*, ed. John Stauffer and Henry Louis Gates, Jr. (New York: Penguin, 2016), 231.

5. Wilson writes to his wife that he would like to buy it on August 13, 1902. See Wilson to Ellen Axson, August 13, 1902, *PWW*, vol. 14, 79.

6. James M. McPherson, *Battle Cry of Freedom: The Civil War Era* (New York: Oxford University Press, 1988), 81.

7. Saidiya V. Hartman, *Lose Your Mother: A Journey along the Atlantic Slave Route* (New York: Farrar, Straus and Giroux, 2007), 6, 45, 73, 107, 133.

8. Daphne A. Brooks, *Bodies in Dissent: Spectacular Performances of Race and Freedom, 1850–1910* (Durham, NC: Duke University Press, 2006), 20.

9. "Artist Conversation: Henry Louis Gates, Jr., Professor Sarah Lewis, and Sir Isaac Julien," Wadsworth Atheneum Museum of Art, May 19, 2023, https://www.thewadsworth.org/iamseen/.

10. Both Douglass and Jacques Rancière are interested in the constructive qualities of aesthetics, of images, and their potential for rupturing the logic of political rules governing social life. "Images change our gaze and the landscape of the possible," Rancière concludes, if they are not used for instrumental purposes, as propaganda. Jacques Rancière, *The Emancipated Spectator* (London: Verso, 2009), 13, 105.

11. Nell Painter, *Sojourner Truth: A Life, a Symbol* (New York: Norton, 1996); Darcy Grigsby, *Enduring Truths: Sojourner Truth, Shadow and Substance* (Chicago: University of Chicago Press, 2015). Rancière saw the relation of art and politics in the dramatically different context of the 1990s and has focused almost exclusively on aesthetics over the past few decades. See, for example, Rancière, *The Politics of Aesthetics: The Distribution of the Sensible* (New York: Continuum, 2004).

12. A short history of the idea of picturing moves from perspective—resolving an image to approximate natural sight in the land—to picturing a figure. But the boundaries of the category itself, as Robin Kelsey notes, are "neither as obvious nor as firm as they may seem." Picturing, inextricably conditioned by race in the United States, was not merely about scrutinizing the individual body, but became an operation of assessing global narratives to support ideas of racial hierarchy. Robin Kelsey, "Pictorialism as Theory," in *Picturing*, ed. Rachael Z. DeLue (Chicago: Terra Foundation for American Art, 2016), 176–211.

13. James McCune Smith, "Introduction to My Bondage and My Freedom (1855)," in *Douglass in His Own Time: A Bibliographical Chronicle of His Life, Drawn from Recollections, Interviews, and Memoirs by Family, Friends, and Associates*, ed. John Ernest (Iowa City: University of Iowa Press, 2014), 105–119; 134.

14. As Mirzoeff writes, "the ability to assemble a visualization manifests the authority of the visualizer." See Nicholas Mirzoeff, *The Right to Look: A Counterhistory of Visuality* (Durham, NC: Duke University Press, 2011), 2.

15. The scholarship on this history is vast, and includes Aston Gonzalez, *Visualizing Equality: African American Rights and Visual Culture in the Nineteenth Century* (Chapel Hill: University of North Carolina Press, 2020); Jasmine Nichole Cobb, *Picture Freedom: Remaking Black Visuality in the Early Nineteenth Century* (New York: New York University Press, 2015); Matthew Fox-Amato, *Exposing Slavery: Photography, Human Bondage, and the Birth of Modern Visual Politics in America* (New York: Oxford University Press, 2019); Deborah Willis, *The Black Civil War Solider: A Visual History of Conflict and Citizenship* (New York: New York University Press, 2021).

16. Kaja Silverman as read through Nicole Fleetwood, *Troubling Vision: Performance, Visuality, and Blackness* (Chicago: University of Chicago Press, 2011).

17. James McCune Smith, "Introduction to *My Bondage and My Freedom* (1855)."

18. Eisenmann's studio, opened in 1879 at 229 Bowery, is shown in "New York City, Insurance Maps, Rivington St. to East 22nd Street, 1868," in *Insurance Maps of the City of New York*, vol. 2 (New York: Perris & Browne, 1868). Mark Caldwell, *New York Night: Its Mystique and Mystery* (New York: Scribner's, 2005), 127.

19. Similarly, performance scholar Tavia Nyong'o considers the hardness of antebellum black ceramic figurines of kitsch memorabilia as a suggestion of

"blackness as a hardened form of subjectivity." See Tavia Nyong'o, "Racial Kitsch and Black Performance," *Yale Journal of Criticism* 15 (2002): 377.

20. Christopher R. Smit, "A Collaborative Aesthetic: Levinas's Idea of Responsibility and the Photographs of Charles Eisenmann and the Late Nineteenth-Century Freak-Performer," in *Victorian Freaks: The Social Context of Freakery in Britain,* ed. Marlene Tromp (Columbus: Ohio State University Press, 2008), 294. Connected to this idea is that of the performance of surrogation—as defined by Joseph Roach, a process of cultural reproduction in which individuals perform "who they thought they were not" to arrive at clarified self-definition. See Joseph Roach, *Cities of the Dead: Circum-Atlantic Performance* (New York: Columbia University Press, 1996), 3.

21. Robin Bernstein, *Racial Innocence: Performing American Childhood from Slavery to Civil Rights* (New York: New York University, 2011); Robin Bernstein, "Dances with Things: Material Culture and the Performance of Race," *Social Text* 101, no. 4 (2009): 67–94.

22. "Freaks: Their Salaries and Their Jealousies," *Telegraph and Messenger* (Macon, GA), November 11, 1883, 8.

23. See Jean François Lyotard, *Libidinal Economy* (Bloomington: Indiana University Press, 1993). My profound gratitude to my friend and colleague Huey Copeland for an exchange about this concept and so many others in this manuscript.

24. Kevin Young, *Bunk: The Rise of Hoaxes, Humbug, Plagiarists, Phonies, Post-Facts, and Fake News* (Minneapolis: Graywolf, 2017).

25. Oliver Wendell Holmes, "The Stereoscope and the Stereograph," *Atlantic Monthly* 3 (June 1859).

26. Jonathan Crary, *Techniques of the Observer: On Vision and Modernity in the Nineteenth Century* (Cambridge, MA: MIT Press, 1990), 13; John Tagg, "The Currency of the Photograph," in *Thinking Photography,* ed. Victor Burgin (London 1982), 110–141; Allan Sekula, "The Traffic in Photographs," in *Photography against the Grain: Essays and Photo Works, 1973–1983* (Halifax: Press of the Nova Scotia College of Art and Design, 1984), 96–101; Deborah Willis, *The Black Civil War Soldier: A Visual History of Conflict and Citizenship* (New York: New York University Press, 2021).

27. Smit, "Collaborative Aesthetic," 293.

28. Oliver Wendell Holmes, "Doings of the Sunbeam," *Atlantic Monthly* 12 (July 1863): 15; Elizabeth Anne McCauley, *A. A. E. Disdéri and the Carte de Visite Portrait Photograph* (New Haven, CT: Yale University Press, 1985), 3.

29. Douglass, "Pictures and Progress," *FDP,* vol. 3, 454.

30. My thanks to Laura Wexler for her lecture about these attempts to photograph the moon in the nineteenth century in April 2012.

31. Michael Leja, *Looking Askance: Skepticism and American Art from Eakins to Duchamp* (Berkeley: University of California Press, 2004), 12.

32. See "White and Colored Slaves," *Harper's Weekly,* January 30, 1864, 71; Mary Niall Mitchell, "'Rosebloom and Pure White,' or so It Seemed," *American Quarterly* 54, no. 3 (September 2002): 398. See also Laura Wexler, "Seeing Sentiment: Photography, Race, and the Innocent Eye," in *Female Subjects in Black and White: Race, Psychoanalysis, and Feminism,* ed. Elizabeth Abel, Barbara Christian, and Helene Moglen (Berkeley: University of California Press, 1997).

33. *American Missionary* (March 1860): 68–69.

34. Mitchell, "'Rosebloom and Pure White,'" 378, 397–398.

35. Frederick Douglass, "White Slaves Recover Their Freedom," *FDP,* September 21, 1855.

36. Michael Mitchell, *Monsters of the Gilded Age: The Photographs of Chas. Eisenmann* (New York: ECW Press, 2002), 11.

37. "The Circassian Girl's Despair," *Cleveland Plain Dealer* (OH), January 24, 1884, 1.

38. Caldwell, *New York Night,* 139.

39. Armond Fields and L. Marc Fields, *From the Bowery to Broadway: Lew Fields and the Roots of American Popular Theater* (New York: Oxford University Press, 1993), 55.

40. Fields and Fields, *From the Bowery to Broadway,* 21.

41. Rachel Adams, *Sideshow USA: Freaks and the American Cultural Imagination* (Chicago: University of Chicago Press, 2001).

42. Fields and Fields, *From the Bowery to Broadway,* 7.

43. Marlene Tromp with Karyn Valerius, "Introduction: Toward Situating the Victorian Freak," in *Victorian Freaks: The Social Context of Freakery in Britain,* ed. Marlene Tromp (Columbus: Ohio State University Press, 2008), 7.

44. Susan Stewart, *On Longing: Narratives of the Miniature, the Gigantic, the Souvenir, the Collection* (Durham, NC: Duke University Press, 1993), 109–110.

45. Mitchell, *Monsters of the Gilded Age,* 33. "Circassian Girl's Despair," 1; Smit, "Collaborative Aesthetic," 293.

46. "Circassian Girl's Despair," 1.

47. The ordinariness of the cartes that pervaded people's homes moved "the burden of imaginative thought from the artist to the viewer." See Geoffrey Batchen, "Dreams of Ordinary Life: Cartes-de-visite and the Bourgeois Imagination," in *Photography: Theoretical Snapshots* (London: Routledge, 2009), 94.

48. Batchen, "Dreams of Ordinary Life," 91.

49. Quoted in McCauley, "Introduction," in *A. A. E. Disdéri and the Carte de Visite Portrait Photograph,* 2. See also *Émile Zola: Oeuvres Completes,* ed. Maurice Le Blond, vol. 6: *La Curée* (Paris, 1927), 124–125.

50. Matthew Frye Jacobson, *Whiteness of a Different Color: European Immigrants and the Alchemy of Race* (Cambridge, MA: Harvard University Press, 1998), 11.

51. "The Circus in the Rain: How Barnum's Ethnological Congress Spends Sunday," *Springfield Daily Republican* (MA), June 1, 1885, 5.

52. In much the same way that the tightly regulated system of anthropometry "transforms space" behind the camera into an "instrument" of racial measurement through graphs and measurements, the Circassian Beauty was offered up as an object of racial inspection, but was measured by the eyes of the audience. Instead of using the skull, J. H. Lamprey and T. H. Huxley took the profile and frontal head views as the new standard of the racial classification practice beginning in the 1860s. Michel de Certeau, *Heterologies: Discourse on the Other* (Minneapolis: University of Minnesota Press, 1986).

53. Strother outlines the many lawsuits brought by abolitionist groups led by Zachary Macaulay who read the body language, gestures, and disposition of Sara Baartman—featured in a nineteenth-century freak show under the name Hottentot Venus—as a sign not of her character, but of the inappropriateness of the display. See Z. S. Strother, "Display of the Body Hottentot," in *Africans on Stage*, ed. Bernth Lindfors (Bloomington: Indiana University Press, 1999), 27, 31. The italics on page 27 (i.e. *"how to interpret what they see"*) and "... did *not* speak for itself" are both in Strother's scholarship.

54. Frances E. W. Harper, *Iola Leroy or Shadows Uplifted* (Oxford: Oxford University Press, 1988 [1892]), 229; Gabrielle Foreman, "Reading Aright: White Slavery, Black Referents, and the Strategy of Histotextuality in Iola Leroy," *Yale Journal of Criticism* 10, no. 2 (1997): 327–354.

55. Leja, *Looking Askance*, 15. Also see Neil Harris, *Humbug: The Art of P. T. Barnum* (Chicago: University of Chicago Press, 1981).

56. Leja, *Looking Askance*, 12.

57. Tavia Nyong'o, *The Amalgamation Waltz: Race, Performance, and the Ruses of Memory* (Minneapolis: University of Minnesota Press, 2009).

58. Thomas Jefferson, *Notes on the State of Virginia* (Boston: Lily and Wait, 1832), 75.

59. Charles D. Martin, *The White African American Body: A Cultural and Literary Exploration* (New Brunswick, NJ: Rutgers University Press, 2002), 22–33.

60. Adam Cohen, *Imbeciles: The Supreme Court, American Eugenics, and the Sterilization of Carrie Buck* (New York: Penguin, 2016); Paul A. Lombardo, *Three Generations, No Imbeciles: Eugenics, the Supreme Court, and Buck v. Bell* (Baltimore: Johns Hopkins University Press, 2008); Nell Painter, *The History of White People* (New York: W. W. Norton, 2010).

61. *New York Times*, December 15, 1859, 4. Also see Laura Wexler, *Tender Violence: Domestic Visions in an Age of U.S. Imperialism* (Chapel Hill: University of North Carolina Press, 2000). *The Octoroon*, which opened as an "immediate success" on December 6, 1859, at the Winter Garden Theater and in 1860 at both the New Bowery Theater and the Old Bowery Theater, could have added another semiotic charge to Eisenmann's comparative set of images.

62. See "Theater Going," *Christian Recorder* (Philadelphia), May 21, 1870.

63. Dion Boucicault, *The Octoroon* (reprint; Whitefish, MT: Kissinger, 2004), 55.

64. Lee Baker, "'The Racist Anti-Racism of American Anthropology,'" Hutchins Center for African and African American Research, Harvard University, March 4, 2021.

65. Brooks, *Bodies in Dissent*, 154.

66. Nearly 150 years later, Branden Jacobs-Jenkins's Obie award-winning play *An Octoroon* reinterpreted and revised Boucicault's play, making the issue of adjudication central. After restaging the central scene—overseer McClosky's treacherous murder of an enslaved boy, Paul, being captured on film, and his attempt to frame the indigenous man Wanhotee for Paul's murder—the play breaks through the fourth wall, offering a bridge from the present to the past. Jacobs-Jenkins interjects: "we've gotten so used to photos and photographic images that we've basically learned how to take them, so the kind of justice around which this whole thing hangs is actually a little dated."

67. Brooks, *Bodies in Dissent*, 154.

68. Brooks, *Bodies in Dissent*, 20.

69. Brooks, *Bodies in Dissent*, 34; and Sheldon Faulkner, "The 'Octoroon' War," *Educational Theatre Journal* 15, no. 1 (March 1963): 33–38.

70. Brooks, *Bodies in Dissent*, 29–30.

71. Brooks, *Bodies in Dissent*, 30.

72. Brooks, *Bodies in Dissent*, 3.

73. Volpe, "Embodying the Octoroon: Abolitionist Performance at the London Crystal Palace, 1851." See Dorothy Sterling, "Free at Last," in *Black Foremothers: Three Lives*, 2d ed. (New York: Feminist Press, 1988), 25. See also "Eyre, Artemus Ward and Ellen Craft," *Cincinnati Daily Gazette*, January 16, 1867, 1.

74. James McPherson, *Battle Cry of Freedom: The Civil War Era* (New York: Oxford University Press, 1989), 81. Macon, Georgia's issue of the *Georgia Telegraph* on February 13, 1849, ran a reprint about the Crafts from a New England news-paper. There was one difference: the addendum at the end read, "The Mr. and Mrs. Crafts who figure so largely in the above paragraph will be recognized at once by our city leaders as the slaves belonging to Dr. Collins and Mr. Ira H. Taylor, of this place, who runaway [*sic*] or were decoyed from their owners in December last." See Sterling, *Black Foremothers*, 25–26; "William and Ellen Crafts, [*sic*]" *Lowell Daily Citizen and News* (MA), September 9, 1869, 2.

75. "William Wells Brown to William Lloyd Garrison," *The Liberator*, January 12, 1849.

76. For her to speak on stage would have gone against all nineteenth-century Victorian customs for women in the presence of a mixed-gender audience. As McMillan notes, she could "speak through her body." See Uri McMillan, "Ellen Craft's Radical Techniques of Subversion," *e-misférica: Performance and Politics in the Americas* 5, no. 2 (2008). Also see McMillan, *Embodied Avatars: Genealogies of Black Feminist Art and Performance* (New York: New York University Press, 2015).

77. Sterling, *Black Foremothers*, 22, 23, 26.

78. "England; October," *Cincinnati Commercial Tribune*, September 10, 1869, 4. Also see Sterling, *Black Foremothers*, 50.

79. Foreman, "Who's Your Mama?," 508, 527. The italics in the text are Foreman's own.

80. Jacobson, *Whiteness of a Different Color*, 46.

81. John F. Baddeley, *The Russian Conquest of the Caucasus* (New York: Longmans, Green, 1908), 249.

82. The sense of the divide between Asia and the West would remain even in allusions to the region in twentieth-century literature. In Brecht's play *The Caucasian Chalk Circle*, for example, set after World War II in the Caucasus mountains, the chalk circle itself is an allusion to a Chinese legend and a story of Solomon's judgment in the Bible.

83. Richard Dyer, *White* (New York: Routledge, 2017); Theodore Allen, *The Invention of the White Race* (London: Verso, 2012).

84. George Kennan, "The Mountains and the Mountaineers of the Eastern Caucasus," *Journal of the American Geographical Society of New York* no. 5 (1874): 177. Kennan delivered this speech in December of 1873.

85. Quoting Vissarion Belinsky in Susan Layton, *Russian Literature and Empire: Conquest of the Caucasus from Pushkin to Tolstoy* (Cambridge: Cambridge University Press, 1994), 15. Not only did this region inspire literature and theatrical productions of imaginative license, panegyric prose, and poetry, but the texts often focused on Circassian women as well. See Austin Jersild, *Orientalism and Empire: North Caucasus Mountain Peoples and the Georgian Frontier, 1845–1917* (Montreal: McGill-Queen's University Press, 2002), 4.

86. Faddei Bulgarin launched a satirical public attack on Pushkin's African ancestry in August 1830, which prompted the poet to respond. In the letter to Pushkin, Nashchokin wrote, "I am sending you your ancestor with inkwells that open and reveal him to be a farsighted person [*a double vue*]." See Catharine Theimer Nepomnyashchy and Ludmilla A. Trigos, "Introduction: Was Pushkin Black and Does It Matter?" in *Under the Sky of My Africa: Alexander Pushkin and Blackness*, ed. C. T. Nepomnyashchy, N. Svobodny, and L. A. Trigos (Evanston, IL: Northwestern University Press, 2006), 18; J. Thomas Shaw, "Pushkin on His African Heritage: Publications during His Lifetime," in *Under the Sky of My Africa: Alexander Pushkin and Blackness*, ed. C. T. Nepomnyashchy, N. Svobodny, and L. A. Trigos (Evanston, IL: Northwestern University Press, 2006), 93–94.

87. Nepomnyashchy and Trigos, "Introduction," 18.

88. While in the Caucasus, Pushkin wrote the poems "The Caucasus," "Avalanche," and "Monastery of Mount Kazbek," in addition to *The Journey to Arzrum* (1836), which extends the motif of escaping the social confines of an "elite cultural milieu" that runs throughout *The Prisoner of the Caucasus*. The final text was based on his notes from his travels along the Russo-Turkish

border. Harsha Ram, *The Imperial Sublime: The Russian Poetics of Empire* (Madison: University of Wisconsin Press, 2006), 396.

89. Pushkin, *Polnoe sobranie sochinenii* (Moscow and Leningrad, 1937–1959) [hereafter *PSS*] 7: 61; David M. Bethea, "How Black Was Pushkin? Otherness and Self-Creation," in Nepomnyashchy, Svobodny, and Trigos, *Under the Sky of My Africa*, 138.

90. In a June 24, 1824, letter, Pushkin states, "One can think of the fate of the Greeks in the same way as the fate of my brother Negroes, and one can wish both of them liberation from unendurable slavery." *PSS* 13:99, Nepomnyashchy and Trigos, "Introduction," 15. In fall 1824, on a visit to the brother of his great-grandfather, Petr Abramovich, "my old Negro of a Great-uncle" as Pushkin would call him, Pushkin studied the German notes about his father's biography recounted to him in childhood. Pushkin left Abramovich's home with them in his possession and would go on to make his heritage public with many of his texts. See "Introduction," 7. It was well known that Pushkin's great-grandfather, christened Abram Petrovich Gannibal, was born in sub-Saharan Africa, though scholars would debate from where, precisely, until well into the twentieth century. Dieudonné Gnammankou has now established that Pushkin's great-grandfather's place of birth was Logon, part of what is now within the state of Cameroon, near Lake Chad. Part of his evidence rests on a letter that Gannibal wrote to Empress Elizabeth I in 1742 in which he claims, "I was born in the domain of my father, in the town of Logon." See N. K. Teletova, "A. P. Gannibal: On the Occasion of the Three Hundredth Anniversary of the Birth of Alexander Pushkin's Great-Grandfather," *Under the Sky of My Africa*, 51, n.10.

91. Abram Tertz, *Strolls with Pushkin*, trans. Catharine Theimer Nepomnyashchy and Slava I. Yastremski (New Haven, CT: Yale University Press, 1993), 49. Also see Richard C. Borden, "Making a True Image: Blackness and Pushkin Portraits," in *Under the Sky of My Africa*, 174.

92. Nabokov quoted in Liza Knapp, "Tsvetaeva's 'Blackest of Black' (*Naicherneishii*) Pushkin," *Under the Sky of My Africa*, 279.

93. Borden, "Making a True Image," 182.

94. The friend was Pavel Voinovich Nashchoken. Borden, "Making a True Image," 179.

95. Maria Tsvetaeva quoted in Knapp, "Tsvetaeva's 'Blackest of Black' (*Naicherneishii*) Pushkin," 279.

96. In 1828, the first African American newspaper, *Freedom's Journal*, published a piece about Pushkin's great-grandfather as "evidence for what William Wells Brown called the 'genius, capacity, and intellectual development' of black people." See Gates, "Foreword," *Under the Sky of My Africa*, xii. In 1847, American abolitionist John Greenleaf Whittier would raise the writer to "the status of a black icon," when the abolitionist newspaper *The National Era* published an article about Pushkin's heritage and high standing in Russian society.

97. *National Era*, February 11, 1847, 147. Pushkin's biography became a subject of interest that often filtered into readings of his Caucasus-based prose in Russia and beyond. The American public was aware that Pushkin had been "banished to the Caucasus," as the *Connecticut Gazette* put it in January 1830. See *Connecticut Gazette* 67, no. 3455 (January 1830), 2. Pushkin had fled to the Russian "South" in defiance of the Russian authorities from May through November 1829. When he was in the Caucasus for the second time he wrote the poems "The Caucasus," "Avalanche," "Monastery of Mount Kazbek," and *The Journey to Arzrum* (1836). The motif of escaping the social confines of an "elite cultural milieu" runs throughout *The Prisoner of the Caucasus*—in the *poema*, a young Russian man leaves for the Northern Caucasus and there falls in love with a Circassian, Fatima, a name of one of Barnum's Circassian Beauties. Harsha Ram and Susan Layton argue that Pushkin's own narrative persona comes through in *The Journey to Arzrum* such that it becomes a prismatic text through which one can see Pushkin "ponder his personal and cultural identity." See Ram, *Imperial Sublime*, 396; Layton, *Russian Literature and Empire.*

98. "Married in a Snowstorm" was printed in *New Hampshire Sentinel*, August 15, 1872, 1; *Jackson Citizen Patriot* (Jackson, MI), August 17, 1872, 3; and *Evening Bulletin* (San Francisco), September 21, 1872, (supplement), 1. For "Queen of Spades" see "The September Magazines," *St. Albans Daily Messenger* (St. Albans, VT), August 21, 1876, 2. For *Marie* see "Marie!" *The Inter Ocean* (Chicago), January 25, 1877, 1. And for *The Final Shot* see "The Final Shot," *New Haven Register,* July 21, 1887, 3; and "The Final Shot," *Daily Inter Ocean* (Chicago), July 22, 1887, 3.

99. "Literature and Recent Essays in Literary Criticism by Henry Holt Hutton," *Quincy Daily Whig* (Quincy, IL), December 12, 1876, 4.

100. Toni Morrison, *Playing in the Dark*, 14, 16.

101. Addressing such silences is nothing new for the field of Black Studies. In her exemplary methodology, for example, Farah Jasmine Griffin speaks about how black women scholars dedicate themselves to "make sense of the silence that surrounds black women's lives and experiences." See Griffin, *Beloved Sisters, Loving Friends: Letters from Rebecca Primus of Royal Oak, Maryland and Addie Brown of Hartford, Connecticut, 1854–1868* (New York: Knopf, 1999), 3, as well as the incisive model of critical fabulation crafted by Saidiya Hartman, "Venus in Two Acts," *Small Axe: A Journal of Criticism* 12, no. 2 (2008).

102. Morrison, *Playing in the Dark*, 2–33.

103. Dexter W. Fellows and Andrew A. Freeman, *This Way to the Big Show* (New York: Viking, 1936), 293.

104. Quoted in Bogdan, "The Social Construction of Freaks," in Rosemarie Garland Thomson, *Freakery: Cultural Spectacles of the Extraordinary Body* (New York: New York University Press, 1996), 238. See also John Dingess,

unpublished manuscript, Hertzberg Circus Collection, Witte Museum, San Antonio, TX, ca. 1899, 923–926.

105. "Knickerbocker Gossip: Topics That Interest the People of the Metropolis," *Cincinnati Daily Gazette*, December 4, 1880, 5.

106. *Scientific American*, March 28, 1908; *New York Medical Journal*, n.d. (available online at www.disabilitymuseum.org, accessed May 25, 2005).

107. "The Jackson Whites," *Salt Lake Telegram*, September 17, 1922, 36.

108. "A Community of Outcasts," *Appleton's Journal of Literature, Science, and Art* 7 (1872): 325.

109. "Jackson Whites," 36.

110. For "peerless" see "Fondling Snake. Diamond Rattles Are Said to Make Good Pets When Handled Properly," *Biloxi Daily Herald*, February 19, 1902, 2; and "Right Way to Handle Snakes. Won't Bite unless They're Angry," *Charlotte Observer*, December 23, 1901, 5. Also see "Barnum," *Charlotte Daily Observer*, August 27, 1911, 4.

111. "She Was the Limit," *Trenton Evening Times*, February 12, 1910, p. 12. Also see "She Was the Limit," *Gulfport Daily Herald* (Biloxi, MS), April 12, 1910, 6.

112. "Knickerbocker Gossip: Topics That Interest the People of the Metropolis," *Cincinnati Daily Gazette*, December 4, 1880, 5.

113. "The Beautiful Circassian," *Kansas City Star*, July 26, 1885, 16.

114. Scholars such as Sianne Ngai have argued that Dietrich's performance of the Circassian-like performer in the Hot Voodoo scene in *Blonde Venus* is an oblique inversion of "Black Venus" Josephine Baker. See Sianne Ngai, "Black Venus, Blonde Venus," in *Bad Modernisms*, ed. Douglas Mao and Rebecca L. Walkowitz (Durham, NC: Duke University Press, 2006), 145–178; Jean-Claude Baker and Chris Chase, *Josephine: The Hungry Heart* (New York: Random House, 1993); James A. Snead, *White Screens/Black Images: Hollywood from the Dark Side* (New York: Routledge, 1994), 72.

115. Adams, *Sideshow USA*, 14.

116. Painter, *History of White People*, 71.

117. See Box 36: Clippings, 1917–1920, 1931, James G. Harbord Papers, Library of Congress; "General J. G. Harbord Narrowly Escapes Capture by Bandits," *August Chronicle,* October 24, 1919, 8.

118. "Strange-Looking Men Speak a Language Nobody in Immigrant Service Understands," *Baltimore America*, March 18, 1911, 1, reprinted in *Trenton Evening Times*, March 18, 1911, 7.

119. The literature on European immigrants and their negotiated entrance into the category of whiteness is too vast to cite here fully, but key works include Noel Ignatiev, *How the Irish Became White* (New York: Routledge, 1995); Matthew Frye Jacobson, *Barbarian Virtues: The United States Encounters Foreign Peoples at Home and Abroad, 1876–1917* (New York: Hill and Wang, 2000); David R. Roediger, *Working towards Whiteness: How America's Immigrants Became White* (New York: Basic Books, 2005); Peter Mesenhöller, *Augustus F.*

Sherman: Ellis Island Portraits, 1905–1920 (New York: Aperture, 2005); Patrick R. O'Malley, *The Irish and the Imagination of Race: White Supremacy across the Atlantic in the Nineteenth Century* (Charlottesville: University of Virginia Press, 2023).

120. Jennifer L. Hochschild and Brenna Marea Powell, "Racial Reorganization and the United States Census, 1850–1930: Mulattoes, Half-Breeds, Mixed Parentage, Hindoos, and the Mexican Race," *Studies in American Political Development* 22 (Spring 2008): 59–96, quotation on 90. They conclude that "geographers and demographers might shake up the study of American political development." This is most acutely possible through using the framework of an emphatically visual analysis of mapping—an increasingly vital method of measuring social life in the United States. Henry Louis Gates, Jr., *Stony the Road: Reconstruction, White Supremacy, and the Rise of Jim Crow* (New York: Penguin, 2019); C. Vann Woodward, *The Strange Career of Jim Crow* (New York: Oxford University Press, 1971); *Jumpin' Jim Crow: Southern Politics from Civil War to Civil Rights,* ed. Jane Dailey, Glenda Gilmore, and Bryant Simon (Princeton, NJ: Princeton University Press, 2000).

121. Melissa Nobles, *Shades of Citizenship: Race and Census in Modern Politics* (Stanford: Stanford University Press, 2000), 188.

122. Hochschild and Powell in "Racial Reorganization" cite that the reason for this lack of instruction could be that it was practiced, or as Margo Anderson notes, the information is harder to ascertain because a fire destroyed many of the 1890 Census original schedules. Margo Anderson, *The American Census: A Social History* (New Haven, CT: Yale University Press, 1988). Statisticians, congressmen (all men at the time), and census officials all registered their concerns about the instability of both assessment and the boundaries of racial categories. See Richmond Mayo-Smith, "On Census Methods," *Political Science Quarterly* 5 (1890): 260. For more on racial classification and the census, see Jennifer Hochschild and Velsa Weaver, "Policies of Racial Classification and the Politics of Racial Inequality," in *Remaking America: Democracy and Public Policy in an Age of Inequality,* ed. Joe Soss, Jacob Hacker, and Suzanne Mettler (New York: Russell Sage Foundation, 2007), 159–182; Nobles, *Shades of Citizenship,* 188; Brendan A. Shanahan, "Enforcing the Colorline and Counting White Races: Race and the Census in North America, 1900–1941," *American Studies* 44, no. 3 (2014): 293–307.

123. As Ian Haney López writes, naturalization itself did not generate formal court proceedings, but there were many racial prerequisite cases about the definition of the term Caucasian at the federal or even Supreme Court level. Ian Haney López, *White by Law: The Legal Construction of Race* (New York: New York University Press, 1996), 1, 36.

124. Jacobson, *Whiteness of a Different Color,* 158.

125. Jacobson, *Whiteness of a Different Color,* 160. For more on the significance of Asian exclusion to the formation of citizenship and immigration, see scholarship

including Beth Lew-Williams, *The Chinese Must Go: Violence, Exclusion, and the Making of the Alien in America* (Cambridge, MA: Harvard University Press, 2018); Erika Lee, *At America's Gates: Chinese Immigration during the Exclusion Era, 1882–1943* (Chapel Hill: University of North Carolina Press, 2003); Adam McKeown, *Melancholy Order: Asian Migration and the Globalization of Borders* (New York: Columbia University Press, 2008); Lucy Salyer, *Laws Harsh as Tigers* (Chapel Hill: University of North Carolina Press, 1995).

126. Lauren Kroiz has used "composite" to describe what she argues is a discourse about racial "difference" in modernism, citing another use of the term by poet Benjamin de Casseres in a 1910 issue of Stieglitz's journal *Camera Work*. For Kroiz, this "conflicted and shifting racial discourse at the turn of the century was fundamental to the formulation of modern art." Lauren Kroiz, *Creative Composites: Modernism, Race, and the Stieglitz Circle* (Berkeley: University of California Press, The Phillips Collection, 2012), 2, 8.

127. Jill Lepore, "A New Americanism: Why a Nation Needs a National Story," *Foreign Affairs* 98, no. 2 (May / April 2019): 10–19.

128. David W. Blight, "The Possibility of America: Frederick Douglass's Most Sanguine Vision of a Pluralist National Rebirth," *The Atlantic* (December 2019): 128–130; Douglass, "Our Composite Nationality," in *The Speeches of Frederick Douglas: A Critical Edition* (New Haven, CT: Yale University Press, 2018), 278–303.

129. Douglass, "Our Composite Nationality," 278–303.

130. Charmaine A. Nelson, "A 'Tone of Voice Peculiar to New-England': Fugitive Slave Advertisements and the Heterogeneity of Enslaved People of African Descent in Eighteenth-Century Quebec," *Current Anthropology* 61, supp. 22 (October 2020): S303–S316. Nelson has elsewhere argued that the study of slavery should feature fugitive slave advertisements as a key historical source that is "fundamentally visual." See "Art Talk with Art Historian Charmaine Nelson," Field Trip: Art Across Canada website, December 4, 2020, https://www.fieldtrip.art/field-trips/arttalk-with-art-historian-charmaine -nelson-causerie-sur-lart-avec-lhistorienne-de-lart-charmaine-nelson. Also see Jasmine Nichole Cobb, "A Peculiarly 'Ocular' Institution," in *Picture Freedom: Remaking Black Visuality in the Early Nineteenth Century* (New York: New York University Press, 2015); Nicholas Mirzoeff, *The Right to Look: A Counterhistory of Visuality* (Durham, NC: Duke University Press, 2011); Huey Copeland, *Bound to Appear: Art, Slavery, and the Site of Blackness in Multicultural America* (Chicago: University of Chicago Press, 2013).

131. *Ex parte Shahid*, 205 Fed. 813 (1013); Haney López, *White by Law*, 54–55.

132. Smith cited in Haney López, *White by Law*, 55.

133. Haney López, *White by Law*, 55.

134. Frederick Douglass, "Lessons of the Hour," January 9, 1894. Douglass gave many variations of this speech in the last year of his life. Douglass, "Lessons of the Hour," in *Portable Frederick Douglass*, 377–410.

135. Lawrence Oliphant, *The Russian Shores of the Black Sea in the Autumn of 1852: With a Voyage down the Volga, and a Tour through the Country of the Don Cossacks* (New York: Redfield, 1854).

136. Gates, "Foreword," *Stony the Road,* xii.

3. Unsilencing the Past

1. This often-cited comment was first noted in Norbert Heerman, *Frank Duveneck* (Boston: Houghton Mifflin, 1918), 1. See André Dombrowski, "'Everything Is Moist': Frank Duveneck and Munich's Painterly Realism," in *Frank Duveneck: American Master,* ed. Julie Aronson (Cincinnati: Cincinnati Art Museum, 2020), 51–52, n.4. First cited in J. Nilsen Laurvik, "Frank Duveneck" in *Catalogue De Luxe of the Department of Fine Arts, Panama-Pacific International Exposition,* ed. John Ellingwood, Donnell Trask, and J. Nilsen Laurvik (San Francisco: Paul Elder, 1915), 1–29.

2. Henry James called him "an unsuspected man of genius" in *The Nation,* June 3, 1875.

3. Huey Copeland, Sampada Aranke, Faye R. Gleisser, "Let's Ride: Art History after Black Studies," *Artforum* (October 2023).

4. Michel-Rolph Trouillot, *Silencing the Past: Power and the Production of History* (Boston: Beacon, 2015), 106.

5. "Duveneck's Painting," *Boston Daily Advertiser,* March 6, 1877.

6. Julie Aronson, "A Tale of Two Cities: Cincinnati, Boston, and Duveneck's Reputation," in the exhibition catalogue *Frank Duveneck: American Master* (Cincinnati: Cincinnati Art Museum, 2020), 36. As mentioned in Chapter 2, this is part of the idea of skeptical vision that Michael extended here to discuss racial formation. See Leja, *Looking Askance.*

7. On the idea of "epistemological worries," see Lorraine Daston and Peter Galison, *Objectivity* (New York: Zone, 2007), 35.

8. Woodrow Wilson, "Mere Literature," *Atlantic Monthly* (December 1893): 820–828.

9. "The Circassian Revolt," *The Daily Critic* (Washington, DC), July 31, 1876; "Revolt of the Mahomedans," *The Daily Critic,* May 14, 1877, 7; "By Telegraph. Troops for Salt Lake. The Russians Crossing the Danube. The Mahamedan Insurrection," *Daily Critic,* May 15, 1877, 1; "Trouble in the Caucasus," *New York Herald,* November 1, 1886, 4.

10. With enormous gratitude to Matthew Wittman, curator at the Houghton Library, for so generously directing me to materials related to the route of Barnum's show in the Houghton archive at Harvard. See R. Arnold and P. T. Barnum, *Statistics of P. T. Barnum's New and Greatest Show on Earth, for the Season of 1876: Through the Principal Cities and Towns in the Eastern and Middle States and British Provinces* (Buffalo, NY: Courier Co., 1876).

11. Kirk Savage, *Standing Soldiers, Kneeling Slaves: Race, War, and Monument in Nineteenth-Century America* (Princeton, NJ: Princeton University Press, 1997), 19, 162–208.

12. Tanya Sheehan, "A Time and a Place: Rethinking Race in American Art History," in *A Companion to American Art,* ed. John Davis, Jennifer A. Greenhill, and Jason D. LaFountain (Oxford: John Wiley & Sons, 2015), 49–67.

13. Foundational scholarship in visual culture and cultural studies often treats the instability of racial construction in historic context by discussing the instability of the very category of the Caucasus. This literature is vast. Salient texts include Tavia Amolo Ochieng' Nyongó, *The Amalgamation Waltz: Race, Performance, and the Ruses of Memory* (Minneapolis: University of Minnesota Press, 2009), Kirsten Pai Buick, *Child of the Fire: Mary Edmonia Lewis and the Problem of Art History's Black and Indian Subject* (Durham, NC: Duke University Press, 2010), and Adrienne R. Brown, *The Black Skyscraper: Architecture and the Perception of Race* (Baltimore: Johns Hopkins University Press, 2017).

14. Michel-Rolph Trouillot, *Silencing the Past,* 82; Pierre Bourdieu, *The Logic of Practice,* trans. Richard Nice (Stanford, CA: Stanford University Press, 1990), 5.

15. Ann Laura Stoler, *Along the Archival Grain: Epistemic Anxieties and Colonial Common Sense* (Princeton, NJ: Princeton University Press, 2010), 3. Stoler's account is focused on Dutch colonial archives with methodological applicability beyond this. I read Stoler's comment here, as does Charmaine Nelson, as an invitation to consider other reasons. See "Art Talk with Art Historian Charmaine Nelson," Field Trip: Art across Canada website, December 4, 2020, https://www.fieldtrip.art/field-trips/arttalk-with-art-historian-charmaine-nelson-causerie-sur-lart-avec-lhistorienne-de-lart-charmaine-nelson.

16. Evelynn Hammonds, "Black (W)holes and the Geometry of Black Female Sexuality," in *Differences: A Journal of Feminist Cultural Studies* 6, nos. 2–3 (1994): 126–145.

17. Of the many exemplary texts here is Steven Nelson's discussion of the marriage of representation, absence, vision, and subjectivity in African American art history. See Steven Nelson, "Emancipation and the Freed in American Sculpture: Race, Representation, and the Beginnings of an African American History of Art," in *Art History and Its Institutions: Foundations of a Discipline,* ed. Elizabeth Mansfield (London: Routledge, 2002), 283–294.

18. Here I am thinking of a reflection by Alexander Nemerov about the distinction between art and the archives, challenging us to consider whether locating a work in the archive ever fully "explains a work of art," and arguing that this is less possible than our practices and art historical methods train us to believe. Alexander Nemerov, "Art Is Not the Archive," *Archives of American Art Journal* 56, no. 2 (Fall 2017): 77–83.

19. Trouillot, *Silencing the Past,* 26–27. While I'm focused here on structural silence, this chapter is inspired by Kirsten Pai Buick's deft analysis and parallel method for considering the silences in art history as a product of a sequential

set of decisions in key, authoritative texts in American art. See Buick, "Confessions of an Unintended Reader: African American Art, American Art, and the Crucible of Naming," in *The Routledge Companion to African American Art History* (New York: Routledge, 2020), 82-91, and "Seeing the Survey Anew: Compositional Absences That Structure Ideological Presences," *American Art* 34, no. 3 (Fall 2020): 24-30.

20. Sean Anderson and Mabel O. Wilson, "Introduction," in *Reconstructions: Architecture and Blackness in America* (New York: Museum of Modern Art, 2021), 16; Nicholas Mirzoeff, *White Sight: Visual Politics and Practices of Whiteness* (Cambridge, MA: MIT Press, 2023).

21. Walter Muir Whitehill, *Museum of Fine Arts, Boston Centennial History* (Cambridge, MA: Belknap Press of Harvard University Press, 1970), vol. 1, 40.

22. The only other signature that comes close to this prominence is his self-portrait from circa 1878. See the reproduction of "Self-Portrait," ca. 1878, Courtesy of Indianapolis Museum of Art at Newfields, in *Frank Duveneck: American Master*, 191. Duveneck altered his style for his signatures from work to work. A range is shown in *Frank Duveneck: American Master*, 156-157.

23. Michael Quick, *An American Painter Abroad: Frank Duveneck's European Years* (Cincinnati: Cincinnati Art Museum, 1987), 10. After Mahonri Sharp Young's analysis of Duveneck's work in the 1960s, scholars began to feature the larger set of the painter's contributions. See Robert Neuhaus, "The Two Worlds of Frank Duveneck," *American Art Journal* 1, no. 1 (1969): 92-103; "Duveneck's Painting," *Boston Daily Advertiser*, March 6, 1877, col. D.

24. Sarah Burns, "A Dangerous Class of Painting: Ugliness, Masculinity, and the Munich Style in Gilded Age America," in *Frank Duveneck: American Master*, 73-85.

25. When Duveneck painted *A Circassian*, the younger sister of Louisa May Alcott, May Alcott Nieriker, wrote, "Much is said just now in favor of the Munich school," in *Studying Art Abroad, and How To Do It Cheaply*. Duveneck was part of the reason for the popularity, as opposed to, say, Düsseldorf. On the role of Munich in artistic training, see Susanne Boller, *American Artists in Munich: Artistic Migration and Cultural Exchange Processes*, ed. Christian Fuhrmeister, Hubertus Kohle, and Veerle Thielemans (Berlin: Deutscher Kunstverlag, 2009), and Elizabeth Wylie, *Explorations in Realism, 1870-1880: Frank Duveneck and His Circle from Bavaria to Venice* (Framingham, MA: Danforth Museum of Art, 1989).

26. Elizabeth Boott cited in Dombrowkski, "Everything Is Moist," 53.

27. Henry James, "Of Some Pictures Lately Exhibited," *The Galaxy*, 20, no. 1 (July 1875).

28. *Frank Duveneck* (New York: Chapellier Gallery, 1972), 129.

29. Dombrowski, "Everything Is Moist," 59.

30. Burns, "Dangerous Class of Painting," 73-85. As Lisa N. Peters notes in her review of the Duveneck exhibition at the Cincinnati Art Museum, Burns and Dombrowski seem to present two different views on the reception of

Duveneck's work in the US context. See Lisa N. Peters, review of *Frank Duveneck: American Master*, in *Panorama: Journal of the Association of Historians of American Art* 7, no. 1 (Spring 2021), https://doi.org/10.24926/24716839.11839.

31. Burns, "Dangerous Class of Painting," 73–74.

32. Burns, "Dangerous Class of Painting," 85.

33. Mary Kinkead of Lexington, Kentucky, studied at the Art Academy of Cincinnati from 1886 to 1891. In 1890, Duveneck was hired to create a school that would serve as a contrast to the McMicken School at the Art Academy. Kinkead began studies with Duveneck during that initial period. See Rachel Sadinsky to John Wilson, October 8, 1997, Archives of the University of Kentucky Art Museum; and Josephine W. Duveneck, *Frank Duveneck: Painter-Teacher* (San Francisco: John Howell Books, 1970), 129–131.

34. For a methodological parallel on the silence surrounding the history of black models in Euro-American art history, see Denise Murrell, *Posing Modernity: The Black Model from Manet and Matisse to Today* (New Haven, CT: Yale University Press with The Miriam and Ira D. Wallach Art Gallery, Columbia University, 2018); and Saidiya Hartman, *Wayward Lives, Beautiful Experiments: Intimate Histories of Social Upheaval* (New York: W. W. Norton, 2019).

35. Sidney Kaplan, "The Negro in the Art of Homer and Eakins," *Massachusetts Review* 7, no. 1 (Winter 1966): 105–120.

36. Edgar Preston Richardson, *Painting in America: The Story of 450 Years* (Cornwall, NY: Crowell, 1956), 274–275.

37. Holger Cahill and Alfred H. Barr Jr., *Art in America: A Complete Survey* (New York: Reynel & Hitchcock, 1935); Henry McBride, "Studying Art in Europe," *New York Sun*, April 16, 1938.

38. William Walton, "Art, Two Schools of: Frank Duveneck, Frederick C. Frieseke: Illustrated," *Scribner's Magazine* 58 (1915): 643–646.

39. Matthew Frye Jacobson, *Barbarian Virtues: The United States Encounters Foreign Peoples at Home and Abroad, 1876–1917* (New York: Hill and Wang, 2000), 155.

40. Jacobson, *Barbarian Virtues*, 181.

41. Emma Acker, "A Pageant of American Art: Constructing Nation and Empire at the Fair," in the exhibition catalogue *Jewel City: Art from San Francisco's Panama-Pacific International Exposition* (Oakland: University of California Press, 2015), 111–124; Robert W. Rydell, "The Expositions in San Francisco and San Diego: Toward the World of Tomorrow," in *All the World's a Fair: Visions of Empire at American International Expositions, 1876–1916* (Chicago: University of Chicago Press, 1984), 208–233. For more on public art, see Abigail Margaret Markwyn, "The Spectacle of the Fair," in *Empress San Francisco: The Pacific Rim, the Great West, and California at the Panama-Pacific International Exposition* (Lincoln: University of Nebraska Press, 2014), 23–62.

42. Adam Cohen, *Imbeciles: The Supreme Court, American Eugenics, and the Sterilization of Carrie Buck* (New York: Penguin Press, 2016), 2–3, 70.

43. Cohen, *Imbeciles*; Paul A. Lombardo, *Three Generations, No Imbeciles: Eugenics, the Supreme Court, and Buck v. Bell* (Baltimore: Johns Hopkins University Press, 2008); Nell Painter, *The History of White People* (New York: W. W. Norton, 2010).

44. For example, I complete this chapter at the end of the proceedings of the Legacies of Eugenics at Harvard (and Boston) conference, where scholars from Evelynn Hammonds, Paul Lombardo, and Suzanne Blier presented new research on how the imbrication of aesthetics, assessment, and pedagogy has been influenced by this formative period.

45. Marianne Kinkel, *Races of Mankind: The Sculptures of Malvina Hoffman* (Urbana: University of Illinois Press, 2011), 12–13.

46. Kinkel, *Races of Mankind*, 14.

47. Michael Quick is one of the scholars who points to 1872–1873 as the period when Duveneck worked "miracles of paint" in his technique. See Quick, *American Painter Abroad*, 10; Neuhaus, "The Two Worlds of Frank Duveneck."

48. Dombrowski, "Everything Is Moist," 52.

49. For more on the significance of collectors for assessing Duveneck's history and biography, see Aronson, "Tale of Two Cities," 25–49.

50. Hooper to Major General Charles Greely Loring, July 24, 1870, object files, Department of Art of the Americas, Museum of Fine Arts, Boston.

51. See Stephen J. May, *Voyage of the Slave Ship: J. M. W. Turner's Masterpiece in Historical Context* (Jefferson, NC: McFarland, 2014).

52. Wendy W. Walters's *Archives of the Black Atlantic* treats one of the fictional accounts of Hooper's life through the centrality of her display of Turner's painting in the novel *Free Enterprise* by Michelle Cliff. Cliff contrasts Hooper's world with that of the main protagonist, Mary Ellen Pleasant, the eponymous former slave turned wealthy businessperson known for her role on the underground railroad. Michelle Cliff, *Free Enterprise: A Novel of Mary Ellen Pleasant* (1993; San Francisco: City Lights, 2004). Aronson notes this confusion as well and settles this; See Aronson, "Tale of Two Cities," 34, 47n31.

53. It was even included in her obituary; see "Alice Hooper: Obit," *Boston Evening Transcript*, September 27, 1879.

54. See William Sturgis's will, executed on June 6, 1862, 7, Sturgis-Hooper Family Papers, Massachusetts Historical Society. Lothrop had married Alice S. Hooper's sister Anne Hooper, another daughter of Ann and Samuel Hooper, a Massachusetts-based lawyer and Republican congressman.

55. Alice Sturgis Hooper, "Reasons Why Women Should Vote," *The Nation*, November 21, 1867, 416–418.

56. John Ruskin, *Modern Painters*, ed. David Barrie (London: Deutsche, 1987), 160. The relationship between John Ruskin and J. M. W. Turner occupies the back section of Gordon Parks's novel about Turner. See Gordon Parks, *The Sun Stalker: A Novel Based on the Life of Joseph Mallord William Turner* (New York: Ruder Finn Press, 2002).

57. See Paul Gilroy, *The Black Atlantic: Modernity and Double Consciousness* (Cambridge, MA: Harvard University Press, 1993), 14.

58. Albert Boime, "Turner's Slave Ship: The Victim of Empire," *Turner Studies* 10, no. 1 (1990), 34–43. For a sense of the critical response to Boime's assertion connecting Turner's work to the history of the slave ship *Zong*'s history, see John McCoubrey, "Turner's Slave Ship: Abolition, Ruskin, and Reception," *Word & Image* 14, no. 4 (October–December 1998): 319–353.

59. Toni Morrison, *Playing in the Dark: Whiteness in the Literary Imagination* (Cambridge, MA: Harvard University Press, 1992), 6, 46.

60. See Norman Bryson, "Enchantment and Displacement in Turner," *Huntington Library Quarterly* 49 (1986): 49–65.

61. Marcus Wood, *Blind Memory: Visual Representations of Slavery in England and America, 1780–1865* (New York: Routledge, 2000), 41. For more on the history of representations of slavery, see Cheryl Finley, *The Art of the Slave Ship Icon* (Princeton, NJ: Princeton University Press, 2018). For a meditation on the work of the slave ship as motif and prompt for reflection, also see Eddie Chambers, "We Might Not Be Surprised: Visualizing Slavery and the Slave Ship in the Works of Charles Campbell and Mary Evans," in *Visualizing Slavery: Art across the African Diaspora,* ed. Celeste-Marie Bernier and Hannah Durkin (Liverpool: Liverpool University Press, 2016), 216–217.

62. "Hieronymous Pop and the Baby," in *Harper's New Monthly Magazine* 61 (June 1880): 20–25.

63. Wood, *Blind Memory,* 42. See also Jerrold Ziff, "Turner's 'Slave Ship': What Red Rag Is to a Bull," *Turner Studies* 3, no. 4 (1984): 28.

64. Richard J. Powell, *Going There: Black Visual Satire* (New Haven, CT: Yale University Press in association with Hutchins Center for African & African American Research, Harvard University, 2020); Glenda R. Carpio, *Laughing Fit to Kill: Black Humor in the Fictions of Slavery* (New York: Oxford University Press, 2008); Rebecca Wanzo, *The Content of Our Caricature: African American Comic Art and Political Belonging* (New York: New York University Press, 2020). For more on the tradition of black comics specifically, see Brannon Costello and Qiana Whitted, eds., *Comics and the U.S. South* (Jackson: University Press of Mississippi, 2012). Also see anthologies including Sheena Howard and Ronald L. Jackson, eds., *Black Comics: Politics of Race and Representation* (New York: Bloomsbury, 2013); Frances Gateward and John Jennings, *The Blacker the Ink: Constructions of Black Identity in Comics and Sequential Art* (New Brunswick, NJ: Rutgers University Press, 2015).

65. *A Circassian* had been on display in Cincinnati before coming to Boston. For more on the provenance, see Aronson, "Tale of Two Cities," 34. There is confusion in scholarship about what precisely was shown, specifically whether or not *A Circassian* was displayed alongside such works as *The Old Professor* and *Portrait of William Adams.* Yet Hooper's letter and acquisition of the work

settles the fact that not only was it there; her interest in the canvas lay in the importance of its subject matter.

66. Duveneck's character appears in Henry James's novels *The Portrait of a Lady* (1881), *Washington Square* (1880), and *The Golden Bowl* (1904). Each are inspired by the relationship between Francis Boott, his daughter, Elizabeth "Lizzie" Boott, and Duveneck, who went on to marry Lizzie Boott. Colm Tóibín, "Henry James: Shadow and Substance," in *Henry James and American Painting* (University Park: Pennsylvania State University Press, 2017), 13, 15. Mahonri Sharp Young, "The Two Worlds of Frank Duveneck," *American Art Journal* 1, no. 1 (Spring 1969): 92–103.

67. Colm Tóibín, "Frank Duveneck and Henry James," in *Frank Duveneck: American Master*, ed. Julie Aronson (Cincinnati: Cincinnati Art Museum, 2020), 95; Henry James, "Notes," *The Nation*, September 9, 1875.

68. Hooper to Loring, July 24, 1870; Turner's *Slave Ship* files, Art of Europe Department, Museum of Fine Arts, Boston.

69. Aronson, "Tale of Two Cities," 25–49, 34.

70. Elliot Bostwick Davis and Dennis Carr, "Germany," in *A New World Imagined: Art of the Americas*, ed. Elliot Bostwick Davis et al. (Boston: Museum of Fine Arts, Boston publications, 2010), 184. Also see Paul B. Henze, "Marx on Muslims and Russians," *Central Asian Survey* 6, no. 4 (1987): 33–45.

71. Aronson, "Tale of Two Cities," 34.

72. Daniel Immerwahr, *How to Hide an Empire: A History of the Greater United States* (New York: Farrar, Straus and Giroux, 2019), 68.

73. Reginald Horsman, *Race and Manifest Destiny: The Origins of American Racial Anglo-Saxonism* (Cambridge, MA: Harvard University Press, 1981).

74. Ian Haney López, *White by Law: The Legal Construction of Race* (New York: New York University Press, 1996), 55.

75. Sarah Elizabeth Lewis, "The Insistent Reveal: Louis Agassiz, Joseph T. Zealy, Carrie Mae Weems, and the Politics of Undress in the Photography of Racial Science," in *To Make Their Own Way in the World: The Enduring Legacy of the Zealy Daguerreotypes*, ed. Ilisa Barbash, Molly Rogers, and Deborah Willis (Cambridge, MA: Peabody Museum Press and Aperture, 2020), 297–321.

76. Elizabeth M. Smith-Pryor, *Property Rites: The Rhinelander Trial, Passing, and the Protection of Whiteness* (Chapel Hill: University of North Carolina Press, 2009), 196. I am grateful to Evelyn Brooks Higginbotham for her encouragement to consider this case as it related to the argument of this chapter. I subsequently mentioned this trial to Kalia Howell, a graduate student in Harvard University's History of Art and Architecture department, who explored this topic for a final research paper. I would like to commend her for identifying extraordinary unpublished visual material related to this trial.

77. Smith-Pryor, *Property Rites*, 198.

78. Smith-Pryor, *Property Rites*, 197.

79. "Duveneck's Painting," *Boston Daily Advertiser,* March 6, 1877, col. D; Aronson, "Tale of Two Cities," 34.

80. "Duveneck's Painting."

81. "The Fine Arts, Interesting Paintings at Doll & Richards," *Boston Daily Advertiser,* October 17, 1877.

82. Edward W. Said, *Orientalism* (New York: Vintage, 1979).

83. For more on Orientalism and representations of empire, see Darcy Grigsby, *Extremities: Painting Empire in Post-Revolutionary France* (New Haven, CT: Yale University Press, 2002).

84. Linda Nochlin, "The Imaginary Orient," in *The Politics of Vision: Essays on Nineteenth-Century Art and Society* (New York: Harper & Row, 1989), 34, 37. For a case study on the "visual discrimination" invited by a nuanced rendering of racial types and skin tones in the eighteenth century, see Oliver Wunsch, "Rosalba Carriera's Four Contents and the Commerce of Skin," *Journal18* 10 (Fall 2020), https://www.journal18.org/5218. Also see Anne Lafont, *L'art et la race: l'Africain (tout) contre l'œil des Lumières* (Dijon: Les presses du réel, 2019); Lafont, "How Skin Color Became a Racial Marker: Art Historical Perspectives on Race," *Eighteenth-Century Studies* 51, no. 1 (2017): 89–113; Mechthild Fend, *Fleshing Out Surfaces: Skin in French Art and Medicine, 1650–1850* (Manchester: Manchester University Press, 2017), 143–191.

85. Shawn Michelle Smith, *American Archives: Gender, Race, and Class in Visual Culture* (Princeton, NJ: Princeton University Press, 1999).

86. Henry James, *The Real Thing and Other Tales* (London: Macmillan, 1893), 55–56. For more about how this story relates to class, social identity, and the portrayal of interiority, see Smith, *American Archives,* 64.

87. James, *Real Thing,* 21.

88. Said, *Orientalism,* 3, 64, 360.

89. By "legible," I am thinking of Robert C. Allen, *Horrible Prettiness: Burlesque and American Culture* (Chapel Hill: University of North Carolina Press, 1991), 25–42 via Daphne A. Brooks, *Bodies in Dissent: Spectacular Performances of Race and Freedom, 1850–1910* (Durham, NC: Duke University Press, 2006), 9.

90. J. E. A. Smith, ed., *The Proceedings at the Dedication of the Soldiers' Monument, at Pittsfield, Mass., September 24, 1872, Including the Oration of Hon. Geo. Wm. Curtis* (Pittsfield, MA: Chickering & Axtell, 1872), 10.

91. Sarah Beetham, "'An Army of Bronze Simulacra': The Copied Soldier Monument and the American Civil War," *Nierika: Revista de Estudios de Arte* 4, no. 7 (January–June 2015): 34–45.

92. Noel Ignatiev, *How the Irish Became White* (London: Routledge, 1995).

93. See Michael Quick, "Frank Duveneck, Carl Marr, and the Other German-Americans in Munich, 1870–1885," in *American Artists in Munich: Artistic Migration and Cultural Exchange Processes,* ed. Christian Fuhrmeister, Hubertus Kohle, and Veerle Thielemans (Berlin: Deutscher Kunstverlag, 2009), 176.

94. Savage, *Standing Soldiers,* 19, 162–208. For more on the Lost Cause narrative, see Charles Reagan Wilson, *Baptized in Blood: The Religion of the Lost Cause* (Athens: University of Georgia Press, 2009).

95. Savage, *Standing Soldiers,* 162.

96. Drew Gilpin Faust, *This Republic of Suffering: Death and the American Civil War* (New York: Alfred A. Knopf, 2008).

97. Savage, *Standing Soldiers,* 11.

98. Dell Upton, *What Can't Be Said: Race, Uplift, and Monument Building in the Contemporary South* (New Haven, CT: Yale University Press, 2015), chap. 1, n10.

99. See Savage, *Standing Soldiers,* 253; John W. Thompson, *An Authentic History of the Douglass Monument* (1903; Freeport, NY: Books for Libraries Press, 1971), 39–40.

100. Sarah Beetham, "Confederate Monuments: Southern Heritage or Southern Art?" *Panorama* 6, no. 1 (Spring 2002), https://editions.lib.umn.edu/panorama /article/little-of-artistic-merit/confederate-monuments/; Sarah Beetham, "Sculpting the Citizen Soldier: Reproduction and National Memory, 1865–1917," PhD diss., University of Delaware, 2014.

101. Carol A. Grissom, *Zinc Sculpture in America, 1850–1950* (Newark: University of Delaware Press, 2009), 509–537.

102. See Cheryl Finley, "Visual Legacies of Slavery and Emancipation," *Callaloo* 37, no. 4 (Fall 2014): 1023–1032; Patricia A. Cahill and Kim F. Hall, "Forum: Shakespeare and Black America," *Journal of American Studies* 54, no. 1 (February 2020): 1–11.

103. Powell, *Going There,* 8; Constance C. McPhee and Nadine M. Orenstein, *Infinite Jest: Caricature and Satire from Leonardo to Levine* (New York: Metro-politan Museum of Art, 2011), 5–6, 155; Ralph Shikes, *The Indignant Eye: The Artist as Social Critic in Prints and Drawings from the Fifteenth Century to Picasso* (Boston: Beacon Press,1969), 304–318. Also see Rebecca Wanzo, *The Content of Our Caricature: African American Comic Art and Political Belonging* (New York: New York University Press, 2020), 74–82.

104. Painter, *History of White People,* 203–204.

105. Frith Maier, "Introduction," in *Vagabond Life: The Caucasus Journals of George Kennan,* ed. F. Maier (Seattle: University of Washington Press, 2003), 10.

106. "Life above the Clouds: George Kennan's Talk about the People of the Caucasus," *Chicago Daily Tribune,* February 7, 1890.

107. While in St. Petersburg, he aimed to buy works by all those known for their vivid descriptions of the region, including Lermontov, Pushkin, and Tolstoy. Maier, *Vagabond Life,* 70.

108. Maier, *Vagabond Life.* See also Raffi Khatchadourian, "The Curse of the Caucasus," *The Nation,* November 17, 2003, 3–36.

109. "The Caucasus: Mr. George Kennan's Lecture on This Interesting Land," *Seattle Times,* February 19, 1895.

110. George Kennan in Lecture on the Caucasus, box 63, George Kennan Papers, Manuscripts Division, Library of Congress.

111. George Kennan, "The Mountains and the Mountaineers of the Eastern Caucasus," *Journal of the American Geographical Society of New York* 5 (1874): 177. Kennan delivered this speech on December 10, 1873.

112. David Fairchild, "George Kennan: The Inborn and Acquired Characteristics Which Made Him a Great Explorer of the Russian People," *Journal of Heredity* 15 (October 1924): 403, quoted in Maier, *Vagabond Life*, 12.

113. "Recent Accessions," *Metropolitan Museum of Art Bulletin* 19, no. 1 (January 1924): 20–21, http://www.jstor.org/stable/3254639.

114. Quick, *American Painter Abroad*, 19–20; Robert Neuhaus, *Unsuspected Genius: The Art and Life of Frank Duveneck* (San Francisco: Bedford, 1987), 6; *American Paintings in the Museum of Fine Arts, Boston*, vol. 1 (Boston: Museum of Fine Arts, 1969), 100.

115. I'm grateful to former MFA, Boston curators Elliot Bostwick Davis and Cody Hartley for the access they kindly offered to their curatorial records to document this history, and for their dedication to the research it required.

116. See Cody Hartley to Erica Hirshler and Elliot Davis, "Duveneck title—A Circassian," email correspondence, August 25, 2009.

117. Dorothy Berry, "Take Me into the Library and Show Me Myself: Toward Authentic Accessibility in Digital Libraries," in *The Past, Present, and Future of Libraries* (Philadelphia: American Philosophical Society Press, 2022), 111–126, https://www.jstor.org/stable/45420503; Brian Keough, "Documenting Diversity: Developing Special Collections of Underdocumented Groups," *Library Collections, Acquisitions, & Technical Services* 26, no. 3 (2002): 241–251; Ian Johnston, "Whose History Is It Anyway?" *Journal of the Society of Archivists* 22, no. 2 (2001): 213–229; Kären M. Mason, "Fostering Diversity in Archival Collections," *Collection Management* 40, no. 2 (2005): 123–145; Sanford Berman, *Prejudices and Antipathies: A Tract on the LC Subject Heads Concerning People* (Metuchen, NJ: Scarecrow Press, 1971).

118. Arthur C. Danto, "Philosophy and Art," in Danto, *The Transfiguration of the Commonplace: A Philosophy of Art* (Cambridge, MA: Harvard University Press, 1981), 56.

119. Gail Levin, "Anglo-Saxon: Nationalism and Race in the Promotion of Edward Hopper," *Panorama: Journal of the Association of Historians of American Art* 7, no. 1 (Spring 2021), https://doi.org/10.24926/24716839.11712.

120. Rose Kinsley, Margaret Middleton, and Porchia Moore, "(Re)Frame: The Case for Changing Language in the 21st-Century Museum," *Exhibition* 36, no. 1 (Spring 2016): 56–63.

121. Saidiya V. Hartman, *Scenes of Subjection: Terror, Slavery, and Self-Making in Nineteenth-Century America* (New York: Oxford University Press, 1997), 11.

122. Nathaniel Hawthorne, *The Marble Faun; or, The Romance of the Monte Beni. The Centenary Edition of the Works of Nathaniel Hawthorne*, vol. 4 (1860;

Columbus: Ohio State University Press, 1968), 4; Eddie Chambers, "African American Art History: Some Concluding Considerations," in *The Routledge Companion to African American Art History* (New York: Routledge, 2019), 461–462.

123. Wade Roush, "The MFA Plays an Artful Mind Game with Its Visitors—And They Love the 'Epiphany,'" WBUR News, November 7, 2016, https://www .wbur.org/news/2016/11/07/mfa-museum-epiphany-three.

124. Buick, "Confessions of an Unintended Reader," 82, and "Seeing the Survey Anew," 29. Buick is joined by scholars including Eddie Chambers and John Bowles who also make these silences explicit. See Eddie Chambers, "The Difficulties of Naming White Things," *small axe* 16, no. 2 (38) (July 2012): 186–197, and John P. Bowles, "Forum: Blinded by the White: Art and History at the Limits of Whiteness," *Art Journal* 60, no. 4 (2001): 38–43.

125. See Sarah Elizabeth Lewis, "From Here We Saw What Happened: Carrie Mae Weems and the Practice of Art History," in *Carrie Mae Weems,* ed. Sarah Elizabeth Lewis with Christine Garnier (Cambridge, MA: MIT Press, 2021), 3. Also see Thompson, "A Sidelong Glance: The Practice of African Diaspora Art History in the United States," *Art History* 70, no. 3 (2011): 8, 19. See Martin A. Berger, *Sight Unseen: Whiteness and American Visual Culture* (Berkeley: University of California Press, 2005); Maurice Berger, "Are Art Museums Racist?," *Art in America* 78, no. 9 (1990): 68; Maurice Berger, *White Lies: Race and the Myths of Whiteness* (New York: Farrar, Straus, Giroux, 1999); Hal Foster, *Recodings: Art, Spectacle, Cultural Politics* (Port Townsend, WA: Bay Press, 1985); Édouard Glissant, "For Opacity," in *Over Here: International Perspectives on Art and Culture,* ed. Gerardo Mosquera and Jean Fisher (New York: New Museum of Contemporary Art, 2004), 252–257; Morrison, *Playing in the Dark;* Nelson, "Emancipation and the Freed," 284; Smith, *American Archives;* Nicholas Mirzoeff, *Diaspora and Visual Culture: Representing Africans and Jews* (New York: Routledge, 2000); W. J. T. Mitchell, *Picture Theory: Essays on Verbal and Visual Representation* (Chicago: University of Chicago Press, 1994); Michele Wallace, "Modernism, Postmodernism and the Problem of the Visual in Afro-American Culture," in *Out There: Marginalization and Contemporary Cultures,* ed. Russell Ferguson, Martha Gever, Trinh T. Minh-ha, and Cornel West (Cambridge, MA: MIT Press, 1990), 39–50; Deborah Willis, *Picturing Us: African American Identity in Photography* (New York: New Press, 1994); Deborah Willis, *Reflections in Black: A History of Black Photographers, 1840 to the Present* (New York: W. W. Norton, 2000); Deborah Willis and Carla Williams, *The Black Female Body: A Photographic History* (Philadelphia: Temple University Press, 2002); Deborah Willis, *Constructing History: A Requiem to Mark the Moment* (Savannah, GA: Savannah College of Art and Design, 2008).

126. See Martin Jay, "Scopic Regimes of Modernity," in *Vision and Visuality: Discussions in Contemporary Culture*, ed. Hal Foster (Seattle: Bay Press, 1988), 4.

127. Arthur C. Danto, *What Art Is* (New Haven, CT: Yale University Press, 2013), 128.

128. Berger, *Sight Unseen*, 14. Jacqueline Francis, "Sights Made and Seen," in Art and Politics in the US Capitol, special section of *Panorama: Journal of the Association of Historians of American Art 7*, no. 1 (Spring 2021), https://doi.org /10.24926/24716839.11756.

129. Berger, *Sight Unseen*, 1, 2, and 14.

130. See Sara Ahmed, "A Phenomenology of Whiteness," *Feminist Theory* 8, no. 2 (2007): 149–168; Berger, *Sight Unseen*, 14; Berger, *White Lies;* Adrienne Brown, *The Black Skyscraper: Architecture and the Perception of Race* (Baltimore, MD: Johns Hopkins University Press, 2017); Jasmine Nichole Cobb, *Picture Freedom: Remaking Black Visuality in the Early Nineteenth Century* (New York: New York University Press, 2015); Matthew Pratt Guterl, *Seeing Race in Modern America* (Chapel Hill: University of North Carolina Press, 2013); Matthew Frye Jacobson, *Whiteness of a Different Color: European Immigrants and the Alchemy of Race* (Cambridge, MA: Harvard University Press, 1998); Lauren Kroiz, *Creative Composites: Modernism, Race, and the Stieglitz Circle* (Berkeley: University of California Press, 2012); Michael Leja, *Looking Askance: Skepticism and American Art from Eakins to Duchamp* (Berkeley: University of California Press, 2004); Nicholas Mirzoeff, *The Right to Look: A Counterhistory of Visuality* (Durham, NC: Duke University Press, 2011); W. J. T. Mitchell, *Seeing through Race* (Cambridge, MA: Harvard University Press, 2012); Painter, *History of White People;* Smith, *American Archives;* and Shawn Michelle Smith, *At the Edge of Sight: Photography and the Unseen* (Durham, NC: Duke University Press, 2013).

131. I have discussed this history in "From Here We Saw What Happened: Carrie Mae Weems and the Practice of Art History," in *Carrie Mae Weems,* ed. Sarah Elizabeth Lewis with Christine Garnier (Cambridge, MA: MIT Press, 2021), 1–6; Berger, "Are Art Museums Racist?," 68; Berger, *White Lies;* Foster, *Recodings;* Glissant, "For Opacity"; Morrison, *Playing in the Dark;* Smith, *American Archives;* Mirzoeff, *Diaspora and Visual Culture;* Mitchell, *Picture Theory;* Michele Wallace, "Modernism, Postmodernism and the Problem of the Visual in Afro-American Culture," in *Out There: Marginalization and Contemporary Cultures,* ed. Russell Ferguson, Martha Gever, Trinh T. Minh-ha, and Cornel West (Cambridge, MA: MIT Press, 1990), 39–50; Willis, *Picturing Us;* Willis, *Reflections in Black;* Willis and Williams, *Black Female Body;* Willis, *Constructing History.*

132. Johann Joachim Winckelmann, *History of the Art of Antiquity,* ed. Alex Potts, trans. Francis Mallgrave (1764; Los Angeles, CA: Getty Research Institute, 2006), 195.

133. Jonathan Crary, *Techniques of the Observer: On Vision and Modernity in the Nineteenth Century* (Cambridge, MA: MIT Press, 1990).

134. This work also builds on the exemplary scholarship of W. J. T. Mitchell and Martin Berger, both of whom have deftly discussed the imbrication of race

and vision, both even using at one point the same title for their books, *Seeing through Race*, along with that of Matthew Guterl in his work, *Seeing Race in Modern America*. See W. J. T. Mitchell, *Seeing through Race* (Cambridge, MA: Harvard University Press, 2012), 13; Martin A. Berger, *Seeing through Race: A Reinterpretation of Civil Rights Photography* (Berkeley: University of California Press, 2011).

135. Michael Leja has maintained, without a discussion of racial formation, that skeptical viewing dominated late-nineteenth-century visual culture of the United States and socialized the conditioned act of "distinguishing truth from humbug." Michael Leja, *Looking Askance: Skepticism and American Art from Eakins to Duchamp* (Berkeley: University of California Press, 2004), 15. Also see Neil Harris, *Humbug: The Art of P. T. Barnum* (Chicago: University of Chicago Press, 1973).

4. Negative Assembly

1. W. E. B. Du Bois, "Of Mr. Booker T. Washington and Others," in Du Bois, *The Souls of Black Folk* (New York: Penguin Classics, 2018), 40; Jacqueline Fear-Segal, *White Man's Club: Schools, Race, and the Struggle of Indian Accul-turation* (Lincoln: University of Nebraska Press, 2007); *Indigenous Bodies: Reviewing, Relocating, Reclaiming*, ed. Jacqueline Fear-Segal and Rebecca Tillett (Albany: SUNY Press, 2013); David Wallace Adams, "Education in Hues: Red and Black at Hampton Institute, 1878–1893," *South Atlantic Quarterly* 76, no. 2 (Spring 1977): 159–176. I use Native here without the word American so as not to negate the sovereignty of the Indigenous people on the land we now call the United States of America. For more on these practices, see Linda Tuhawai Smith, *Decolonizing Methodologies: Research and Indigenous Peoples* (London: Zed Books, 2012); Karen Kramer, "Bringing It All Back Home," *Panorama: Journal of the Association of Historians of American Art* 4, no. 2 (2018).

2. Rayford W. Logan, *The Betrayal of The Negro: From Rutherford B. Hayes to Woodrow Wilson* (New York: Hachette, 1965).

3. Laura Wexler, *Tender Violence: Domestic Visions in an Age of U.S. Imperialism* (Chapel Hill: University of North Carolina Press, 2000), 139–142; *The Hampton Album*, ed. Lincoln Kirstein (New York: Museum of Modern Art, 1966), 11. For more on Hampton photography and the project of uplift cinema, see Allyson Nadia Field, *Uplift Cinema: The Emergence of African American Film and the Possibility of Black Modernity* (Durham, NC: Duke University Press, 2015).

4. The term "negative assembly" is also indebted to Paul C. Taylor's work, and there is a homolog here with the idea of assemblage in the context of Alexander G. Weheliye's scholarship—via his engagement with scholars

Sylvia Wynter and Hortense Spillers, as well as Gilles Deleuze and Félix Guattari—around the idea of "racialized assemblages." Deleuze and Guattari have discussed the precarity of a consonant idea to that of assembly, the idea of assemblage, as subject to the instability of the geographic project. See Alexander G. Weheliye, *Habeas Viscus: Racializing Assemblages, Biopolitics, and Black Feminist Theories of the Human* (Durham, NC: Duke University Press, 2014), 47; Manuel DeLanda, *A New Philosophy of Society: Assemblage Theory and Social Complexity* (New York: Continuum, 2006), 28.

5. The editions and various versions of Tarr and McMurry's *Geographies* consulted for this analysis were *Tarr and McMurry Geographies, A Complete Geography* (New York: Macmillan, 1902-1922).

6. See George Tolias, "Isolarii, Fifteenth to Seventeenth Century," in *The History of Cartography*, ed. David Woodward, vol. 3 (Chicago: University of Chicago Press, 2007), 263-284. My study focuses on atlases, maps, and geography textbooks in the United States; it does not include the maps produced by the US Geological Survey. My research also does not include general, popular school readers such as Noah Webster's and William H. McGuffey's, but instead treats the less frequently studied geography readers.

7. Henry Louis Gates, Jr., *Stony the Road: Reconstruction, White Supremacy, and the Rise of Jim Crow* (New York: Penguin, 2019).

8. Gates, *Stony the Road*, xxi.

9. Here I follow George Frederickson and Dylan Rodríguez and their definition of white supremacy as a set of social practices and organizations that define the production of "'human' difference," and take on the question of how these practices are instantiated through pedagogy as a "normative" condition, per Charles Mills. See George M. Frederickson, *White Supremacy: A Comparative Study of American and South African History* (Oxford: Oxford University Press, 1981), xi; Charles Mills, *Blackness Visible: Essays on Philosophy and Race* (Ithaca, NY: Cornell University Press, 1998), chap. 6; Dylan Rodríguez, *Forced Passages: Imprisoned Radical Intellectuals and the U.S. Prison Regime* (Minneapolis: University of Minnesota Press, 2006), 11.

10. Benedict Anderson, *Imagined Communities*, rev. ed. (London: Verso, 2006), 163-164.

11. Ian Haney López, *White by Law: The Legal Construction of Race* (New York: New York University Press, 1997); Melissa Nobles, *Shades of Citizenship: Race and Census in Modern Politics* (Stanford, CA: Stanford University Press, 2000), 188.

12. Anderson, *Imagined Communities*, 6-7. See also Caroline Desbiens, "Imaginative Geographies," in *The International Encyclopedia of Geography: People, the Earth, Environment, and Technology*, ed. Douglas Richardson, Noel Castree, Michael F. Goodchild, et al. (Malden, MA: John Wiley & Sons, Ltd., 2017), 1-6; and Derek Gregory, "Imaginative Geographies," *Progress in Human Geography* 19, no. 4 (1995): 447-485.

13. Aldon Morris, *The Scholar Denied: W. E. B. Du Bois and the Birth of Modern Sociology* (Berkeley: University of California Press, 2015); Aldon Morris, "American Negro at Paris, 1900," in *W. E. B. Du Bois's Data Portraits: Visualizing Black America*, ed. Whitney Battle-Baptiste and Britt Rusert (Amherst, MA: W. E. B. Du Bois Center at the University of Massachusetts, Princeton University Architectural Press, 2018); Autumn Womack, *The Matter of Black Living: The Aesthetic Experiment of Racial Data, 1880–1930* (Chicago: University of Chicago Press, 2022).

14. Guy-Uriel Charles, "Democracy and Distortion," *Cornell Law Review* 92 (2007): 601–677; Ruth Wilson Gilmore, *Golden Gulag: Prisons, Surplus, Crisis, and Opposition in Globalizing California* (Berkeley: University of California Press, 2007); Alex Keena, Michael Latner, Anthony J. McGann, and Charles Anthony Smith, *Gerrymandering the States: Partisanship, Race, and the Transformation of American Federalism* (Cambridge: Cambridge University Press, 2021); Stephen K. Medvic, *Gerrymandering: The Politics of Redistricting in the United States* (Medford, MA: Polity, 2021); Richard Rothstein, *The Color of Law: A Forgotten History of How Our Government Segregated America* (New York: Norton, 2017).

15. Fred Moten, *A Poetics of the Undercommons* (Butte, MT: Sputnik & Fizzle, 2016), 12.

16. Susan Schulten's study of school geography remains the most extensive treatment of the material. See Schulten's chapters "School Geography, the 'Mother of All Sciences,' 1880–1914," and "School Geography in the Age of Internationalism, 1914–1950" in Susan Schulten, *The Geographical Imagination in America, 1880–1950* (Chicago: University of Chicago Press, 2001), 92–117, 121–147; Susan Schulten, *Mapping the Nation: History and Cartography in Nineteenth-Century America* (Chicago: University of Chicago Press, 2012), esp. 11–18. See also Katherine McKittrick, *Demonic Grounds: Black Women and the Cartographies of Struggle* (Minneapolis: University of Minnesota Press, 2006), 10–11; Laura Pulido, "Reflections of a White Discipline," *Professional Geographer* 54, no. 1 (2002): 42–29; Linda Peake and Audrey Koyayashi, "Policies and Practices for an Antiracist Geography at the Millennium," *Professional Geographer* 54, no. 1 (2002): 50–61, 50; Katherine McKittrick and Linda Peake, "What Difference Does Difference Make to Geography?" in *Questioning Geography*, ed. Noel Castree, Alisdair Rogers, and Douglas Sherman (Oxford: Blackwell, 2005), 39–54.

17. Michel Omi and Howard Winant, *Racial Formation in the United States*, 2nd ed. (New York: Routledge, 1994), 55.

18. Richard Dyer, *White* (New York: Routledge, 2017); Theodore Allen, *The Invention of the White Race* (London: Verso, 2012).

19. Nell Painter, *The History of White People* (New York: W. W. Norton, 2010), 111, 151–164, 188, 212, 226.

20. Martin Brückner, "Literacy for Empire: The ABCs of Geography and the Rule of Territoriality in Early Nineteenth-Century America," in *Nineteenth-Century Geographies: The Transformation of Space from the Victoria Age to the American Century,* ed. Helena Michie and Ronald Thomas (New Brunswick, NJ: Rutgers University Press, 2003); Matthew Edney, *Cartography: The Ideal and Its History* (Chicago: University of Chicago Press, 2019); Thomas DaCosta Kaufmann, *Toward a Geography of Art* (Chicago: University of Chicago Press, 2004); Schulten, *Geographical Imagination,* 5.

21. Simone Browne, *Dark Matters: On the Surveillance of Blackness* (Durham, NC: Duke University Press, 2015); Jasmine Nichole Cobb, *Picture Freedom: Remaking Black Visuality in the Early Nineteenth Century* (New York: New York University Press, 2015); Nicholas Mirzoeff, *The Right to Look: A Counterhistory of Visuality* (Durham, NC: Duke University Press, 2011).

22. Schulten, *Geographical Imagination,* 6. Also see Branden W. Joseph, *Beyond the Dream Syndicate: Tony Conrad and the Arts after Cage (A "Minor" History)* (New York: Zone Books, 2008), 47–51. Roland Bentacourt distinguishes this "minor history" from the framework of microhistory, the productive examination of a discreet aspect of social life to illuminate its broader claims and developments. See Roland Bentacourt, *Byzantine Intersectionality* (Princeton, NJ: Princeton University Press, 2020).

23. Michel-Rolph Trouillot, *Global Transformations: Anthropology and the Modern World* (New York: Palgrave Macmillan, 2003), 38, 45.

24. Jacques Derrida, "White Mythology: Metaphor in the Text of Philosophy," *New Literary History* 6, no. 1 (Autumn 1974): 11. In W. J. T. Mitchell's probing analysis of this idea, the idea of "assembly" is not considered, although maps show us how literal this act was. W. J. T. Mitchell, *Seeing through Race* (Cambridge, MA: Harvard University Press, 2012), 23.

25. Paul C. Taylor, *Black Is Beautiful: A Philosophy of Black Aesthetics* (Chichester, UK: Wiley Blackwell, 2016), 3. Also see Taylor, *Race: A Philosophical Introduction,* 2nd ed. (Cambridge: Polity Press, 2013); and Charles Mills, *The Racial Contract* (Ithaca, NY: Cornell University Press, 1997).

26. Taylor, *Black Is Beautiful,* 3.

27. As Dennis Cosgrove notes, "mapping's record is not confined to the archival; it includes the remembered, the imagined, the contemplated." Dennis Cosgrove, *Mapping* (London: Reaktion Books, 1999), 1–2.

28. Schulten, *Geographical Imagination,* 26; *Johnson's New Illustrated Family Atlas of the World* (New York: A. J. Johnson, 1873). For more on geography texts keeping up with the latest discoveries, see Donald C. Dahmann, *Geography in America's Schools, Libraries, and Homes* (Washington, DC: National Council for Geographic Education, 2010), lxx–lxxi.

29. Schulten, *Geographical Imagination,* 18. See also Patricia Cline Cohen, "Statistics and the State: Changing Social Thought and the Emergence of a

Qualitative Mentality in America, 1790 to 1820," *William and Mary Quarterly* 38, no. 1 (1981): 35–55.

30. Daniel Immerwahr, *How to Hide an Empire: A History of the Greater United States* (New York: Farrar, Straus, and Giroux, 2019), 8, 9–11, 18–19. For more on "map-as-logo" see Anderson, *Imagined Communities*, 170–178.

31. Arthur Tsutsiev, trans. Nora Seligman Favorov, *Atlas of the Ethno-Political History of the Caucasus* (New Haven, CT: Yale University Press, 2014), 3–4. For more about the Caucasus as a limit zone in medieval maps, see Rouben Galichian, *Countries South of the Caucasus in Medieval Maps: Armenia, Georgia and Azerbaijan* (London: Printinfo Art Books / Gomidas Institute, 2007).

32. Nicole Fleetwood, *On Racial Icons: Blackness and the Public Imagination* (New Brunswick, NJ: Rutgers University Press, 2015), 9–10; W. J. T. Mitchell, *Seeing through Race*, 13; and W. J. T. Mitchell, *Iconology: Image, Text, Ideology* (Chicago: University of Chicago Press, 1987), 13.

33. In terms of accessibility, Schulten has noted the difficulty of researching map material due to how the material is interleaved within other bound publications. What are often imprecisely called thematic maps often remain unseen because they lie "scattered in treatises, journals, reports, and textbooks." Schulten, *Mapping the Nation*, 3.

34. Katherine McKittrick, *Dear Science and Other Stories* (Durham, NC: Duke University Press, 2021).

35. I flag this because I believe it is important to discuss the "extra labor at the archives" required for what Trouillot calls the "unearthing of silences." Michel-Rolph Trouillot, *Silencing the Past: Power and the Production of History* (Boston: Beacon Press, 2015), 58. For more about the Caucasus as a limit zone in medieval maps, see Galichian, *Countries South of the Caucasus*.

36. In this "extractive" conceptualization, I am considering the work of Kathryn Yussof in the framework of geology through a critique of the grammar of geography. Kathryn Yussof, *A Billion Black Anthropocenes or None* (Minneapolis: University of Minnesota Press, 2018).

37. *Scribner-Black* was printed and engraved in Scotland, but distributed in the United States.

38. Reverend Kensey Johns Stewart, *A Geography for Beginners* (Richmond, VA: J. W. Randolph, 1864), 114–115.

39. Francis Walker, *Discussions in Economics and Statistics*, vol. 2: *Statistics, National Growth, and Social Economics* (New York: Henry Holt, 1899), 447. For more on Walker's maps, see Schulten, *Mapping the Nation*, 185–195.

40. It is worth noting that the preface of many of the *Scribner* atlases mentions that the book was continually revised. Many were based on *"Black's General Atlas of the World* which was first published in 1839 and has been subject to continuous revision and enlargement in no less than seventeen editions, the

last having appeared in 1886." See *The Scribner-Black Atlas of the World*, library ed. (New York: Charles Scribner's Sons, 1899).

41. Blumenbach's Enlightenment-era racial tracts ushered in this fivefold categorization of humankind.

42. David Woodward, *The All-American Map: Wax Engraving and Its Influence on Cartography* (Chicago: University of Chicago Press, 1977), 16–28, 118–119.

43. Schulten, *Geographical Imagination*, 23, 24.

44. Schulten, *Geographical Imagination*, 26, 31; Woodward, *All-American Map*.

45. The history of what Jennifer Roberts has aptly called the negative intelligence of printmaking is wedded to the development of racial formation in the United States. See Jennifer Roberts, "Reversing American Art," *National Gallery of Art* (2013), https://www.nga.gov/content/dam/ngaweb/research /CASVA/Meetings/roberts-lecturecard.pdf, where Roberts writes about the many forms of reversal and inversion in the printmaking process. While excisions do not feature in this discussion, her framework allows for a discussion of the excisions and negations that emerge in this history of cartographic printmaking.

46. By the 1870s, even the dictionary definition of the term Caucasian changes. In the mid-nineteenth century, the entry in Webster's for the term Caucasian was geographical, "pertaining to Mount Caucasus in Asia." See *An American Dictionary of the English Language Exhibiting the Origin, Orthography, Pronunciation, and Definitions of Words by Noah Webster, LL.D.* (Springfield, MA: G. & C. Merriam, 1869). Circa 1869, Webster's began to print a second entry for Caucasian: a noun, defined as "Any one belonging to the Indo-European race, and the white races originating near Mount Caucasus." See *An American Dictionary of the English Language, by Noah Webster, LL.D.* (Springfield, MA: G. & C. Merriam, 1875).

47. To the right in this image is a diagram of a "Chinaman," evidence of the negotiations about the contours of the definition of the term Caucasian in the 1880s, as discussed in Chapter 2.

48. As early as the 1888 volume of Cram's, this diagram has been deleted from the pages. See *Cram's Unrivaled Family Atlas of the World Indexed* (1888).

49. S. Augustus Mitchell, *A System of Modern Geography Designed for the Use of Schools and Academies* (Philadelphia: J. H. Butler & Co., 1877). Van Ingen & Snyder operated out of a wood engraving shop in Philadelphia between 1853 and 1873. Among the books that feature these engravings are Anno Domini, *The Suppressed Book about Slavery! Prepared for the Public 1857, Never Published until the Present Time* (New York: Carleton, 1864) and Franz Hoffman, *The Treasure of the Inca* (Philadelphia: Lutheran Board of Publication, 1870).

50. See, e.g., S. Augustus Mitchell, *Mitchell's New Intermediate Geography: A System of Modern Geography for Use of Schools and Academies* (Philadelphia: J. H. Butler and Co., 1877); *National Standard Atlas of the World* (Chicago: Ford Dearborn Publishing, 1896).

51. Within the over two-hundred-page atlas, it is the only page containing figures save a set of engravings of US presidents. The engravings, ordered chronologically, appear first, set opposite overview maps of the world sliced into sections, starting with Mexico, then South America, then an image of the four corners of the globe across from a map of Europe.

52. *Cram's Unrivaled*, 13-14.

53. On the affordability of maps, see Martin Brückner, *The Social Life of Maps in America, 1750-1860* (Chapel Hill, NC: Omohundro Institute and University of North Carolina Press, 2017).

54. Walter Benjamin, "Theses on the Philosophy of History," *Walter Benjamin: Illuminations*, trans. Harry Zohn (New York: Schocken, 1968), 253-264.

55. Paul Gilroy, *The Black Atlantic: Modernity and Double Consciousness* (Cambridge, MA: Harvard University Press. 1993), x.

56. Wexler, *Tender Violence*, 132; Sarah Meister, *The Hampton Album* (New York: Museum of Modern Art, 2019), 8-11.

57. These new features in the science building, such as "the moulding tables where ten or twelve may mold at once" are a source of pride at Hampton in the principal's report from 1890. *The Hampton Normal and Agricultural Institute, Principal's Report for Year Ending June 30, 1890* (Hampton, VA: Normal School Steam Press Print, 1890), 39. A condensed version of this report (with a mention of *Yaggy's Atlas*) was also published as: S. C. Armstrong, "The Twentieth Annual Report of the Hampton Normal and Agricultural Institute, July 1890," in *Virginia School Reports, 1890 and 1891, Twentieth and Twenty-First Annual Reports of the Superintendent of Public Instruction of the Commonwealth of Virginia with Accompanying Documents* (Richmond, VA: J. H. O'Bannon, Superintendent of Public Printing, 1891), 236-263.

58. See Rita Barnard, "Of Riots and Rainbows: South Africa, the US, and the Pitfalls of Comparison," *American Literary History* 17, no. 2 (2005): 399-416; Jacques Derrida, "Racism's Last Word," in *Race, Writing, and Difference*, ed. Henry Louis Gates, Jr., trans. Peggy Kamuf (Chicago: University of Chicago Press, 1986); Maurice Smethurst Evans, *Black and White in the Southern States. A Study of the Race Problem in the United States from a South African Point of View* (London: Longmans, Green, 1915). Also see Frederickson, *White Supremacy;* David Theo Goldberg, *Racist Culture: Philosophy and the Politics of Meaning* (Oxford: Blackwell, 1993); Robert Miller, "Science and Society in the Early Career of H. F. Verwoerd," *Journal of Southern African Studies* 19, no. 4 (1993): 634-661; and Kirk B. Sides, "Precedence and Warning: Global Apartheid and South Africa's Long Conversation on Race with the United States," in *Safundi: The Journal of South African and American Studies* 18, no. 3 (2017): 232.

59. As one of many examples, Charles A. McMurry notes in the *Special Method in Geography: From the Third through the Eighth Grade*, "the general movement is from the home and home neighborhood outward, first to the home state, then

to the surrounding states, to the United States and to North America as a whole, later to Europe and the rest of the world." See Charles A. McMurry, *Special Method in Geography: From the Third through the Eighth Grade* (New York: Macmillan, 1903), 15. Also see Edney, *Cartography*, 153; Schulten, *Mapping the Nation*, 11; Schulten, *Geographical Imagination*, 99.

60. Sides, "Precedence and Warning," 221–238. The geography lesson typifies the imbrication of power and ideology inherent in maps as social documents as discussed by Brian Harley. See J. B. Harley, "Maps, Knowledge, and Power," in *The Iconography of Landscape: Essays on the Symbolic Representation, Design and Use of Past Environments*, ed. Dennis Cosgrove and Stephen Daniels (Cambridge: Cambridge University Press, 1988); J. B. Harley and David Woodward, *The History of Cartography*, vols. 1 and 2, bks. 1–3 (Chicago: University of Chicago Press, 1987–1998).

61. This image appears in Edith C. Westcott, *The New Education Illustrated*, vol. 3: *Geography* (Richmond, VA: B. F. Johnson Publishing, 1900), pl. 7.

62. Michael Leja, *Looking Askance: Skepticism and American Art from Eakins to Duchamp* (Berkeley: University of California Press, 2004).

63. Louis R. Harlan, *Booker T. Washington: The Making of a Black Leader, 1856–1901*, vol. 1 (New York: Oxford University Press, 1972), 106. For a time, Washington served as head of the dormitory for Indian students. See Booker T. Washington, "Incidents of Indian Life at Hampton," *Southern Workman* 10 (April 1881): 43.

64. Sylvia Wynter, "No Humans Involved: An Open Letter to My Colleagues (May 1992)," *Forum N.H.I. Knowledge for the 21st Century* 1, no. 1 (Fall 1994): 32–67; Wynter, "Textbooks and What They Do: The Conceptual Breakthrough of Carter G. Woodson," in Wynter, *Do Not Call Us Negro: How "Multicultural" Textbooks Perpetuate Racism* (San Francisco: Aspire, 1990); Mishuana Goeman, *Mark My Words: Native Women Mapping Our Nations* (Minneapolis: University of Minnesota Press, 2013).

65. William Lloyd Garrison, *Thoughts on African Colonization; or, An Impartial Exhibit of the Doctrines, Principles, and Purposes of the American Colonization Society; Together with the Resolutions, Addresses, and Remonstrances of the Free People of Color* (Boston: Garrison and Knapp, 1832).

66. Samantha Seeley, *Race, Removal, and the Right to Remain: Migration and the Making of the United States* (Williamsburg, VA: Omohundro Institute of Early American History and Culture, 2021).

67. Woodrow Wilson to David Lloyd-George, March 28, 1919, From the Diary of Dr. Grayson, *The Papers of Woodrow Wilson* (hereafter *PWW*), ed. Arthur S. Link et al., vol. 56 (Princeton, NJ: Princeton University Press, 1966–1993), 347–348. This comparative reference to teaching geography and the work of policy emerges in other diary entries by Dr. Grayson, e.g., May 23, 1919, *PWW*, vol. 59, 420.

68. Brückner, "Literacy for Empire," 209.

69. Schulten, *Mapping the Nation,* 163. Also see Bahar Gürsel, "Teaching National Identity and Alterity: Nineteenth Century American Primary School Geography Textbooks," *Journal of Educational Medica, Memory, and Society* 10, no. 1 (Spring 2018): 106–126, esp. 106. Also see James H. Williams, "Nation, State, School, Textbook," in *(Re)constructing Memory: School Textbooks and the Imagination of the Nation,* ed. James H. Williams (Rotterdam: Sense Publishers, 2014), 1–9, esp. 1.

70. Charles A. McMurry, *Special Method in Geography* (New York: Macmillan, 1903), 109.

71. Sheridan Ploughe, "Edward Esher Yaggy," in *History of Reno County, Kansas: Its People, Industries and Institutions,* vol. 2 (Indianapolis, Indiana: B. F. Bowen, 1917), 88–90. Edward Esher Yaggy Sr. was Levi Yaggy's son.

72. Brückner, "Literacy for Empire," 175, cited in "Massachusetts' Schools," *Niles Weekly Register* 20, no. 7 (1821): 108. When Carter G. Woodson obtained his teacher's certificate in West Virginia in 1901, for example, the record shows that geography was a compulsory exam subject as well. See No. 18, "Teacher's High School Certificate, Huntington, West Virginia Public Schools," issued May 18, 1901, for Woodson, published in *The Negro History Bulletin,* (May 1, 1950), 180.

73. In Nevada, for example, where there were few school libraries and "none in rural districts," reporting from 1887–1888 reveals that "a large number of schools, however, have been supplied with Yaggy's Geographical Study and Yaggy's Anatomical Study." See N. H. R. Dawson, *United States Department of the Interior, Bureau of Education, Report of the Commissioner of Education for the Year 1887–1888* (Washington, DC: Government Printing Office, 1889); Helen W. Ludlow, "Review of Academic Work," in *The Hampton Normal and Agricultural Institute, Principal's Report for the Academic and Fiscal Year Ending June 30, 1889* (Hampton, VA: Normal School Steam Press Print, 1889), 39–46. The specific mention of "Yaggy's Geography Study" occurs in this report on page 42. Also see Elizabeth Hyde, "Review of Academic Work," in *The Hampton Normal and Agricultural Institute, Annual Reports for Year Ending June 30, 1890* (Hampton, VA: Normal School Steam Press Print, 1890), 36–47 (specific mention of "Yaggy's Atlas" is on page 39).

74. As Schulten notes, Frye's was one of the first books to come after the National Educational Association's reform efforts after the "Committee of Ten." Schulten, *Geographical Imagination,* 103. For a contemporary response to the racial bias that was part of these geography texts, see Peter Smagorinsky, "'The Ideal Head': Bizarre Racial Teachings from a 1906 Textbook," *The Atlantic,* July 19, 2014, https://www.theatlantic.com/education/archive/2014/07/the-ideal-head-bizarre-racial-teachings-from-a-100-year-old-textbook/374693/; Dahmann, *Geography in America's Schools,* lxxiii.

75. Henry H. Rassweiler, *Teacher's Hand Book: Designed to Accompany Yaggy's Geographical Study* (Chicago: Western Pub. House, ca. 1888), 39, https://

archive.org/details/teachershandbookoorass/page/38/mode/2up. This was designed to accompany *Yaggy's Geographical Study.* Unless otherwise indicated, all quotations from this lesson are from Rassweiler's textbook to accompany Yaggy's maps.

76. Ruth Elson, *Guardians of Tradition: American Schoolbooks of the Nineteenth Century* (Lincoln: University of Nebraska Press, 1964), viii. Also see AnneMarie Brosnan, "Representations of Race and Racism in the Textbooks Used in Southern Black Schools during the American Civil War and Reconstruction Era, 1861–1876," *Paedagogica Historica* 52, no. 6, (2016): 718–733. I am unaware of any study that analyzed geography textbooks used in black segregated schools. As Brosnan notes, financial constraints often meant that these schools did not use any textbooks, even as new subjects were added to the curriculum. Brosnan's study also notes that fewer geography textbooks were published for free black students (721).

77. Elson, *Guardians of Tradition*, 66. Elson's study does not include Yaggy's manual because it was published at the turn of the twentieth century and her study focuses on the nineteenth.

78. Matthew Edney also discusses *Yaggy's Geographical Study* (1887) as an example of analytical mapping. See Edney's post on his site, Mapping as Process: A Blog on the Study of Mapping Processes: Production, Circulation, and Consumption, "Why I Don't Like Thematic Maps," January 2018. https://www.mappingasprocess.net/blog/2018/1/15/why-i-dont-like-thematic-maps.

79. Rassweiler, *Teacher's Hand Book*, 39.

80. Rassweiler, *Teacher's Hand Book*, 39.

81. Katherine McKittrick and Clyde Woods, "No One Knows the Mysteries at the Bottom of the Ocean," in *Black Geographies and the Politics of Place,* ed. McKittrick and Woods (Cambridge, MA: South End, 2007), 4.

82. Allan Sekula, "The Body and the Archive," *October* 39 (Winter 1986): 3–64.

83. Here Yaggy's instructions expose maps as creating what Edney, via Bruno Latour, would call "social relations" as opposed to what is often considered a "social practice" created by the "production, circulation, and consumption" of mapping. However, whereas Edney focuses on the need to study maps as part of the "formation of class identities," this framework must be expanded to consider racial identity formation as well. Edney, *Cartography,* 47; Bruno Latour, *Reassembling the Social: An Introduction to Actor-Network-Theory* (Oxford: Oxford University Press, 2005). While this study does not focus on US Surveys, Robin Kelsey's deft discussion of the connection between sightlines and surveys commissioned by Congress in the nineteenth century inspired much of this chapter's method. See Robin Kelsey, *Archive Style: Photographs and Illustrations for U.S. Surveys, 1850–1890* (Berkeley: University of California Press, 2007).

84. Wynter, "No Humans Involved," 49.

85. Frantz Fanon, *Black Skin, White Masks* (New York: Grove, 2008), 91. All passages are from this text. Also see George Yancy, *Look, A White! Philosophical Essays on Whiteness* (Philadelphia: Temple University Press, 2012), 1–3; and Robert Gooding-Williams, "Look, a Negro!" in *Reading Rodney King, Reading Urban Uprising*, ed. Robert Gooding-Williams (New York: Routledge, 1993), 165.

86. Fanon, *Black Skin, White Masks*, 89, 95.

87. The literature here is vast and includes, for example, talks given for WISER's Public Positions Series "Fanon after Fanon," hosted by the University of the Witwatersrand in 2021. See also Gavin Arnall, *The Subterranean Fanon: An Underground Theory of Radical Change* (New York: Columbia University Press, 2019); Achille Mbembe, "Metamorphic Thoughts: The Works of Frantz Fanon," *African Studies* 71, no. 1 (April 2012): 19–28; Achille Mbembe, *Out of the Dark Night: Essays on Decolonization* (New York: Columbia University Press, 2021); David Scott, *Conscripts of Modernity* (Durham, NC: Duke University Press, 2004), 3; Homi K. Bhabha, "Foreword: Framing Fanon," in *The Wretched of the Earth* (New York: Grove Press, 2021), xiii–xlviii.

88. Brandon Terry, "On Fanon and Nietzsche," in *Nietzsche 13 / 13: Fanon*, part of the 13 / 13 Seminars produced by the Columbia Center for Contemporary Critical Thought with the collaboration and support of the Society of Fellows and the Heyman Center for the Humanities, January 18, 2017, https://blogs .law.columbia.edu/nietzsche1313/brandon-terry-on-fanon-and-nietzsche/.

89. Rob Kitchin and Martin Dodge, "Rethinking Maps," in *Progress in Human Geography* 31, no. 3 (2007): 335, 343.

90. The sample of the reports from these states include N. H. R. Dawson, *United States Department of the Interior, Bureau of Education, Report of the Commissioner of Education for the Year 1887–1888* (Washington, DC: Government Printing Office, 1889); Pennsylvania Dept. of Public Instruction, *Report for the Superintendent of Public Instruction of the Commonwealth of Pennsylvania, for the year ending June 5, 1894 [Philadelphia], 1893;* and "Reports of County Superintendents," in *Common Schools of Pennsylvania, Report of the Superintendent of Public Instruction of the Commonwealth of Pennsylvania for the Year Ending June 5, 1893* (Clarence M. Busch, State Printer to Pennsylvania, 1893), 16. This information and report are repeated for the following counties in Pennsylvania alone: Butler County, N. C. McCollough; Northampton County, W. F. Hoch; Perry County, E. U. Aumiller; Schuylkill County, G. W. Weiss; Warren County, H. M. Putnam; Phoenixville, H. F. Leister, 24, 86, 89, 98–100, 112, 166. For reports from these states, see Jesse B. Thayer, State Superintendent, *Biennial Report of the State Superintendent of the State of Wisconsin for the Two Years Ending June 30, 1888* (Madison, WI: Democrat Printing Company, State Printers, 1888); JAS. H. Rice, State Superintendent of Education, *Twenty-Second Annual Report of the State Superintendent of Education of the State of South Carolina, 1890* (Columbia, SC: James H. Woodrow, State Printer, 1890);

for Utah, see *Ninth Annual Report of the New West Education Commission* (Chicago: S. Ettlinger, Printer, 1889); "Reports of County Commissioners of Schools for the School Year 1892–93," in *Fifty-Seventh Annual Report of the Superintendent of Public Instruction of the State of Michigan and Accompanying Documents for the Year 1893* (Lansing: Robert Smith & Co., State Printers and Binders, 1894); "Books and Apparatus" in *Catalogue of the Schoolcraft Public School, by Order of the Board of Education, April 1892* (Kalamazoo, MI: Ihling Bros. & Everard, Printers and Binders, 1892); *First Biennial Report of the Superintendent of Public Instruction to the Governor of North Dakota for the Two Years Ending June 30, 1890* (Bismarck, ND: Tribune, State Printers and Binders, 1890); "Reports of Incorporated Schools," in "Appendix G: Report of the State Board of Education," in *Journal of the House of Representatives of the State of Delaware* (Dover, DE: James Kirk & Son, Printers, 1891); *Twenty-First Biennial Report of the Superintendent of Public Instruction of the State of Illinois, July 1, 1894—June 30, 1896* (Springfield, IL: Phillips Bros., State Printers, 1896); *Biennial Report of the State Superintendent of Public Education to the Legislature of Mississippi for the Scholastic Years 1889-90 and 1890-91* (Jackson, MS: Power & McNeily, State Printers, 1892); "School Supplies and Equipments [*sic*]," *School Board Journal: We Report the Important Transactions of Every School Board in the United States and Canada* 6, no. 8 (August 1894). Also see Herbert M. Kliebard, *The Struggle for the American Curriculum, 1893-1958*, 3rd ed. (London: Taylor and Francis Group, 2004).

91. Rassweiler, *Teacher's Hand Book*, 39.

92. Terrance Hayes, "What It Look Like," in *How to Be Drawn* (New York: Penguin, 2015), 3.

93. Trouillot, *Silencing the Past*, 20; Randal Marlin, *Propaganda and the Ethics of Persuasion* (Peterborough, ON: Broadview Press, 2002); for a discussion of propaganda as "flawed ideology" see Jason Stanley, *How Propaganda Works* (Princeton, NJ: Princeton University Press, 2015).

94. See Donald Yacovone, *Teaching White Supremacy: America's Democratic Ordeal and the Forging of Our National Identity* (New York: Penguin Random House, 2022); "Textbook Racism: How Scholars Sustained White Supremacy," *Chronicle of Higher Education*, April 8, 2018; Donald Yacovone, "Teaching White Supremacy: The Textbook Battle over Race in American History," *Harvard Gazette*, September 4, 2020, https://news.harvard.edu /gazette/story/2020/09/harvard-historian-examines-how-textbooks-taught -white-supremacy/.

95. W. E. B. Du Bois, *Black Reconstruction, 1860-1880* (New York: Russell, 1938), 700; David Roediger, *The Wages of Whiteness: Race and the Making of the American Working Class* (London: Verso, 1991).

96. Elson, *Guardians of Tradition*, 66.

97. Alexander G. Weheliye, "Diagrammatics as Physiognomy: W. E. B. Du Bois's Graphic Modernities," *CR: The New Centennial Review* 15, no. 2 (2015): 29.

98. Edney, *Cartography*.

99. Yacovone's study addresses this topic from the vantage point of history textbooks. See Yacovone, "Teaching White Supremacy."

100. *Tarr and McMurry Geographies, Third Book: Europe and Other Continents with Review of North America* (New York: Macmillan, 1901), 76.

101. Ralph Tarr and Frank M. McMurry, *New Geographies, Second Book* (New York: Macmillan, 1917).

102. Tarr and McMurry, *New Geographies, Second Book*, 235. Other geography texts used a similar question. S. Augustus Mitchell, *A System of Modern Geography* framed it this way: "What is said of the Caucasian race?" The answer in italics states, "The Caucasian race is found among the civilized nations of Europe and America, and is superior to the rest in mind, courage, and activity," 8.

103. Wynter, "No Humans Involved," 50.

104. Jarvis R. Givens, *Fugitive Pedagogy: Carter G. Woodson and the Art of Black Teaching* (Cambridge, MA: Harvard University Press, 2021), 135 quoting Henry Elson, *Modern Times and the Living Past*. The Elson textbook was listed in the 1929 "Louisiana High School Standards Manual of Organization and Administration (Section on Social Science Curriculum)," bulletin no. 161 (Baton Rouge: State Department of Education of Louisiana, July 1, 1929), 29, Harvard Graduate School of Education, Gutman Library Special Collections.

105. This focus on the linguistic analysis and rationale for racial science has a literature too extensive to recount here. For an incisive summary, see Painter, *History of White People*, 81, 196.

106. *Tarr and McMurry Geographies, Third Book*, 74.

107. The editions and various versions of Tarr and McMurry's Geographies consulted for this analysis were the following: *Tarr and McMurry Geographies, A Complete Geography* (New York: Macmillan, 1902); *Tarr and McMurry Geographies, Fourth Part, General Geography, South America and Europe* (New York: Macmillan, 1905); Ralph S. Tarr and Frank M. McMurry, *Advanced Geography* (New York: Macmillan, 1907); Ralph S. Tarr and Frank M. McMurry, *Advanced Geography* (Sacramento: Robert L. Telper, Supt. State Printing, 1909); Ralph S. Tarr and Frank M. McMurry, *New Geographies, Second Book* (New York: Macmillan, 1913, 1916, 1917); Ralph S. Tarr and Frank M. McMurry, *World Geographies, Second Book, Texas Edition* (New York: Macmillan, 1919); Ralph S. Tarr and Frank M. McMurry, *New Geographies, Second Book* (New York: Macmillan, 1920); Ralph S. Tarr and Frank M. McMurry, *New Geographies, Second Book, Part Two* (New York: Macmillan, 1922).

108. Toni Morrison, "The Individual Artist," in Morrison, *The Source of Self-Regard: Selected Essays, Speeches, and Meditations* (New York: Knopf, 2019), 83. Here, we start to see the conditioning that could lead to Ta-Nehisi Coates's formulation, "people who *believe* themselves to be white" (italics here are mine). See Ta-Nehisi Coates, *Between the World and Me* (New York: One World / Random House, 2015), 42.

109. *Universal Cyclopedia and Atlas, vol. 2 (of 12), by Charles Kendall Adams (President of Wisconsin, Editor-in-Chief of the New Edition) and Rossiter Johnson (Editor of Revision), with Colored Plans, Plates and Engravings* (New York: D. Appleton, 1902), 405.

110. *A Teacher's Manual for the Webster-Knowlton-Hazen European History Maps* (Chicago: A. J. Nystrom, ca. 1923), 92.

111. Jacques W. Redway, *The New Basis of Geography: A Manual for the Preparation of the Teacher* (New York: MacMillan, 1907).

112. Intelligence testing received the imprimatur of the US military, and the interest of the American public, when Carl Campbell Brigham published a primer on the topic, *A Study of American Intelligence* (1923). He focused on Princeton schoolchildren for his Binet tests. For more, see an extensive discussion in Painter, *History of White People*, 285-286. For more on geography exams, see Schulten, *Geographical Imagination*, 75-77, 94.

113. "Parent Anger Up over 'Silly' Tests: Brand Exams for Youthful Pupils Too Advanced and Ludicrous," *Plain Dealer* (Cleveland), April 5, 1911, 10.

114. Jennifer Roberts emphasizes that Pierre Bourdieu "admonished scholars looking back on historical exchanges not to 'abolish the interval' that originally separated the actions in question." Jennifer Roberts, *Transporting Visions: The Movement of Images in Early America* (Berkeley: University of California Press, 2014), 1, 15.

115. On the topic of mobile objects, I am also considering "portability" via the work of art historian Alina Payne, who considers the significance of the displacement of objects, leaving an invaluable "geographic footprint." Payne, "The Portability of Art: Prolegomena to Art and Architecture on the Move," in *Territories and Trajectories: Cultures in Circulation,* ed. Diana Sorenson (Durham, NC: Duke University Press, 2018).

116. Painter created this series two years after the publication of *History of White People.* Her serial attention to this region suggests that despite authoring the incisive book about the construction of racial whiteness, something unstated remained to be declared and explored through other means. See, for example, "Maps and Margins" in *Afro-Atlantic Histories* (New York: DelMonico Books, 2021), 61-80.

117. Halford J. Mackinder, "The Geographical Pivot of History," *Geographical Journal* 23 (1904): 421-437. Also see Imani Perry, "Unmaking the Territory and Remapping the Landscape," in Perry, *Vexy Thing: On Gender and Liberation* (Durham, NC: Duke University Press, 2018), 177-180.

118. Matthew Frye Jacobson, *Whiteness of a Different Color: European Immigrants and the Alchemy of Race* (Cambridge, MA: Harvard University Press, 1998), 135.

119. Jacobson, *Whiteness of a Different Color*, 41.

120. Mirzoeff, *Right to Look;* Nicholas Mirzoeff, *White Sight: Visual Politics and Practices of Whiteness* (Cambridge, MA: MIT Press, 2023).

121. Wynter, "No Humans Involved," 46.

122. Toni Morrison, *Playing in the Dark: Whiteness in the Literary Imagination* (Cambridge, MA: Harvard University Press, 1992).

123. Nour Kteily and Sarah Cotterill, "Is the Defendant White or Not?" *New York Times,* January 23, 2015.

124. George Lipsitz, *The Possessive Investment in Whiteness: How White People Profit from Identity Politics* (Philadelphia: Temple University Press, 1998), 1.

125. Ruth Frankenberg, "The Mirage of Unmarked Whiteness," in *The Making and Unmaking of Whiteness,* ed. Birgit Brander Rasmussen, Eric Klinenberg, Irene J. Nexica, and Matt Wray (Durham, NC: Duke University Press, 2001), 74.

126. Matthew Pratt Guterl, *Seeing Race in Modern America* (Chapel Hill: University of North Carolina Press, 2013).

127. Carter G. Woodson, *The Mis-Education of the Negro* (Washington, DC: Associated Publishers, 1933).

128. Givens, *Fugitive Pedagogy,* my italics.

129. Givens, *Fugitive Pedagogy,* 11. In keeping with Amiri Baraka per Nathaniel Mackey, this fugitivity "slides away from the proposed." See Nathaniel Mackey, "Cante Moro," in *Sound States: Innovative Poetics and Acoustical Technologies,* ed. A. Morris (Chapel Hill: University of North Carolina Press, 2007), 200.

130. Givens, *Fugitive Pedagogy,* 6.

131. Edward A. Johnson, *A School History of the Negro Race in America, from 1619 to 1890, with a Short Introduction as to the Origin of the Race,* rev. ed. (Chicago: W. B. Conkey, 1895); Leila Amos Pendleton, *A Narrative of the Negro* (Washington, DC: Press of R. L. Pendleton, 1912). See Jarvis R. Givens, "Teaching to 'Undo Their Narratively Condemned Status': Black Educators and the Problem of Curricular Violence," in *Schooling the Movement: The Activism of Southern Black Educators from Reconstruction through the Civil Rights Era,* ed. D. Alridge, J. Hale, and T. Loder-Jackson (Columbia: University of South Carolina Press, 2023).

132. Examples include Orland Maxfield, "Geography and the Social Studies" in *Bulletin of the Arkansas Teachers Association* 34, no. 2 (1966): 26, https://iiif.lib .harvard.edu/manifests/view/drs:493058608$26i. The 1967 report in Alabama focused on improving the teaching of geography; see "Improving the Teaching of Geography," in *Alabama State Teachers Association Journal* 7, no. 4 (December 1967), University of Georgia Libraries, Black Teacher Archive, https://iiif.lib.harvard.edu/manifests/view/drs:493430644$29i.

133. 1900 Exposition Gold Medal Award, ca. August 1900. W. E. B. Du Bois Papers, Special Collections and University Archives, University of Massachusetts Amherst Libraries.

134. The full Exhibit of American Negroes includes a second installation, attributed to Thomas J. Calloway, titled *A Series of Statistical Charts, Illustrating the Condition of the Descendants of Former African Slaves Now Resident in the United States of America.* This, too, has an opening plate that includes a map. The

maps were prepared by students at Atlanta University. Currently available sources suggest that William Andrew Rogers, an alumnus of Atlanta University in 1899, and a recent graduate in sociology, worked with Du Bois on these graphics. See *Catalogue of the Officers and Students of Atlanta University, 1899–1900 through 1906–1907* (Atlanta: Atlanta University Press), 37; "Atlanta University Exhibit at Paris," *Atlanta Journal*, February 22, 1900; *Bulletin of Atlanta University* 110 (1900): 3; Shawn Michelle Smith, *Photography on the Color Line: W. E. B. Du Bois, Race, and Visual Culture* (Durham, NC: Duke University Press, 2004), 162; Britt Rusert quoted in Jackie Mansey, "W. E. B. Du Bois' Visionary Infographics Come Together for the First Time in Full Color," *Smithsonian Magazine*, November 15, 2018.

135. See "Plate 2," *W. E. B. Du Bois's Data Portraits: Visualizing Black America*, 52; "Progressive disclosure," Nielsen Norman Group, https://www.nngroup.com/articles/progressive-disclosure.

136. W. E. B. Du Bois, *The Autobiography of W. E. B. Du Bois: A Soliloquy on Viewing My Life from the Last Decade of Its First Century* (New York: Oxford University Press, 2014), 141. Quoted in Whitney Battle-Baptiste and Britt Rusert, "Introduction," in W. E. B. Du Bois et al., *W. E. B. Du Bois's Data Portraits: Visualizing Black America* (Amherst, MA: W. E. B. Du Bois Center at the University of Massachusetts, Princeton University Architectural Press, 2018), 17.

137. Eugene F. Provenzo, *W. E. B. Du Bois's Exhibit of American Negroes: African Americans at the Beginning of the Twentieth Century* (Lanham, MD: Rowman & Littlefield, 2013), 18. For analysis of the exhibition, please see scholarship by David Levering Lewis and Deborah Willis alongside the introduction by Linda Osborne in *A Small Nation of People: W. E. B. Du Bois and African American Portraits of Progress* (New York: Amistad, 2003).

138. Du Bois, *Dusk of Dawn* (New York: Oxford University Press, 2007), 34.

139. Du Bois, *Dusk of Dawn*, 34. Also see "W. E. B. Du Bois: A Recorded Autobiography, Interview with Moses Asch," Smithsonian Folkways FW05511, provided courtesy of Smithsonian Folkways Recordings. ©1961. https://www.loc.gov/exhibits/civil-rights-act/multimedia/w-e-b-du-bois.html.

140. Du Bois, *Dusk of Dawn*, 34.

141. Du Bois first states this in July 1900 at the Pan-African Association's conference in London. He traveled to Paris directly afterward. Provenzo, *W. E. B. Du Bois's Exhibit of American Negroes*, 91.

142. Weheliye deftly notes that within the exposition, "diagrammatic lines" are key for Du Bois, citing this relational interest in what, as Latour articulates, "draws things together." Weheliye, "Diagrammatics as Physiognomy," 30, 32, 35, citing Bruno Latour, "Drawing Things Together," in *Representations in Scientific Practice*, ed. Michael Lynch and Steven Woolgar (Cambridge, MA: MIT Press, 1990), 19–68, 60; Saidiya V. Hartman, *Lose Your Mother: A Journey along the Atlantic Slave Route* (New York: Farrar, Straus and Giroux, 2007), 6, 45, 73, 107, 133.

143. Whitney Battle-Baptiste and Britt Rusert, "Introduction," in *W. E. B. Du Bois's Data Portraits: Visualizing Black America; The Color Line at the Turn of the Twentieth Century*, ed. Whitney Battle-Baptiste and Britt Rusert (Amherst, MA: W. E. B. Du Bois Center at the University of Massachusetts Amherst and Princeton University Architectural Press, 2018), 19-22.

144. Frederick Douglass, "Lessons of the Hour: An Address," in *Frederick Douglass: Speeches and Writings*, ed. David W. Blight (New York: Library of America, 2022), 762-790.

145. Mabel O. Wilson, "The Cartography of W. E. B. Du Bois's Color Line," in *W. E. B. Du Bois's Data Portraits: Visualizing Black America: The Color Line at the Turn of the Twentieth Century*, ed. Whitney Battle-Baptiste and Britt Rusert (New York: W. E. B. Du Bois Center at the University of Massachusetts Amherst and Princeton Architectural Press, 2018), 39, 42; Mabel O. Wilson, *Negro Building: Black Americans in the World of Fairs and Museums* (Berkeley: University of California Press, 2012).

146. Du Bois, *Souls of Black Folk*, 47.

147. Howard N. Rabinowitz, "Half a Loaf: The Shift from White to Black Teachers in the Negro Schools of the Urban South, 1865-1890," *Journal of Southern History* 40, no. 4 (1974): 565-594, esp. 586. The Tennessee Act of 1873 had set geography as one of the required courses. See W. R. Garrett, *Annual Report of the State Superintendent of Public Instruction for Tennessee (Dept. of Education), for the Scholastic Year Ending June 30, 1891* (Nashville, TN: Marshall & Bruce, State Printers, 1892), 16; see also "Circular No. 2, Laws Relating to the Emancipation and License of School-Teachers," Department of Public Instruction, Nashville, Tenn., June 1, 1891.

148. Garrett, *Annual Report of the State Superintendent of Public Instruction for Tennessee*, 16.

149. W. E. B. Du Bois, "The Twelfth Census and the Negro Problems," *Southern Workman* 29 (1900): 307. For more on Du Bois's analysis of black agriculture, see U.S. Census Office, *Bulletin 8, Negroes in the United States* (Washington, DC: Government Printing Office, 1904).

150. Du Bois was singular in this space, perhaps with the exception of Charles S. Johnson, *The Negro in American Civilization* (1930). See Lawrence D. Bobo, "Reclaiming a Du Boisian Perspective on Racial Attitudes," *Annals of the American Academy of Political and Social Science* 568 (2000): 186-202, esp. 193-195.

151. For Du Bois's critique of Hoffman, see Du Bois, "Review: Race Traits and Tendencies of the American Negro by Frederick L. Hoffman," *Annals of the American Academy of Political and Social Science* 9, no. 1 (July 1897): 127-133; Weheliye, "Diagrammatics as Physiognomy," 37; Womack, *The Matter of Black Living*; Rebecka Rutledge Fisher, "Cultural Artifacts and the Narrative of History: W. E. B. Du Bois and the Exhibiting of Culture at the 1900 Paris Exposition Universelle," *Modern Fiction Studies* 51, no. 4 (2005): 741-774; Jason

Forrest, "Data Journalism in the Study of W. E. B. Du Bois's 'The Negro Problem,'" Medium, July 31, 2018, https://medium.com/nightingale/data -journalism-in-the-study-of-w-e-b-du-bois-the-negro-problem-part-2-of-4 -e5ea9b976adc.

152. Megan J. Wolff, "The Myth of the Actuary: Life Insurance and Frederick L. Hoffman's 'Race Traits and Tendencies of the American Negro,'" *Public Health Reports* 121, no. 1 (2006): 84–91; Julie K. Brown, "Making 'Social Facts' Visible in the Early Progressive Era: The Harvard Social Museum and Its Counterparts," in *Instituting Reform: The Social Museum of Harvard University 1903–1931*, ed. Deborah Martin Kao and Michelle Lamunière (New Haven, CT: Yale University Press and Harvard Art Museums, 2012), 103–105.

153. For more on the visual epistemology of mapping, see Johanna Drucker, *Graphesis: Visual Forms of Knowledge Production* (Cambridge, MA: Harvard University Press, 2014), and Mirzoeff, *Right to Look*.

154. Douglass, "Lessons of the Hour," 762–790.

155. For a history of the transition between the departments of Social Ethics and Sociology at Harvard, see Lawrence T. Nichols, "The Establishment of Sociology at Harvard: A Case of Organizational Ambivalence and Scientific Vulnerability," in *Science at Harvard University: Historical Perspectives*, ed. Clark A. Elliott and Margaret W. Rossiter (Bethlehem, PA: Lehigh University Press, 1992), 191–222.

156. Senators such as Henry Cabot Lodge intervened with the US Treasury Department on behalf of Peabody to obtain exhibition materials from foreign pavilions at World's Fairs. Henry Cabot Lodge to Francis Greenwood Peabody, December 7, 1904; Peabody to Lodge, December 9, 1904, HUG 1676.582, folder L, in Letters to F. G. Peabody, concerning a Social Science Exhibit, 1903–06, Harvard University Archives.

157. For several years, the department was the department of "sociology and social ethics." Karl Bigelow, Tutor, memo, December 11, 1928, Harvard University Committee on Sociology and Social Ethics, Committee on Concentration in Sociology and Social Ethics, 1928–1931, Harvard University Archives, III.10.104.

158. Francis Greenwood Peabody, "Voluntary Worship 1886–1929," in *The Development of Harvard University since the Inauguration of President Eliot, 1869–1929*, ed. Samuel Eliot Morison (Cambridge, MA: Harvard University Press, 1930), li–lviii; Julie A. Reuben, *The Making of the Modern University: Intellectual Transformation and the Marginalization of Morality* (Chicago: University of Chicago Press, 1996), 163, 167. The Department of Social Ethics was initially part of the Philosophy Department at Harvard. The term "social ethics" was one that Peabody's colleague, William James, would suggest. See James Ford, "Social Ethics, 1905–1929," in *Development of Harvard University*, 223, 230.

159. "Races" was one of the ten major categories of the Social Museum's management system, alongside "Health, Housing, Industrial Problems, Religious Agencies, Crime, Detectives, Charity, and Social Settlements." See Appendix

A in Francis Greenwood Peabody, *The Social Museum as an Instrument of University Teaching* (Cambridge, MA: Harvard University, 1911).

160. "W. E. B. Du Bois," in Faculty of Arts and Sciences, *Record of Class of 1890*, 314, UAIII 15.75.10 F, box 1, Harvard University Archives. Peabody's course was then Philosophy 11. See Harvard University, Faculty of Arts and Sciences. *Announcement of Courses of Instruction Provided by the Faculty of Harvard College for the Academic Year, 1889–90* (Cambridge, MA: Published by the University, May 1889), 18.

161. Julie K. Brown, "Making 'Social Facts' Visible in the Early Progressive Era: The Harvard Social Museum and Its Counterparts," in *Instituting Reform: The Social Museum of Harvard University 1903–1931*, ed. Deborah Martin Kao and Michelle Lamunière (New Haven, CT: Yale University Press and Harvard Art Museums, 2012), 94. Michelle Lamunière notes that by the 1906–1907 academic year, 146 undergraduates were enrolled in the course, of 2,247 undergraduates attending. See Potts, "Social Ethics at Harvard," 94–95; *Reports of the President and Treasurer of Harvard College 1906–07* (Cambridge, MA: Harvard University, 1908), 73, 101.

162. David Levering Lewis does not mention that Peabody taught Du Bois, but he does stress the influence of Peabody's teaching on the social landscape at that time. See David Levering Lewis, *W. E. B. Du Bois: A Biography* (New York: Henry Holt, 2009), 71. For a discussion of the popularity of Peabody's course, see David B. Potts, "Social Ethics at Harvard, 1881–1931: A Study in Academic Activism," in Paul Buck, ed., *Social Sciences at Harvard, 1860–1920: From Inculcation to the Open Mind* (Cambridge, MA: Harvard University Press, 1965), 91–128.

163. Lewis, *W. E. B. Du Bois*, 7.

164. Edwin de Turck Bechtel, Philosophy 5, Lecture Notes, 1902–3, Curriculum Collection, Harvard University Catalog, 8899.321, Harvard University Archives.

165. The collection of photographs, charts, and maps were consigned to storage for thirty years when the Department of Social Ethics was closed and merged with the Department of Sociology, only to be unearthed in the 1960s and accessioned as part of Harvard's Museum collection. The preservation of this collection is in no small measure due to the work of Barbara (Bobbie) Norfleet, curator of photographs at the Carpenter Center for the Visual Arts, where the Social Museum collection was held in the 1960s before being transferred to the Harvard Art Museums in 2002. Norfleet also earned her doctorate in Sociology from Harvard. See Deborah Martin Kao and Michelle Lamunière, "Acknowledgments," in *Instituting Reform: The Social Museum of Harvard University 1903–1931*, ed. Kao and Lamunière (New Haven, CT: Yale University Press and Harvard Art Museums, 2012), 12.

166. Peabody, *Social Museum*, 4.

167. Papers of Francis Greenwood Peabody, 1886–1925; David Camp Rogers to Peabody, January 1, 1906, HUG 1676.582; Peabody to Guy Lowell, Esq.,

May 15, 1905, HUG 1676.582.2; Peabody to F. R. Cope, Jr. May 3, 1903, HUG 1676.582.2—all in Harvard University Archives. The titles were hand-lettered by students but mounted by the Department of Fine Arts.

168. Books assigned included Herbert Spencer's *Theoretical Principals of Sociology* and Charles Booth's statistical study *Life and Labour of the People* as well as Washington Gladden's *Applied Christianity,* Evelyn Fanshawe's *Liquor Legislation in the United States and Canada,* and Jacob Riis's *How the Other Half Lives.* See Michelle Lamunière, "Sentiment and Science: Francis Greenwood Peabody and the Social Museum in Context," in *Instituting Reform: The Social Museum of Harvard University 1903–1931,* ed. Deborah Martin Kao and Michelle Lamunière (New Haven, CT: Yale University Press and Harvard Art Museums, 2012), 42; David B. Potts, "Social Ethics at Harvard, 1881–1931: A Study of Academic Activism," *Social Sciences at Harvard, 1860–1920,* ed. Paul Buck (Cambridge, MA: Harvard University Press, 1965), 101–111.

169. Peabody, *Social Museum,* 1.

170. Brown, "Making 'Social Facts' Visible," 99, 101, 165.

171. Lamunière, *Instituting Reform,* 48; Julie K. Brown, *Health and Medicine on Display: International Expositions in the United States, 1876–1904* (Cambridge, MA: MIT Press, 2009); Brown, "Making 'Social Facts' Visible," 99, 105.

172. Through the research of Deborah Willis, we know the identity of the photographer, Thomas Askew, along with the identities of some of the subjects, the first time that "anyone had been named since the photos were on display in 1900." The identities of the photographers besides Askew is not currently known. See Deborah Willis, "The Sociologist's Eye: W. E. B. Du Bois and the Paris Exposition," in David Levering Lewis and Deborah Willis, *A Small Nation of People: W. E. B. Du Bois and African American Portraits of Progress* (New York: Amistad, 2003), 67. This presentation in Paris was a distinct arrangement from how the charts appeared at the Pan-American Exposition in Buffalo in 1901. Nevertheless, there, too, this first plate was bookended by photographs.

173. Lewis and Willis, *Small Nation of People;* Shawn Michelle Smith, *Photography on the Color Line: W. E. B. Du Bois, Race, and Visual Culture* (Durham, NC: Duke University Press, 2004).

174. For a discussion of these photographs as a "counterarchive" to the photographs that subtend the history of racial domination, see Smith, *Photography on the Color Line,* 12.

175. Alain Locke, "Art or Propaganda?" *Harlem: A Forum of Negro Life* (November 1928); also see Kobena Mercer, *Alain Locke and the Visual Arts* (New Haven, CT: Yale University Press, 2022).

176. Du Bois, "Criteria of Negro Art," *The Crisis* (October 1926): 290–297.

177. Du Bois, "Criteria of Negro Art."

178. Taylor, *Black Is Beautiful,* 88–99. I return to this focus on propaganda at greater length in Chapter 5.

179. Robert Gooding-Williams, "Beauty as Propaganda: On the Political Aesthetics of W. E. B. Du Bois," in *Philosophical Topics* 49, no. 1 (Spring 2021): 13–33. Du Bois's story "Jesus Christ in Texas" initially appeared in 1911 in *The Crisis* as "Jesus Christ in Georgia." The updated story connects the narrative to the 1916 Waco, Texas, lynching of Jesse Washington, which prompted the NAACP to develop its anti-lynching strategy.

180. Gooding-Williams notes that he follows Joseph Leo Koerner's reading of the painting. See Robert Gooding-Williams, "The Epiphany of the Black Magus Circa 1500" in *The Image of the Black in Western Art III, Part I,* ed. David Bindman and Henry Louis Gates, Jr. (Cambridge, MA: Harvard University Press, 2010), 81–92.

181. For more on "undisciplining cartography," see Jeremy W. Crampton and John Krygier, "An Introduction to Critical Cartography," *ACME: An International E-Journal for Critical Geographies* 4, no. 1 (2005): 12. On "undisciplining" racial data, see Womack, *Matter of Black Living,* 8. For more on "racial data revolutions" also see Khalil Muhammad, *The Condemnation of Blackness: Race, Crime, and the Making of Modern Urban America* (Cambridge, MA: Harvard University Press, 2010), 19.

182. For a consideration of how a study of aesthetics might have influenced Du Bois's seminal text *The Souls of Black Folk* (1903), see Anne E. Carroll's analysis of Du Bois's rigorous study of aesthetics. Carroll suggests his potential influence by Richard Wagner's conceptualization of the *Gesamtkunstwerk,* a "total work of art." See Anne E. Carroll, "Du Bois and Art Theory: *The Souls of Black Folk* as a 'Total Work of Art,'" *Public Culture* 17, no. 2 (2005): 235–254.

183. Du Bois, "The Souls of White Folk," in Bob Blaisdell ed., *W. E. B. Du Bois: Selections from Hist Writings* (Mineola, NY: Dover Publications, 2014), 165; Du Bois, "The Souls of White Folk," *The Independent* 69 (August 18, 1910): 339–342. For more on Du Bois and rhetoric, see Melvin Rogers, "The People, Rhetoric, and Affect: On the Political Force of Du Bois's *The Souls of Black Folk,*" *American Political Science Review* 106, no. 1 (February 2012): 194–195.

184. Henry Louis Gates, Jr., *The Signifying Monkey: A Theory of Afro-American Literary Criticism* (Oxford: Oxford University Press, 1998).

185. Bobo, "Reclaiming a Du Boisian Perspective," 187; Aldon Morris, *The Scholar Denied.*

186. *Tarr and McMurry Geographies, Third Book,* 76.

187. Du Bois drew on his essay "On the Culture of White Folk" for the *Darkwater* volume along with the essay, "The Souls of White Folk," from 1910. See W. E. B. Du Bois, "The Souls of White Folk," *The Independent* 69 (August 18, 1910): 339–42; Du Bois, "On the Culture of White Folk," *Journal of Race Development* 7, no. 4 (1917): 434–447.

188. Du Bois, "The Souls of White Folk," in Bob Blaisdell ed., *W. E. B. Du Bois: Selections from His Writings* (Mineola, NY: Dover, 1999), 172. The volume

contains the unabridged 1920 essay first published by Harcourt, Brace and Company, New York.

189. Du Bois, *Darkwater,* 23, italics in the original. Here we have an example of what McKittrick and Woods call the centrality of "black geographies" for the "reconstruction of the global community." McKittrick and Woods, "No One Knows the Mysteries," 6.

190. Robert Gooding-Williams, "W. E. B. Du Bois," *Stanford Encyclopedia of Philosophy,* (first published September 13, 2017). See section 3.3: Historical Inquiry and Moral Knowledge, https://plato.stanford.edu/entries/dubois/.

191. W. E. B. Du Bois, *Black Reconstruction in America* (New York: Touchstone, 1935), 713–715, 725.

192. Alain Locke, *Negro Art: Past and Present* (Washington, DC: Associates in Negro Folk Education, 1936), 45–46. "A hundred years from now," an 1879 review asserted, Homer's "pictures [of blacks] alone will have kept him famous." See "American Art in Water Colors. The Twelfth Annual Exhibition of the Water Color Society in the National Academy," *New York Evening Post,* March 1, 1879, 1, cited in Richard J. Powell, "Introduction: Winslow Homer, Afro-Americans, and the 'New Order of Things,'" *Winslow Homer's Images of Blacks: The Civil War and Reconstruction Years,* exh. cat. (Austin: The Menil Collection and University of Texas, Austin, 1988), 9. For more on the petition, see Natalie Spassky, "Winslow Homer at the Metropolitan Museum of Art," *Metropolitan Museum of Art Bulletin* 39, no. 4 (1982): 39. For a reading of Homer's handling of black figures that offers a contrasting context to Locke's praise, see Gwendolyn Du Bois Shaw, "'The Various Colors and Types of Negroes': Winslow Homer Learns to Paint Race," in *Winslow Homer: Crosscurrents* (New Haven, CT: Metropolitan Museum and Yale University Press, 2022), 44–52, 185–186. What is at issue in this chapter is not how Homer painted black figures, but what his retort shows about the status of mapping by the turn of the twentieth century as an arbiter of racialized American society. The painting was purchased by the Metropolitan Museum in 1906 after being shown at the National Academy of Design in New York.

193. Derek Walcott would seize on the directionality of the subject's face. He imagined in his poem *Omeros* that the figure was between "our island and the coast of Guinea" while his head tilted "toward Africa." Derek Walcott, *Omeros* (New York: Farrar, Straus, and Giroux, 1990), 183–184. Also see Peter H. Wood, *Weathering the Storm: Inside Winslow Homer's Gulf Stream* (Athens: University of Georgia Press, 2004), 42.

194. This account comes from the review by Riter Fitzgerald, "Philadelphia Item," n.d., quoted in William Howe Downes, *The Life and Works of Winslow Homer* (Boston: Houghton Mifflin Company, 1911), 135.

195. After the initial debut in 1900, it went on view in 1902 at M. Knoedler and Co. in New York City. Winslow Homer to M. Knoedler and Co., February 17, 1902, Artists' Letters and Manuscripts Collection, series folder 2, Crystal

Bridges Museum of American Art. Dahmann notes that the most popular of Maury's books, as ascertained from royalties, were *First Lessons, Elementary Geography,* and *Manual Geography.* As a Confederate leader, a monument to Maury was even erected in Richmond on Monument Avenue and removed during the summer of 2020. Dahmann, *Geography in America's Schools,* xxix.

196. Eleanor Jones Harvey, *The Civil War and American Art* (New Haven, CT: Smithsonian American Art Museum and Yale University Press, 2012), 19–23; Robert Slifkin, "Fitz Henry Lane and the Compromised Landscape, 1848–1865," *American Art* 27, no. 3 (2013): 64–83. For more on maritime metaphors for national identity in nineteenth-century painting in America, see David C. Miller, "The Iconology of Wrecked or Stranded Boats in Mid to Late Nineteenth-Century American Culture," in *American Iconology: New Approaches to Nineteenth-Century Art and Literature,* ed. David C. Miller (New Haven, CT: Yale University Press, 1993), 186–203.

197. Daniel Immerwahr, "Frontier, Ocean, Empire: Vistas of Expansion in Winslow Homer's United States," in *Winslow Homer: Crosscurrents* (New Haven, CT: Metropolitan Museum and Yale University Press, 2022), 20–26, 184–185.

198. Schulten, *Mapping the Nation,* 6; Matthew Edney, "Cartography without Progress: The Nature and Historical Development of Mapmaking," *Cartographica* 60 (1993): 54–68; and Jeremy W. Crampton, "Cartography's Defining Moment: The Peters Projection Controversy, 1974–1990," *Cartographica* 31 (Winter 1994): 16–32. For more on the field of critical cartography, see, e.g., Jeremy W. Crampton and John Krygier, "An Introduction to Critical Cartography," *ACME* 4, no. 1 (2005): 11–33. For an incisive meditation on this history as it relates to mapping, see Elizabeth Alexander, *The Trayvon Generation* (New York: Grand Central Publishing, 2022).

199. McKittrick, *Demonic Grounds,* xii.

200. See, for example, *The Black Geographic: Praxis, Resistance, Futurity,* ed. Camilla Hawthorne and Jovan Scott Lewis (Durham, NC: Duke University Press, 2023).

201. Gates, *Stony the Road,* xvii.

202. bell hooks, "In Our Glory: Photography and Black Life," in *Art on My Mind* (New York: New Press, 1995), 57.

203. hooks, "In Our Glory," 63, my italics.

204. One of the earliest examinations of this nexus is by Valerie Babb with a focus on both Early America and the creation of whiteness. See Valerie Babb, *Whiteness Visible: The Meaning of Whiteness in American Literature and Culture* (New York: New York University Press, 1998).

205. See, e.g., McKittrick and Woods, "No One Knows the Mysteries," 6; Simone Browne, *Dark Matters: On the Surveillance of Blackness* (Durham, NC: Duke University Press, 2015); Dionne Brand, *A Map to the Door of No Return: Notes to Belonging* (Toronto: Doubleday Canada, 2001); Farah Jasmine Griffin, *"Who*

Set You Flowin'?": The African-American Migration Narrative (New York: Oxford University Press, 1996); Elleza Kelley, "'Follow the Tree Flowers': Fugitive Mapping in *Beloved*," *Antipode* 53, no. 1 (2021): 181–199; Fred Moten, *In the Break: The Aesthetics of the Black Radical Tradition* (Minneapolis: University of Minnesota Press, 2003); Marcus Anthony Hunter and Zandria F. Robinson, *Chocolate Cities: The Black Map of American Life* (Berkeley: University of California Press, 2018). As Vincent Brown argues, there is still a gulf between an increased focus on spatial and cartographic histories and the focus on Black Atlantic histories in the digital humanities. See Vincent Brown, "Mapping a Slave Revolt: Visualizing Spatial History through the Archives of Slavery," *Social Text* 33, no. 4 (2015): 134–141; Moya Z. Bailey, "All of the Digital Humanists Are White, All the Nerds Are Men, but Some of Us Are Brave," *Journal of Digital Humanities* 1, no. 1 (2011).

206. Dennis Wood has cited the distinction between mapmaking and mapping as the difference between the "gesture" and the "sketch," the discourse and the object. See Dennis Wood, "The fine line between mapping and mapmaking," *Cartographica* 30, no. 4 (Winter 1993): 50–60.

207. See Nicholas Mirzoeff, *An Introduction to Visual Culture* (London: Routledge, 2009).

208. At Harvard, the study of geography would later come under direct attack for reasons including "'profound skepticism concerning the importance of human geography"—specifically that it was "descriptive" and "nonscientific." The attack would lead, quite controversially, to the Geography Department being disbanded in the 1940s. See Neil Smith, "'Academic War over the Field of Geography': The Elimination of Geography at Harvard, 1947–1951," *Annals of the Association of American Geographers* 77, no. 2 (1987): 152–172, esp. 158, 166.

209. Toni Morrison, "Preface," in *The Black Book*, n.p. Morrison includes a double-page spread of the issue of the *New-York (Weekly) Caucasian* from January 24, 1863.

210. Jacobson, *Whiteness of a Different Color*, 53.

211. See Brig. Gen. G. Wright to Brig. Gen. L. Thomas, "Headquarters Department of the Pacific," San Francisco, May 26, 1863, in *The War of the Rebellion: A Compilation of the Official Records of the Union and Confederate Armies, Series One, Volume One, Part II—Correspondence, etc.* (Washington, DC: Government Printing Office, 1897), 456–457.

212. The paper was published in New York as *The Weekly Day Book* from 1848 to 1861. It was renamed *The New York Weekly Caucasian* from 1861 to 1863 and in 1863–1868 was published as *The New York Weekly Day Book Caucasian*. There is also a mention of this newspaper in Jacobson, *Whiteness of a Different Color*, as well as *War of the Rebellion*. Despite the sustained publication of this journal, this newspaper was banned from mail for US regiments, for example, during the Civil War. See *The Dollar Weekly Bulletin*, Maysville, KY, January 1, 1863, as one of many examples.

213. It is this method from *The Black Book* that I would argue, too, anticipated the focus on the pregnant silences of the archive that Morrison would argue are crucial in her 1992 seminal text *Playing in the Dark: Whiteness and the Literary Imagination*. For more on Toni Morrison and unrecovered memory, see Paul Gilroy, "Living Memory: A Meeting with Toni Morrison," in *Small Acts: Thoughts on the Politics of Black Cultures* (New York: Serpent's Tail, 1993), 175–182.

214. Charles A. McMurry, *Special Method in Geography* (New York: Macmillan, 1903), 109.

215. Sarah Schwartz, "Map: Where Critical Race Theory Is under Attack," *Education Week*, June 11, 2021.

216. Victor Ray, *On Critical Race Theory: Why It Matters and Why You Should Care* (New York: Random House, 2022).

217. Imani Perry to Jelani Cobb, "The Man behind Critical Race Theory," *New Yorker*, September 13, 2021.

218. Jennifer Schuessler, "Bans on Critical Race Theory Threaten Free Speech, Advocacy Group Says," *New York Times*, November 8, 2021. The national conversation around critical race theory emerged after a 2020 Executive Order putatively aimed to "Combat Race and Sex Stereotyping." It was later rescinded by President Biden.

219. Alex Keena, Michael Latner, Anthony J. McGann, and Charles Anthony Smith, *Gerrymandering the States: Partisanship, Race, and the Transformation of American Federalism* (Cambridge: Cambridge University Press, 2021); and Nick Seabrook, *One Person, One Vote: A Surprising History of Gerrymandering in America* (New York: Pantheon, 2022).

220. Saidiya Hartman, "Venus in Two Acts," *Small Axe: A Journal of Criticism* 12, no. 2 (2008): 1–14; Annette Gordon-Reed, *On Juneteenth* (New York: Liveright, 2021); Saidiya Hartman, *Wayward Lives, Beautiful Experiments: Intimate Histories of Social Upheaval* (New York: W. W. Norton, 2019).

221. Hortense Spillers, "The Crisis of the Negro Intellectual: A Post-date" in Spillers, *Black, White, and in Color: Essays on American Literature and Culture* (Chicago: University of Chicago Press, 2003), 428–470.

222. Roscoe C. Bruce, "Report of the Assistant Superintendent in Charge of Colored Schools," *Report of the Commissioners of the District of Columbia*, July 1, 1915, 249–250; Givens, "Teaching to 'Undo Their Narratively Condemned Status,'" 13.

223. Vanessa K. Valdés, *Diasporic Blackness: The Life and Times of Arturo Alfonso Schomburg* (Albany: State University of New York Press, 2017); Albert N. D. Brooks, "Organizing Negro Leadership," *NHB* (May 1945): 180.

224. Givens, "Teaching to 'Undo Their Narratively Condemned Status,'" 22; Tamah Richardson and Annie Rivers, "Progress of the Negro: A Unit of Work for the Third Grade," *Virginia Teachers Bulletin* (May 1936): 3–8.

225. See article by regular contributor Samuel Francis, "Prospects for Racial and Cultural Survival," *American Renaissance* 6 (March 1995): 1–6. Also see Robert Wald Sussman, *The Myth of Race: The Troubling Persistence of an Unscientific Idea* (Cambridge, MA: Harvard University Press, 2014), 274–282.

226. The history of Great Replacement exceeds the scope of this particular chapter, but key texts include Renaud Camus, *The Great Replacement (Le grand remplacement),* and J. Enoch Powell, speech, "Rivers of Blood" in 1968 in Great Britain. See Renaud Camus, *Le grand remplacement* (Paris: Reinharc, 2011); and J. Enoch Powell, *Freedom and Reality,* ed. John Wood (New Rochelle, NY: Arlington House, 1970), 213. Alexander D. Barder offers an effective summary of this history in Alexander D. Barder, "The Great Replacement: Racial War in the Twenty-First Century," in *Global Race War: International Politics and Racial Hierarchy* (Oxford: Oxford University Press, 2021), 211–236. Also see Reece Jones, "Conclusion: The Great Replacement," in Reece Jones, *White Borders: The History of Race and Immigration in the United States from Chinese Exclusion to the Border Wall* (Boston: Beacon, 2021), 204–214; Cassie Miller, "SPLC Poll Finds Substantial Support for 'Great Replacement' Theory and Other Hard-Right Ideas," Southern Poverty Law Center, June 1, 2022, https://www.splcenter.org/news/2022/06/01/poll -finds-support-great-replacement-hard-right-ideas; "Transcript of Pelosi Remarks at Press Conference on Resolution Condemning the 'Great Replacement Theory," Speaker of the House Blog, Washington, DC, June 8, 2022, https://pelosi.house.gov/news/press-releases/transcript-of-pelosi -remarks-at-press-conference-on-resolution-condemning-the.

227. The work of "overcoming international hierarchy" in a postimperial landscape, as Adom Getachew argues, indicates the real need to blunt and dismantle the geographic language of racial dominance. Adom Getachew, *Worldmaking after Empire: The Rise and Fall of Self-Determination* (Princeton, NJ: Princeton University Press, 2019), 23.

5. The Unseen Dream

1. Swan Marshall Kendrick to Ruby Moyse, February 1, 1913, box 5, folder 2, Kendrick-Brooks Family Papers (hereafter KBFP), Manuscript Division, Library of Congress, Washington, DC. Also see Eric S. Yellin, *Racism in the Nation's Service: Government Workers and the Color Line in Woodrow Wilson's America* (Chapel Hill: University of North Carolina Press, 2013), 3.

2. Swan M. Kendrick to Ruby Moyse, July 2, 1912, page 2, box 5, folder 2, KBFP.

3. "Buried" is from Kendrick to Moyse, February 15, 1914, box 5, folder 3, KBFP; "chances for advancement" and "absolutely negligible" are from box 5, folder 8, Family Kendrick-Swan, Transcriptions, 1917–1922, KBFP.

4. Swan M. Kendrick to Ruby Moyse, August 8, 1912, box 5, folder 2, KBFP.

5. Ruby Moyse to Swan M. Kendrick, Sunday, November 14, box 5, folder 1, Ruby Kendrick Correspondence, Family Kendrick-Swan, Originals, n.d., KBFP.

6. Swan M. Kendrick to Ruby Moyse, October 14, 1913, box 4, folder 2, KBFP; Swan M. Kendrick to Ruby Moyse, October 2, 1913, box 5, folder 2, KBFP.

7. Swan M. Kendrick to Ruby Moyse, May 25, 1913, and Swan M. Kendrick to Ruby M. Kendrick, n.d., box 6, folder 1, KBFP. File placement suggests that this undated note was written before 1916.

8. Swan M. Kendrick to Ruby Moyse, January 27, 1914, box 5, folder 2, KBFP.

9. Swan M. Kendrick to Ruby Moyse, August 7, 1913, box 5, folder 2, KBFP. At the bottom of a letter from September 7, 1913, box 5, folder 2, KBFP a light pencil note indicates that his daughter Martha "went on with the career based upon Spanish, and his son, Webster, inherited his mathematical ability."

10. Swan M. Kendrick to Ruby Moyse, August 7, 1913, box 5, folder 2, KBFP.

11. Kendrick was offered a job at Fisk in that September 7 letter, box 5, folder 2, KBFP. Kendrick also graduated from Fisk in 1909 after attending Knoxville College and Alcorn College.

12. Quote from Ruby Moyse, letter postmarked March 17, 1917, box 5, folder 3, KBFP.

13. Saidiya V. Hartman, *Scenes of Subjection: Terror, Slavery and Self-Making in Nineteenth-Century America* (New York: Oxford University Press, 1997).

14. Swan M. Kendrick to Ruby Moyse, April 22, 1913, box 5, folder 2, KBFP.

15. Swan M. Kendrick to Ruby Moyse, October 2, 1913, page 3, box 5, folder 2, KBFP, from 906 T Street N.W.

16. Swan M. Kendrick to Ruby Moyse, October 2, 1913, box 5, folder 2, KBFP.

17. Swan M. Kendrick to Ruby Moyse, April 22, 1913, box 5, folder 2, KBFP.

18. Stephen O. Plummer to NAACP, June 10, 1915, boxes 39–25, folder 512, Archibald Grimké Collection, Moorland-Spingarn Research Center, Howard University, Washington, DC; Yellin, *Racism in the Nation's Service*, 166; Swan M. Kendrick to Ruby Moyse, April 25, 1915, box 5, folder 5, KBFP.

19. Swan M. Kendrick to State War and Navy Bldg. Superintendent, May 12, 1919, box 8, folder 8, KBFP; Swan M. Kendrick to Ruby M. Kendrick, January 27, 1922, and January 1, 1922, box 6, folder 1, KBFP.

20. Art historian Michael Baxandall developed the concept of a period eye to describe the developments that came out of an evaluative culture of viewing in the commerce of art and goods in fifteenth-century Florentine Italy. The term also references the concept reframed and inflected by art historian Carrie Lambert-Beatty to describe an engagement with the porous domains of bodily presentation. See Michael Baxandall, *Painting and Experience in Fifteenth-Century Italy: A Primer in the Social History of Pictorial Style* (Oxford: Oxford University Press, 1972); Carrie Lambert-Beatty, *Being Watched: Yvonne Rainer and the 1960s* (Cambridge, MA: MIT Press, 2008).

21. Simon Gikandi, *Slavery and the Culture of Taste* (Princeton, NJ: Princeton University Press, 2011); Saidiya V. Hartman, *Lose Your Mother: A Journey along*

the Atlantic Slave Route (New York: Farrar, Straus and Giroux, 2007), 6, 45, 73, 107, 133.

22. While this work identifies the key shift in scale to detail that secured the transition of vision as a tactic for racial surveillance, it builds on the connection between visuality, racial science, and criminology. See Nicole R. Fleetwood, *Marking Time: Art in the Age of Mass Incarceration* (Cambridge, MA: Harvard University Press, 2020); Allan Sekula, "The Body and the Archive" *October* 39 (Winter 1986): 3–64; Tina M. Campt, *Listening to Images* (Durham, NC: Duke University Press, 2017); Shawn Michelle Smith, *American Archives: Gender, Race, and Class in Visual Culture* (Princeton, NJ: Princeton University Press, 1999).

23. Mary White Ovington, "Segregation," *The Crisis* 9, no. 3 (January 1915): 142.

24. Christopher L. Eisgruber, "President Eisgruber's Message to Community on Removal of Woodrow Wilson Name from Public Policy School and Wilson College," June 27, 2020, the Office of Communications, https://www .princeton.edu/news/2020/06/27/president-eisgrubers-message-community -removal-woodrow-wilson-name-public-policy. This de-naming was particularly important given Wilson's transformation of Princeton through both curricular redesign and residential colleges. See *Woodrow Wilson: Essential Writings and Speeches of the Scholar-President,* ed. Mark R. DiNunzio (New York: New York University Press, 2006), 9.

25. Velma Davis quoted in Elizabeth Clark-Lewis, "'For a Real Better Life': Voices of African American Women Migrants, 1900–1930," in *Urban Odyssey: A Multicultural History of Washington D.C.,* ed. Francine Curro Cary (Washington, DC: Smithsonian Institution Press, 1996), 99.

26. "No Rest for the Negro," *Washington Bee,* May 2, 1891, 2; Yellin, *Racism in the Nation's Service,* 21.

27. Langston Hughes, "Our Wonderful Society: Washington," *Opportunity* 5 (August 1927): 226.

28. Sarah Luria, *Capital Speculations: Writing and Building Washington, D.C.* (Lebanon: University of New Hampshire Press, 2006).

29. Civil service reformer El Bie Foltz notes that the term "clerk" denoted a much larger sphere of endeavor, from "copyists, stenographers, typewriters, transcribers, indexers, cataloguers, assistant librarians, certain kinds of attendants, translators, statisticians, section chiefs, abstracters, assistant chiefs of division, and a large number of miscellaneous employ[ee]s whose duties are of a clerical nature." See Foltz, *The Federal Civil Service: A Manual for Applicants for Positions and Those in the Civil Service of the Nation* (New York: G. P. Putnam's Sons, 1909), 168–169.

30. Kathleen L. Wolgemuth, "Woodrow Wilson's Appointment Policy and the Negro," *Journal of Southern History* 24, no. 1 (February 1958): 467. There were four demotions or forced resignations between 1909 and 1912 in the previous Taft administration, compared to twenty-two between 1913 and 1916 in Wilson's. See Yellin, *Racism in the Nation's Service.*

31. This was the case with two civil servants, Arthur Gray and Thomas Dent, in the Division of Statistics in the Commerce Department. Their "promotions" left them segregated; they were to work only on statistics relevant to black living in the United States. Dent was with the only other black clerk in the division, and both were meant to work in their own room. Yellin, *Racism in the Nation's Service,* 127; John S. Colins to Dr. Pratt, March 11, 1915, box 332, Department of Commerce, Office of the Secretary, RG 40, National Archives and Records Administration; Walter White and W. T. Andrews to NAACP, August 1928, part 1: C403, Records of the National Association for the Advancement of Colored People, Manuscript Division, Library of Congress, Washington, DC.

32. "Opportunities for Employment in Washington Departmental Service," *Civil Service Advocate,* (September 1914): 1065–1066; Paul P. Van Riper, *History of the United States Civil Service* (Evanston, IL.: Row Peterson, 1958), 243, 251; Yellin, *Racism in the Nation's Service,* 128. This data can be found in the Department of Agriculture Chief Clerk to Chiefs of Bureaus, Divisions, and Offices, July 14, 1914, entry 17, box 1, Correspondence Relating to Negroes, Records of the Department of Agriculture, General Correspondence Relating to Negroes, 1909–1955, RG 16, National Archives and Records Administration; and Lucretia Mott Kelly papers in Personnel File, National Personnel Records Center, St. Louis, MO.

33. "Editorial: Politics," *The Crisis* 4, no. 4 (August 1912): 180–181; "Editorial: The Last Word in Politics," *The Crisis* 5, no. 1 (November 1912): 29.

34. "Editorial: Politics," *The Crisis* 4, no. 4 (August 1912): 181; *The Crisis* 5, no. 1 (November 1912): 29; "An Open Letter to Woodrow Wilson," *The Crisis* 5, no. 5 (March 1913): 236–237; "Mr. Hughes" *The Crisis* 13, no. 1 (November 1916): 12.

35. "Probe the Riot Tragedy," *Washington Evening Star,* July 29, 1919, 6; William M. Tuttle, *Race Riot: Chicago in the Red Summer of 1919* (Urbana: University of Illinois Press, 1996), 14.

36. "Thirteen," *The Crisis* 15, no. 3 (January 1918): 163.

37. Rayford W. Logan, *The Betrayal of the Negro: From Rutherford B. Hayes to Woodrow Wilson* (New York: Da Capo Press, 1997), 362; Lawrence Jacob Friedman, "A Nation of Savages," in *The White Savage: Racial Fantasies in the Postbellum South* (Englewood Cliffs, NJ: Prentice-Hall, 1970), 150–172; April C. Armstrong, "Erased Pasts and Altered Legacies: Princeton's First African American Students," Princeton & Slavery Project, https://slavery.princeton .edu/stories/erased-pasts-and-altered-legacies-princetons-first-african -american-students.

38. Nancy J. Weiss, "The Negro and the New Freedom: Fighting Wilsonian Segregation," *Political Science Quarterly* 84, no. 1 (March 1969): 61–79, esp. 66.

39. Yellin, *Racism in the Nation's Service,* 126.

40. Van Riper, *History of the United States Civil Service,* 238.

41. Weiss, "Negro and the New Freedom," 71.

42. Yellin, *Racism in the Nation's Service,* 133.

43. Charles S. Hamlin Diary, March 9, 1914, 100, Charles Hamlin Papers (hereafter CHP), Manuscript Division, Library of Congress, Washington, DC.

44. Louis Kaplan, "Formations of American Community: Mole and Thomas's Living Photographs," *Palais* 9 (Summer 2009): 42–55.

45. Louis Kaplan, "A Patriotic Mole: A Living Photograph," *CR: The New Centennial Review* 1, no. 1 (2001): 123. For more see David L. Fisk, "Arthur S. Mole: The Photographer from Zion and the Composer of the World's First 'Living Photographs,'" History of Photography Monograph series, Arizona State University, 1983, and Jeffrey T. Schnapp, "The Mass Panorama," *Modernism/modernity* 9, no. 2 (2002): 243–281.

46. Siegfried Kracauer, *The Mass Ornament (Weimar Essays),* ed. Thomas Y. Levin (Cambridge, MA: Harvard University Press, 1995); Walter Benjamin, *The Arcades Project,* trans. Howard Eiland and Kevin McLaughlin (Cambridge, MA: Harvard University Press, 1999); *Illuminations,* ed. Hannah Arendt, trans. H. Zohn (New York: Schocken, 1976); Horst Bredekamp, "Thomas Hobbes's Visual Strategies" in *Cambridge Companion to Hobbes's "Leviathan,"* ed. Patricia Springborg (Cambridge: Cambridge University Press, 2007); Horst Bredekamp, *Leviathan: Body Politic as Visual Strategy in the Work of Thomas Hobbes* (Boston: De Gruyer, 2020); Allan Gabriel Cardoso dos Santos, "The Scholastic's Dilemma: Hobbes Critique of Scholastic Politics and Papal Power on the Leviathan Frontispiece," *History of European Ideas* (April 2023): 1–16; Jeffrey T. Schnapp, "Mob Porn," in *Crowds,* ed. Jeffrey T. Schnapp and Matthew Tiews (Stanford, CA: Stanford University Press, 2006), 1–45.

47. Jeffrey T. Schnapp, "The Mass Panorama," *Modernism/modernity* 9, no. 2 (April 2002): 250.

48. Other photographers such as Eugene O. Goldbeck would continue Mole's tradition of mass photographs, or "living photographs," creating large panoramas predominantly of military units celebrating victory in World War II.

49. Mole's photography, as a photographic panorama, could be considered an extension of the discussion of modes of assembly to telegraph the characteristics of a society. See Kracauer, *The Mass Ornament.*

50. See Woodrow Wilson, "An Address at the Gettysburg Battlefield," July 4, 1913, in *The Papers of Woodrow Wilson* (hereafter *PWW*), ed. Arthur S. Link et al. (Princeton, NJ: Princeton University Press, 1966–1993), vol. 28, 23–25.

51. David W. Blight, *Race and Reunion: The Civil War in American Memory* (Cambridge, MA: Harvard University Press, 2001), 6–10.

52. Erez Manela, *The Wilsonian Moment: Self Determination and the Origins of Anticolonial Nationalism* (Oxford: Oxford University Press, 2007), 60.

53. Manela, *Wilsonian Moment,* 60.

54. Manela, *Wilsonian Moment,* 111.

55. See Wilson, "A Nonpartisan Address in Cincinnati," October 26, 1916, *PWW,* vol. 38, 539.

56. Here Wilson is citing the sorts of pleas for assistance he received from citizens who came to the White House to make a case for aid to other nations. See Wilson, "Nonpartisan Address in Cincinnati," 539.

57. Wilson had been determined to make his mark through words. He wrote to Ellen Axson, his then fiancée, "I want to contribute to our literature what no American has ever contributed." See Woodrow Wilson to Ellen Axson, October 30, 1883, *PWW*, vol. 2, 501–502. This decision came about while he was a student at Princeton in 1875, after reading an article, "The Orator," about British Prime Minister William Gladstone in an 1874 magazine. He wrote to his father about the effect it had on him. See Patrick Weil, *The Madman in the White House: Sigmund Freud, Ambassador Bullitt, and the Lost Psychobiography of Woodrow Wilson* (Cambridge, MA: Harvard University Press, 2023). Also see William Hale, *Woodrow Wilson: The Story of His Life* (Garden City, NY: Doubleday, 1912), 63–65.

58. W. E. Burghardt Du Bois, "My First Impressions of Woodrow Wilson," *Journal of Negro History* 58, no. 4 (1973): 453. Wilson's book *The State* was translated into other languages and adopted by many universities. See *Woodrow Wilson: Essential Writings and Speeches of the Scholar-President*, ed. Mark R. DiNunzio (New York: New York University Press, 2006).

59. Clifford is the maternal great-granduncle of Henry Louis Gates, Jr.

60. As Herbert Aptheker wrote, "regrettably, neither version of *A Dictionary of American Negro Biography* (1983), edited by R. W. Logan and M. R. Winston list anything on Murray, who merits extended biographical notice." Herbert Aptheker, "Introduction," in *Writings in Periodicals Edited by W. E. B. Du Bois, Selections from the Horizon*, comp. and ed. Herbert Aptheker (White Plains, NY: Kraus-Thomson, 1985), viii. Also see Anita Hackley-Lambert, *F. H. M. Murray: First Biography of a Forgotten Pioneer for Civil Justice* (Fort Washington, MD: HLE Publishing, 2006).

61. Albert Biome, "Emancipation and the Freed," *The Art of Exclusion: Representing Blacks in the Nineteenth Century* (Washington, DC: Smithsonian Institution Press, 1990), esp. 156–157; Hackley-Lambert, *F. H. M. Murray*; Patricia Hills, "'History Must Restore What Slavery Took Away': Freeman H. M. Murray, Double Consciousness, and the Historiography of African American Art History," in *The Routledge Companion to African American Art History*, ed. Eddie Chambers (New York: Routledge, 2019), 3–15; Richard J. Powell, "Freeman Henry Morris Murray" (Review of *Emancipation and the Freed in American Sculpture*), *Art Bulletin* 95, no. 4 (2013): 646–649; Steven Nelson, "Emancipation and the Freed in American Sculpture: Race, Representation, and the Beginnings of an African American History of Art," in *Art History and Its Institutions: Foundations of a Discipline*, ed. Elizabeth Mansfield (London: Routledge, 2002), 297–308; James Smalls, "Freeman Murray and the Art of Social Justice," in *Writing History from the Margins: African Americans and the Quest for Freedom*, ed. Claire Parfait, Hélène Le

Dantec-Lowry, and Claire Bourhis-Mariotti (New York: Routledge, 2017), 131–142.

62. Clipping from *The Washington Herald*, February 28, 1916. In "Writings by Freeman, Organizational Affiliation, Printed Materials, 74-2," folder: "Emancipation and the Freed in American Sculpture—Announcement flyer," Freeman H. M. Murray Papers (hereafter FHMMP), Moorland-Spingarn Research Center, Howard University, Washington, DC.

63. Patricia Hills notes that Murray was interested in what was "*absent,*" while Nelson notes that Murray was focused on "representational silences." See Hills, "History Must Restore," 9; Nelson, "Emancipation and the Freed in American Sculpture," 284.

64. Clipping by Murray, "*The Cynic* Says: Jim Crow," n.d. in Writings by Freeman, Organizational Affiliation, Printed Materials, 74-2, Newspaper Columns, folder 27, FHMMP.

65. Jasmine Nichole Cobb, *Picture Freedom: Remaking Black Visuality in the Early Nineteenth Century* (New York: New York University Press, 2015), 37; Nicholas Mirzoeff, *The Right to Look: A Counterhistory of Visuality* (Durham, NC: Duke University Press, 2011), 8.

66. Kobena Mercer, *James Van Der Zee* (London: Phaidon, 2003), n.p.; Henry Louis Gates, Jr., "Foreword," in *Harlem on My Mind: Cultural Capital of Black America, 1900–1968,* ed. Allon Schoener (New York: New Press, 1995); Bridget R. Cooks, "Black Artists and Activism: *Harlem on my Mind* (1969)," *American Studies* 48, no. 1 (2007): 5–39; Emilie Boone, *A Nimble Arc: James Van Der Zee and Photography* (Durham, NC: Duke University Press, 2023).

67. Caitlin Rosenthal, *Accounting for Slavery: Masters and Management* (Cambridge, MA: Harvard University Press, 2018); Sven Lindqvist, *"Exterminate All the Brutes": One Man's Odyssey into the Heart of Darkness and the Origins of European Genocide* (New York: New Press, 2007), 5; Mark Sealy, *Decolonising the Camera: Photography in Racial Time* (London: Lawrence & Wishart, 2019), 5; Autumn Womack, *The Matter of Black Living: The Aesthetic Experiment of Racial Data, 1880–1930* (Chicago: University of Chicago Press, 2021), 23.

68. Foucault declared the need for writing a "History of the Detail" in his *Discipline and Punish: The Birth of the Prison,* focused on the eighteenth and nineteenth centuries. Hegel uses detail to distinguish between aesthetic conventions and periods, (i.e., Symbolism, Classicism, and Romanticism) in his *Lectures on Aesthetics.* Also see Naomi Schor, *Reading in Detail: Aesthetics and the Feminine* (New York: Methuen, 1987), 3, 23.

69. Womack, *Matter of Black Living,* 8.

70. Womack, *Matter of Black Living,* 23.

71. Womack, *Matter of Black Living,* 215.

72. Hackley-Lambert, *F. H. M. Murray,* 174–175; Swan M. Kendrick to Ruby Moyse, November 8, 1913, box 5, folder 2, KBFP; "City News in Brief," *Washington Post,* November 8, 1913, 2; Yellin, *Racism in the Nation's Service,* 145.

73. Hackley-Lambert, *F. H. M. Murray*, 174–175, 178; Francis J. Grimké, *Excerpts from a Thanksgiving Sermon, Delivered November 26, 1914, and Two Letters Addressed to Hon. Woodrow Wilson, President of the U.S.* (Washington, DC: R.L. Pendleton, 1914).

74. Kenneth O'Reilly, "The Jim Crow Policies of Woodrow Wilson," *Journal of Blacks in Higher Education* 17 (Autumn 1997): 118; Arthur S. Link, *Wilson: The Road to the White House* (Princeton, NJ: Princeton University Press, 2015), 3, 502; Weiss, "Negro and the New Freedom," 62; Josephus Daniels, *The Cabinet Diaries of Josephus Daniels, 1913–1921*, ed. E. David Cronon (Lincoln: University of Nebraska Press, 1963), 234, 32.

75. "Address of the General Assembly of the Presbyterian Church in the Confederate States of America, to all the Churches of Jesus Christ throughout the Earth," adopted in Augusta, Georgia, December 1861, Hathi Trust Digital Library, https://catalog.hathitrust.org/Record/010944332.

76. Patricia O'Toole, *The Moralist: Woodrow Wilson and the World He Made* (New York: Simon & Schuster, 2018), 368–369. As Erez Manela notes, Wilson's negation of Japan's request for a "racial equality" amendment in the League of Nations Covenant was not a straightforward example of his own racism. See Manela, "'People of Many Races': The World beyond Europe in the Wilsonian Imagination," in *Jefferson, Lincoln, and Wilson: the American Dilemma of Race and Democracy*, ed. John Milton Cooper and Thomas Knock (Charlottesville: University of Virginia Press, 2010), 193; Kristofer Allerfeldt, "Wilsonian Pragmatism? Woodrow Wilson, Japanese Immigration, and the Paris Peace Conference," *Diplomacy & Statecraft* 15 (September 2004): 545–572; Naoko Shimazu, *Japan, Race, and Equity: The Racial Equality Proposal of 1919* (London: Routledge, 2009).

77. To my knowledge, a significant exception here, though it is not a biography, is Manela's scholarship in "People of Many Races."

78. Arthur S. Link quoted by the journal's editors in O'Reilly, "The Jim Crow Policies of Woodrow Wilson," 120.

79. Woodrow Wilson, "The Reconstruction of the Southern States," *Atlantic Monthly* (January 1901): 11; Woodrow Wilson, *History of the American People*, vol. 5 (New York: Harper and Brothers, 1902), 46–52.

80. Wilson, "Reconstruction," 6.

81. Manela notes Wilson's use of oblique language in the context of his international discussions, using terms such as "enlightened" and "modern" as proxy, and in his discussions on the military invasion of Haiti where he never mentions race. See Manela, "People of Many Races," 187–188, 200.

82. Max Weber, *Economy and Society: An Outline of Interpretative Sociology*, ed. Guenther Roth and Claus Wittich, vol. 3 (New York: Bedminster, 1968), 973–974.

83. Woodrow Wilson, "The Study of Administration," *Political Science Quarterly* 2 (July 1887): 197–222, esp. 162.

84. R. R. Thompson to Alain Locke, July 15, 1917, Alain Locke Papers, Moorland-Spingarn Research Center, Howard University, Washington, DC. See Jeffrey C. Stewart, *The New Negro: The Life of Alain Locke* (New York: Oxford University Press, 2018), 289.

85. "Mr. Trotter and Mr. Wilson" (A conversation between William Monroe Trotter and Woodrow Wilson), *The Crisis* 9, no. 3 (January 1915): 119.

86. Yellin, *Racism in the Nation's Service*, 162.

87. Yellin, *Racism in the Nation's Service*, 164–165.

88. Woodrow Wilson to Ellen Axson, October 30, 1883, *PWW*, vol. 2, 501–502.

89. Ray Stannard Baker Diary, entry for March 32, 1919, *PWW*, vol. 56, 491. Wilson's professorial habits while governing in the White House are well documented, but his own comments offer the most color. He told Democratic senator Henry Ashurst of Arizona, in a tense moment in negotiations with the German government over their agreement to the Fourteen Points, "I am willing if I can serve the country to go into a cellar and read poetry the remainder of my life." Henry F. Ashurst diary, entry for October 14, 1918, *PWW*, vol. 51, 339–340.

90. Wilson, "Study of Administration," 203. Yellin, *Racism in the Nation's Service*, 162.

91. Wilson, "Study of Administration," 198, 217.

92. Wilson, "Study of Administration," 210, italics are Wilson's.

93. Wilson, "Study of Administration," 202, 204, 209–210.

94. Wilson, "Study of Administration," 206–207.

95. The closest I have seen a scholar come is Benjamin Slomski, who does not analyze that text but is among the scholars who suggests that "Darwinian arguments were present" in Wilson's administrative policy. Slomski writes, "It is possible that Wilson's administrative thought is unrelated to his racism, but it is also possible that Wilson understood his administrative theory and his racism to be part of an organic whole." See Benjamin Slomski, "Darwin and American Public Administration: Woodrow Wilson's Darwinian Argument for Administration," *Politics and Life Sciences* 41, no. 1 (Spring 2022): 105–113, quotation on 109.

96. See Woodrow Wilson, "The Study of Politics," in *An Old Master and Other Political Essays* (New York: Scribner's Sons, 1893), 55.

97. Wilson, "The Study of Politics," 53–54.

98. Wilson, "The Study of Politics," 56.

99. *Woodrow Wilson: Essential Writings and Speeches of the Scholar-President*, ed. Mario R. DiNunzio (New York: New York University Press, 2006), 7–8.

100. Joseph R. Wilson to Woodrow Wilson, December 22, 1879, *PWW*, vol. 1, 589. For more on Wilson's personal relationships, Patrick Weil argues that the psychobiography of Wilson, co-authored by William C. Bullitt and Sigmund Freud, warrants more careful analysis than the dismissals it initially received when published in 1966; see Weil, *Madman in the White House*. Adam Tooze, *The Deluge: The Great War, America, and the Remaking of Global Order,*

1916–1931 (New York: Viking Adult, 2014), 335. This use of the term "mere literature" has come up in art historical scholarship in the context of modernism in the early twentieth century, without reference to this political context, so divorced is the study of the history of segregation from the study of visual culture of the period. See Lauren Kroiz's discussion of Alfred Stieglitz's break from American realism by calling its painting "mere literature." Lauren Kroiz, *Composite Modernism: Modernism, Race, and the Stieglitz Circle* (Berkeley: University of California Press, 2012), 4; Dorothy Norman, *Alfred Stieglitz: An American Seer* (New York: Aperture, 1990), 67.

101. Woodrow Wilson, *Mere Literature and Other Essays* (Boston: Houghton Mifflin, 1910), 18; "President Woodrow Wilson of Princeton," *The World's Work* 19, no. 6 (April 1910): 12762–12763. Wilson was not alone in his focus on this term the "constructive imagination." In 1903, Harvard president Charles W. Eliot featured the term in his well-attended Presidential Address of the National Education Association in Boston, defining it as one of the four characteristics of the "New Definition of the Cultivated Man." Eliot saw the fourth and final skill of the "cultivated man" as the "training of the constructive imagination," which "implies the creation or building of a new thing." He likened this to the work of a sculptor and painter, but also to those working in the realm "of science, the investigator" placing Darwin, Pasteur, Dante, and Shakespeare in the same breath. The usage pattern of the term "constructive imagination," using the American History Newspapers Database, shows that it appears between 1850 and 1919 in the United States, peaks in use between 1910 and 1919, then declines in 1920, slipping out of usage altogether by the middle of the twentieth century. The term is commonly used to describe the creative faculty of mind. See examples, including, "The Limitation of the Constructive Imagination," *Daily Picayune*, October 5, 1890, 12; and "Reminiscences of Prof. Tyndall. Herbert Spencer's Analysis of the Life and Character and Achievements of hist Friends," *St. Louis Republic*, November 2, 1894, 32.

102. Review of *Mere Literature* (author unknown), *New York Times*, January 9, 1897; *PWW*, vol. 10, 99–101.

103. Wilson, "Address on the Nature of History," *PWW*, vol. 15, 476, 485.

104. Henry Louis Gates, Jr., *Stony the Road: Reconstruction, White Supremacy, and the Rise of Jim Crow* (New York: Penguin, 2019), xx.

105. Jennifer Raab, *Frederic Church: The Art and Science of Detail* (New Haven, CT: Yale University Press, 2015), 7, 84–85; "Cotopaxi," *Harper's Weekly* 7 (April 4, 1863): 210.

106. Raab, *Frederic Church*, 2, 5.

107. Raab, *Frederic Church*, 19; Lorraine Daston and Peter Galison, *Objectivity* (New York: Zone, 2007), 16–17.

108. Joseph Ruggles Wilson to Wilson, *PWW*, vol. 8, 276.

109. Ellen Axson had gone to study in New York City at the Art Students League when George de Forest Brush and Thomas Eakins were teaching, right after her engagement to Wilson, which frustrated him. He would pursue his graduate

work in political science at Johns Hopkins. Ellen Axson Wilson, Kevin Grogan, Cary Wilkins, Amy Kurtz Lansing, and Erick Montgomery, *First Lady Ellen Axson and Her Circle* (Augusta, GA: Morris Museum of Art, 2013), ix.

110. Wilson to Ellen Axson, December 22, 1883, *PWW,* vol. 2, 597; and Wilson to Ellen Axon, July 16, 1883, *PWW,* vol. 2, 389.

111. Ellen Axson to Wilson, February 10, 1885, *PWW,* vol. 4, 234; and Ellen Axson to Wilson, December 11, 1884, *PWW,* vol. 3, 533.

112. Wilson to Ellen Axson, December 12, 1884, *PWW,* vol. 3, 534-535.

113. James T. Mock and Cedric Larson, *Words That Won the War: The Story of the Committee on Public Information, 1917-1919* (Princeton, NJ: Princeton University Press, 1939), vii-ix, 4, 7, 16, 62, 74, 166.

114. Michael Leja, *Looking Askance: Skepticism and American Art from Eakins to Duchamp* (Berkeley: University of California Press, 2004), 12-13.

115. Charles S. Hamlin Diary, March 12, 1914, 108, CHP.

116. Charles S. Hamlin Diary, March 13, 1914, 108, CHP.

117. Charles S. Hamlin Diary, March 13, 1914, 108, CHP.

118. Yellin, *Racism in the Nation's Service,* 121.

119. Charles S. Hamlin Diary, March 16, 1914, 110, CHP.

120. Womack, *Matter of Black Living,* 12-13; Khalil Gibran Muhammad, *The Condemnation of Blackness: Race, Crime, and the Making of Modern Urban America* (Cambridge, MA: Harvard University Press, 2010), esp. chapter 1, "Saving the Nation: The Racial Data Revolution and the Negro Problem."

121. Katherine McKittrick, "Mathematics Black Life," *Black Scholar* 44, no. 2 (2014): 19-20.

122. Charles S. Hamlin Diary, March 9, 1914, 100, CHP.

123. J. E. Ralph to Charles Hamlin, included in Charles S. Hamlin Diary, March 7, 1914, 99, CHP. Also see Yellin, *Racism in the Nation's Service,* 120.

124. Charles S. Hamlin Diary, November 9, 1913, 95, CHP.

125. Yellin, *Racism in the Nation's Service,* 120.

126. Yellin, *Racism in the Nation's Service,* 121.

127. Mary Church Terrell, *A Colored Woman in a White World* (Washington, DC: Ransdell, 1940), 297-298. In 1953, Terrell began the process of desegregating the nation's capital, and at the end of her life, she helped lead a case that went to the Supreme Court. The case focused on Thompson's Restaurant, which had refused to serve the committee she chaired, the Coordinating Committee for the Enforcement of District of Columbia Anti-Discrimination Laws (19).

128. Terrell, *Colored Woman,* 298.

129. Edward Christopher Williams, *When Washington Was in Vogue: A Lost Novel of the Harlem Renaissance* (New York: Amistad, 2003), 48. Also see "Threat to Use Vitriol," *Washington Evening Star,* February 4, 1915, 14.

130. Swan M. Kendrick to Ruby Moyse, October 22, 1913, box 5, folder 2, KBFP.

131. Charles S. Hamlin to Archibald Grimké, June 16, 1914, box 39-25, folder 499, Archibald Grimké Collection (AGC), Moorland-Spingarn Research Center, Howard University, Washington, DC.

132. US Congress, House Select Committee on Reform in the Civil Service, *Hearing on Segregation of Clerks and Employees in the Civil Service, 63rd Congress, 2nd Session,* March 6, 1914 (Washington, DC: Government Printing Office, 1914), 20–21; Yellin, *Racism in the Nation's Service,* 156.

133. "The Correspondents' Club: Statement of Principles," Kendrick, Swan M., General Correspondence, 1908–1909, 1915–1918, box 8, folder 1, KBFP.

134. Kendrick to *The Red Cross Magazine,* Garden City, NY, January 22, 1919, box 8, folder 1, KBFP.

135. Nell Irvin Painter, *The History of White People* (New York: W. W. Norton, 2010), 301.

136. Swan Marshall Kendrick to Samuel G. Blythe, February 23, 1919, box 8, folder 2, KBFP.

137. Kendrick to M.A. Donahue & Co., November 24, 1919, box 8, folder 2, KBFP.

138. M. A. Donohue & Co. to S. M. Kendrick, December 22, 1919, box 8, folder 2, KBFP.

139. Kendrick to Mr. R. P. Andrews, Washington, DC, January 17, 1917, box 8, folder 1, KBFP.

140. Kendrick to Mr. Ray Stannard Baker, July 10, 1916, box 8, folder 1, KBFP.

141. Kendrick to Harrison Rhodes, c/o *The Metropolitan Magazine,* October 10, 1918, box 8, folder 1, KBFP.

142. Chad L. Williams, *The Wounded World: W. E. B. Du Bois and the First World War* (New York: Farrar, Straus, and Giroux, 2023), 125–127, 173; L. Linard, "Au sujet des tropues noires américaines," August 7, 1918, 17N 76, Service Historique de l'Armée de Terre, Château de Vincennes, Paris; W. E. B. Du Bois, "Editing the *Crisis,*" *The Crisis* 58, no. 3 (March 1951): 149.

143. Du Bois, "Documents of the War," *The Crisis* 18, no. 1 (May 1919): 21; Williams, *Wounded World,* 173.

144. Lorraine Boissoneault, "What Will Happen to Stone Mountain, America's Largest Confederate Memorial," Smithsonian.com, August 22, 2017, https://www.smithsonianmag.com/history/what-will-happen-stone-mountain-americas-largest-confederate-memorial-180964588/. For more on the enslaved labor that built the Capitol, see William C. Allen, "History of Slave Laborers in the Construction of the US Capitol," *Office of the Architect of the Capitol* (June 1, 2005); Bob Arnebeck, *Slave Labor in the Capital: Building Washington's Iconic Federal Landmarks* (Charleston, SC: History Press, 2014); Felicia A. Bell, "'The Negroes Alone Work': Enslaved Craftsmen, the Building Trades, and the Construction of the United States Capitol, 1790–1800," PhD diss., Howard University, 2009. For more on the timing of monuments erected in Washington, DC, see Kirk Savage, *Monument Wars: Washington D.C., the National Mall, and the Transformation of the Memorial Landscape* (Berkeley: University of California Press, 2009), especially the chapter "Covering Ground," 63–105.

145. Darcy Grimaldo Grigsby, "Blow-Up: Photographic Projection, Dynamite, and the Sculpting of American Mountains," in *Scale,* ed. Jennifer Roberts (Chicago: Terra Foundation for American Art, 2016), 66–102; David Freeman, *Carved in*

Stone: The History of Stone Mountain (Macon, GA: Mercer University Press, 1997), 62; Grace Elizabeth Hale, "Granite Stopped Time: Stone Mountain Memorial and the Representation of Southern Identity," in *Monuments to the Lost Cause: Women, Art, and the Landscapes of Southern Memory,* ed. Cynthia Mills and Pamela H. Simpson (Knoxville: University of Tennessee Press, 2019), 219–233. See also Grace Elizabeth Hale, "Granite Stopped Time: The Stone Mountain Memorial and the Representation of White Southern Identity," *Georgia Historical Quarterly* 82, no. 1 (1998): 22–44, http://www.jstor .org/stable/40583695; Robyn Autry, "Elastic Monumentality? The Stone Mountain Confederate Memorial and Counterpublic Historical Space," *Social Identities: Journal for the Study of Race, Nation, and Culture* 25, no. 2 (2019): 69–185, doi:10.1080/13504630.2017.1376278.

146. Joseph Biden, Commencement Speech, Howard University, May 13, 2023. https://www.politico.com/news/2023/05/13/biden-howard-university-white -supremacy-terrorism-00096811.

147. According to research by the Southern Poverty Law Center, there are nearly five hundred symbols that honor Robert E. Lee, Jefferson Davis, and Stonewall Jackson in the United States, and most were not installed immediately after the Civil War but during segregation. See "Whose Heritage? Public Symbols of the Confederacy," Southern Poverty Law Center, February 1, 2019, https://www.splcenter.org/20190201/whose-heritage-public-symbols -confederacy#findings; Sherrilyn Ifill, *On the Courthouse Lawn: Confronting the Legacy of Lynching in the Twenty- First Century,* foreword by Bryan Stevenson (Boston: Beacon, 2007). The literature on Confederate monuments is vast and includes Sarah Beetham, "From Spray Cans to Minivans: Contesting the Legacy of Confederate Soldier Monuments in the Era of 'Black Lives Matter,'" *Public Art Dialogue* 6, no. 1 (2016): 9–33; Keisha N. Blain, "Destroying Confederate Monuments Isn't 'Erasing' History. It's Learning from It," *Washington Post,* June 19, 2020; Lonnie Bunch, "Putting White Supremacy on a Pedestal," National Museum of African American History and Culture, March 7, 2018, https://nmaahc.si.edu/blog-post/putting-white-supremacy -pedestal; Karen Cox, "The Whole Point of Confederate Monuments Is to Celebrate White Supremacy," *Washington Post,* August 16, 2017; Brian Palmer and Seth Freed Wessler, "The Costs of the Confederacy," *Smithsonian Magazine,* December 2018, https://www.smithsonianmag.com/history/costs -confederacy-special-report-180970731/; Dell Upton, "Monuments and Crimes," *Journal18* (June 2020), https://www.journal18.org/nq/monuments -and-crimes-by-dell-upton/; Dell Upton, "Confederate Monuments, Public Memory, and Public History," *Panorama* 4 no. 1 (Spring 2018), https://editions .lib.umn.edu/panorama/article/confederate-monuments-public-memory-and -public-history/; Kirk Savage, "The Politics of Memory: Black Emancipation and the Civil War Monument," in *Commemorations: The Politics of National Identity,* ed. John R. Gillis (Princeton, NJ: Princeton University Press, 2018), 127–149; Kirk Savage, *Standing Soldiers, Kneeling Slaves: Race, War, and*

Monument in Nineteenth-Century America, new ed. (Princeton, NJ: Princeton University Press, 2018); National Monument Audit, produced by the Monument Lab in partnership with The Andrew W. Mellon Foundation, https://monumentlab.com/audit.

148. Robert Musil put it this way, "What strikes one most about monuments is that one doesn't notice them. There is nothing in the world as invisible as monuments." See Robert Musil, "Monuments," trans. Burton Pike, in *Selected Writings,* ed. Burton Pike (New York: Continuum, 1986), 320. For a brilliant analysis of this essay and its implications on contemporary interpretations of monuments, see Joseph Koerner, "On Monuments," *Res: Anthropology and Aesthetics* 67 / 68 (2016–2017): 5–20; Alois Riegl, "The Modern Cult of Monuments: Its Character and Its Origin," trans. Kurt S. Forster and Diane Ghirlardo, *Oppositions* 25 (1982): 21–50; Michelle Lamprakos, "Riegl's 'Modern Cult of Monuments' and the Problem of Value," *Change over Time* 4, no. 2 (Fall 2014): 418–435.

149. Freeman Henry Morris Murray, *Emancipation and the Freed in American Sculpture: A Study in Interpretation* (Washington, DC: Press of Murray Brothers, 1916), 177.

150. Hackley-Lambert, *F. H. M. Murray,* 165. Freeman Henry Morris Murray to The Macmillan Company, February 15, 1915, in "Emancipation . . . Correspondence, G-Z," June 25, 1915, FHMMP. The manuscript began as part of his lecture series in 1913 at the African Methodist Episcopal Church's Summer School and the Chautauqua National Religious Training School at Durham, North Carolina in 1913 and in writings for the *AME Church Review.* Anita Hackley-Lambert notes that book began as early as 1904 with his studies of black art. Hackley-Lambert, *F. H. M. Murray,* 189.

151. Allyson Nadia Field, *Uplift Cinema: The Emergence of African American Film and the Possibility of Black Modernity* (Durham, NC: Duke University Press, 2015), 156; "Confers on Cuts in Photo Play Films," *Boston Daily Globe,* April 13, 1915; "Progress of Negro Race," *Boston Daily Globe,* April 15, 1915; "Will Improve Big Picture," *Boston Evening Record,* April 15, 1915, microfilm reel 2, D. W. Griffith Papers, 1897-1954 (Frederick, MD: University Publications of America, 1982); "Will Add New Film to 'The Birth of a Nation,'" *Boston Herald,* April 15, 1915, Griffith Papers; "'Birth of a Nation' to Have New Film," *Traveler and Evening Herald,* April 15, 1915, Griffith Papers.

152. Field, *Uplift Cinema,* 171–172.

153. Field, *Uplift Cinema,* 174; "Ohio's Censors Ban Photo Play," *New York Age,* October 7, 1915.

154. Field, *Uplift Cinema,* 174; Leslie Pinckney Hill to Mr. Emlen, Pennsylvania Armstrong Association, September 23, 1915, Hampton University Archives, Hampton University Museum. Hampton, Virginia (hereafter Hampton Archives).

155. Field, *Uplift Cinema,* 159.

156. Field, *Uplift Cinema,* 174.

157. Field, *Uplift Cinema*, 174.

158. The first antilynching bill in Congress was H.R. 6963, A Bill for the Protection of All Citizens of the United States against Mob Violence, and the Penalty for Breaking Such Laws. It was introduced on January 20, 1900, by Representative George Henry White of North Carolina.

159. Richard J. Powell, *Black Art: A Cultural History*, 3rd ed. (London: Thames and Hudson, 2021), 16.

160. Murray, *Emancipation and the Freed*, 2, xx.

161. Murray, *Emancipation and the Freed*, 45.

162. Murray, *Emancipation and the Freed*, xx.

163. Draft of a lecture, box 1, folder 5, FHMMP.

164. Murray, *Emancipation and the Freed*, xx.

165. Alfred A. Moss Jr., *The American Negro Academy: Voice of the Talented Tenth* (Baton Rouge: Louisiana State University Press, 1981), 119, 209.

166. Murray to the Librarian, The Public Library, New London, Connecticut, May 15, 1916, "Emancipation and the Freed . . . Correspondence, G-Z," FHMMP.

167. Murray, *Emancipation and the Freed*, 92-101.

168. Their correspondence shows a respectful but frank exchange as Murray often wrote to Du Bois asking for more attention to the meaning of particular words. As one of many examples, when editing one of Du Bois's essays for *The Horizon*, Murray had taken issue with the use of the word "business." He said, "I do not wish to be hypocritical, but I do not like the word 'business,'" and asked Du Bois to make it plain. "If 'business done,' . . . means <u>money</u> actually <u>taken in</u>. Why not say the latter, in so many words?" F. H. M. Murray to W. E. B. Du Bois [fragment], 1907, W. E. B. Du Bois Papers (MS 312), Special Collections and University Archives, University of Massachusetts Amherst Libraries.

169. Hills, "'History Must Restore What Slavery Took Away,'" 3-15; Early draft of the Preface, not dated, box 2, folder 1, FHMMP.

170. See Adrienne Brown and Britt Rusert, "Introduction," to "W. E. B. Du Bois: The Princess Steel" in *Little Known Documents: Publications of the Modern Languages Association of America* 130, no. 3 (2015): 819-829.

171. Whitney Battle-Baptiste and Britt Rusert, *W. E. B. Du Bois's Data Portraits: Visualizing Black America*, ed. Whitney Battle-Baptiste and Britt Rusert (New York: Princeton Architectural Press, 2018), 22.

172. Beyond the scholarship already cited regarding Du Bois's design, please note the exhibition at the Cooper Hewitt, *Deconstructing Power: W. E. B. Du Bois at the 1900 World's Fair*, 2022-2023, curated by Devon Zimmerman, associate curator of modern and contemporary art at the Ogunquit Museum of American Art, in consultation with Lanisa Kitchiner, chief of the African and Middle Eastern Division, Library of Congress, and with support from Yao-Fen You, senior curator and head of product design and decorative arts at Cooper

Hewitt, and Christina De León, associate curator of Latino Design at Cooper Hewitt.

173. Hills, "'History Must Restore What Slavery Took Away,'" 6. See exchange with former Atlanta University president Dr. Horace Bumstead. The falling out with Du Bois was over Murray's son's management of *The Horizon* and later Murray's attacks on the NAACP through a jeremiad in *The Guardian*. Du Bois to F. Morris Murray, November 1, 1910, Hackley-Lambert Family Papers, cited in Hackley-Lambert, *F. H. M. Murray*, 163–165.

174. W. E. B. Du Bois Papers, Numerical Listing of Books in Du Bois's Library, 1952, Special Collections and University Archives, University of Massachusetts Amherst Libraries, https://credo.library.umass.edu/cgi-bin/pdf.cgi?id=scua:mums312-b239-i003.

175. "Leaders of Negro Race to Meet Here: Writers and Scholars of American Academy to Gather this Month," *Evening Star* (Washington, DC), December 16, 1923. The listing indicates that that the following officers of the academy would be present: Arthur A. Schomburg, Brooklyn, NY; vice presidents J. R. Clifford, Charles D. Martin, L. Z. Johnson, Joseph J. France; recording secretary Thomas M. Dent; librarian T. Montgomery Gregory; treasurer Lafayette M. Hershaw; executive committee members John W. Cromwell, Kelly Miller, Alain LeRoy Locke, F. H. M. Murray, and John E. Bruce, and corresponding secretary Robert A. Pelham, Washington, DC.

176. Moss, *American Negro Academy*, 121.

177. W. E. B. Du Bois, "The Art and Art Galleries of Modern Europe," ca. 1895, W. E. B. Du Bois Papers (MS 312), Special Collections and University Archives, University of Massachusetts Amherst Libraries, https://credo.library.umass.edu/view/full/mums312-b196-i033. See pages 10–13 for Du Bois's focus on sculpture. The speech might have also interested Murray, because Du Bois paid particular attention to the origins of sculpture, the topic of Murray's 1916 publication.

178. Stewart, *New Negro*, 396.

179. Richard J. Powell, "Review of Freeman Henry Morris Murray, *Emancipation and the Freed in American Sculpture*," *Art Bulletin* 95, no. 4 (December 2013): 646–649; Smalls, "Freeman Murray," 132. Murray's work had inspired, as Smalls also notes, seminal books including James A. Porter's *Modern Negro Art* (1937) and Kirk Savage's *Standing Soldiers, Kneeling Slaves*. As Powell notes, the digital life of Murray's *Emancipation and the Freed* nearly a century after it had long been out of print is thanks to the work of art historian Albert Boime (1933–2008).

180. David Levering Lewis, *W. E. B. Du Bois: A Biography* (New York: Henry Holt, 2009), 216, 227.

181. Hackley-Lambert, *F. H. M. Murray*, 222.

182. Ifill, *On the Courthouse Lawn;* also see the Bryan Stevenson–founded Equal Justice Initiative publication *Lynching in America: Confronting the Legacy of*

Racial Terror, https://eji.org/wp-content/uploads/2019/10/lynching-in
-america-3d-ed-080219.pdf; Ida B. Wells-Barnett, "Lynch Law in Georgia"
(Chicago: Chicago Colored Citizens, 1899); Ida B. Wells-Barnett, *On Lynchings*
(Amherst, NY: Humanity Books, 2002); Robyn Wiegman, "The Anatomy of
Lynching," *Journal of the History of Sexuality* 3, no. 3 (1993): 445–467.

183. "John Hartfield Will Be Lynched by Ellisville Mob at 5 O'Clock This After-
noon," *New Orleans States,* June 26, 1919.

184. It is important to note that these lynchings were a nodal point for the forma-
tion of racial identity for white citizens. See David Marriott, *On Black Men*
(New York: Columbia University Press, 2000).

185. C. Porter to P. G. Cooper, March 13, 1919, Federal Surveillance of African
Americans. See Robert Whitaker, *On the Laps of the Gods: The Red Summer of
1919 and the Struggle for Justice That Remade a Nation* (New York: Crown,
2008), 38.

186. Committee of the Negro Silent Protest Parade, "Petition re: Lynching: To the
President and Congress of the United States," typeset carbon, signed and
printed version, July 28, 1917, James Weldon Johnson and Grace Nail Johnson
Papers (JWJ MSS 49), Series II: Writings, Beinecke Rare Book and Manuscript
Library, https://collections.library.yale.edu/catalog/16748066.

187. Jacqueline Goldsby describes the visual rule by which lynching was represented
to and known by the broader American public. See Jacqueline Goldsby, *A
Spectacular Secret: Lynching in American Life and Literature* (Chicago: University
of Chicago Press, 2006); also see Dora Apel, *Imagery of Lynching: Black Men,
White Women and the Mob* (New Brunswick, NJ: Rutgers University Press,
2004); Ken Gonzalez-Day, *Lynching in the West, 1850–1935* (Durham, NC:
Duke University Press, 2006); Leigh Raiford, "The Consumption of Lynching
Images," in *Only Skin Deep: Changing Visions of the American Self,* ed. Coco
Fusco and Brian Walls (New York: International Center of Photography and
Harry N. Abrams, 2003), 266–273; Shawn Michelle Smith and Dora Apel,
Lynching Photographs (Berkeley: University of California Press, 2007).

188. Syreeta McFadden, "What Do You Do After Surviving Your Own Lynching?"
Buzzfeed News, June 23, 2016, https://www.buzzfeednews.com/article
/syreetamcfadden/how-to-survive-a-lynching, quoting an 1988 article in the
Marion Chronicle Tribune.

189. Kerry James Marshall, Smart Museum of Art, Chicago, video interview: https://
vimeo.com/45605233.

190. US Congress, House Select Committee on Reform in the Civil Service,
Hearing on Segregation of Clerks and Employees in the Civil Service, 63rd Cong.,
2nd sess., 20–21.

191. The story of Parks's first days recounted here is from Gordon Parks, *A Choice
of Weapons* (St. Paul: Minnesota Historical Society Press, 1986), 222–223.

192. Parks, *Choice of Weapons,* 223.

193. Parks quoted in Martin H. Bush, "A Conversation with Gordon Parks," in Bush, *The Photographs of Gordon Parks* (Wichita, KS: Wichita State University, 1983).

194. Deborah Willis, "Ella Watson: The Empowered Woman of Gordon Parks' American Gothic," *New York Times*, May 14, 2018.

195. LaToya Ruby Frazier quoted in *A Choice of Weapons: Inspired by Gordon Parks*, HBO Documentary (November 10, 2021).

196. Louis Menand, *The Metaphysical Club: A Story of Ideas in America* (New York: Farrar, Straus and Giroux, 2001), 67. This too is part of the dynamic of, as Syliva Wynter puts it, "redefining *White* America as simply *America*." See Wynter, "No Humans Involved," 57. The slippage between race and nation began with Immanuel Kant, who defined race as one category of "human variety" in his 1775 essay "On the Different Races of Mankind," yet often the word "nation" was used instead of "race" as David Bindman points out in *Ape to Apollo: Aesthetics and the Idea of Race in the 18th Century* (London: Reaktion, 2002), 16. I have written about this image in "America's Destiny in Pictures," *Aperture* blog, March 7, 2017, http://aperture.org/blog/american-destiny-pictures/.

197. Charlotte Swan Kendrick Brooks, Joseph Kendrick Brooks, and Walter Henderson Brooks, *The Kendrick Kin: An African American Family Saga* (Washington, DC: Brooks Associates, Charlotte K. Brooks, 1993).

198. Brooks, Brooks, and Brooks, *Kendrick Kin*.

Epilogue

1. Evie Terrono, "'Great Generals and Christian Soldiers': Commemorations of Robert E. Lee and Stonewall Jackson in the Civil Rights Era," in *The Civil War in Art and Memory*, ed. Kirk Savage (New Haven, CT: Yale University Press, 2016), 147–170; "The Proposed Memorial to General Robert Edward Lee in the Washington Cathedral," *Virginian Magazine of History and Biography* 57, no. 3 (July 1949): 301–306; Vylla Poe Wilson, "U.D.C. Given 'Go Light' on Lee Memorial," *Washington Times Herald*, November 29, 1947; G. Gardner Monks to Elizabeth B. Bashinsky, December 13, 1951, stained glass, Lee-Jackson Bay folder, Washington National Cathedral Archives.

APPRECIATION

While working on this book, I had a near-death experience in a car collision—it was a miracle I survived it. I had written one draft of the book before the accident, a more timid version of what is laid out here. After the miracle of the event, I could see the book—what it needed to be—and knew that I needed to rewrite it almost completely with as much fire as I could muster. It needed to also be worth the effort to regain my life.

True appreciation for the inspiration that comes from the beyond transcends what I could possibly say here, goes beyond words. My profound thanks to all that is, with unspeakable joy, for the gift of life itself. I am so grateful to have the ability to contribute to this collective dance here together.

Some people in particular were an invaluable part of the mission of finishing this book. To incredible Cory Booker for profound love through the process of finalizing this manuscript, and for the joy of being expanded by the constant inspiration of your life and work. To my dream of an editor, Kathleen McDermott, for your patience and steadfast belief in this book when it was just an embryo of an idea. You stood there like a light I looked toward as I made my way through the material. I cannot possibly thank you enough for willing this book into existence. To Julie Carlson, I'm not sure where this manuscript would be without you. Immeasurable thanks to Jessica Williams Stark, my research assistant extraordinaire and emerging scholar, an absolute treasure. I am grateful to Christine Garnier, Layla Bermeo, Rachel Vogel, and Rachel Burke, all fantastic scholars whose research assistance as I combed archives was invaluable in the early stages of finishing this book, and to Ian Fowler at the New York Public Library for helping me find this project's keystone.

To Henry Louis Gates, Jr., for gently pushing me to write the book, for reminding me that this idea needed to be, and for his constant inspiration. To Nell Painter, for seeing that my idea was a full manuscript when I could not, for her sharp eye and absolute generosity, for the depth of her care and discernment, for modeling a well-lived life of the heart and mind. To Evelynn Hammonds for her steadfast support, fellowship, in all stages. To Chelsea Clinton Mezvinsky, for the reminder over the years to see this book through, not back down from the material, and to come with the fire of truth—and for her friendship throughout this process and beyond. To Joseph Koerner for always being willing to read and think alongside me. To Jeneé Osterheldt for constant light, true sisterhood, and held vision for this book. To Laura Lynne Jackson, who helped me keep the vision given to me for this book, you are a gift from the beyond. To Wynton Marsalis, for our meditations on form when I needed it most and the power of your example.

To my agent and my dear friend, Eric Simonoff, for advocating for me so deftly and reading my work with such care.

To my Harvard University colleagues in the Departments of African and African American Studies and the History of Art and Architecture, as well as in American Studies, Women, Gender, and Sexuality; to the Cullman Center for Writers at the New York Public Library; the Ford Foundation; the Hutchins Center for African & African American Research; and the Andrew Carnegie fellowship, all for the inspiration. To my parents, and the gift of having their constant belief. To my great students who remind me the future will not wait.

Some aspects of the research for this book were not straightforward, and not simply because so much of it is based on primary material. I mention this as a transparent presentation of what it actually took to write about, and gain access to, materials that expose fictions used to justify racial hierarchies in American life. I mention it because those experiences made me more grateful to have the care of others—from friends, to colleagues, to research assistants.

Fear has no place in the pursuit of truth. This book is dedicated to the forces, some in the form of dear friends who have passed, who remind me of that: Maurice Berger, Greg Tate, and Robert Farris Thompson among them. I learned before Maurice passed on that he had peer-reviewed this manuscript and asked the press to disclose this to me. He did not believe

in anonymous reviews. Our last conversation over dinner with his partner, Marvin Heiferman, was about this book.

This book began while I was a graduate student at Yale University and a doctoral co-advisee of Robert Farris Thompson, one of the first to believe in this project. One of the few people I shared this book with was Greg Tate, and he would check in about it when I needed it most. I dedicate this book to them both and the spirit of my grands and greats who inspire me onward: Shadrach and Ann, Margaret, Enoch, Shadrach Emmanuel Lee, Sarah Lewis of Antigua, and the countless others who gave rise to them.

In addition to those angels, there are more, though the full set of individuals I must thank are too countless to name. Many other friends offered fellowship; colleagues offered to read portions of the manuscript and attend work-in-progress talks; archivists often went above and beyond to help. They include: Andrea Achi, Courtney Baker, Tim Barringer, Robin Bernstein, Dorothy Berry, Suzanne Blier, Sarah Melvoin Bridich, Jennifer Brody, Daphne Brooks, Adrienne Brown, Vincent Brown, Kirsten Pai Buick, Sharese Bullock-Bailey, Garnette Cadogan, Huey Copeland, Junot Díaz, Elliot Bostwick Davis, Kimberly Drew, Caroline Elkins, Casey Gerald, Jarvis Givens, Rebecca Gould, Farah Griffin, Agnes Gund, Carla Hayden, Marvin Heiferman, Christine Jacobson, Matthew Frye Jacobson, Dodie Kazanjian, Robin Kelsey, Joseph Koerner, Amma Ghartey-Tagoe Kootin, Ewa Lajer-Burcharth, Shola Lynch, John MacKay, Sharon Macklin, Erez Manela, Christopher Myers, Nicholas Mirzoeff, Ingrid Monson, Alexander Nemerov, Temi Odumosu, Richard Powell, Jennifer Raab, Leigh Raiford, Petra Richterova, Jennifer Roberts, Will Schwalbe, Tommie Shelby, Doris Sommer, Paul C. Taylor, Hank Willis Thomas, Darren Walker, Laura Wexler, Careina Williams, Deborah Willis, and Matthew Wittmann. To Daniel Sanchez-Torres, I'm not sure where this manuscript would be without you (perhaps still on my computer).

To Shaka Abuko, Erica Collier, Mark Hyman, Raven Keyes, Ashley LaRosa, Louisa Mastromarino, Isis Medina, Janice Moynihan, Dean Ornish, David Nso, Luke Peretti, Jeff Rosenberg, and Dale—what would I have done without you all getting my instrument aligned so I could complete this assignment?

To those guides giving me nudges to follow up on what seemed to be the most irrelevant of things that ended up defining the entire book—thank you.

This book began by following up on an idea in a footnote in a book about the images of the Caucasus—some urge led me to look at what seemed a very unusual picture of a Circassian Beauty in the Beinecke Rare Book & Manuscript Library at Yale University one day.

The research ended when I followed an instinct to ask for a tour of Washington National Cathedral despite a pressured day filled with travel.

These were all just seemingly small nudges and instincts, and yet, in those visits, a new world emerged.

To the force from that unseen realm, I hope I felt it all. Thank you so.

ILLUSTRATION CREDITS

I.I. President Woodrow Wilson House. A Site of the National Trust for Historic Preservation, Washington, DC.

I.2. National Portrait Gallery, Smithsonian Institution; Frederick Hill Meserve Collection.

1.3*A*. Randolph Linsly Simpson African-American Collection. James Weldon Johnson Memorial Collection in the Yale Collection of American Literature, Beinecke Rare Book and Manuscript Library.

1.3*B*. Ronald G. Becker Collection of Charles Eisenmann Photographs, Special Collections Research Center, Syracuse University Libraries.

1.4. Prints and Photographs Division, Library of Congress, Washington, DC, LC-USZ62-128166.

1.5. Langston Hughes Papers. James Weldon Johnson Collection in the Yale Collection of American Literature, Beinecke Rare Book and Manuscript Library. Reprinted by permission of Harold Ober Associates. © Langston Hughes Estate.

1.6. Reproduction © National Portrait Gallery, London.

1.7. American Minstrel Show Collection, 1823–1947. MS Thr 556 (456), Harvard Theatre Collection, Houghton Library, Harvard University.

1.8*A, B*. Ronald G. Becker Collection of Charles Eisenmann Photographs, Special Collections Research Center, Syracuse University Libraries.

1.9. Olive Louise Dann Fund. Yale University Art Gallery. 1962.43.

1.10*A*. National Portrait Gallery, Smithsonian Institution, Frederick Hill Meserve Collection.

1.10*B.* Album / Alamy Stock Photo.

1.11*A.* National Portrait Gallery, Smithsonian Institution; Frederick Hill Meserve Collection.

1.11*B.* National Parliamentary Library of Georgia, Iverieli.

1.12. The J. Paul Getty Museum.

1.13*A.* Reproduced from Raphael P. Thian, "Illustrations to Part II" in *Documentary History of the Flag and Seal of the Confederate States of America, 1861–1865* (Washington, DC: 1880), plate 66.

1.13*B.* Reproduced from Raphael P. Thian, "Editorials, Communications, etc., Relating to the Confederate Flag and Seal, Appendix—Part III," in *Documentary History of the Flag and Seal of the Confederate States of America, 1861–1865* (Washington, DC: 1880), 30.

1.14. Bequest of Miss Adelaide Milton de Groot (1876–1967). The Metropolitan Museum of Art, New York. 67.187.131.

1.15. Reproduction © State Russian Museum, St. Petersburg.

1.16. Harvard Theatre Collection of playbills and programs from New York City theaters, ca. 1800–1930. TCS 65. Houghton Library, Harvard University.

2.1. Major Acquisitions Centennial Endowment. The Art Institute of Chicago, 1996.433.

2.2. Harvard Fine Arts Library, Digital Images and Slides Collection.

2.3*A.* Randolph Linsly Simpson African-American Collection. James Weldon Johnson Memorial Collection in the Yale Collection of American Literature, Beinecke Rare Book and Manuscript Library.

2.3*B.* Ronald G. Becker Collection of Charles Eisenmann Photographs, Special Collections Research Center, Syracuse University Libraries.

2.4*A, B.* Ronald G. Becker Collection of Charles Eisenmann Photographs, Special Collections Research Center, Syracuse University Libraries.

2.5. Artefact / Alamy Stock Photo.

2.6*A.* Harvard Art Museums / Fogg Museum, Kate, Maurice R. and Melvin R. Seiden Purchase Fund for Photographs. P2004.6. Photo © President and Fellows of Harvard College.

2.6*B*. Harvard Art Museums / Fogg Museum, Transfer from Special Collections, Fine Arts Library, Harvard College Library, Bequest of Evert Jansen Wendell. 2010.86. Photo © President and Fellows of Harvard College.

2.7. Alexander Pushkin Museum and Memorial Apartment, St. Petersburg, KP-8105.

2.8. Image courtesy State Tretyakov Gallery, Moscow.

3.1. Gift of Miss Alice Hooper, Museum of Fine Arts, Boston, 76.296. Photograph © 2024 Museum of Fine Arts, Boston.

3.2. Photograph © 2024, Museum of Fine Arts, Boston.

3.3. Collection of the University of Kentucky Art Museum. Bequest of William P. Welsh.

3.4. Frank Duveneck Collection, Mary R. Schiff Library & Archives, Cincinnati Art Museum.

3.5. Photograph by Malcolm Farmer. Image provided by the Museum of Us, P000036.

3.6. 91_18564-2894, Ralph P. Stineman Collection, San Diego History Center.

3.7. Henry Lillie Pierce Fund. Museum of Fine Arts, Boston, 99.22. Photograph © 2024 Museum of Fine Arts, Boston.

3.8. Reproduction courtesy of the Pennsylvania Academy of the Fine Arts, Philadelphia. Joseph E. Temple Fund, 1894.1.

3.9. Prints and Photographs Division, Library of Congress, Washington, DC, LC-DIG-stereo-1s02994.

3.10. Gift of Charles Anthony Lamb and Barea Lamb Seeley, in memory of their grandfather, Charles Rollinson Lamb, 1979. Metropolitan Museum of Art, New York. 1979.394.

3.11. Collection of the Smithsonian National Museum of African American History and Culture.

3.12. Gift of David and Victoria Croll, Museum of Fine Arts, Boston, 2012.131. Photograph © 2024 Museum of Fine Arts, Boston.

3.13. Photograph courtesy of the author.

4.1. Digital image © The Museum of Modern Art / Licensed by SCALA / Art Resource, NY.

4.2. The Lionel Pincus and Princess Firyal Map Division, The New York Public Library.

4.3. The Lionel Pincus and Princess Firyal Map Division, The New York Public Library.

4.4. The Lionel Pincus and Princess Firyal Map Division, The New York Public Library.

4.5. The Lionel Pincus and Princess Firyal Map Division, The New York Public Library.

4.6. Digital image © The Museum of Modern Art / Licensed by SCALA / Art Resource, NY.

4.7. Prints and Photographs Division, Library of Congress, Washington, DC, LC-USZ62-138996.

4.8. David Rumsey Map Collection, David Rumsey Map Center, Stanford Libraries.

4.9. The Lionel Pincus and Princess Firyal Map Division, The New York Public Library.

4.10. Photo © Greg Leshé.

4.11. Photo © Greg Leshé.

4.12. Prints and Photographs Division, Library of Congress, Washington, DC, LC-DIG-ppmsca-33863.

4.13. Harvard Art Museums / Fogg Museum, Transfer from the Carpenter Center for the Visual Arts, Social Museum Collection, Photo © President and Fellows of Harvard College, 3.2002.2395.

4.14. UAV 800.150.5p, olvwork 369292, Harvard University Archives.

4.15. W. E. B. DuBois Papers, Robert S. Cox Special Collections and University Archives Research Center, UMASS, Amherst Libraries.

4.16. Catharine Lorillard Wolfe Collection, Wolfe Fund, 1906. The Metropolitan Museum of Art, New York. 06.1234.

4.17. Image © The Metropolitan Museum of Art. Image source: Art Resource, NY.

4.18. American Antiquarian Society.

5.1A, B. Kendrick-Brooks Family Papers, Library of Congress, Washington, DC.

5.2. National Park Service (FRDO 11001).

5.3. Prints and Photographs Division, Library of Congress, Washington, DC, LC-DIG-ppmsca-33933.

5.4. Prints and Photographs Division, Library of Congress, Washington, DC, LC-USZ62-108282.

5.5. Prints and Photographs Division, Library of Congress, Washington, DC, LC-DIG-ppmsca-40861.

5.6. W. E. B. Du Bois Papers, Robert S. Cox Special Collections and University Archives Research Center, UMASS Amherst Libraries.

5.7. The Miriam and Ira D. Wallach Division of Art, Prints and Photographs: Photography Collection, The New York Public Library.

5.8. Museum of Fine Arts, Boston, The Heritage Fund for a Diverse Collection, 2018.472.

5.9. MARELBU / Wikimedia / CC BY 3.0 DEED.

5.10. Prints and Photographs Division, Library of Congress, Washington, DC, LC-DIG-ppmsca-33883.

5.11. Prints and Photographs Division, Library of Congress, Washington, DC, LC-USZC4-4734.

5.12. Box I: C360, folder 4, National Association for the Advancement of Colored People Records, Manuscript Division, Library of Congress, Washington, DC.

5.13. Prints and Photographs Division, Library of Congress, LC-DIG-ds-00894.

5.14. Bettmann Archive / Getty Images.

5.15*A, B.* Courtesy Rennie Collection, Vancouver, photographer: Blaine Campbell. © Kerry James Marshall. Courtesy of the artist and Jack Shainman Gallery, New York.

5.16*A.* Harvard Art Museums / Fogg Museum, Transfer from the Carpenter Center for the Visual Arts, Beinecke Fund © Gordon Parks Foundation, Photo © President and Fellows of Harvard College, 2.2002.1000.

5.16*B.* Digital image © The Museum of Modern Art/Licensed by SCALA/Art Resource, NY.

E.1*A.* Photo © 2023 The Associated Press.

E.1*B.* Photo © Jared Soares.

INDEX

Figures are denoted by *italicized* page numbers. Endnotes are denoted by n and note number following the page number.